MW00476967

——————— PHOTOPOETICS AT TLATELOLCO ———————

Border Hispanisms
Jon Beasley-Murray, Alberto Moreiras,
and Gareth Williams, Series Editors

PHOTOPOETICS AT TLATELOLCO

Afterimages of Mexico, 1968

SAMUEL STEINBERG

UNIVERSITY OF TEXAS PRESS
Austin

Copyright © 2016 by the University of Texas Press

All rights reserved
Printed in the United States of America
First edition, 2016

Requests for permission to reproduce material
from this work should be sent to:
Permissions
University of Texas Press
P.O. Box 7819
Austin, TX 78713-7819
http://utpress.utexas.edu/index.php/rp-form

♾ The paper used in this book meets the minimum requirements of
ANSI/NISO Z39.48-1992 (R1997) (Permanence of Paper).

LIBRARY OF CONGRESS CATALOGING-IN-PUBLICATION DATA
Steinberg, Samuel (Assistant professor of Spanish), author.
Photopoetics at Tlatelolco : afterimages of Mexico, 1968 /
Samuel Steinberg. — First edition.
pages cm — (Border Hispanisms)
Includes bibliographical references and index.
ISBN 978-1-4773-0548-5 (cloth : alk. paper)
ISBN 978-1-4773-0748-9 (pbk. : alk. paper)
ISBN 978-1-4773-0749-6 (library e-book)
ISBN 978-1-4773-0750-2 (non-library e-book)
1. Tlatelolco Massacre, Mexico City, Mexico, 1968. 2. Tlatelolco
(Mexico)—History. 3. Student movements—Mexico—
Mexico City—History—20th century. 4. Mexico—Politics and
government—1946–1970. 5. Documentary films—Mexico—
History—20th century. 6. Mexican literature—20th century—
History and criticism. I. Title.
F1386.4.T597S74 2016
972'.530831—dc23
2014044824

doi:10.7560/305485

To Natalia and Aura

CONTENTS

ACKNOWLEDGMENTS

Every book encrypts a history far more collective than the proper name that eventually imposes itself on its contents. In the acknowledgments the writer hopes to unencrypt that collectivity and yet simultaneously he opens himself to the anxieties proper to the archive: something will be left out.

I began thinking about 1968 as an undergraduate at Santa Cruz, where my professors were Jonathan L. Beller, Christopher Breu, Christopher L. Connery, and Norma Klahn; at Irvine, where I began a PhD in comparative literature, Luis Áviles, Adriana Johnson, Horacio Legrás, and Jane Newman patiently mentored me. The first identifiable traces of this manuscript emerged as a dissertation at Penn. I am grateful to my committee—Reinaldo Laddaga, Gabriela Nouzeilles, and Michael Solomon—for reading this material at an embryonic stage, and also to Carlos J. Alonso and Eunice Rodríguez Ferguson, who supported my work in my first years there.

Since arriving at the University of Southern California in 2012, I have enjoyed the generous research support of the Dornsife College of Letters, Arts and Sciences; I am particularly grateful to the office of the Dean of Dornsife for special assistance in the final stages. I have been extraordinarily fortunate to work with truly wonderful colleagues in the Department of Spanish and Portuguese: Roberto Ignacio Díaz, Erin Graff Zivin, Julián Gutiérrez-Albilla, Brenno Kaneyasu Maranhao, Natalia Pérez, and Sherry Velasco. Likewise, I thank Peggy Kamuf, Akira Lippit, and Pani Norindr for their interest and their keen advice. Amelia Acosta provided patient assistance in this endeavor and in many others.

Beyond the intellectual debt I owe to the Border Hispanisms series editors, I am grateful to Jon Beasley-Murray, Alberto Moreiras, and Gareth Williams for believing in this project and nurturing it. My editors, Theresa May and Kerry Webb, have been a joy to work with. My writing is infinitely more readable thanks to Kathy Bork's attentive

copyediting. Francis Alÿs, Rafael Lozano-Hemmer, UNAM's Filmo-
teca, and Revista Proceso generously granted permissions for images re-
produced here. Marco Dorfsman revised and improved upon my trans-
lations into English of quoted materials. Ryan Long, Ignacio Sánchez
Prado, and Gareth Williams read the entire manuscript, and their kind
suggestions and at times ruthless criticism improved this book immea-
surably; indeed, I prefer not to imagine what this project might have
been without their wisdom, grace, and enthusiasm. I alone bear the re-
sponsibility for whatever in it remains insufficient. I am very grateful as
well to John Beverley for having provided this project a push at just the
right moment, and to David E. Johnson for likewise offering encourage-
ment, advice, and criticism when it was greatly needed. And thanks to
David, the book has the subtitle it does.

My friends were my first interlocutors, and then my interlocutors be-
came my friends. While I cannot be exhaustive, the following individ-
uals were instrumental to the completion of this work: Bram Acosta,
Roger Bellin, Hall Bjornstad, Anna Cox, Paula Cucurella, Hernán
Díaz, Craig Epplin, Francisco Goldman, Carl Good, Sergio Gutiérrez
Negrón, Edgar Illas, Kate Jenckes, Jacques Lezra, Juan Carlos López,
Pedro Ángel Palou, Phillip Penix-Tadsen, César Pérez, Nic Poppe,
Brian Price, Rachel Price, Justin Read, Dierdra Reber, Jaime Rodrí-
guez Matos, Sonia Velázquez, and Sergio Villalobos-Ruminott. A spe-
cial note of thanks is owed to Patrick Dove and Erin Graff Zivin, exem-
plary mentors and dear friends, through thick and thin.

I am grateful to my family and to two women in particular: my
mother, Elaine, whose books by Leonard Cohen and records by Richie
Havens and Gil Scott-Heron made me responsible to this legacy, and to
my sister-in-law Gabriela, who has given me asylum, *mezcal*, keen ad-
vice, and endless political debate in Mexico City for more than a decade.

This book was thought about and written over many years and
through frequent geographical displacement: the constant in my life
since Irvine has been Natalia. She and our daughter, Aura, have made
me happy: roof, brick, and door. To them I dedicate this book.

Earlier versions of material contained here were published as "Re-
cinema: Hauntology of 1968," *Discourse* 33, no. 1 (2011): 3–26; "'Tla-
telolco me bautizó': Literary Renewal and the Neoliberal Transition,"
Mexican Studies / Estudios Mexicanos 28, no. 2 (2012): 265–286; and "Pol-
itics of the Line," *Política Común* 2 (2012), http://hdl.handle.net/2027
/spo.12322227.0002.005.

PHOTOPOETICS AT TLATELOLCO

INTRODUCTION

We have not been defeated . . .

JOSÉ REVUELTAS

In filming *El grito* (1968), Leobardo López Arretche could not have known that he was performing a task that would become fully archival, much less that its very circumstances would change, that our world would return to its habits, and that his name would become the signature of a film that was, in fact, collectively produced.[1] That destiny of working, living, thinking, and being-in-common is precisely what is at stake in the present book. Composed of diverse materials (moving images, photographs, sounds, communiqués, speeches, and testimonies transmitted both diegetically and extradiegetically), *El grito* offers a certain archival coordination, edited, as it was, not long after the end of Mexico's 1968 student-popular movement.

That, too, is what is at stake here: reflection understood as secondary revision, reflection always in the "uncertain light" of what we might properly call afterlife, for the final production and appearance of *El grito* is ruled by the violence that ended the student movement.[2] Each moment of protest, of excitement, of experience, or of experiment that *El grito* captured can only lead to the grisly moment that organizes it; I would, like the film, prefer to linger for as long as possible on that moment-before. Yet the film announces a central inquietude—which is also to be our own—from the very beginning: How are we to think of such a moment-before?

El grito begins with moving images of students who have not yet entered the time of crisis. Their lives are as they were: young people walking to class, resting, conversing with their friends. A voiceover narrates the origins of the student movement even as these students seem unaware of what will come. And yet, the footage is interrupted by a series

of still images of the initial acts of repression that partially instigated the uprising, set to the extradiegetic sound of marching and then that of typewriters clacking. The opening sequence thus forecasts what is to come, for it knows what is to come.

What is to come: toward the end of the documentary, an intertitle reads "octubre," and thus the film begins its narration of the act that rules it. Moving images capture the beginning of a meeting on the Plaza de las Tres Culturas, where it is decided that the intended itinerary of the students' march has become too dangerous, for the protesters have found themselves surrounded by military forces. The leaders ask the students to return home—reports the voiceover—as the sound of helicopter blades rises. The documentary then returns to still images to document the fall of the flares dropped by helicopters that were to signal the beginning of gunfire.

The massacre as such is not seen or made visible: only its preparation, its surroundings, its aftermath. A division is presented between the moving image and the photograph on which it is based. As John Mraz puts it: "The moving footage often appears to limit itself to simply presenting events, a result no doubt of the participation of so many different cameramen with greatly varying experience. However, the edition of still photographs and the soundtrack are a searing indictment of the army and police, as well as the president and ruling class, for their role in the repression."[3] On this account, the still image becomes a critique of the continuity and consensus of the moving image. What happens on the square is thus, as Georges Didi-Huberman suggests in the context of holocaust photography, *"only imaginable."* The images we have are somehow "deficient," for which reason, as Didi-Huberman puts it, we must "try to understand their necessity through their very function of remaining deficient."[4] The place of the still image in reflection on 1968 is thus to hold the viewer at a critical distance, to submit the event to the standstill (the Benjaminian "zero-hour," or *Stillstellung*) required by imagination and critical thought.[5]

The documentary turns then to the opening of the Olympic Games (through, to be sure, the Games' representation in the moving image) as the film's double ending set to the tune of yet another kind of march. That march is once more suggested by the extradiegetic sound of a dissonant funereal procession, which then modulates itself to the triumphant tones of Mexico's achieved modernity, which now can only be read as sadly ironic. In a second ending, the closing credits play to Oscar Chávez's passionate rendition of the song "Mexico '68" while they are

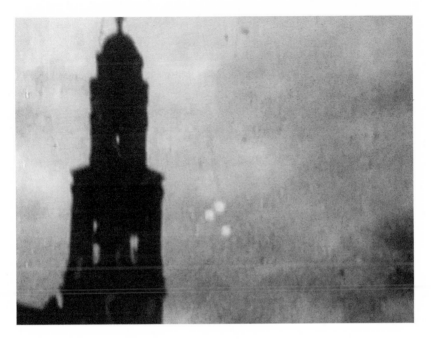

FIGURE O.I
Still from El grito, dir. Leobardo López Arretche, 1968.

intercut with footage—moving images of a still pose—of a child facing the camera and making the "V" with his fingers.

It thus bears underlining that despite its having been organized retrospectively by a catastrophic still image, we find no visual account of the massacre as such, only its suggestion or index in the photograph of the flares that precede it. A more complete account would only come to light in time for a later, forensic, and thus even more highly archaeological documentary, *Tlatelolco: Claves de la masacre* (dir. Carlos Mendoza, 2003), which uses newly available footage shot on the square that day by government photographers and cinematographers in order to prove beyond all doubt the state's responsibility for the mass crime.

I argue here that Tlatelolco is itself the site of a photo-graphy, a making with light that I call "photopoetics." The recovered footage of the massacre on which *Tlatelolco: Claves de la masacre* centers makes visible the terrifyingly literal nature of my suggestion. As the students run about, panicked, on the ground in front of the Chihuahua Building, where it all took place, there reads the sign of a local business, a lapidary

statement for the present volume: "Foto estudio." This study should be read in the light of that coincidence.

The thing we call 1968 has until now been bound to reflection in a hegemonic key: finding or discerning its points of unity, discussing, cataloguing, and, too often, hastily resolving its contradictions, producing—finally, we are always promised—its definitive archive, the better to arrive at its truth. In the present study, while I have learned from previous work, I hope to proceed differently by occupying 1968 as itself a theoretical practice of a piece with and perhaps in some ways even anticipating the so-called posthegemonic turn: posthegemony, as Alberto Moreiras puts it, "establishes itself, as theoretical practice, in the place of indifferentiation between theory and practice."[6] José Revueltas, perceived intellectual architect of the student-popular movement, comes closest to such a conception when he writes of the uprising as the site for a new university whose guiding principle would be the form of thought-praxis that he called "autogestión," which we might translate, though quite insufficiently, as "self-management." In "autogestión," argues Revueltas, "the collective consciousness is expressed."[7] That notion of "collective consciousness," however, would be fundamentally agonistic, without consensual claim, without hegemonic demand or hegemonizing desire. As Revueltas puts it: "Collective consciousness does not mean uniformity or regimentation, but, rather, the freedom of tendencies, confrontation, self-confrontation."[8]

Yet as an unintended illustration of the very difficulty of producing and sustaining *autogestión*, the volume containing Revueltas's writings on 1968 reproduces the text "Nuestra bandera," signed by the Comité de Lucha de la Facultad de Filosofía y Letras and dated 26 August. The text bears a striking resemblance to the response (of 3 September) of the Consejo Nacional de Huelga (CNH) to President Díaz Ordaz's rather threatening Informe Presidencial of 1 September: "It has been said that the Student Movement (Movimiento Estudiantil julio-agosto) lacks a flag—that is, clear objectives or 'high sights' . . . They're trying to create a smokescreen that obscures not only the real content of our proposals but their root and reason."[9] Remarkably, the text reproduced in the Revueltas collection does not coincide directly with the way in which the movement is named in the CNH's own direct response ("el movimiento estudiantil comenzado en julio"), nor do the two texts follow the same itinerary for more than a few paragraphs. Above all, the CNH's text responds to the state's claim that the movement is somehow illegitimate, and does so in the mode of marking its reasonable demands. Revueltas's

text, however, mounts a rather passionate diatribe and concludes, returning to the question of the "bandera" with which both texts begin: "We are a Revolution! That is our flag."[10]

Such a decision in favor of some "regimenting" instance, symbol, or signifier partly belies the posthegemonic practice that Revueltas invokes in the writings on *autogestión*, and yet, it also resolves it without resolution: the movement's flag, its image, is something yet to come. From the beginning of the struggle its very thinkability is framed by the tension between what one might call, however provisionally, the anomic constituency on the street and the nominalism that would like to claim it and claim *for* it some demand.[11] However, despite Revueltas's own proposal, as if to introduce yet another spiral, he himself seems to most often refer to the movement as the "Movimiento Estudiantil julio-agosto," quite contrary to its reduction to any pragmatic "flag," or its bequeathal, in a more radical reading, to the project of its own futurity ("a Revolution"). For our purposes, this reductive procedure assumes its final form through the name of the date (2 October 1968) on which the massacre occurred or in the name of the place (Tlatelolco) where it occurred.

Thus ends the search upon which Revueltas set out for the production of the name of what happened or what might happen, the hegemonizing impulse to consign it to a classifiable body, or legible image, and produce its archive. The student-popular movement raises the flag on a most dramatic posthumousness, which would impose itself following the massacre of 2 October and the movement's official dissolution, decided by the CNH, that December. If representation is a kind of repression or mortification, 1968 in Mexico assumes the mortifying form of its *own* mortification. *Photopoetics at Tlatelolco* is nothing more than an attack on that legacy of double mortification, along with a modest proposal that we do things a bit differently.

For his part, Mark Kurlansky begins his popular world history of the year with the assertion that "there has never been a year like 1968, and it is unlikely that there will ever be one again."[12] Rather than writing, as perhaps he intends, that 1968 is a unique, unparalleled, seemingly unrepeatable world-historical experience, Kurlansky betrays a deeper, more symptomatic, and also more interesting way of approaching 1968. The statement is as ambiguous as the year it describes: "There has never been a year like 1968," he writes, curiously omitting or forgetting the "another"—"There has never been *another* year like 1968"—that would assure the statement's reference to a kind of repetition, reenactment, reactivation, or return that has not occurred, that perhaps will not occur.

Rather, as it stands, the reader faces the possibility that there has never been a year like 1968, that 1968 was not like 1968, that 1968 did not occur. "There has never been a year like 1968," that is, a year like the 1968 that we think of when we think of 1968, like the 1968 that is invented in the unfolding of Kurlansky's book, or, indeed, in the unfolding of any thought that hopes to encounter 1968 in the cinder we call its afterlife. Kurlansky points thus to the singularity of 1968 and also to its nonexistence. The year stands not only as a youth rebellion on a global scale, as he puts it, "a spontaneous *combustion* of rebellious *spirits* around the world," but also a youth rebellion that turned on unlikely alliances and, most important, on a student-worker alliance "of temporary convenience . . . quickly dissolved."[13] For Kurlansky, as for many others, 1968 hinges on this singularity and its nonexistence—a spontaneous combustion and a quick dissolution, the seeming impossibility of its own event. On this account, 1968 stands now as the time preceding a fall (and, in Kurlansky's seasonally organized book, also an autumn), the time of hope before today, when, as Kurlansky puts it, "even the idea of new inventions has become banal."[14] After 1968, we can be sure that nothing else will happen. It is the hinge of a certain history, just at the end of a politics that would seem to have deserved that name, before our "disoriented" present.[15]

Kurlansky's observation offers an accidental citation of Gilles Deleuze, who writes, in a brief essay with the same title, that "May '68 Did Not Take Place." Writes Deleuze: "There is always one part of the *event* that is irreducible to any social determinism, or to causal chains. Historians are not very fond of this aspect: they restore causality after the fact. Yet the event is itself a splitting off from, or a breaking with causality; it is a bifurcation, a deviation with respect to laws, an unstable condition which opens up a new field of the possible."[16]

At times, I am astounded at the simplicity of the task I claim as this book's endeavor, which is precisely the demarcation of an absence of the thing that did not take place, even as that thing—in the guise of something else—is constantly unburied and covered over in archival dust, as it is submitted to perverse lamentations and melancholy sciences, as it is explained, imaged, retrieved, and reterritorialized. In the face of that archaeology, of that archive, I can only follow Deleuze: Mexico, 1968 did not take place (or, again, as Kurlansky puts it, "There has never been a year like 1968").

Yet, to be sure, something did take place, and it took the place of what *did not take place*. On 2 October 1968, only ten days before Mexico

City was to host the Summer Olympics, a helicopter dropped flares over the Plaza de las Tres Culturas, cuing paramilitary forces to open fire on the square, where several thousand participants in the Mexican student-popular movement had assembled. The regular military forces returned fire, and in the ensuing battle a still uncounted number of people fell. Because the movement did not fizzle out—or, put more cynically, because it did not live long enough to betray itself—2 October 1968 marks both a tragic act of state-sponsored terror and a moment of unrealized possibility for the birth of a new world. It marks this possibility and recalls this hope globally (Paris, Prague, Tokyo, Berlin, Chicago, and so on) by witnessing the formation of a new politics and also the proliferation of oppositional cultural formations and alternative approaches to social being. The present reflection thus sets out in the ruins of Tlatelolco in order to think—today—not what remains of that past, but *how* it has passed. In these pages I attempt not so much to catalogue as to read symptomatically the ways in which the Mexican student-popular movement of 1968 and its violent crushing at Tlatelolco are remembered, forgotten, betrayed, and avenged in contemporary political thought and aesthetic production.

What is referred to in the texts I read as "Tlatelolco," "1968," or the "Mexican student movement" is the subjective figure of a process, real or imagined, after which this book situates itself, which frames the period from 1968 to the present; a rethinking of that process would be a first condition for understanding the contemporary forms of relation between art and politics in light of the seeming decline of the Mexican sovereign power's historically immense capacity to explicitly organize that relation, as a result of the discredit it faced following 1968, throughout the major democratizing events that 1968 supposedly initiates, and through the neoliberal transition.[17] Naturally, I will be taking none of that for granted, either, but such an investigation, I think, is central to accounting for the afterimage of 1968.

We are not really certain what is an event. The year 1968 teaches us that this uncertainty is, in effect, central to an apprehension of the evental or eventful. As Kurlansky correctly notes, in 1968, Mexican students, like their global counterparts, were in the process of forming alliances with workers. Their struggle has been read as a simple democratic challenge posed to decades of domination by Mexico's "revolutionary" party, the PRI, as a youthful diversion, as a first opening to neoliberal freedom, as part of an unfolding toward the communist horizon, or as something more nameless still. In the light of its violent repression on 2 October

7

1968 at the hands of Mexican state power, the struggle's legacy has been coded as a point of breakdown in the dominance of the PRI (and yet, has it broken down?), a watershed for the crisis of the Mexican state's sovereignty, and also as the tragic point of origin for the overly celebrated participatory social form of Mexican civil society. Again, I will try to take none of that for granted here.

The indecision regarding the movement's goals and its legacy suggests in what measure the forms of rebellion associated with the student-popular movement have been particularly difficult to articulate in Mexico, where the party-state formation has held such broadly inscribed power that it has been difficult to merely forge lines of difference in the hermeneutic circle of Mexican politics. Kurlansky's reading of 1968, while partially correct, is also, for this reason, insufficient, above all because it assumes the instrumentalization of tragedy and thus maintains the very form of historical thinking that has been the order of Mexican order. His account ends up repeating the gesture of so many other readings, beginning with what we might call the foundational reading offered by Octavio Paz, which I discuss at length in the first chapter. Accordingly, the massacre founds or continues a narrative of Mexican history, understood as progress through sacrifice: "Tlatelolco was the unseen beginning of the end of the PRI."[18] Such an appropriative reading inserts the violent crushing of a prodemocratic movement into the narrative of progress (toward democracy) and thus redeems the violence at its center. Violence is transformed into nonviolence by mere ideology: "The PRI was voted out of power, and it was done democratically, in a slow process over decades, without the use of violence."[19]

In a similar key, Mexican anthropologist Roger Bartra has written of the dual legacy of 1968/Tlatelolco along the following lines: "1968 has left us with two legacies: defeat and transition."[20] The transition he refers to is, again, the slow, ongoing "democratic transition" in Mexico, once seemingly confirmed by the twelve-year ouster of the PRI from presidential power, from 2000 to 2012. Yet to assert the duality of this legacy as if there were some twin face of the coin at work conceals a rather disturbing homology: defeat is precisely transition. And, moreover, as recent events make even clearer, transition is not simply "democratic transition" but something that is still quite obscure.

Given, then, the extent to which this "transitional" process is both slow and also extremely violent (and that there seems to be ample reason to doubt the PRI's exit from power), any link between the slow process of so-called transition to 1968 and the massacre should be read in a fe-

tishistic register. Rather, one should consider the very slowness of transition as a result of the massacre: the PRI's endurance benefited from the massacre, which is to say, against dominant accounts, not that "Tlatelolco was the unseen beginning of the end of the PRI" (a statement in which perhaps every word is now highly questionable) or that there was any miscalculation on the part of Mexican state power, but that the massacre itself was successful in protecting the state and the interests it represented from its real enemy: the student-popular movement.

One of the most significant scholarly studies of 1968 to have been published in English, Elaine Carey's *Plaza of Sacrifices*, partially repeats this gesture, concluding that "the 1968 Mexican student movement was a window into the future of Mexico, and it continues to be a watershed event."[21] Carey's study admirably combats the reductive field in which 1968 has been read by, on the one hand, insisting on how the 1968 movement proved decisive for the reconfiguration of gender politics in Mexico, and, on the other, producing the history of 1968 on the horizon of its *longue durée* and its broader territorial purview, emphatically constructing a constellation of social and political struggles from the late 1950s and into the 1970s and beyond the confines of Mexico City.[22] Leaving aside the reductive field that might be suggested by Carey's title, itself a return to the plaza, her book opens a certain unbinding of the movement's existence from a hegemonic territoriality and temporality. Yet despite the book's cited insistence on the movement's particular *actuality* in the present, it does not sufficiently open itself to reflection on what are here conceived to be the central theoretical categories that impinge on such an actuality: democracy, progress, transition, and, perhaps above all, neoliberalism.

On some level, one should regard such tendencies not as a theoretical failure of the Mexicanist humanities as such. While scholars in the social sciences have been writing about Mexico's neoliberal and democratizing tendencies since at least the presidency of Carlos Salinas (1988–1994) and, depending on one's periodization of those processes, perhaps even long before, the Latin Americanist humanities have largely failed to aver the kind of powerful theoretical speculation with respect to the Mexican transition that has for years been the norm in Southern Cone studies.[23] This is owed, as I intimate above, to the almost exaggerated illegibility of the historical trajectory that constitutes the so-called Mexican transition and also the obscurity with which those events have been received. Mexican dictatorship is itself never fully intelligible as a repressive regime utterly bound to the order of order, which, historically,

maintains the only guarantee, however symbolic or strategic that promise appears to be now, of social reconciliation, racial equality, or economic justice. Indeed, the PRI held what remained of the legacy of the Mexican Revolution, and the 1917 Constitution's demands for agrarian reform and the redistribution of wealth and justice, in near exclusivity. As Soledad Loaeza has noted: "Compared with other authoritarian regimes, the Mexican one had the advantage of revolutionary origins, which allowed it to claim a popular representativity at the level of the state, rather than in open elections."[24]

While it preserved the names of revolutionary figures like Emiliano Zapata in the pantheon of national heroes, however, the PRI did not generally pursue his demand for land and freedom beyond the mere capture of that rhetoric. This rhetoric, in turn, was deployed in order to assert the PRI's claim to be the embodiment of popular sovereignty, which it alone commanded for some seventy years—until late 2000—as the ruling official party in Mexico, and which it now commands even more perversely following its reentry after twelve years of exile from the presidency, a period throughout which it nevertheless continued to dominate state politics.[25] PRI fashioned itself as the guarantor of the claims of the Mexican Revolution, in effect, asserting itself as an edifice that subsumed the plurality of political desires for which the various combatants in the Revolution (and, indeed, their enemies) struggled; that is to say, it represented the containment of Mexico's profound social antagonisms, holding "together," however tenuously and at great human cost, the war called Mexican society, sutured by the architecture of its twentieth-century state-form. As Gareth Williams puts it: "Modernity in Mexico was orchestrated by a total state that strived at all times to suppress the duality of state and society."[26] The Mexican state, its dispersed institutions, its sovereign ethos and effects have long held as a principal *razón de ser* the mediation of such contradictions and the containment of such divisions, a logic Bartra once described as the Mexican Leviathan: "It would seem, then, that the Mexican state maintains within its ample bosom groups of the conservative bourgeoisie, social-democratic currents, Marxists, Catholics, unions, peasants and middle classes, populists and the military: everything fits in the Mexican Leviathan."[27] Let us consider a recent and monumental attempt (to which I will turn again in the final chapter).

In Mexico City, in a museum housed in the former building of the Secretaría de Relaciones Exteriores, halfway down a long corridor, on

the right-hand side, the Memorial del 68 displays a dozen or so books.[28] These are the books, so it is said, that were read in 1968 by the students and perhaps also by some of the other participants in the popular uprising that occurred in the summer months of that year. The books are on display: texts not to be read but now the surface of an object that is referential in a different sense, the very body of a secret now behind glass and physically inaccessible to the viewer—the body of the secret of 1968. These books' selection, their appearance, their association, and the curatorial text that now binds them, however, all suggest that these tomes form a certain written archive of 1968, if in an unusual way. And yet their appearance under glass, their inaccessibility, must be made to stand in juxtaposition to books that are displayed in the Memorial, which are indeed legible, open, for at a point later in the exhibition (in a sense, after the exhibition) there is another hall, with tables and books chained to them. These are the books we will already have associated with 1968 in Mexico: volumes like *Días de guardar*, *Los días y los años*, *La noche de Tlatelolco*, and also the Memorial del 68's large catalogue. These books are the books we *can* read; they are not guarded behind glass. Their disposition at the Memorial del 68 suggests that their relation to the world, to 1968, to life and to history, will always be clearer and more evident.

Thus the Memorial offers an archival coordination that not only links place to history, but also offers something like a total interpretation of that history. The student movement is associated with global cultural and political phenomena as they are filtered through their particular reception in the Mexican context. Global anticolonial war, the Mexican national-popular state, the railroad workers' strike of 1959, and rock music are given as the diverse conditions of possibility for the student movement.[29] These books in the display case (in turn, largely divided between expressly radical political thought and writings of the Onda countercultural movement, of which José Agustín remains the most prominent accomplice) produce a contradictory image that is not easily resolved. This constellation of books offers, or is supposed to offer, the intellectual milieu of Mexican youth and perhaps obliquely suggests the very postpolitical aftermath in which the cultural field would in effect become the only site for what was properly political contestation.[30]

The relation of these books "read in 1968" to the actions of 1968 is therefore more obscure if also deeper (deeper, because it is buried and protected, but not only for that reason). Naturally, these books could never have told the story of 1968, could never have produced its archive

in the same sense that many of the texts I will engage here—Ramón Ramírez or, in a different way, Elena Poniatowska, or, in a fashion more removed still, Carlos Monsiváis—all sought to do. There is, from the beginning, the problem that the books were all published before 1968 was going on. They can never bear witness (or so it would seem) to that story for they necessarily anticipate its moment. These books can never exactly, faithfully tell the story of the times to come. So what is their story? There are twelve books here, Carlos Fuentes's *Cambio de piel*, Salvador Elizondo's *Farabeuf*, José Agustín's *De perfil*, and Jorge Ibargüengoitia's *Los relámpagos de agosto* among them. And yet one also finds here Ernesto Guevara's Bolivian diaries wherein we find collected the archive of a failed war. The first communiqué to the Bolivian people, as treatise or tract, but not as artistic formalization, convokes the subject of that struggle: "In publicly announcing the first battle of the war, we are establishing what will be our norm: revolutionary truth."[31]

The display case produces a relationship among twelve books that would be almost impossible to satisfactorily verify, and yet it would be perilous to ignore the suggestion it opens, for these diverse texts all foster a novel way of being, an experimental disposition. These principles of experimentation might be unified, emblematized, or archived in the body of Elizondo's *Farabeuf*; indeed, Elizondo's text perhaps more than Guevara's stands before these other texts as the secret code of their reading; this future archive was always what *Farabeuf* awaited. Or, rather, Guevara's text is not quite as different from its novelistic counterpart as it should be. Like *Farabeuf*, the Bolivian diaries produce in excess the logic of an archivization. Both texts, finally, could be said to pursue the retelling of a singular death and thus to explicate the relation between archive and mortification that is at stake here.

Those open books, on the other hand, the books chained to the tables in the hall at the end of the museum, offer something like an ekphrasis, understood according to the terms of Alberto Moreiras's reading of *Farabeuf* as a "postponement of meaning," which here achieves a spatial inscription, standing as the books do at the very end of the memorial exhibition.[32] *Farabeuf* is in this sense the key to interpreting the ekphrastic moment of so many books on 1968. Such postponement of meaning results from the faithfulness to its object that the work of ekphrasis proposes to carry out: too much fidelity, perhaps, even if the faithful will only have stared into the mirror image of the novel they are reading. *Farabeuf*, the reader will recall, begins with an "undeniable fact": "Re-

member . . .? It is an undeniable fact that precisely in the moment in which Farabeuf crossed the door's threshold, she, seated at the end of the hall, shook three coins in her cupped hands and then let them fall on the table."[33]

Through a series of nonchronological scenes, Elizondo explores a disturbing photograph of a man who is undergoing (who has just undergone) a grisly public execution during the Boxer Rebellion. Indeed, the photograph is said to capture the very instant of his death. It depicts the appalling scene of the Hundred Pieces, the death by torture of Fou-Tchou-Li, convicted of regicide. It is Dr. Farabeuf, Elizondo tells us, who has committed the event to film; Farabeuf, we learn, studied with Étienne-Jules Marey. In keeping with the scientific, kinesiological, and medical approach to optics that drove Marey, the narrator notes that photography is quite similar to surgery: they are both sharp.[34] They are both forms of cutting, of mutilating—the body, the visual field, the time of the event captured.

Just as the work posits its own duration through the repeated interrogative that opens, closes, and reappears throughout the novel—"Remember?"—a remarkable homology obtains between photographic means of impression and the horrifying act captured. Photography is surgical, as is the disturbing mutilation it commits to film. Mutilation describes both photography's formal procedures as well as, in this case, its object. The novel reproduces this image in the seventh chapter, when the event is said to take place, and this image evokes memory's surgical quality. In consignation to oblivion and also to the archive, the instant that concerns memory must be severed from the surrounding instants that do not.[35] Such capture proposes to be the event of photography. This procedure is a kind of repression or censorship that occurs even in advance of an institutional censorship.

Precision becomes necessity: "It is necessary to evoke everything."[36] The short novel turns on the relationship between some unquestionable fact to be extensively remembered, recounted, faithfully transferred from the imprint of memory or the imprint of photography (the two surfaces are, in Elizondo's text, contiguous) onto the place on which the novel is written. There, in the site of its narration, begins the demand also for "evocation." Beyond memory, it is necessary to summon or to conjure something more than what is in memory, indeed, all that is in memory, and all that one might conjure in its name. The certainty of incontestable facts shifts, in this instant, as it were, to the shadow of the event: "In

fact, it is not even possible to clarify the exact nature of that act."[37] Thus from "undeniable fact" the narration turns toward conjecture, a shadow or "uncertain light," to again borrow Elizondo's phrase.

A book mediates and archives what occurred, for there is always something in it that will have been extrinsic to it. Elizondo's text thus vacillates between event—a secret future that voids any possible calculation or determination in the name of its own unfolding—and ekphrasis—a past that is hidden from us in the moment of its telling. To make things more difficult still, a mirror, or a pane of glass that we cannot see through or beyond, has already consigned us to the present of our own reading and thus distorts any possible relation to a world, encrypting our relation *of* or *to* any truth. In other words, can we even tell that we are in the "foto estudio"? As Elizondo puts it: "Do you see? The existence of a huge mirror, with gilded frame, raises an essential ambiguity in our narration of the events."[38]

It is too clear now that even the most diligent or obsessive collection of facts ("unquestionable" though they are) cannot disclose without effacement, without destruction, the event it documents. At best it sets the stage for an imaginative re-creation or reenactment that once again merely proposes a representation, understood as the substitution of something by its likeness. The photograph at the center of Elizondo's narration (also Bataille's photograph) is thus both evidentiary and artistic; it both renders visible the torture and execution of a man who has participated in the Rebellion and presages the photo-graphic violence to unfold in Mexico just a few years later.[39] Hidden in the museum, Elizondo's novel offers a secret habitation, pushing the archival principle to its limit.

Photopoetics at Tlatelolco likewise inhabits the narration of Mexico, 1968 in order to unravel its order, to push it toward its limit, to establish against the archival principle an an-archival reflection. The study operates within the obscure legacy that 1968 has bequeathed: so often the standard-bearers of 1968 have imagined themselves to be speaking of a political event or emancipatory mobilization, but have, rather, ended up thinking about a massacre, for that is the "flag," to return to Revueltas's word, that we continue to raise to mark its event. The line of critique that runs through these pages traces how even the survivors and legatees of 1968 have submitted to the possibility that this crime itself might well open some new political formation. By means of a reflection on the sacrificial narrative that *encrypts* an event that took place around 1968, I will read the very work of memorialization as the second-order repres-

sion that followed the Mexican state's criminal violence, acts of literal and also symbolic encryption. In *Photopoetics at Tlatelolco* I thus hope to begin the task of a *secularization*, a reading against sacrificial reason and toward a more operative and open thinking worthy of 1968. In so doing, I pursue the critique begun by Gareth Williams of what he calls the "essentially Christian narrative of 1968 as inescapable martyrdom, sacrifice, and social trauma."[40]

The book roughly follows a chronological order in addressing the representation of 1968, for the story it tells is also that of the so-called Mexican transition. Mine is a highly selective account; its selectivity not only is necessary, but also hopes to serve as a corrective to the archival madness that I read symptomatically throughout the study. I do not aim to be exhaustive in this endeavor, for to do so would not serve my broad aims toward the development of something like a theory of the Mexican present founded in the symptomatic reading of 1968's afterimage. Put otherwise, the book's principle of organization is straightforward: each chapter takes up the genre (in order: essay, chronicle, *testimonio*, cinema, the novel, the plastic arts) that most forcefully expresses its particular juncture of the so-called democratic transition. With each chapter I will further displace the photo-trace and the object it indexes.

I should also note here that the book's theoretical engagement is likely susceptible to charges of a certain promiscuousness, and that is possibly justified. I will take the word "posthegemony" as the orienting horizon of the book's theoretical operation, because my book seeks to prolong the torsion between theory and practice. At the same time, it is no coincidence that the proper names that appear in my citations—if perhaps the theoretical sources more so than the so-called primary texts (though that is a ruse that I hope to expose as what protoposthegemonic thinker Carlos Monsiváis would call "emotional blackmail")—are largely thinkers engaged with or bound to the signifier 1968, if, most frequently, in another geographical context.

The first chapter reads the literal and figurative encryption of the student-popular movement at Tlatelolco through its topo-nomological registration. The term "topo-nomological" comes from Jacques Derrida in his discussion of the conflation of law and place in an archive that, once formed, will gather to itself the traces of 1968.[41] Reading 1968's reception in the work of writers as ideologically different as José Revueltas and Octavio Paz, I will begin to establish an alternative account of what occurred around the signifier 1968. As an alternative, this version of 1968 will try to be an-archival, that is, anomic and atopic. Hopefully, by the

end of the present study, the trace of *that* 1968 will remain, somehow, for the reader.

The second chapter reads Carlos Monsiváis's reflections on 1968 and focuses on the collection *Días de guardar*, one of the first books published on 1968, as a photo-aesthetic writing that preserves the days it marks—frozen in time, against mourning and against redemption. A somewhat inaugural text, *Días de guardar* remains one of the few that offers the tools to think critically about both sacrifice and democratic consensus as they become bound together by the long trajectory of reflection on 1968.

The third chapter continues to a reading of Elena Poniatowska's *La noche de Tlatelolco*, a testimonial work notable for its attempt to inscribe a new form of collectivity through the nascent civil society movement and thus announce a new kind of political and social being. Here I argue that Poniatowska's text, rather, constructs a restitutive narrative of Mexican peoplehood following the massacre at Tlatelolco, and that this narrative is of a piece with that of the state to which it is ostensibly opposed. The text no longer fears doing some injustice to 1968 through its very representation, but, rather, assumes the seemingly graver and more properly political injustice of the massacre at Tlatelolco. It takes up the massacre as a political duty and thus as a point of departure for a different politics of the nation under the avatar of civil society, which formalizes a compensatory political space in anticipation of the Mexican state's retreat from many of its former responsibilities.

The cinematic representation of the massacre emerged with the full-fledged onset of Mexico's neoliberal transition in the late eighties. While the fourth chapter reads a number of attempts to film Tlatelolco, it centers on the most significant and, indeed, the best such film, Jorge Fons's *Rojo amanecer* (1989), which I read as the symptom of its historical juncture; as cinematic reflection, Fons's film condenses the very process of postpolitical forgetting that is the requirement of its moment (that of Salinas's political transition). Cinema (as technology) brings the viewer through a continuous visual realization of transition in the rather literal, temporal sense that organizes the moving image as such.

The fifth chapter studies the relative lack of a "novel of '68" in Mexico. I argue that Jorge Volpi's 2003 *El fin de la locura* constitutes the final writing of such a novel, to appear some decades, now, after the events of that year. The double renewal pursued by Volpi's work is explored both as an intended restoration of the literary to a place of social privilege following the period of its perceived decline and as a conservative restora-

tion of police order in the neoliberal era following the revolutionary se-
quences of the twentieth century. However, I argue, Volpi's novel cannot
commit to artistic renewal without also confirming the madness of the
century. The text thus forges the future of the necessary return to 1968
as the site of an experiment in art and politics that is vital today. The lit-
erary renewal pursued in Volpi's text thus becomes the very political re-
newal that he seeks to avoid. Emancipatory politics returns, accidentally,
through the literary, to what was set aside both by the original repres-
sion at Tlatelolco and in the subsequent photopoïesis of its representa-
tion, which guides the critical operation of my book.

The final chapter takes as its point of departure the museum-based
reflection on 1968 that emerged in the 2000s and that found its first sig-
nificant expression in Olivier Debroise and Cuauhtémoc Medina's repe-
riodization of late-twentieth-century Mexican art. Opened at the Uni-
versidad Nacional Autónoma de México (UNAM) in 2008 and titled *La
era de la discrepancia: Arte y cultura visual en México, 1968–1997*, the exhi-
bition took its name from UNAM rector Javier Barros Sierra's defense of
the university's autonomy during the 1968 upheavals ("Nos atacan por-
que discrepamos. Viva la discrepancia" [They attack the university be-
cause we differ. Long live discrepancy, for it is the spirit of the univer-
sity. Long live discrepancy, because it allows us to serve]).[42] Studying
this periodization as a statement on the possibilities for art and poli-
tics after 1968, the chapter proposes a critical affirmation of the possi-
bilities of the political (artistic and otherwise) in the works of Belgian-
Mexican artist Francis Alÿs, centering on his 2002 project, *When Faith
Moves Mountains*, a collaboration with Medina. Reading the work as
anomic and atopic, unbound from law or place, I compare *When Faith
Moves Mountains* to Alÿs's *Cuentos patrióticos* (1997), an earlier and more
directly referential piece on 1968, which is on display at the Memorial
del 68. I engage the work through both recent theory and recent art crit-
icism (primarily the discourse around so-called relational aesthetics) in
order to read it, somewhat against the grain, as a kind of immaterial
monument to 1968, or, rather, the erasure of its monument in practice,
an an-archive of its past, a nonsite in which to rehearse and reactivate an
experimental being-in-common after Tlatelolco.

As Ryan F. Long puts it: "The shots the flare cued, intended to close
the book on a period of social conflict, instead initiated a process of in-
terpretation of that conflict and its revelations about Mexican poli-
tics that continues to reverberate almost 40 years after the shots were
fired."[43] The pages that follow capture this reverberation, allow it to in-

tone and resound. Despite its having been consistently awaited by Mexican writing and visual culture (not to mention Mexican society) over the last half century, the future that any representation of Tlatelolco promises will refuse to arrive, or will refuse to arrive on time. The object here is thus the unraveling of that story, an an-archival approach to 1968, which establishes itself between the archive and what escapes it, holding to a trace of what did not properly take place, to the possibility of the event, its limits, and also its futures, in order to, as Deleuze put it, "keep it open, hang on to something possible."[44]

ARCHIVE AND EVENT

. . . (because repression is an archivization) . . .

JACQUES DERRIDA

It is a question here, as with the coming of any event worthy of this name, of an unforeseeable coming of the other, of a heteronomy, of a law come from the other, of a responsibility and decision of the other—of the other in me, an other greater and older than I am.

JACQUES DERRIDA

The last half century has been visited by an enduring discomfort, a disturbance or out-of-jointedness that recalls the notable spectral invocation of political philosopher and novelist José Revueltas, written during his incarceration at Lecumberri for his having served as the "intellectual architect" of the 1968 disturbances: "A specter is haunting Mexico, our lives. We are Tlatelolco."[1] Quite soon after the massacre, the specter of an already too phantasmal place, and the events that took place there, has begun to haunt Mexico and "our lives." "Un fantasma recorre México" is an obvious reference to the opening line of the *Manifest der Kommunistischen Partei*: "Ein Gespenst geht um in Europa" (A specter is haunting Europe); Tlatelolco is the site that names an event that took place there, a site from which, or in whose name, an event haunts Mexico, not *only* the properly political event and not *only* the mass crime that continues to enclose and frame the possibility of an event for politics, but, rather, these two possibilities, confused from their beginning and consigned to and by the destructive light of Tlatelolco.

Conditioned by an insufficiency or lack with regard to the narrative framework that discloses 1968, 2 October marks both a tragic act of state-

sponsored terror and a moment of unrealized possibility for the birth of a new world. Reflection on this year invokes the very name of rebellion. 1968—Paris, Prague, Tokyo, Berlin, Chicago, and so on—forces our remembrance of the formation of a new politics and also the proliferation of oppositional cultural formations and alternative approaches to social being. Despite (or perhaps due to) the fact that the 1968 revolts today seem to have failed to bring into being the radically different order that they promised—that is, despite a superficial or "mediocre" democratization—the structures of Mexican power remain relatively unchanged.[2] The massacre on the Plaza de las Tres Culturas essentially ended the Mexican student-popular movement on 2 October 1968, and yet its moment organizes the archive of 1968; the photographic capture of this moment from all other moments establishes the principle of the historical, cultural memory of 1968.[3] This sacrificial image sutures Mexican history and regrounds Mexicanism, understood as the ideological proposal of an eternal Mexican peoplehood that underwrote the sovereign power of a diffuse Mexican state. The countervailing force of what I will call, following Revueltas, the "theoretical action" of the student movement pierces the surface engraved in the photo-graphic light of Tlatelolco.[4]

From this perspective, the massacre at Tlatelolco was the sovereign making-visible of 1968's desire and also its archival guarantee, which would long orient a pursuit of justice linked primarily to collective and public mourning, what Diana Sorensen has called the "collective memory of Tlatelolco and its powers of resistance."[5] We still have to put that notion to rest; for now, I return to Revueltas, who long ago stumbled upon the destiny of this signifier: "Tlatelolco . . . a story that will never end because others will continue writing it."[6] The story, whatever it is, will remain unfinished or open as long as it continues to demand that its writing continue. The seemingly unfinished nature of "Tlatelolco" thus resides in the obscurity of what the signifier hopes to name, the constitutive failure of its consignation to the name that rules over it. Its story will continue being written because the subjective name for whatever event occurred in 1968 has not yet satisfactorily emerged.

An encryption assures that what took place properly took place and has a place.[7] But what if 1968 did not take place and has no place? What if the thing we associate with the signifier 1968 can only be or remain in its very lack of place? Such is, ultimately, the wager that guides this chapter. What happened—or what might yet still occur—around the signifier 1968 serves as the horizon of the present reflection, framed by the tension between the event, on the one hand, and the archive, on

the other. What event might be archived? And what archive might keep that event *as event*?

Rather than assume the possibility of some popular archive, or some personal act of faith that would adequately permit the transit between archive and event and would do so with justice (and without at the same time necessarily denying the insights or the potentials of either one of those options), I will adopt a more speculative and perhaps also more negative method, influenced by subaltern studies in its most idiosyncratic and powerful form, and perhaps also its most originary, for it is in "The Prose of Counter-Insurgency" that Ranajit Guha convincingly suggests that the writing of the history of the nineteenth-century Santal Rebellion in India, even when committed to the archive by its more sympathetic writers, amounts to no less than a counterinsurgent prose, an appropriation of their struggle. Of such historiography (what Guha calls "tertiary discourse"), he writes "a prisoner of empty abstractions tertiary discourse, even of the radical kind, has thus distanced itself from the prose of counter-insurgency only by declaration of sentiment so far. It has still to go a long way before it can prove that the insurgent can rely on its performance to recover his *place* in history."[8] To be sure, however, it is not my claim that writing the history of 1968 is necessarily something like writing the history of the subaltern, nor to endorse a return to engagement with the field of subaltern studies, a question beyond the scope of my argument here. Rather, I follow Guha in this opening to the possibility of a thought of rebellion beyond the archive that domesticates or commits it to domiciliation. At the same time, still in a subalternist key, I am not suggesting that some other, more complete account of the thing we call 1968 would substantially liberate its legacy. Indeed, I will argue at length that the relentless—if necessary—pursuit of such a complete account should be regarded as symptomatic. Rather, its event, if there is an event, is precisely, as Gyan Prakash says of subalternity itself, encountered only as a textual "effect."[9] An "event" in this perspective—the event whose trace structure might be discerned—is that thing that is produced as a secondary effect of all attempts to authorize an archive; it is the effect of a certain technology of appearance.

However, though I am writing under the lingering influence of so-called subaltern studies, mine is surely not a subalternist book, and not only for fear of the seeming anachronism of that designation. The material that interests me here is the *visual* phenomenon that Georges Didi-Huberman describes, in a register that evokes the trace structure through which we encounter subalternity. "With the visible," he writes,

"we are of course in the realm of what manifests itself. The visual, by contrast, would designate that irregular net of event-symptoms that reaches the visible as so many gleams or radiances, 'traces of articulation,' as so many indices . . . Indices of what? Of something—a work, a memory in process—that has nowhere been fully described, attested, or set down in an archive, because its signifying 'material' is first of all the image."[10] It is thus necessary to engage the tense status of the signifier 1968 (and the signifiers around it) as both archive and event, as that which makes legible and also represses something that occurred in 1968, and that which simultaneously exceeds any name we would care to grant it. This splitting and slippage of the referent proper to the signifier (and also regarding the signifier proper to what event might have occurred) is at the very heart of the problem that will occupy us in the chapters that follow. Carlos Monsiváis identified this tension as problematically as was required when he wrote, in a late book of essays, "Unfortunately, and with troubling consequences [*resonancias interrumpidas*], the outward appearance and great symbolic shelter of the 1968 Student Movement is the Plaza de las Tres Culturas."[11] The mass crime of the student-popular movement's annihilation thus becomes the representative apparatus of what happened in 1968, its ill-fated promise of the event-to-come, obscured by the "media-theatricalized" crime of the Mexican state, which in turn comes to be misrecognized as a major event when it is merely a historical fact, to use Octavio Paz's formulation, "un hecho histórico."[12]

And yet, Monsiváis permits himself a characteristically difficult and perhaps also equivocal expression that evokes both the haunting of history, its perturbed or interrupted nature, and the "domiciliation" what occurred around the year.[13] The phrase itself is haunted by an interruption: "Unfortunately . . . the outward appearance and great symbolic shelter of the 1968 Student Movement is the Plaza de las Tres Culturas." My ellipsis elides this interruption, "and with troubling consequences [*resonancias interrumpidas*]," which severs the expected signification of these lines and illustrates the intractable problem it announces. The phrase is a crypt in the way that Jacques Derrida suggests: "The crypt is thus not a natural place [*lieu*], but the striking history of an artifice, an *architecture*, an artifact: of a place *comprehended* within another but rigorously separate from it, isolated from general space by partitions, an enclosure, an enclave. So as to purloin *the thing* from the rest."[14]

For a crypt is also the Plaza de las Tres Culturas: the place of buried bodies and also an encryption, "the striking history of an artifice, an *architecture*, an artifact." Monsiváis recalls how "Plaza de las Tres Cultu-

ras" is another metonymic substitution for 2 October 1968: the massacre itself is *sheltered* by the place-name of its site, its topo-nomological order. The massacre has come to obscure, conceal, and protect the memory of the more properly political *event* that it was intended to interrupt. Its own name cannot avoid being overdetermined by its site, which should be read as the symbolic shelter of a most enthusiastic and ambitious projection of modern Mexicanism.

The Conjunto Urbano Nonoalco-Tlatelolco was constructed in the mid-sixties, in what were then the northern reaches of Mexico City. A grand residential block, it was designed by Mario Pani, following Le Corbusier's principle of the *unité d'habitation* for dense population. A collection of layers, reducible, perhaps, to indigenous and Spanish substrata—indeed, a foundation for the house of the mestizo future it hoped to inaugurate—the apartments surround the Plaza de las Tres Culturas, *sheltering*, in *unité*, as Monsiváis suggests, the name of what event occurred in or near 1968, for there is also Tlatelolco, the name of a gruesome massacre that occurred there. As the plaza's name suggests, it houses three cultures; it archives the architectural artifacts that allow a progressive vision of modern Mexico's historical telos to unfold. It is this *consignation*, or gathering of signs, as Derrida describes it, that repeats itself across the substrata of the plaza and in the historical tragedy that repeats itself there. Consignation requires the placing or transfer of what is consigned, coming out of itself and into another place (external to itself). That consignation assures the iterability, the reiterability, and also the distribution and dissemination of what is consigned. And yet, because it is consigned and brought into the possibility of "memorization, of repetition, of reproduction, or of reimpression," it partakes too of the logic of compulsion.[15]

But what is consigned? Says Derrida: "The archontic power, which also gathers the functions of unification, of identification, of classification, must be paired with what we will call the power of *consignation*. By consignation we do not only mean, in the ordinary sense of the word, the act of assigning residence or of entrusting so as to put into reserve (to consign, to deposit) in a place and on a substrate, but here the act of *con*signing through *gathering together signs* . . . *Consignation* aims to coordinate a single corpus."[16] Tlatelolco here names the procedure of such a consignation; the technological impression of a massacre that I call "photopoetics," or making with light, gathers all that is already signified by "1968" and "student movement," identifying those with a second principle of consignation (what Gareth Williams aptly designates as "po-

lice narrativization") and thus with the topo-nomological violence with which the name Tlatelolco will always have been associated.[17]

On the Plaza de las Tres Culturas stand an Aztec ruin, a colonial Spanish church, and the modern (and thus *Mexican*) Tlatelolco apartments. If three cultures are made present there, they are not contemporaneous with one another. Theirs is a peculiar reunion in destruction and survival, for they reside in a succession; they obey a telos, which is explained by the memorial sign that overlooks the ruins. It reads: "The 13th of August, 1521, heroically defended by Cuauhtémoc, Tlatelolco fell to the power of Hernán Cortés. It was neither victory, nor defeat. It was the painful birth of the mestizo people, which is the Mexico of today."[18] Mexico's foundational conflict resolves in this symbolic reunion: a modern subject emerges from its own tragic origin and thus restitutes the very tragedy of its birth. The Plaza de las Tres Culturas founds the archive of some incalculable experience, some event without measure, which is also measured by the name 1968 and given up to its domiciliation under the sign of the plaza, which houses both the action of the massacre and also, now more symbolically, a history of sacrifice as politics.[19] This massacre's perceived 1968 repetition promises to reveal the lie of this originary sacrifice and thus to redeem itself once again. In other words, the 1968 massacre-as-archive offers to renew the grounds of Mexicanism, obeying the maxim that there is neither triumph nor defeat, but *always* the painful birth of the mestizo people. The massacre forms, literally, an archiving flash of light that "produces as much as it records the event." In the massacre, 1968 gathers and coordinates its corpus at Tlatelolco, producing an event that is recorded and consigned to memory and splitting from memory some other event, which it consigns to the light of its destruction.[20]

The advent of an encrypting violence serves as a revelation that ruptures the continuity of Mexican history as well as, more punctually for some observers, the logic of the deferred promise of the Revolution that sustained Mexico's one-party state for over seventy years. And yet by so productively restituting the lack at the heart of Mexico's narrative of origin, it structurally reproduces that origin. As a retelling of origin, Tlatelolco proposes social and political progress through a sacrificial lesson. Tlatelolco is thus the site that names some originary thing that took place there (not once, but twice), a site from which, or in whose name, an "event" haunts Mexico, posing as the event of an origin, rather than the fact of a crime.

The student-popular movement was in effect desolated that day, and

while it lingered on in a purely formal sense for some months afterward, it began to fade as an event in favor of the timely task of freeing political prisoners, seeking justice for the murdered, and pursuing evidence of the crime. Yet this process tied the legacy of 1968 to its most tragic unfolding; if this was quite understandable, it also evoked precisely the sacrificial ethos that grounded the reason of Mexico's modern state form, according to which strife and violence give way to social progress. The sphere of being-together "politically" takes as its object the innocence of sacrificed bodies, horizontally displayed, and not the legacy of the march, the demonstration, or, indeed, the riot.

It is thus my suggestion here that an understanding of Mexico, 1968 in a properly political register can occur only by critically traversing the *double* repression that conditions its reception. This double repression originates, on the one hand, in the military and paramilitary policing of the student movement on 2 October 1968 and *also* in the policing before 2 October against which the movement constituted itself. It proceeds, on the other, as the subsequent *assumption* of that massacre as the point of departure for any future organized around 1968, for any thought or action to come in its aftermath. Thinking 1968 concerns the act of violent political repression that is linked (but only partially) to a representational repression and affective displacement in the psychoanalytic sense (*Verdrängung*). By encasing it in the "symbolic shelter" of its own violence, this "outward appearance and great symbolic shelter" for the experience of 1968, to cite Monsiváis once more, protects the state (and its investment in the social and political order) from any possible active incidence of the student movement. At the same time, the symbolic shelter displaces other possible significations; it is thus a literal and metaphorical crypt, a place of rest for the bodies of the dead and also for their struggle, the place of an encryption that *gathers* the double repression of the student-popular movement.[21]

"What is a crypt?" asks Derrida. "No crypt presents itself. The grounds [*lieux*] are so disposed as to disguise and hide: something, always a body in some way. But also to disguise the act of hiding and to hide the disguise: the crypt hides as it holds."[22] The crypt, like Derrida's notion of the archive, fixes the *place* of the thing it hides (though with a decidedly more secretive valence) and, to some degree, also the parameters of its signification.

Tlatelolco might accordingly be read as the *police's* subjective name for the mass movement of 1968, imposed by force and inscribed in the cordite and magnesium flashes that condition the massacre's historical

appearance.[23] Even the putative defenders of a certain legacy of 1968—whose aesthetic and political interventions form the corpus of the present book—have assumed this name and have seemingly reconstituted the objectives of that moment in the avatar of its very loss and repression. Put in still other terms, 1968 has been *subjectivized* as the massacre that obscured its event.

Though this book in part constitutes an extended critique of the sacrificial notion of the political, mine is, nevertheless, not a moral judgment on the guardians of 1968's tradition. Indeed, I assume the duplicitous repression that has conditioned this tradition, by means of which the Tlatelolco massacre has become the horizon for thinking about 1968, for organizing the thought of its legacy or aftermath. For, quite characteristically, even this very signifier, repression, has been repressed from the thinking of 1968. By way of beginning, then, Lacan offers one entry to the thinking about repression that will be helpful in the discussion to follow: "With a machine," he writes, "whatever doesn't come on time simply falls by the wayside and makes no claims on anything. This is not true for man, the scansion is alive, and whatever doesn't come on time remains in suspense. That is what is involved in repression."[24] He continues that thought in the following manner: "No doubt something which isn't expressed doesn't exist. But the repressed is always there, insisting, and demanding to be. The fundamental relation of man to this symbolic order is very precisely what founds the symbolic order itself—the relation of non-being to being."[25] This is not to say, tautologically, that something that does not exist is something that does not exist, but, rather, to connect repression to expression as the foundation of the symbolic order, understood as the relation of being to nonbeing. The repressed is object-cause of the symbolic order, a yearning or *desire* for the presence of the thing not yet here or no longer there that produces the symbolic order and the need for symbolization, which is to say, again, what Didi-Huberman called the "visual."

In a debate with Ernesto Laclau over the course of a few issues of *Critical Inquiry*, Slavoj Žižek warns against what he calls the "populist temptation," itself a kind of destructive compulsion or consignation. Populism, he observes, is not the political, but class struggle's other, its containment. "It is clear now," he writes, "why Laclau prefers populism to class struggle: populism provides a neutral, 'transcendental' matrix of an open struggle whose content and stakes are themselves defined by the contingent struggle for hegemony, while the class struggle presup-

poses a particular social group (the working class) as a privileged political agent."[26]

For Laclau's conception of politics, the elements of the student-popular movement (the students, on the one hand, and the popular, on the other) would be linked only by a shared opposition to the "system," or state as categorical figure of the enemy, for they have other, more particular demands (under the figures of communisms, anarchisms, nihilisms, and so on). The tragic fate of the student movement became itself the empty signifier that named this vague or open antisystemic struggle. Laclau has described this relationship in terms of a procedure by means of which "one particular difference assumes the representation of a totality that exceeds it."[27] Hegemony is nothing if not a consignation to an archive by a name that might gather what is otherwise incalculable. One of the Mexican state's strengths has been the efficiency with which it has proven able to reconfigure such equivalences, that is, by desuturing the demands of the middle class from those of its others and symbolically linking the diverse elements of the social field in the capacious logic of Mexicanism. By providing for particular demands—increasingly without the symbolic shelter of the previous state formation—it grows difficult to sustain the idea that the students' pursuit of individual freedom and personal desires had a collective moment and moreover that this collective moment was of a piece with the formation of a collective and emancipatory politics. Put otherwise, the state dealt with the trace of 1968 by slowly allowing some of the student movement's original content to pass into the state's own democratizing trajectory under the guise of greater "freedom." This passage, as hegemonic capture, is the state's *secondary* and depoliticizing recognition of the student movement, following the first-order recognition of the students as properly political enemies along the friend/enemy divide. By allowing for "freedom," the other social demands long ago sutured to it are resolved, forgotten, or conjured away.

In this sense, 1968 serves as the name for a broad assortment of demands that it can, with time, no longer represent. Rather than attempting to break this alliance of diverse demands by disarticulating the name that organizes it, the state adds its own demand for a certain democratization and a certain freedom to this chain, slowly but unmistakably allowing the more obscure elements of this antisystemic demand to conjure away 1968's terrifying specter or at least to domesticate its ghost. Once this demand becomes hegemonic, its organizing signifier, 1968,

is lost to all of the other demands that it might have represented. In other words, it can no longer function politically in the sense that we have more or less come to expect. For this reason, I suggest that the de-mand—for politics, for class struggle, for being-in-common—continues to haunt the cultural discourse of 1968 and every attempt to finally re-solve those energies as hegemonic calculation, that is, without politics.

AN IMPOPULAR TRACE

Since the earliest reflection on 1968 in Mexico, writers have invoked the trope of photographic representation to describe the events of the massa-cre at Tlatelolco, just as they have recruited the visual support of photo-journalistic images in order to establish a more faithful and convincing narrative of that night's occurrences. The conceit of such texts is that the camera functions as the prosthetic extension of the eye of the witness, in whose authority the truth of the text is to be grounded. Such is the pho-tograph's indexical relation to the event: a trace of late afternoon light recorded for history in cordite and magnesium flashes.

The violence of that inscription makes it all the more difficult to imagine a student-popular movement without Tlatelolco. Tlatelolco as signifier becomes the metonymic designation not only for the apart-ment buildings constructed there, not only for the modernity that, it was hoped, would restitute originary violence and continued inequality by reconciling them in the modern edifice of the mestizo state. Tlate-lolco also names the sacred sign of its lost object: the political movement whose sacrifice on the Plaza de las Tres Culturas would undo—so goes the story—the narrative of Mexican futurity whose long-deferred prom-ise underwrote Mexican sovereignty.[28] We cannot imagine a student-popular movement without this death, for it is this death that forges the movement's historical appearance; it is this death that historical think-ing has cited and formed into the image to which thought must cling.

Sacrifice—the word comes from Octavio Paz. The relation in the shared root *sacra* between sacrifice and the sacred sign of photography underlies this photographic rendering: "The double reality of October 2, 1968: it is a historical fact and it is a symbolic acting-out of what could be called our subterranean or invisible history . . . what unfolded before our eyes was a ritual, a sacrifice."[29] We hold not only to the photographs of the dead, to the death in photography, but to the death, these deaths, that they *are* photographic, that these deaths partake of the citational

logic that is photography in order to capture and sustain a moment as an object for thought.[30] For Paz, the massacre is both a representation *and* the thing itself; it is both a representative image of contemporary Mexico and an unearthing of the Aztec ruins that underlie Mexican political history: sacrifice, a political ethos that maintains (despite all claims to modernity, indeed, despite the very representation of modernity that the Olympics, ten days later, promised to uphold) that it is sacrifice that promises the continuity of the world, that sacrifice is the motor of all progress, that sacrifice is the very guarantee of futurity. The duality of the massacre's signification confirms for Paz that the project of a mestizo modernity has never come into its own, that no mediation has ever occurred between Spaniard and Aztec, that our present is still that of conquest and war. Indeed, for Paz, the Mexican state's national-populist embrace of the social whole meets its spectacular failure at Tlatelolco and yet is also reestablished by the persistence of the mythic thought that grounds it. As Ignacio Sánchez Prado puts it: "Paz's reconciled nation is based on the sublimation of conflict, resistance, disagreement, through identification with myth."[31] Tlatelolco thus becomes the revelation of the long-buried truth and the refoundation of the myth that concealed it.

Following the massacre at Tlatelolco—as it has been perhaps too frequently remembered—Paz renounced his position as Mexico's ambassador to India. In line with anyone's expectations for a state intellectual of his stature, the diplomatic response was coupled with a poetic one. "Intermitencias del oeste (3)," the third of a series of four Western "interruptions" (from the Soviet Union, Mexico, and France), forges his commitment to the trace, which here both founds and then disappears from the archive. Ink on paper takes the place of the blood on the plaza (of the "sacrificed," as he puts it), for the traces of violence have already been washed away, in an *iconographic* substitution and a syntagmatic substitution: one liquid for another and one signifier for the other.[32] The ink stands in for the trace of blood as the emulsification of an image: janitors in daylight wash away the residue of a night, invisible in the image-rendering of the poem.

Paz thus establishes a photo-graphy as the trope proper to this thinking, a political thought beyond the evidentiary bearing-witness most readily (and exhaustingly) associated with photographic capture: "Photography, with a capital 'P'," as Didi-Huberman describes it: "I mean the ideal of photography, an incontestable Trace, incontestably faithful, durable, transmissible."[33] This trace is always self-evident. It grounds the

nonthought of the political, the political, that is, in its most ideological visage, understood as the merely commonsensical appearance of history, and of the particular forms that nonthought takes after 1968 (in Mexico and elsewhere). Iconography here becomes nearly indistinguishable from discourse in ordering the tense relation between the photographic image and its rendering in language, the relation between the faithful, durable, and transmissible thing that language finds in photography.

The self-evidence of this trace and of its visibility cannot but resonate with Paz's own conflicted assertion of an ideal photography. Indeed, Paz, or Elena Poniatowska in his name, would later evoke the journalistic and perhaps also the vernacular evidentiary photograph as, again, "an incontestable Trace" in order to assert the truth of the massacre at Tlatelolco in its aftermath and of its faithful, durable, and transmissible capacity to serve as a critique of both the collective politics organized by the Mexican state and of the very possibility of a politics of the collective. "I don't believe that images can ever lie," Paz is quoted in Poniatowska's *La noche de Tlatelolco.* "I have seen the newsreels, the photographs."[34]

But first I return to the poem, to its interruption. Despite any endurance of the trace it exposes, the final lines touch on the futility of writing and also, now indirectly, on the unfinished nature of the revolts, whose place in memory has already given way to the memory of a massacre:

> stained
> before anything worth it
> was said:
> lucidity.[35]

The poem has failed to say anything worth itself, worth the staining of the page on which it is written, just as the student movement has failed to accomplish anything worth its own desolation. Yet this is the very stain that reappears in Paz's *Postdata*: "a bloodstain dispelled the official optimism"—a stain, but also a revelation, what I want to call an "impopular" trace, which lives on, barely, of the student-popular movement and which is consumed in the process of the dominant political classes' own disarticulation of the populist ethos that the student-popular movement itself exceeded.[36]

At the same time, there is another image or another face to the image (another face, perhaps also, to Octavio Paz's relation to 1968 and to the task of thinking 1968): his definition of critique, understood as the

thinking of the impopular, is, precisely, an end to the image, rooted in the faithful, durable, transmissible, and "incontestable Trace" of an image rendering. As he puts it in *Postdata*, it is "criticism, the acid that dissolves images."[37] Critique works against the trace, a certain trace, indeed, the trace of what past inhabits us; all the melancholy and moralism of the image dissolves in the acid of critique, the impopular form that thought takes in order to render itself as thought. Critical thought is precisely "impopular," Paz says: "Independent thought is almost always unpopular [*impopular*]."[38] Almost always.

An independent thought will not be popular, for the common ground of any populist articulation is always the linking of the nonindependent. Indeed, I have used the unfortunate term "nonindependent" because I am not sure that Paz's formulation leaves room for something precisely "dependent." That is, "independent thought" would not be autonomous but, instead, the proper name of the exception that Paz reserves for his own thought. Naturally, as he was a state intellectual par excellence, his thought *depends* in the deepest sense possible. For Paz, such an independent thought will also have the power to efface the image, even the image-trace, whose incontestable power veils and protects the linking of the social that has not yet fully allowed for the emergence of politics proper. Mine is a strong misreading to be sure. For surely there can be nothing "independent," much less "political"—and I think we here still know nothing about whether we agree upon what the latter signifier could now designate—in the essay of a man who evokes Aztec ritual and immemorial barbarity to explain the crimes of a state he has faithfully served. This trace stands as a critique of populism from within populism. Through the trace, Paz occupies the minimal distance required for him to render his judgment against the Mexican state. As he asserts: "The massacre at Tlatelolco teaches us [*nos revela*] that the past which we thought buried is still alive and has burst out among us."[39]

Written twenty years after *The Labyrinth of Solitude* as a kind of postscript (from whence the title), *Postdata* originated as the Hackett Memorial Lecture at the University of Texas at Austin in 1969. Fitting for the occasion, the speaker, the historical moment and site at which the original lecture was given, the text begins with the universal critique of progress, advancing a common though secret hatred of the twentieth century and everything for which it stood.[40] Writes Paz: "We now know that the kingdom of progress is not of this world: the paradise it promises us is in the future, a future that is impalpable, unreachable, perpetual. Progress has peopled history with the marvels and monsters of technology but

it has depopulated the life of man. It has given us more things but not more being."[41] The true face of our world (of our world as it was in the late sixties and early seventies) is its desire for some other world, a place not its own, some future becoming and transformation that will never fulfill itself in the way it has been expected.

This goes for all utopianisms, as much for the technological future that will never arrive as for the finally Messianic politics of the sixties. All future becomings conceal the logic of a deferral that sustains their violent and unyielding desire. And so, too, this logic attends the endurance of the Mexican party-state. Writes Sergio Zermeño:

> In conditions like those of our society, the presence of a strong or structural-populist State has become the only form of organization capable of maintaining order and, therefore, able to ensure that minimal coherence and political stability that our late capitalist development requires. The redistributive measures of this enduring populist system ensure its legitimacy and fertilize the market in which the regime of private property will flourish. From this unfolds, at the same time, the principle of progress, development, and thus the legitimacy of the strong populist state is doubly fed. In this way, at the same time, the principle of progress, development begins to grow, and thus the legitimacy of the strong Populist state remains doubly upheld.[42]

The Mexican state is only one symbolization of the desire for a hegemonic politics of progress-oriented collective being. That very desire, under any form, in any epoch, is for Paz the Real of a modernity or a promised modernization that has not been achieved. Such desire commanded everything, counted everything, and posited as its *razón de ser* the incomplete fulfillment of the task that it held in reserve, to be carried out exclusively by the Mexican state.[43]

To desire, to the logic of an unending becoming, of a waiting, of a future, or a postponement, Paz responds with the present. The student movement is the impopular irruption of the "now" against populist futurity: "The deeper meaning of the protest movement—not overlooking its reasons and its immediate, circumstantial aims—consists in having opposed the implacable phantasm of the future with the spontaneous reality of the now. This outbreak of the now signifies the apparition, in the midst of contemporary life, of that forbidden, that damned word 'pleasure.' A word no less explosive and no less beautiful than the word

'justice.'"[44] For Paz, 2 October 1968 serves as the violent revelation that gives end to, or ruptures, the succession of Mexican history as well as the logic of the deferred promise of the Revolution that sustained Mexico's one-party state for over seventy years. Moreover, the bullets that pierce the bodies on the square inadvertently pierce the symbolic shelter painstakingly and forcefully constructed by revolutionary ideology since its consolidation in the first half of the twentieth century, which "has supported the existence of a strong national state which systematically tries to encompass the social whole."[45] For Paz, the massacre excavates Tlatelolco, illuminates, and consigns its archive in order to begin anew. The revolutionary state's hold on the social, centering on a "mestizo nationalism" as its ultimate horizon, can no longer be sustained.[46] The progress it postulated has not occurred. To repeat Paz's formulation: "The massacre at Tlatelolco teaches us that the past which we thought buried is still alive and has burst out among us."[47]

The massacre is thus for Paz a revelatory sacrifice. Illuminating the true conditions of life in Mexico, it opposes the specter of the future—a future specter, the spectral futurity and future return of a specter—with the materiality of a present death. This illumination occurs, however, not by means of the present, nor on the terms of the present and the spontaneity of the present that, for Paz, is opened by the student movement, but in the sudden return of the past. Indeed, and quite strangely, a brutal past returns to teach us that its moment is our present. Paz thus proposes the structure of an illumination that occurs instantaneously on the Plaza de las Tres Culturas. The student movement's "sacrifice" arrives as a bloody illumination not only of the brutally authoritarian ethos of the Mexican state, but also of the whole of Mexican history. And this always living, never dead past arrives to kill a student-popular movement with its eyes opened to "the spontaneous reality of the now."

Herein lies the peculiarity of Paz's assertion of sacrifice, of a sacrificial illumination on the Plaza de las Tres Culturas. On the site that preserves and marks one originary moment—the violent clash between Aztec and Spaniard that founded Mexico—there emerges the violent truth that is concealed by this archive: that this foundation never happened, or did not happen as it is said to have happened. The massacre reveals that a modern Mexico has never existed and that the primitive violence that is symbolically overcome on the plaza is little more that a hastily applied suture to be torn apart by the sudden movement of a long-dormant intensity, simply waiting to emerge from the archive-domicile that tem-

porarily housed it. This new, more recent massacre, however, is neither triumph nor defeat, but an awakening to the Mexico of today, to "the spontaneous reality of the now," which is also the real presence of a past. It is in this sense the expiatory rite that makes visible what Paz calls "the true, though invisible, history of Mexico."[48] That is to say, the student movement is the prophecy of the present return of a past that is always already present, but which has been made invisible. The movement foretells its own death, its own sacrifice, in order that its death *be* a sacrifice, in order that this sacrifice productively render visible the true history of Mexico, locked in the archive, here concealed beneath the stones of the plaza, there exposed in the museumlike display of an appropriated past. *There*, in that place, remains a layered topography of trauma, excavated only in the mid-twentieth century by the designs of the modernizing national-popular state in its drive to produce a built environment adequate to the future of a mestizo people (that is, the Unidad Habitacional Nonoalco-Tlatelolco). The planning state's project unearths, makes visible the very "intrahistorical" archive of trauma that it most sought to conceal or consign.[49]

This revelation should be understood also in a photographic sense, *revelar* suggesting not only "revelation," but also the development of photographic film. The brutality of a long-buried past comes to light or makes itself visible only after it rests in the darkroom of history. The presence of the past erupts and becomes visible to "us," the figure of a "we" that throughout the violent unfolding that is history, had remained largely immune to this violence until 1968. The massacre is, again, a revelatory sacrifice. Immediately, on Paz's account, it is recovered by a "we" who can appropriate it for our own edification. That is, "revelation"—and the photographic valance of this word cannot be ignored or suppressed—spontaneously captures the political instance and employs it in the representation for "us" of what "we" thought buried.

Such an insight, however, is not, finally, the act of illumination that the state intellectual insinuates; rather, Tlatelolco comes to be used by this "we"—the state and the intellectuals who sustain and are sustained by it—for a useless task, for the illumination of what is already visible. The image of the present becomes an image of the past. These distinct temporalities are recognizable to Paz only because he reduces them both to the same revelation, recalling what he describes as an Aztec temporality, an *image*: "The four sides of the pyramid, petrified time, represent the four suns or ages of the world."[50] To consign the present to the past

is thus to violently archive even the very desire that there be politics. The past returns to teach us that its moment is our present, that it was never buried. The present of any political struggle is revealed as barbarism, as yet an iteration of that barbaric past.

The contradictory or conflicted trope of the photographic image in the reflection on 1968 by itself means nothing, but, rather, indexes a crisis for historical thinking and the arts' relation to that historical thinking. But crisis is certainly not the most interesting or the most precise name to grant the juncture for which Paz himself cannot prepare: to embrace a present into which the specters of the past cannot emerge and also without the promise of the future, always disappointing in its arrival by its similarity to the present.

Continuing now the strong misreading that I think Paz is due: the student movement is the opening to yet another unyielding but also immediate possibility. Avoiding the trap—which I would under different circumstances call a responsibility—of reflecting on the circumstantial, conflictive, or programmatic drives of the student movement, Paz evokes here, despite all, the movement's possible event, its own opening to what is incalculable, a spontaneous reality.[51] Against the cynical moralism and sacrificial reason that his own essay invokes, Paz traces the negative image of this archive as event.

THE NAME OF THE EVENT . . .
THAT THERE IS AN EVENT

Gareth Williams and Bruno Bosteels have astutely identified Tlatelolco as the very sacrificial and melancholic subjective name of 1968. It is my intuition that many of the problems posed by thinking Mexico today are linked to the melancholic structure with which a certain Mexicanist thought has tended to receive history.[52] I here depart from this tendency by proposing that the students are not sacrificial lambs. The long history of lamentation through which the narration of 1968 has been largely constituted has been haunted by the desire to prove the students' innocence. This desire, far from preserving the political incidence of 1968, forces it into a melodramatic and Christological register whose vicissitudes I consider at length here. To be sure, my proposed reorientation changes nothing regarding the criminality of the Mexican state and its ruling class; indeed, let us honor the students' commitment in the polit-

ical struggle against past and future crimes by not isolating or patholo-
gizing the state's zealous defense against what should *rightly* have been
regarded as a threat to its—or to any other—sovereignty.

Bosteels has argued for a relation between art and literature, on the
one hand, and between art and political subjectivization, on the other.
As he puts it in the introduction to *Marx and Freud in Latin America*,
which contains a significant reflection on 1968 in Mexico: "I argue in
the chapters of the book that art and literature—the novel, poetry, the-
ater, film—no less than the militant tract or the theoretical treatise, pro-
vide symptomatic sites for the investigation of such processes of subjec-
tivization."[53] If artistic and literary texts (no less than those belonging
to genres that are more or less symptomatic, that are more or less linked
to politics as such rather than to representation) allow us to "investi-
gate such processes" no less well than a tract or a treatise (and merely
no less well), then how or why do we read literature to understand such
processes?[54] "The present book," writes Bosteels, "seeks to reassess the
untimely relevance of certain aspects of the work of Marx (but also of
Lenin and Mao) and Freud (but also of Lacan) in and for Latin Amer-
ica . . . starting from the abovementioned premise that Marxism and
Freudianism strictly speaking are neither philosophical worldviews nor
positive sciences, but rather intervening doctrines of the subject respec-
tively in political and clinical-affective situations."[55] From "intervening
doctrine," then, Bosteels produces a shift to "such," by which we must
understand Marxian (or Marxist) and also Freudian "*processes* of subjec-
tivization."[56] Thus, art and literature become, no less than other more
or less related discourses, a place of study and an archive to which one
might turn in order to understand "such processes of subjectivization" as
"intervening doctrines of the subject."

The question of political subjectivization is inextricable from think-
ing the event's determination as event. In the case at hand, the rhetorical
openness that allows the 1968 movements to convene a collective politics
(however vaguely that collectivity is designated) emerges only *after* its
formalization through an enemy. This formalization, however, appears to
adopt the capacious logic of the state form to which it is opposed. Sergio
Zermeño's early scholarly analysis of the student movement presents the
construction of political identities in the context of the student move-
ment in terms strikingly similar to those set forth by Ernesto Laclau's
elaboration of the theory of hegemonic articulation several years later.
One of the principal tasks that Zermeño sets out in this study turns on
an analysis of the diverse tendencies of the distinct sectors of the student

movement, a task he performs without giving way to the highly synthetic edifice that organizes and ultimately hegemonizes the very plurality of the movement's makeup as if this makeup were its effective ideological content. "On a single Friday afternoon," writes Gareth Williams, "the *granaderos* achieved the impossible: they managed to forge an alliance between the Polytechnic, the university, and the increasingly sectarian and divided political Left."[57] Largely by chance, a group of students protesting a brutal police repression crossed paths with a march commemorating the Cuban Revolution. As Williams puts it: "Though the massacre essentially put an end to the movement, the student movement's true legacy lies not in its relation to the massacre but in relation to the movement for democratization that preceded it." "But," he adds, "does this democratization have a concept?"[58] I want to say yes, along with Williams, but so far we have only read that concept symptomatically in the consequences of the students' defeat.

The name "student movement" and the desires it invoked can only be highly conflictive, "autogestional," and perhaps that is the place of its concept. The sacrificial and melancholic subjectivization evoked by the name "Tlatelolco" advances the state's own hegemonic operation and stitches together a conflictive field in the avatar of national tragedy that is legible to all but a few recalcitrant thugs as a massive crime. But here we have substituted what Badiou would call the "fact" for something perhaps far more interesting, what he might call an "absolute singularity," that is, a political event.[59]

This substitution of the incorrect but comparatively more specific subjective name for 1968 (Tlatelolco) for the also incorrect—because excessively imprecise and ambiguous—name of the year (student movement) offers an entry into the very difficulty of establishing what happened in 1968, its desires and forms, and its politics, if it could be said to operate politically at all. Again, as Revueltas puts it, others will continue writing it. Each writing of 1968 occupies a double movement, on the one hand, standing in reference to and calling forth a larger and more complete archive of that year, and, on the other, hoping to silence this endless writing by naming, finally, what event truly occurred then and there.

Williams captures this task well: "How does one orient a name to what can take place, here and now, for the first and last time?"[60] This thing is an image rendering or photography: what takes place as a flash, once and forever, the first and last time. An event is that thing. But what is an event (the event of a photography, a photopoetics, or writing with light that, we insist, belongs to the archive)? Writes Eduardo Cadava:

"What makes an event an event is its technological reproducibility."[61] On this account, the event is its capacity to be archived and transmitted, the force with which it imprints itself on some surface and thus assures its own continued appearance. An ability to consign the event authorizes this status. Here event and archive are far too tangled to think either term properly or to think their opposition; here events could only be facts, whether they concern the violent light of a massacre or some memory fragment of the demonstration and one's assumption of that fragment.

Both the text of the witness as well as its secondary, critical and historiographical, appropriations seem to nearly always contain some account (as a settling of accounts) of what happened in 1968. The logic of such a narration is not merely informative but, rather, might well stand as a symptom of this very search for the name, an effort to consign what event occurred to some other, seemingly less melancholic name, to again conflate the event with the archive that names it. Beginning with a scuffle between two high school gangs and the police's disproportionate response to it, the summer of 1968 is full of moments that might name or gather to them some more hopeful archive (albeit at the cost of a certain nostalgia).[62] Among such moments stands 26 July 1968, when several thousand Mexicans marching in solidarity with the Cuban Revolution crossed paths with students from the Instituto Politécnico Nacional protesting the police repression that followed a scuffle between students from rival high schools. For several hours this contingent alliance engaged in a battle with the police on the streets of downtown Mexico City. Significant, too, if for different reasons, is 31 July–1 August, when UNAM rector Javier Barros Sierra proclaimed that recent police actions had violated the autonomy of the university. Following this statement, Barros Sierra led a march in which many tens of thousands of students participated. The Silent March of 13 September follows as another highly significant event for its appearance in the aftermath of a televised speech in which President Gustavo Díaz Ordaz both dismissed and threatened the students (the IV Informe de Gobierno, broadcast on 1 September). At the same time, Barros Sierra called upon activists to return to classes (while maintaining their demands). As what might be conceived as a double response, the movement's rather heterogeneous organizing body, the Consejo Nacional de Huelga, or CNH, convoked a silent march of 250,000 people, intended to demonstrate the seriousness and purpose of the movement. To be sure, this silence not only eerily preceded the silence of the grave and of the prison that would soon—not

a month later—impose itself on the movement, it also presents the demand for the movement's internal silence as a mediation of internal discrepancies, which, in turn, are only themselves seemingly overcome in gunfire, the demand for another, more definitive silence.

Such lack of a convincing alternative name for the consignation and memorialization, for some name to grant the event of the student movement, is largely conditioned by the very difficulty of discerning the demands such actions raised. In Zermeño's account—again anticipating Laclau—the movement's most enduring legacy belongs to its more reformist trajectory: "The 1968 Mexican student movement was a reformist movement, which readapted many aspects of social and political organization in Mexico, which 'modernized' Mexican society from within its continuity without actually revolutionizing it—we can say now, years after those events."[63] Some of these reformist tonalities, as Zermeño convincingly suggests, are codified in the movement's *pliego petitorio*, its list of six relatively local demands.[64]

Ramón Ramírez's early rendering of the movement's structure holds that its politics took place in action, protest, and the spirit of solidarity and unity that such mobilizations inspired. His text, indeed, gives particular weight to the Silent March of 13 September, which not only challenged a heightened repressive atmosphere following Díaz Ordaz's threatening Informe Presidencial, but also provided for the strengthening of its support among the popular sectors.[65] "How was the magic worked?" asks Paco Ignacio Taibo II. "What fed the bonfire? Where did they come from, the three hundred thousand students that came to the Zócalo on the day of the Great Silent March?"[66] This gathering is perhaps closest to the principle of unrule and nonorder. An-archic and an-archival, it presents the "disruptive, ruinous appearance or coming of the demos," but silently, perhaps not fully in the plentitude of their disruptive potential.[67]

Turning to Williams's text (and I speak here still of *The Mexican Exception*) the only event worth the name politics must deny calculation (melancholy technocracy, authoritarian humanism, and also any Marxist science), but it must equally deny the subject, the moment of political subjectivization. Writes Williams, of the image of May 1968 that appears in Luis González de Alba's *Los días y los años*: "The recalled image is the beginning of the leap toward an act."[68] Why no theory of the subject? Because "a theory of the subject is incapable of accounting for the slightest decision . . . The relation between contingency, chance, and the decision is certainly enacted by a subject, but it is not the subjectivity of

39

the subject that determines the action."[69] The subjectivity of the subject determines not his or her process of political subjectivization.

Williams's description runs somewhat against the centrality of the subject that we find in Badiou for whom "the subject is what resonates, in its composition, with the power of an event."[70] In other words, according to Badiou, subject and event persist through their encounter and relation. Yet here it is notable that Williams cites approvingly at least one conception of the subject: "Democracy is more precisely the name of a singular disruption of this order of distribution of bodies as a community that we propose to conceptualize in the broader concept of the police. It is the name of what comes and interrupts the smooth working of this order through a singular mechanism of subjectification."[71] The subject is the place of that resonance of a disruptive mechanism. Where, then, to locate this decision, this opening or hospitality that Williams suggests is, in effect, the event of the student movement (without quite adopting that terminology)? In other words, at stake here is perhaps the slightness of the "slightest decision." It is again worth considering how Badiou has put it: "An event is never shared, even if the truth we gather from it is universal, because its recognition *as event* is simply at one with the political decision."[72] The political decision, here understood differently from the *slightest* decision, is, above all, the moment of the subjective experience of and attachment to a politics (in which the political is experienced politically—as opposed to the potentially obscure scenes of militarism, nihilism, poseurism, and so on). And yet this nonsharing of a recognition that is far from slight would seem to elide the heteronomy that in part is what is properly eventful in the event, understood as the possibility of "a responsibility and decision *of* the other."[73] I will argue, following Williams, that the passivity of the (slightest) decision remains irreducible, as the only possibility of an event that denies calculation and thus properly—because improper—deserves that name, because it has no name. Indeed, writes Derrida: "If an event worthy of this name is to arrive or happen, it must, beyond all mastery, affect a passivity."[74]

For his part, Bosteels has suggested that "if the concept of the event nowadays is key to the work of critical theory and cultural critique, then the analysis of the events of 1968 as part of such a critico-theoretical investigation amounts in fact to a rigorous self-reflection." "The question thus becomes," he continues, "'When, and under what conditions, can an event be said to be political?'"[75] Yet before any of this, we should be rightly pressed to ask: What is political? Bosteels follows Badiou in this regard: "Even at the heart of the mass movement, political activity is

an unbinding, and is experienced as such by the movement."[76] To un-
bind: "to unlink society and to sunder the social bond."[77] For Bosteels,
this unbinding must be thought against the common conception of the
1968 revolts, which risks reducing them to a "social rather than a politi-
cal movement."[78] According to that account, the movement turns on the
formation of some alternative social space and persists in the civil society
movement that claims it as precursor. As Bosteels notes, this turn is the-
orized and *upheld* in Sergio Zermeño's *México: Una democracia utópica*;
as I will argue in the third chapter, the initial aesthetic formalization
of such a conception is most powerfully expressed in Poniatowska's *La
noche de Tlatelolco*. In other words, in Mexico, as in France and Czecho-
slovakia, if for somewhat different reasons, the political act assumes as
its grounding gesture (the gesture that assures, for us, the properly po-
litical possibility of the act) an *un*linking rather than, as readers of this
tradition, casual or otherwise, have long imagined, some kind of alter-
native social articulation, understood as a space of refuge from contesta-
tions with and for state power. For 1968, now in a global register, did not
fundamentally turn on the desire for state power. Yet if 1968 captures a
desuturing, its reception opens a hasty reconstitution that wishes to re-
solve the tentative alliance at the heart of that desuturing. Indeed, the
worker-student alliance and the form of the workers' council serve as the
primary mechanism of what for René Viénet—speaking of May '68—or
for José Revueltas's "autogestión" deserves the designation of politics.[79]

This unbinding might also be read in a more undecidable key; a "pol-
itics unbound," to use Badiou's suggestive phrase, would necessarily be
unbound from its archivization. Archive is the law or place that binds the
social bond (here understood as Mexicanism or Mexican peoplehood).
Even in the very attempt to liberate the legacy of what event or events
occurred (or which might yet still come to pass) around the signifier
"1968," Bosteels, perhaps unavoidably, affirms its archival consignation:

> Tlatelolco, then, would not only be the name of the place where state
> power exhibited its intrinsically excessive nature, as always brutally
> superior to the situation at hand, but it would also be the anchoring
> point for the tenacious search for a different "we," or a different sub-
> jective figure of equality, capable of putting a limit on the errancy of
> the state. Instead of expressing a morbid fascination with the mas-
> sacre, this seems to me to be the universalizable hope contained in
> the seemingly simple words of Revueltas in *México 68*: "Un fantasma
> recorre México, nuestras vidas. Somos Tlatelolco."[80]

Bosteels thus begins the search for a new name, or perhaps non-name, by—necessarily—returning to the same place: it is also that name and only that name. It is the "symbolic shelter" that must be addressed by the demolition of critique. Hence the limit of the politics of the subject, for it is the politics of the name (though a different name, perhaps) for that same place of an archive and the drive to consign (to reterritorialize, if you prefer) any opening to its encryption. It is not merely that the politics of the subject cannot countenance the *slightest* decision; rather, it can only ever be the place of an encryption, for the logic of the subjective name as such is that of encryption. *There* at Tlatelolco is encrypted the name (as name) of some event. Instead of embracing that place of encryption and merely revising the contents of the crypt or archive that it shelters, we should, rather, open this legacy, to affirm the political task that Bosteels identifies—"sunder the social bond"—in the strongest sense, and thus to desuture from its encryption (its "outward appearance" as Monsiváis's puts it) not only some event that occurred but also to question any demand that we return to the place of repression, understood here not only as the topological site of the military and para-military violence on the plaza but also as the topo-nomological violence of the name, subjective figure, or calculated operation of *any* encryption and consignation.[81]

And yet, perhaps we have still not encountered the event. The question thus becomes, as Bosteels might have put it, "When, and under what conditions, can an event be said to *be*?" In a way not entirely at odds with Derrida, Bosteels projects the event at the limit of its own legibility: "Events never cease to be in some way indiscernible—or, perhaps, discernible only through various limit-experiences with an abruptly twisted and distorted language, forced to say the unsayable and show the unshowable."[82] But it is also the place of inscription of a new order or law, an opening to foundational violence: "The subject, therefore, in no way pre-exists the process. He is absolutely nonexistent in the situation 'before' the event. We might say that the process of truth induces a subject."[83] On such terms, an event persists in one's courageous assumption of its subjectification. That kind of courage, Bosteels suggests, is a remedy to the present situation: "Today, the only courage of the Left, for large parts of political philosophy, consists in persevering heroically in despair—or in euphoria, which is but the other side of the same melancholy process."[84] That is, the event must, for Bosteels, be placed on the side of the "truly courageous" and not the aleatory, passive, and heteronomic:

When such a sinister or uncanny apparition lays bare the fundamental lack in the structure of the law, the melancholy answer tirelessly reiterates how this lack is the constitutive law of the structure itself, whereas a truly courageous answer would reply by discerning the prescriptive structure of a new law. In one case, the specter must remain as such—out of joint, sign of an insuperable maladjustment that from time immemorial has marked a messianic promise, as Derrida might say: "Of a disjointed or disjunctive time without which there would be neither event nor history nor promise of justice." In the other case, something must come to pass for an event to take place, beyond the impasse signaled by the specter.[85]

Here an event is forged in a resistance to resistance; courageously, it overcomes the impasse. Accordingly, for Bosteels, deconstruction and its associates fail to recognize some further step.[86] His would appear to be the affirmation of some present in which lack will be banished, some future law that would be an unhaunted hegemony, or at least a hegemony haunted in a productive fashion.

An event so understood belongs to the order of order, the principle of an archive and *arkhē* that it serves. Here I suggest we rather pursue a politics infinitely unbound from every *arkhē*, untethered to events. Jacques Rancière has discussed the heterogeneous configurations of police logic and egalitarian logic as the two faces of what is usually called politics. For Rancière, egalitarian logic is the more properly political activity, defined by its antagonism to policing convened by "a principle that does not belong to it: equality."[87] Against the policing that governs and configures the sensible arises an antagonistic logic that questions this configuration by presuming "the equality of speaking beings."[88] If there is some event to be captured, it is thus the resistance of the event to its own capture, following the principle of desuturing, unbinding, and the material inscription of a common world. Says Rancière: "The assertion of a common world thus happens through a paradoxical mise-en-scène that brings the community and the non-community together," not as hegemonic calculation—understood as the forceful and yet always incomplete closure of a world—nor as the inscription and policing of any new order of being, but as the experience of the incalculable, the world in its radical opening: without symbolic shelter, a hospitable opening to a world-in-common.[89]

An event, if there is one, is thus the moment in which, as Ramón Ramírez describes the Silent March of 13 September, "students are con-

fused with workers from various factories and unions; groups of peasants are also present."[90] The students and the workers can be confused with each other, but they also—given the reflexive valence of the "*se*"—confuse themselves with the workers (whether the workers can properly or improperly confuse themselves with the students remains less clear). The peasants are *here* and not elsewhere; they are out of place. That is, let us adopt this moment of the Silent March, and not perhaps even the Silent March itself as an approach to an event worthy of what we mistakenly call Tlatelolco, what we call 1968: "an unforeseeable coming of the other, of a heteronomy"; or "the event of what or who comes" as incalculable exposure to that other and to the event that is other.[91] Nor can it be the overcoming of the student movement's internal contradictions through a subsequent appropriation of its legacy through the banal affirmation that the mass crime against students is a crime. No: it is "the event of what or who comes," that chance encounter in which "students are confused with workers" and in which the peasants are also present—absent from where they properly *should* be. Unconditionally.

POSTPONED IMAGES

The Plenitude of the Unfinished

Don't search in the archives, because no records have been kept.

ROSARIO CASTELLANOS

In a 1978 essay, published as the prologue to Sergio Zermeño's ground-breaking study of 1968, *México: Una democracia utópica*, Carlos Monsiváis conjures a series of snapshots—"photographs suspended in the abyss of memory"—in order to mount a negative commemoration of the amnesia that seemed dominant only ten years after the events of the summer of 1968.[1] He implicitly links the plenitude of representation to lack and to an (impossible) future overcoming of that lack. Indeed, Monsiváis is not writing of the photographic object in its expected sense—images created through the inscription of light on film—but, rather, of those inscribed by light onto a more organic surface, upon the bodies of victim and witness both. As Paco Ignacio Taibo II puts it: "Our retinas invaded and forever marked by the light of the flares that signaled the beginning of the massacre."[2] These images pause and hang in abyssal memory; they are not captured by memory, nor are they available for its reappropriation. They are not memory itself, but a fragment, suspended in the abyss that threatens oblivion, a resistance to oblivion. And let us be very direct and even dense about this question: there is in Monsiváis's gesture the assertion of a future photography capable of capturing the event of politics, the event of a politics that for him would be worthy of answering to that name in its most disruptive sense (in other words, a politics against calculation, management, or domination). But we are enjoined to await such a moment.

Monsiváis's prologue thus intimates a knowledge that, as Walter Benjamin might have put it, fleeing from the catastrophic light of a fire about to consume Europe and to blow its ash over anything that would hope to be a mass event (about which more below): "articulating the past

does not mean recognizing it 'the way it really was,'" but, rather, "appropriating a memory as it flashes up in a moment of danger."[3] These flashes, to be sure, are like the artificial light of the flashbulb: they both illuminate the dark and permit the capture of an image where prevailing conditions would not otherwise allow it. The way our modernity thinks of history and, now, of loss cannot but rely on such image-fragments and has yet to escape the confusion of such frozen moments with the recollection of events.

The year 1977 saw the addition of language to the Mexican Constitution's Article 6 that demanded the release of classified documents; the public's right to information was guaranteed. Yet, by 1978, the tenth anniversary of the student-popular movement and the year in which Siglo Veintiuno published Zermeño's study, the unsealing of the records had not taken place.[4] The truth of the massacre is largely known yet, simultaneously, held as an open secret, in lucid obscurity. By way of partially and temporarily redressing this lack of official recognition, Monsiváis's images seek to prolong this uncertainty in the absence of an archive until the hoped-for arrival of truth at some future date, perhaps because he does not confuse the recognition of an event with an understanding of facts (to return to Alain Badiou's distinction).[5] Monsiváis's text, written as it was ten years after the massacre, gives voice to the fear of forgetting, and by way of addressing that fear, forces one to look into that void.

Along these lines, Sergio Aguayo speaks of an "authoritarian symphony" on the part of the state, which, following the massacre, tried to "impose its version of the events and achieve a quick forgetting."[6] He likens the post-Tlatelolco atmosphere in Mexico to U.S. McCarthyism, which "imposed a strict discipline with blacklists, denunciations and dismissals."[7]

Yet the image is faced, at the time of Monsiváis's writing, with a timely dilemma, what might be called late capital's ongoing saturation of the visual and social fields. Even beyond the post–World War II notions of representation that he must confront, Monsiváis cannot but address a limit to representation that has little to do with the supposedly impossible narration of the traumatic, and little to do with the representation of that which, so goes the conceit, escapes or resists representation.

Perhaps for this reason, Monsiváis, as if to deny its inclusion in the Mexican canon, conspicuously avoids mention of what everyone already knows has happened, forestalling thus the "agreement" necessary for Mexican society to becomes less obscure, as a rector of UNAM, Juan Ramón de la Fuente, once suggested.[8] In other words, at stake in this

image of truth is *consensus*, the ideological restitching together of the division of the social that the student-popular movement recognized and often profoundly articulated.

Monsiváis's elision of the name "Tlatelolco" in his prefatory comments in Zermeño's book thus voids the very logic of national tragedy as the limit to critique and disagreement that has long underwritten Mexican sovereign power's sentimental narrative. Monsiváis seeks, thus, the corrective presentation of truth in its "immediacy" as impossible desideratum. According to the most radical reading of this postponement, truth, understood as archival plenitude, stands in for a justice that can never arrive. In this spirit, Monsiváis writes of the past in the present tense, again largely avoiding mention of the Tlatelolco massacre and thus deferring this agreement, that is, the consensual reappropriation of 1968 as a national tragedy that would conceal its properly political character:

• UNAM's dean Javier Barros Sierra heads the August 1 demonstration . . .

• The youth brigades are excited by the expansion and legitimacy of the student movement. The protest against the occupation of Ciudad Universitaria on September 18 breathes new, though ephemeral, life into that famous abstraction [university community], and they express it in broken voices in movie theaters and buses and marketplaces and cafés.

• A student is shot in the back while he spray-paints a wall

• Students holding hands interrupt traffic in the city's main streets asking for money and promoting the movement

• Honest judges offer moral lessons to the imprisoned students

• The Zócalo is bursting with torches on the night of 27 August

• The mother of a dead student heads his funeral making the victory sign

• The students detained during the army's occupation of University City sing the national anthem

• A group of students defend the Polytechnic University's installations in the Casco de Santo Tomás

• The inhabitants of the Tlatelolco Buildings are in solidarity with the students

- The bureaucrats hauled into the Zócalo laugh at their own sheep-like condition

- The protesters try to keep calm

- The families of the imprisoned or missing look for them in jails, city halls, and hospitals.[9]

Something important has been left out, circumscribed, what might be understood here as what Derrida calls the commemoration of a circumcision. "Each layer here seems to gape slightly," writes Derrida, "as the lips of a wound, permitting glimpses of the abyssal possibility of another depth destined for archeological excavation."[10] Each forward slash announces a tearing, an unnamed wound that demands excavation. And, although unnamed, the wound nevertheless organizes this series from the beginning, promising some future opening, some future archive. Each image announces a future collection of the nearly infinite series of other images to which these images point, an impossible Library of Babel in which the archive will take place without reinstating a cutting violence.[11] Each image thus announces another image, the disruptive or ruptural image-to-come of these very images. "There are other images," writes Olivier Debroise, "rejected in their own time that acquire an indefinable patina that transforms them into the expression of a certain moment . . . The photographic collection is thus never a 'dead archive.'"[12]

Between the fragment "/ the protesters try to keep calm" and the fragment "/ the families of the imprisoned or missing look for them in jails, city halls, and hospitals" one might well expect an image that bears witness to the bloodshed whose date and place-name organize the cultural-political memory of some event, act, or fact: Tlatelolco, 2 October 1968. Monsiváis mutilates the familiar sequence, cutting from it its dramatically violent culmination. Instead of bloodshed, the reader encounters the heroic students who try to remain calm and the families who look for them in jails, city halls, and hospitals. The students' disappearance has disappeared from this series of fragments and underlines the archival cutting that negates what is left. Such cuttings index a pain, indeed, a bodily mutilation.

And yet this omission is precisely what is most photographic about the sequence. The form these fragments take captures the very logic of image production and painful historical inscription as one. In particular, Monsiváis's use of the forward slash as typographic anaphora peculiarly recalls the way in which photographic images are extracted from the vi-

sual field, from both their spatial and temporal contexts, as well as from experience itself.[13] This cutting reminds us that the subject hurts and that society is not whole. This anaphora, as it were, insists on the discontinuity of each fragment. Each image pauses and crystallizes a moment, which, if not for the image, would be lost forever, like all the moments that surround this image, the Real hurt that escapes symbolization and from which images are always cut, a cutting pain that, out of necessity, mutilates the body of history and the bodies of historical subjects alike. This missing narration refers thus to a missing archive—an archive-to-come (yet, as we shall see, for Monsiváis, it indeed, somehow, arrives, at least a little). What remains when the images are cut, that which is off frame, removed from the purview of the flashbulb, is there, in the archive-to-come.

The *arkhē* is both a commencement and a commandment. As Derrida writes: "*There* . . . and *in this place*. How are we to think of *there*? And this *taking place* or this *having a place* of the *arkhē*?"[14] Fashioning itself as the very indecision that awaits an archive, it calls forth an archive, or a counterarchive, that stands in place of another archive to come, which will either create justice or not; in either case, it promises to arrest a haunting.

Two conceptions of the image thus frame this chapter. First, a writing-with-light that constitutes the Tlatelolco massacre is itself a kind of photographic inscription. The violence on the square *records* a history in light and makes visible an instant in time. And the archival and archiving violence of the evidentiary photograph, its deployment, extends the *facticity* of the image in the concealment of its truth. The so-called evidentiary image in this case (I hope to suggest) becomes the very deferral of thought and the site of the extended incidence of the student movement's closure in a repressive *contemplation*. Its status as an active politics is thus arrested in the image of its desolation and submitted to a second-order repression through its postponed return in the name of an archival totality that could never exist. The event of photography stands, in other words, as the nonevent of a politics that haunts the contemplative mode thus far assigned to our engagement with 1968.

This spectrality haunts Ulrich Baer's suggestion of "spectral evidence" in the aftermath of horrific events. Indeed, and not coincidentally, he points to his strong identification with Bataille's decontextualized reading of the Hundred Pieces image around which centers Elizondo's *Farabeuf*.[15] Writes Baer: "I read the photograph not as the parceling-out and preservation of time but as an access to another kind of experience that

is explosive, instantaneous, distinct—a chance to see in a photograph not narrative, not history, but possibly trauma."[16] Using the work of Cathy Caruth, Baer adopts "the model of trauma as a 'reality imprint' because it signals the presence of unresolved questions about the nature of experience."[17]

Here, indeed, Baer means to distinguish between two models of photography: one, a traumatic "reality imprint," the other, a "literal-imprint," which assumes photography's own illusion of reality. Yet, in his discussion there is an unacknowledged convergence between the traumatic mode of understanding photography and a reading of photographs whose primary object is traumatic experience. That is, his interpretations cannot easily render the division he presents because his traumatic model for photography grounds its readings in photographic texts that themselves depict or even thematize traumatic experience (even if this experience is represented rather than presented, conveyed through a paratext that explains and authorizes the substitution in representation of one thing for another). Of Bataille's image, in particular, he writes: "The refusal to engage the moral, legal, or political dimensions of these violent photographs in fact serves an explicitly political purpose. To prevent the suffering of trauma and the human capacity for evil from being obscured or overlooked, [Bataille] suggests that we need an analysis of trauma photographs that provisionally brackets condemnation and moralizing."[18] To be sure, the consideration regarding such a photography that I wish to observe here is the one already offered by Kristin Ross in *May '68 and Its Afterlives*, a book published, like Baer's, in 2002, when it would seem that the traumas of World War II had returned with particular force. Ross takes up the way in which World War II, perhaps understandably, has conditioned our reception of the mass event and—though her analysis does not take up the question of the visual—the mass event's relation to the forms of its representation:

And yet even to raise the question of memory of the recent past is to confront the way in which the whole of our contemporary understanding of processes of social memory and forgetting has been derived from analyses related to another mass event—World War II. World War II has in fact "produced" the memory industry in contemporary scholarship, in France and elsewhere, and the parameters of devastation—catastrophe, administrative massacre, atrocity, collaboration, genocide—have in turn made it easy for certain pathological psychoanalytic categories—"trauma," for example, or "repression"—

to attain legitimacy as ever more generalizable ways of understanding the excesses and deficiencies of collective memory. And these categories have in turn . . . defamiliarized us from any understanding, or even perception, of a "mass event" that does not appear to us in the register of "catastrophe" or "mass extermination." "Masses," in other words, have come to mean masses of dead bodies, not masses of people working together to take charge of their collective lives.[19]

Ross's suggestion raises a particular challenge for the study of 1968 in Mexico, just as it serves as a perhaps more passionate denunciation of the forms of the year's memorialization and study. Whither, then, the mass event of the student movement, reduced now to the bodies on the plaza, extensively photographed and seen? This image—the photographic image—*appears* to subjectivize as event the diffuse or unrecognized phenomena of history, its most secret moments. Such is the tense exploration of the image that is at stake in Carlos Monsiváis's first major work, *Días de guardar* (published in 1970).

In it, Monsiváis offers a duplicitous, always confused, notion of the secret. On the one hand, we can never quite see the massacre, for its representation is constantly postponed until some future date on which, perhaps, its representation will be necessary or will serve the proper purpose. At the same time, there is no systematic engagement, no synthesis to counter the deferred image of the massacre. The student-popular movement is thus cast as the twin face of this secret; its own event (that is to say, not the state's "event," its criminal actions) is never seen. Its only fulfillment, as we shall see, remains its lack of fulfillment.

I would thus like to suggest, now explicitly, that this conceptual confusion is what—despite Monsiváis's own efforts to the contrary—establishes in part the dominant reading of 1968. Through its dual gesture of deferral, through its consignation of massacre to the realm of as-yet-unrepresentable and the political event to the realm of the unfinished and eternal, Monsiváis offers a double misreading that obscures the very thing he would seek to rescue, understood as the event of the student-popular movement.

PLENITUDE

In reading *Días de guardar*, we will encounter the reflection on Tlatelolco at a peculiar origin which regards it as the *absent* center of the narrative

of 1968 (though, to be sure, it will not remain absent). Monsiváis's gesture serves as an evasion of the way in which Mexican sovereign power threatens to capture such episodes; Mexican sovereign power places a narrative of trauma and sacrifice at the center of Mexicanism. In granting the Tlatelolco massacre the status of absent center, an approach reinforced by the photographic and thus seemingly immediate nature of text, Monsiváis hopes to assume a certain distance from the very form of sacrificial origin that grounds Mexicanism's hermeneutic circle.

Each Tlatelolco text contains an image, an inscription of light, the force of photography: gunfire, flares, the Olympic torch, all signaling the night falling on a luminous moment and then a violent luminosity piercing the evening sky. Gareth Williams has offered a certain exception to this tendency in his reading of the appearance of the iconic image of "La Marianne de Mai 68" in González de Alba's *Los días y los años*: "But then, when I remembered that wonderful photograph of the French girl with her flag held high, surrounded by those who are her comrades in discontent and rebellion; when I thought about everything we cannot express clearly, but that she knows and that we know too, I got angry, I was angry at you and your absurd notes and your monogrammed pens and the practice laboratory."[20] Writes Williams:

> In a regime dominated by the social architecture of sovereign decisionism (Lecumberri), González de Alba's nocturnal rendering of 1968 delivers us over, in an unconditionality without sovereignty, to the Paris slogan "Under the Paving Stones, the Beach!" and to the image of "La Marianne de Mai 68" in their Mexican receptivity. This receptivity momentarily uncovers a free zone, an erotic zone of love and friendship, a turn to anger, a call to the friend, an address to the other in the night in a writing that does not resign itself to containment or sovereign administration of the friend-enemy antagonism. In the place of the calculations of sovereign power and reason we encounter a passive hospitality to chance and responsibility before the unconditional arrival of the other. This is the precondition for the affective leap into the void and out into the world of action.[21]

Any counterimage to the traumatic rendering of 1968 comes from elsewhere (as perhaps it should; 1968 should be properly improper, "heteronomous," as Williams has put it). By the time of González de Alba's writing, by the time of this ekphrastic appearance of the image, 1968 in Mexico had nothing left of itself but its own failure or defeat.

Indeed, the image of Tommie Smith and John Carlos serves a similar function in Elena Poniatowska's *La noche de Tlatelolco*. Here we find a rare chance in the postwar period of a photographic event as such, a moment in which photography relates to the possibility of a properly political disruption. And yet the image's event *as photography* eludes representation. González de Alba can offer only its ekphrasis, its return in reenactment, or its secondary revision. It should not be immediate, of course; that is not a judgment to which it should be subjected. Rather, once again, in the context of González de Alba's novel, set in the prison at Lecumberri, it "flashes up" in the Benjaminian sense. My question, however, persists: is there a photography of 1968 in Mexico that avoids the catastrophic light of Tlatelolco?

Early reflection on the massacre at Tlatelolco formally invokes photographic representation while it generally also recruits the visual support of photojournalistic images; the camera functions as the prosthetic extension of the eye of the witness. Yet, as the well-known topos has it, the camera is also a gun. To be sure, the camera/gun topos is not merely a topos. In the early days of modern image capture, Étienne-Jules Marey, following Jules Janssen's experiments with the astronomical revolver, laid claim to the peculiar chronophotographic gun, the first portable camera.[22] The image captured is contingent but not random. To photograph Tlatelolco is also to hold a gun in Tlatelolco; to look through the lens, to focus, is to look down the scope, through the sight, to take aim. Between witness and assassin, two modes of seeing, two modes of making visible and invisible that, yet, possess a formal similarity and a long-standing technocultural association.

Yet each form of taking aim, of focusing, and, finally, of committing to action (shooting) proposes a distinct temporality. The time of the gun, its archive the crypt, transforms 1968 into the past, turns it over to yesterday, whereas the camera arrests the moment, making it constantly visible. As Monsiváis writes: "Before the camera, in a second, those who are about to be shot come back to life."[23] Those about to be shot by the gun will return, forever, in the image as long as, before they are shot, they face the camera. Eternal life: the camera will shoot them, hold them in a moment. In this sense, Tlatelolco reflection arms itself with photography: the image forms a making-visible of what violence sought to make disappear, but the image largely captures the violence before it. For all of its photo-aesthetic force, Monsiváis's *Días de guardar* expends relatively few of its pages on its account of the 1968 student-popular movement.

Photographic immediacy is, in Monsiváis's case, delayed in a bid to protect and keep the days of 1968, in a bid to hold onto what Monsiváis will finally call the "plenitude of the unfinished."[24] The apparent disjunction at the heart of the plenitude of the unfinished underlines the tragic, ironic destiny of the 1968 movement: the demands of the student-popular movement have been redressed through an appeal to the very massacre that leaves the movement unfinished. Yet this disjunctive plenitude also recalls that the movement did reach an end that was a violently forced conclusion. Monsiváis wonders whether by holding onto the time before this conclusion, that is, the time of the student-popular movement before it was crushed, so-called cultural memory can hold onto the full potential of the movement. The question remains one of time and of timing. Reflecting thus on the relation between photography and archive in Monsiváis's writings on 1968, I will argue that his work formulates the messianic persistence of 1968 through a constant refusal to name Tlatelolco and through his postponement of thinking about this violence—even in his narration of 2 October 1968—in the name of *not* prolonging its incidence.

Claire Brewster offers a helpful description of the stylistic difference between Monsiváis and his counterparts, which also serves to underline something like the difference between chronicle and testimony as genres: "Poniatowska tends to be more personal, providing names and details, whereas Monsiváis recreates the atmosphere of the scene as a whole."[25] Yet, if Monsiváis's book betrays a certain photo-aesthetic logic of representation, the original Tlatelolco/1968 books all explicitly and formally partake of the resource of photography. The published book-objects themselves frequently contain photographs, and their narrative form often evokes photography by staging the instantaneous and barely mediated illumination of their moment.

Published by Ediciones Era in the early '70s, Elena Poniatowska's *La noche de Tlatelolco*, Carlos Monsiváis's *Días de guardar*, and González de Alba's testimonial novel *Los días y los años* belong to the same collection. Of the three, only *Los días y los años* lacks an opening photographic sequence, though, as Williams shows us, it contains the ekphrasis of a significant photographic image.[26] It is perhaps important to recall also that González de Alba is unique among these authors for his having been an activist in the student-popular movement. His is also, not coincidentally, the text among the three that most adopts the formal characteristics of the novel.

It also bears mention here that Monsiváis frequently deploys the pho-

tographic image throughout his body of work. There is, indeed, at least one book, published posthumously, dedicated solely to his writings on photography.[27] Whether as trope or as a literal illustration, photography makes its appearance throughout his oeuvre. His chosen genre, the chronicle, imposes a kind visuality upon its readers, one of whom has remarked that "where the essay or the news article or the history lesson *tells*, the chronicle *shows*."[28] Monsiváis's writing frequently centers on the visual artifact (if not on a metaphor of the photographic object). In this sense, Monsiváis explicitly assumes a photographic thinking that remains surprisingly tacit in works by his contemporaries. A collection of *crónicas* originally published in 1977, *Amor perdido* opens with the text "Alto contraste (A manera de foto fija)," a journey through Mexican history choreographed by this photographic metaphor for the social inequalities that seem to organize Mexican history.[29] The piece forms a *collection* of photographs like those found at the Archivo Casasola, a visit to which, as we will see, Monsiváis chronicles in *Días de guardar*. That visit inspired the reflection he undertakes, a melancholic and sardonic reevaluation of modern Mexican history in the aftermath of Tlatelolco.

His 1987 *Entrada libre* is, essentially, to the 1985 Mexico City earthquake and the civil society movement that followed what *Días de guardar* is to 1968 and the student movement. The middle of the book contains photographs culled from journalistic sources, captioned by fragments from the text, and opening with the quite staggering image of the collapsed Hotel Regis and closing with photographs captured at the multitudinous gatherings of an emergent civil society. In the center, in a kind of repetition of, or reference to, a photograph that appears in the sequence that opens *Días de guardar*, the reader encounters an image taken at the Zócalo, full of people, spanning both verso and recto pages of the text, over which stands the quotation: "This is the generation of the earthquake and we no longer believe in the normality of authoritarianism."[30] Here Monsiváis, of a piece with the welcoming of the new social actors of civil society, intimates the perversely illuminating power of catastrophe that he revisits constantly.

In *Los rituales del caos*, the brief prologue is followed by "Parábola de las imágenes en vuelo," a visually exhausting assortment of photographs—of the Mexico City metro, Luis Miguel and Gloria Trevi, María Felix in the Zócalo, and so on—designed to demonstrate the rich visual accumulation that indexes the ever-increasing upswing in Mexico City's population and the visual forms of its intense and idiosyncratic modernity. The photo-essay is followed by the text "The time of

accumulative identity: What photos would you take in the interminable city?"[31] Like the other chronicles contained in *Los rituales del caos*, the question of time is announced in the piece's title. And like many of Monsiváis's writings, this question of time opens also onto a photographic writing, a series of snapshots that one might take in this interminable Distrito Federal. And yet he returns to the question of catastrophe in the milieu of the mid-nineties economic crisis: "Whither the chauvinism of 'There is only one Mexico'? Not very far, naturally, and then it returned starring the chauvinism of catastrophe and the population explosion."[32] In typically sardonic fashion, he notes how Mexicans are now (in 1995) proud of the most unexpected achievements, among others, that Mexico counts among the most populated, most polluted cities on Earth. What Monsiváis identifies as a kind of apocalyptic, ruinous mentality has its antecedent in what he calls elsewhere "the canonization of disaster."[33]

Through their biting irony, Monsiváis's chronicles adopt a certain hope against apocalyptic pessimism while they simultaneously appear to be united by their genesis in the catastrophic moment that seemingly provokes illumination. Tlatelolco, the 1985 earthquake in Mexico City, and the neoliberal crises of the nineties serve as the nodal points of much of Monsiváis's work. Yet, as I began to suggest above, this genesis in catastrophe does not seem to have led to any kind of catastrophic thinking, much less a ruinous one, this despite the centrality of ruins in Monsiváis's writing.[34]

Following its preliminary photographic material, *Días de guardar* contains some twenty dated fragments, arranged again with what seems to be little respect for their chronological order.[35] Frequently following these chronicles, the reader finds a series of even more unusual textual fragments—quizzes, catalogues, reports, and the like. The text adopts Monsiváis's characteristic cutting irony throughout its unfolding as a bulwark against "sentimental apotheosis," the melodramatic mode of culture that, for Monsiváis, serves power through a kind of emotional blackmail. By this ironic disposition, the author hopes to leave the text's regard of the events of 1968 somehow inconclusive in order to formalize the very unfinished nature of those events. For, as Monsiváis observes, by way of a bitterly amusing quiz that follows the book's sixteenth chronicle, "Guess Your Decade" (Adivine su década), the subject is in some sense always the trace of the time to which the reader belongs or through which he or she lived his or her own epoch counterhistorically. The quiz invites the reader to answer a series of multiple-choice

questions in order to determine which decade most stains the reader's present: the neurotic twenties? the militant thirties? the traumatic forties? the schizophrenic fifties? or the unforgettable sixties? (¿los neuróticos veintes? ¿los militantes treintas? ¿los traumáticos cuarentas? ¿los esquizofrénicos cincuentas? o ¿los inolvidables sesentas?). The significance of defining the sixties as unforgettable is probably self-evident in a book that is trying to capture the concept of the history of the sixties culled from the fragments of memory by "Mr. Memory," as Sergio Pitol affectionately names him.[36]

Indeed, Monsiváis exerts an archivo-maniacal dominion over history, culture, and politics; one need merely count the innumerable projects to which he has lent his prologue, not to mention the public museum (Museo del Estanquillo) that houses his personal archive. He is lauded not only for his capacity as a cultural critic, but also for his perceived role as something like a genuine soothsayer. Writes Viviane Mahieux: "At once spectator and protagonist, Monsiváis continually managed to stand out while fitting in, becoming an icon precisely because he possessed the elusive ability to put into words the experiences that city dwellers shared on a daily basis."[37]

Fredric Jameson begins his 1984 essay on the sixties by recalling a historiographical lesson from the period that appears to inform Monsiváis's methodology, which should be understood as another layer of the problem of thinking the sixties. As Jameson's essay illustrates, however diligently and at whatever affective or temporal remove we study the sixties, the decade, perhaps inevitably, ends up studying us. The sixties rule our present and impose themselves as an origin, a commencement (an archive). Jameson, perhaps for this reason, engages the difficulty of producing a concept of the sixties, of procuring its representation for history. He warns that "nothing like a history of the 6os in the traditional, narrative sense will be offered here. But historical representation is just as surely in crisis as its distant cousin, the linear novel and for much the same reasons."[38]

Días de guardar has seemingly integrated into its core a knowledge of both the historiographical and the literary crises to which Jameson refers. This difficulty, in other words, is registered throughout *Días de guardar* and concerns not simply the writing of a history of the sixties but also, more important, a problem that announces itself in the sixties. The solution Jameson offers is close to the one that Monsiváis himself takes up in *Días de guardar* and involves a "reorganization" of historiographical procedures following what Jameson calls an Althusserian

proposal. He continues: "As old fashioned narrative or 'realistic' historiography became problematic, the historian should reformulate her vocation—not any longer to produce some vivid representation of History 'as it really happened,' but rather to produce the concept of history."[39]

Monsiváis addresses more or less directly why the narration of Tlatelolco can never take place for him in quite the fashion it will in, say, Poniatowska's *La noche de Tlatelolco*. Rather, for him it occurs in a more conceptual register: "2 October 1968: every human catastrophe that has no visible consequences (beyond the intention of those who brought it about) is a short-term deterioration, an inexorable, slow bleeding out of the species."[40] A lack of visible consequences requires a haunting, a slow bleeding, to make them visible. Slowly, later on and in the future, these will be housed in an archive to be sorted through and mourned, but not yet. This is a kind of photographic deferral: the image of the past awaits its revelation. As such, *Días de guardar* apparently marks its object as unthinkable: we can only understand what happened through the traces of the slow bleeding of history. These traces, for 1968, are not only the social and political consequences of Tlatelolco and the student movement, but also the effects of light on a surface of inscription.

Monsiváis's reflection on 1968 concerns most directly the Tlatelolco archive, the obscure archive (which is also a secret crypt) that runs through the book's pages. *Días de guardar* thus constitutes a peculiar kind of representation of Tlatelolco that does not regard the violence there as its object but that must nevertheless bring this violence into spectral presence.

The socially critical photographer Héctor García shot many of the photographs that appear in the opening pages of *Días de guardar*; a number of the images collected in Poniatowska's *La noche de Tlatelolco* are likewise García's. These images open onto the counterarchival nature of the text, which, as I note above, includes the chronicle of Monsiváis's visit to the Archivo Casasola, in essence, Mexico's official photographic archive. One of the last entries to appear in *Días de guardar*, "20 de noviembre / La revolución mexicana: Continuidad de las imagines" (20 November / The Mexican Revolution: Continuity of Images), attempts to come to terms with a prototypical Mexican spectacularity whose continuity must be arrested. Here, in the Archivo Casasola's Historia Gráfica de la Revolución Mexicana, Monsiváis encounters "the progression, the proper and persecuted sequence of a few pictures, a few snapshots: Power, People, Defeat, Glory (possibly), Destruction."[41] The series suggests itself as both resemblance and mirror image of the fragments of

1968. For Monsiváis, these images "fill the sight by force," they demon-strate force, and they are force.[42] Writes Monsiváis: "Casasola's photo-graphs do not converse, ever. They are not the idea: they give it to us. The camera is excessive: it traps Power in the exercise of Power."[43] To say that this "excessive" camera "traps Power in the exercise of Power" is to note the dialectical quality of image production.

One might explain this dialectics of the image in relation to Monsiváis's comments regarding "sentimental apotheosis." For Monsi-váis, the student movement's melodramatic charge is what granted the student movement its relatively large base of support among Mexican society. However, this same melodramatic style constantly threatened to transform itself into the style of melodramatic Mexican subjectivity. In like fashion, the camera traps power in the exercise of power; that is, it captures power by wielding power. However, the phrasing also suggests that the camera, in exercising power (image-production) captures power, gives the lie to that power. This power of image-production is also the power of Mexican power, that is, to produce the continuity of its own image-production.

Thus, the question that remains is whether the technology of the im-age is capable of demonstrating anything revelatory about the exercise of power given that it is at pains to produce a distance between itself (as a power) and power. Another way to put this question, to be sure, is whether the archive of 1968 can ever be properly counterarchival in the way that Monsiváis seems to propose. Such images serve memory and yet dissolve once again into the sequence that renders images in-terchangeable, without the singularity of the act or the moment that is their object.

The continuity of the image is thus twofold. On the one hand, image-production labors ceaselessly and almost automatically. On the other, im-ages provide the substance of the continuity of history-without-rupture precisely because the image is violently cut from its moment—abstracted and made fetish—to be placed on the walls of the museums of a false collective history, to be placed in the crypt of archival domestication.

In opening the collection with a series of García's images, known for their socially critical tendency, Monsiváis begins his book in opposition to this museum, as a kind of critical response.[44] He thus establishes once more the tense relationship between two photographic modes, between two orientations of the image, between two archives. Appropriately enough, the visual artifacts do not immediately announce their object to the viewer; one is constantly uncertain about the nature of the event

59

photographed. A strange sort of poem, the fragmentary lines of which curiously, and not seamlessly, provide "captions" for the visual text, accompanies this prefatory sequence.[45] This captioning, however, offers very little in the way of explanation. The sequence establishes a disjunctive relation between word and image that intimates the formal procedure at the heart of the text. In this book, as we shall see, Monsiváis hopes to maintain this disjunctive relation against resolution.

The text thus posits a formal (that is, a nonrepresentational) relationship between the event and the image, according to which the image-form describes for visuality what the event-form describes for politics. The construction of the event, in the present, requires its setting apart. To construct and sustain the ruptural nature of the event for the future requires in every moment following the event a thought and a practice to constantly reclaim it from the continuous flow of history that would otherwise consume it. The image, likewise, and more particularly in spectacular times, is a moment of time visually presented. However, this moment is constantly threatened by, on the one hand, its own power to veil the visual multiplicity from which it was extracted, and, on the other, the structurally opposing possibility that it will be reintegrated into the flow of images, into what Monsiváis calls "the continuity of images."

The notion of continuity here is twofold. Its first orientation obviously draws on the unceasing quality of the image, its ubiquity, the saturation of the visual field. The second orientation, however, indicates the sociohistorical continuity that is granted by images. The image is a form of continuity, which is performed not only by transmitting the image's singular film of memory across time, but also by a singular film that is time, that holds together this time.

HEMOPOLITICS AND PUNCTUM

Like his prologue to Zermeño's book, the photographic collage with which Monsiváis opens *Días de guardar* points only to the elusive trace of something that occurred. There are no facts, no names, only affects and fragments of writing and photographs. The truth has yet to be constructed. The text thus allegorically represents not the thing that occurred, "historia de unos días," but the very obliteration of those days, not in the holocaust that consumed them, but in the mist of the secret and the demand to forget: "oblivion has become essential."[46] These fragments of writing and photography, which do not seem to correspond to

one another in any systematic, identifiable manner, point to the difficulty of narrating experience, that is, to the ease with which one forgets, and also, to the impossible mediation of events, for neither photography nor language, and not even the relation between them, can substitute for or transmit the event. Such a generalized lack of explanatory correspondence between text and image thwarts the reader's expectation that words below a photograph provide some kind of narrative guidance. Here, instead, this kind of opening disassembly of narrative homologizes a symbolic interruption of Mexican sovereign power's capacity to impose such captions to organize not only the cultural field, but also society as a whole. Nevertheless, the photo-poem is not a-signifying. The visual and verbal fragments begin to enter into a relationship, but it is not a relationship between inert photographic text and explanatory caption.

"Días de guardar": this phrase, appearing on the verso side of the title page, at the bottom of a mostly blank page, marks a hesitation. These are holy days of obligation, but they are also days to keep, to hold, and to mourn. The phrase offers a brief moment of visual silence before what is to come. "Let no one be fooled, no, into thinking that what waits longer lasts more than what sees" captions a recto page featuring a photograph of bare-chested, long-haired men holding fists and peace signs in the air.[47] There is something both celebratory and theatrical about the mise-en-scène. Yet, there is a division in the photograph: a line runs through it, cutting the celebration from the bottom third. Only later—upon reading the book—will we realize that this photograph corresponds to the second chronicle, "5 de febrero de 1969. Con címbalos de júbilo" (5 February 1969. With jubilant cymbals), which chronicles Monsiváis's attendance at the opening of the musical *Hair* in Acapulco.[48] Those photographed, we learn, are standing on a stage, which divides the photograph as well as the scene it depicts. Upon this stage appears the graffito "Fuck for piece [*sic*]," an unintentional reference to the fragmentary and antagonistic social field of which Monsiváis is made all too aware throughout the performance and which is intimated by the line the stage cuts through the photograph. In this sense, the obscene graffito functions as a caption for the photograph. In a more speculative mode, one might consider this "Fuck for piece" as the obverse of the rationality of the Tlatelolco massacre—"Kill for peace"—and thus as a caption that reveals all that in this photograph is guarded.

Monsiváis points out the way in which foreign sub- and counter-cultural artifacts were adapted to Mexico on the opening night of *Hair*.

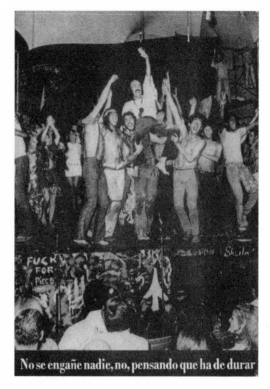

FIGURE 2.1
"Días de guardar," from **Días de guardar** *by Carlos Monsiváis (1970);
photograph by Héctor García © Ediciones Era. Courtesy of Ediciones Era.*

He dryly wishes he knew something about high fashion (and that he could distinguish between the names of the members of the ruling class) so that he could properly report on the piece's debut: "Unfortunately, this reporter cannot distinguish between a nehru and a tuxedo or between a Pucci and a department store knockoff."[49] During the production the actors parade around carrying posters adorned with countercultural slogans: "A parade of not particularly noteworthy signs erupts with slogans that recall those of buttons that have now infested sweaters and jackets in the name of that singular rebellious originality of the masses under the pretext of an industrial acquisition of a sense of humor: 'Jesus had long hair,' 'Going together is magnificent. Coming together is divine.' . . . 'The PRI takes LSD.' An innovation appears: 'REMEMBER OCTOBER 2ND.'"[50] This "hemopolitical allusion," as Monsiváis designates it, is strangely out of place and thus underlines the pretentiousness

of the countercultural spectacle unfolding. After Tlatelolco, Monsiváis fears, emancipatory political desires and collectivities can be structured only by this abjection, by death, violence, and blood, over against any other potential organizing principle. That is, the only fraternity is that of the grave or that of the catastrophic incidence of historical defeat.

Monsiváis goes on to highlight the uncanny nature of the reference by interspersing his narration with fragments from *Hair*'s musical numbers. One way of understanding this breaking-though—the music into the narration, Tlatelolco into *Hair*—would be in terms of the photo-aesthetic concept of the punctum, which here lays claim to two orientations. The first is the moment of Monsiváis's witnessing. This theatrical punctum points to what is outside of the frame, to the death and danger that attend countercultural experience in Mexico and that are not in any sense present in this highly simulated countercultural celebration. He bitterly responds by way of underlining what it means to be a member of the ruling class in the late sixties: "To remind this audience of mass crimes is to invite them to repeat them."[51] Monsiváis records a rare kind of guilt here, which is not the guilt borne by a proper name, that is to say, Gustavo Díaz Ordaz or Luis Echeverría, the respective president and secretary of the interior in 1968, who are traditionally considered to be the men most directly responsible for the Tlatelolco massacre. Rather, Monsiváis indicts a certain audience or public—"este público"—for there is no public as such, no social totality, despite the forceful arguments of the Mexican state and its hegemonizing endeavor. Instead, there is the violence of bifurcation that is sutured and kept secret in the flow of images. As Monsiváis writes: "The stall tactic called National Unity officially postpones class struggle, and the harmonious collaboration between those who command and those who obey now receives the frame of the Olympic Games."[52]

This spectacular social suture, the Olympic Games, forms yet another attempt at averting the full-blown crisis that threatens societies as socially and economically divided as that of Mexico. It frames a period of time as well as an image. To postpone here evokes once more the time of the image and the time of spectacular visuality. A first spectacle appears in the form of National Unity; the very name National Unity (Unidad Nacional), as well as its subsidiaries—Mexico, Mexican Revolution, Hidalgo, and so forth—upholds the hermeneutic circle of Mexicanism, understood as a philosophical discourse whose object is *mexicanidad*, the name of Mexican Being. Despite a certain irony, despite a distance that perhaps Monsiváis would like to keep regarding the object

of this postponement—class struggle—National Unity holds this antagonism in check. To this suture Monsiváis adds the arrival of the spectacle of international sport, which supports the even greater continuity of this now-global stream of images. This particular spectacle, *Hair*, is designed to facilitate a kind of forgetting for "this audience," to protect it from the violence that secures its privilege. Yet this violence pokes through the image's surface and at the same time reveals the fraud of *Hair*'s countercultural ethos.

The scene gives way to a second moment of punctum, in which this knowledge is now reintegrated into the reader's encounter with the photo-poem that begins the book-object. Recall that Barthes defines the punctum as that which comes out of the surface of the photographic image and penetrates, or "pierces," the spectator; it is "a wound" produced by "a pointed instrument."[53] This properly photographic punctum is the stage upon which what we now recognize as the actors stand, separating them from the audience. This separation will henceforth provide an uncanny visual metaphor for that which blocks the fulfillment of harmonious and equitable society (or fraternity). The stage-as-punctum announces the violence of the intense socioeconomic and ethnic divisions that rule the Mexican social field and thus thematizes the social division that orients Monsiváis's text. As such, even in this first, ostensibly celebratory, image, the spectator is faced with the demand to mourn not merely the uncounted dead at Tlatelolco, but also the everyday violence that underwrites the Mexican state and society and his or her complicity in that violence. The poster emblazoned with the words "RECUERDE EL 2 DE OCTUBRE" (Remember October 2nd), which Monsiváis sees at the performance of *Hair*, now jumps from what is off-frame in the book's initial photograph and simultaneously undermines the simulated, happy gathering. That this slogan further points to a literal wound, to a series of punctures in real bodies, demonstrates the link between photographic punctum, the photographic off-frame, and the ontological one, death.[54]

The apparently ruptural form of Monsiváis's book thus compels us to address more rigorously the consequences of this composition for the reader. The analysis I have undertaken, in moving from the book's first photograph to the chronicle that might help explain it, has unintentionally consented to the book's organization. Perhaps I intended to begin elsewhere, but this logic of images and words designed to break any continuous flow of images, that is, the continuity of the properly narrative image, has forced me to look at some other screen, has drawn my eyes

to another page. Or it also might be said that the book proposes to organize an action that breaks with the passivity of viewing. I underline these effects by way of illustrating how *Días de guardar* must be analyzed as a function of its consequences for the reader-spectator. Monsiváis adopts a medium (or media) with whose totalizing necessities he is not entirely comfortable, and this discomfort is registered at the level of the book's organization as a formulation of its politics of 1968.

If *Días de guardar* concerns, in part, a kind of disjunction, a rupture or tearing that begins and yet fears the archive, it is possible that the spirit of this rupture is best captured by a transition between two images. One of these is present and the other is not. The photograph captured at *Hair* has a referent or, rather, a precedent in another rebellious scene from 1968 in which other men stood on a stage with raised fists and whose photographic trace is much more widely recognized. The difference between these two images underlines the disjunctive transition that is constantly repeated throughout the book. I refer, once again, to another political articulation that haunted that year's Olympics despite the violence in Tlatelolco, evidenced not only by a threatened but unrealized African American boycott of the games, but also by the memorable Black Power salute given by Tommie Smith and John Carlos upon receiving gold and bronze medals, respectively, in the 200-meter dash: "As the medals were being awarded, there were disturbed murmurs from the crowd. Smith was wearing a black glove on his right hand and Carlos was wearing a black glove on his left hand. When the 'Star-Spangled Banner' was played and the American flag rose up on the mast, each held a black-gloved fist aloft. Each bowed his head, defiantly refusing to look at the flag."[55] John Kieran and Arthur Daley note the "understandable" fear this incited in the International Olympic Committee (I.O.C.) regarding the future of the Olympics, which had been "hitherto free from all political, sociological, or other intrusions."[56] Kieran and Daley reserve no space for the properly egalitarian claim of the Black Power salute, yet they seem quite in accord with the brutality with which the Mexican student movement was put down only days before.

While it might be foolish to regard any book that seriously countenances the I.O.C.'s fears of "Montezuma's revenge," even if to disregard them, as legitimate historiography, *The Story of the Olympic Games: 776 B.C. to 1968* symptomatically registers the fear that 1968 inspired in the established order. I cite here the conclusion of its narration of the student uprising: "Fearfully [the Mexican organizers] watched the student disorders, wondering if these hotheads would stab them—and all

Mexico—in the heart by preventing the Games from being held. The troops didn't bother with any nice-Nellie tactics. When a student sniper shot at them, they surged into the building and blasted them out. Six student leaders, it was said, were machine-gunned and some innocents were slain during the subjection of the rioters. The official count was 49 dead."[57]

My aim here is not simply to mock the authors' insipid counterfactual claims, which stem largely from their uncritical acceptance of what was then the official story. Rather, what most interests me is the way in which they faithfully reproduce the state's version of this story, evincing a curious solidarity with the Mexican state's brutality. On the one hand, such a move suggests the extent to which Mexico's symbolic modernity was convincing to an international public; that is, these authors adopt the Mexican state's point of view rather than self-righteously criticizing its brutal banana republic–style tactics. On the other, we might perceive the way in which this new solidarity intimates the future of insurrectionary politics on a global scale, that is, as a matter for policing. In our consensual times, as Rancière has described the present, the appearance of the political has been largely confined to an existence as police logic and the pathologization of whatever forces threaten to disrupt such a police logic.

This seeming transformation in the logic of the political is at home in the ambivalent character of the image. And, to be clear, the ambivalence of the image that concerns me here is a function of the ambivalence of 2 October 1968. As Gareth Williams has put it in the context of another quite iconic dialectical image from the Mexican repertoire, *Francisco Villa en la silla presidencial*: "The simultaneous equality and suspension of equality that the image captures is the very aporia that lies at the heart of the constitution of the revolutionary political community."[58] We already know what happened to the men who raised their fists on the medal stand: they were punished, stripped of their awards, and banned from the Olympics (even Peter Norman, the white Australian who stood next to them, wearing a button in solidarity, was unofficially excluded from future Olympiads). The image is always an afterimage, an image after. Even in the moment of its capture, 1968 is over, having been crushed at Tlatelolco only days earlier. Defeat pricks through the image. (Again, as Bartra puts it: "1968 has left us with two legacies: defeat and transition.")[59] And this transition also pricks through, as it is not really democratic transition, but the fade between images, the push toward consensual times. Tommie Smith on the winner's stand bleeds into

a photograph, from 1969, in Acapulco. Black athletes in silent and force-ful dispute will give way to shirtless actors in a musical. The relation of transition and defeat pricks through all of these images: defeat as a form of transition; transition as a form of defeat. That transition, the fear of that defeat, is why Monsiváis holds on to images.

This tearing and tearing-through continue throughout the prefatory sequence. Toward the end of the photo-poem that opens *Días de guardar* appears a kind of veil, a curtain to block or to delay the pricking through of any relation between defeat and transition. If the punctum is that which, "while remaining a 'detail' . . . fills the whole picture," then the culminating photograph of the series—an overhead shot of the multitude spanning both verso and recto—would seem to state its invulner-ability.[60] No detail awaits the spectator's eye. The photograph reverses the depiction of *Hair* with which I began. Rather than centering on a stage, which organizes the division between the theatre and its public, the photograph announces a coming together. Its composition and sub-ject matter recall Tina Modotti's *Workers Parade* (1926) but depict the congregation from a greater distance. At the bottom of the page appears the fragment "ntees the continuity of repression, democratic will, reno-vation of language through" (ntiza la continuidad de represión, voluntad democrática, renovación del lenguaje a partir del)."[61] This mutilation of words—here the "ntiza," cut from the "gara" on the preceding page (*garantiza*, guarantees) —not only evokes the violence of repression but also reproduces a kind of commonality with photography. Such a loss of the transitional continuity between lines once more formalizes a disjunc-tive relation. Like the photographic image, the word fragment "ntiza," torn as it is from what surrounds it, shows an opening to the ruptural power of what Rancière has designated the sentence-image, "the com-bination of two functions that are to be defined aesthetically—that is, by the way in which they undo the relationship between text and im-age." The sentence continues to link the functions "in as much as it is what gives flesh," while "the image has become the active, disruptive power of the leap." Finally, "the sentence-image reins in the power of the great parataxis and stands in the way of its vanishing into schizophre-nia or consensus."[62] The sentence-image is thus one possible posthege-monic projection of the image, undoing the subordination of one text to another, the parataxis that orders and coordinates these texts as archive.

This mutilation of the word "garantiza" seemingly opposes itself to the fullness of the collective that spans the fold and yet also serves to underline how neither language nor photography can account for the

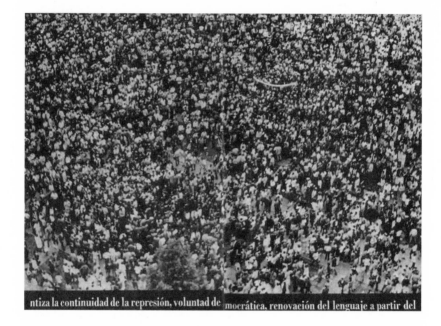

ntiza la continuidad de la represión, voluntad de mocrática, renovación del lenguaje a partir del

FIGURE 2.2

"ntiza la continuidad de la represión," from **Días de guardar** *by Carlos Monsiváis (1970); photograph by Héctor García © Ediciones Era. Courtesy of Ediciones Era.*

event in its plenitude. The fold divides them both. The mutilation of the word is asymmetrical and disobeys a more conventional syllabic division. Gara / ntiza guarantees "the continuity of repression" and, moreover, a repressive continuity. The concept behind this particular chiasmus is explored in Monsiváis's text, perhaps most directly in the chronicle "20 de noviembre / La revolución mexicana: Continuidad de las imágenes," discussed above. The image coheres in its own dialectical appearance by juxtaposing a word violently rent from itself—from the continuity that secures its meaning—with the "democratic will" of the masses who have not yet been torn from themselves, whose bodies are not yet penetrated by bullets. In its first orientation, the density of the composition as well as the hopeful political energies that the photograph captures as studium conceal the very death to which it refers. Yet, in an approach to the photograph's second orientation, the next page will tell the reader that the linguistic renovation announced will take place through "silencio." In turn, Monsiváis reflects on the Silent March narrated in the entry "13 de septiembre de 1968. La manifestación del silencio." The latter reference

overrides or defers the deathly silence in a democratizing celebration of mass (or multitude) that the photograph envisions. The democratizing image-fetish thus takes the place of the silence of the grave and threatens to guard the viewer from its full realization, but also, in a dialectical turn, stands as the only promise of its disclosure. The dialectical relation the text establishes between two kinds of silence—one always deferred and visible in the punctum (understood as the image's unrevealed and partially subjective connotative value) and another, always available as the force of the studium (understood as the image's denotative value)—serves as the sign of the text as a whole.

THE LAST IMAGE

I turn now to the sequence that Linda Egan designates the work's "semantic backbone," that is, the narration of the student movement. "The book's three chronicles on the Student Movement," she writes, "are not presented as a trilogy, but dispersed among other calendrical moments."[63] However, it is the most narrative, sequential, and chronological series in the book or, more pointedly, the final centrality of Tlatelolco as a kind of none too absent center intimates a feigned ambivalence. If this narration fails to form a perfect trilogy, it nevertheless constitutes an increasingly chronological narrative of the student movement in a work that has, on the whole, not adopted a particularly chronological organization. Egan notes that this nontrilogy constitutes a sequence by means of which, as we shall soon see, the part that seemingly does not belong formalizes the content of this misfit chronicle, which speaks of all that did not belong in the student movement itself. A reflection on urban poverty set between episodes narrating the highs and lows of a largely middle-class student movement renders the "1968 trilogy" more "complex."[64]

The first fragment of this series, "Primero de agosto de 1968. La manifestación del Rector" (1 August 1968. The rector's protest) narrates the point that inaugurated the cohesion of the movement, when UNAM's rector, Javier Barros Sierra, demonstrated his support of the students' demands and marched to protest the government's occupation of UNAM. This narration is accompanied by a photograph that does not appear in the prefatory series but, rather, in the body of the chronicle. Its inclusion here repeats a formal cohesive logic narrated in the chronicle as social

solidarity. Spanning both verso and recto pages, we see Barros Sierra and other UNAM officials taking to the streets along with the students: "The 1968 student movement was beginning."[65]

The book's next chronicle, "13 de septiembre de 1968. La manifestación del silencio" (13 September 1968. The silent march), dedicated to José Revueltas, recalls one of the student movement's greatest successes, marching through Mexico City in silence to protest the government's censure and brutal repression. This chronicle takes on a delirious and celebratory tone that captures the atmosphere of the march. Yet a third chronicle ("15 de septiembre. La independencia nacional: Tepito como leyenda") separates the previous two from the nontrilogy's violent culmination, "2 de octubre / 2 de noviembre / Día de muertos. Y era nuestra herencia una red de agujeros" (2 October / 2 November / Day of the Dead. And our inheritance was a web of holes). What Egan suggests as a kind of narrative interruption deserves some attention here.

The chronicle on Tepito once more presents Monsiváis's reflections on social stratification by announcing a bifurcation that at once projects an image of an increasingly modern Mexico in the lead-up to the Olympics and the separation between those living the economic boom of the so-called Mexican Miracle and the inhabitants of a popular neighborhood like Tepito or La Lagunilla (Tepito and Lagunilla are legendary working-class neighborhoods and markets located in Mexico City): "eternally postponed Mexican solidarity."[66] Yet, as I have noted, this particular meditation, dated 1967, appears among three otherwise chronological reflections on the student movement of 1968. Why this interruption? Perhaps Monsiváis is trying to simulate a disjunctive, discontinuous narration of the moment. I would suggest, rather, that this reflection forms part of the series.

Appearing after entries that narrate two of the most successful and emblematic actions of the student movement and before a reflection on destruction and its aftermath, this entry stands as a prolegomenon to failure. Here Monsiváis recalls the emblematic figure of Rodolfo "El Chango" Casanova, who went from triumphant boxer, to street vendor, to patient in a mental hospital: "Casanova is important on our precarious map of symbols because he signifies the legalization of pessimism, the canonization of disaster."[67] El Chango belongs to Mexico, Monsiváis notes with a certain irony, for he is a "*born loser*, nacido para perder."[68] The demand to think the cultural specificity of the "canonization of disaster," placed as it is in the chronicle that appears just before what is perhaps the collection's most direct reflection on Tlatelolco and its after-

math, serves as a warning against fatalistic solidarity with the tragic and as a critique of the use of defeat as a basis for the common, that is, the melodramatic, hemopolitical, or catastrophilic future of politics. This reflection on nonsolidarity also reminds the reader of what—despite efforts to the contrary—remained outside the largely middle-class movement, the urban poor who live in places like La Lagunilla or Tepito (not to mention the peasants). These uncounted poor demand their place in the narration of the movement. Put otherwise, as a prelude to the movement's defeat, these uncounted poor recall what for Monsiváis stands as the movement's failure. In this chronicle more than in any of the others, Monsiváis offers an explication of his own politics of Tlatelolco, and attacks the way in which disaster so often forms the horizon for the construction of the political. Yet in place of such tragic unfoldings, Monsiváis offers a further postponement.

In the chronicle "2 de octubre / 2 de noviembre / Día de muertos. Y era nuestra herencia una red de agujeros," Monsiváis finally writes about Tlatelolco. From the site of reflection, a month later, on the Day of the Dead, a folkloric Mexican death festival, he writes: "It isn't a pilgrimage to the source of darkness: it is a social event, a hint of the duty that is fulfilled against death and against life, without the shelter of transcendence or commitment."[69] He begins the chronicle by describing in detail an example of Mexico's peculiarly spectacular death ritual (on 2 November), which he encounters in the arrival of hippies, the well-heeled "tribus [tribes] de la Zona Rosa," to the town of Mixquic, where they partake of folkloric tourism. He then interrupts this narration to speak of a different day, a different congregation: "A month ago, there was a meeting in Tlatelolco."[70] This October meeting, a haunting, pierces the surface of November. Confirming a certain prejudice glimpsed in the chronicle about the Acapulco production of *Hair*, Monsiváis is already a bit embittered about the hippie question and yet seems to view it dialectically, as it were, for its countercultural ethos nevertheless convokes the specter of what it seems to exclude.

Yet again, the representational logic of the photograph is brought to bear on Monsiváis's narration of the events of 2 October: "The V for victory sign stood opposite to the hand with the revolver, and the agonistic twilight used both gestures and eternalized them and fragmented them and united them without end, plenitude of the unfinished, plenitude of the Eleatic proposition: the hand will never stop brandishing the revolver, the hand will never abandon the protection of the V."[71] The image's plenitude holds at its core the crystallization of the disjunctive rela-

tion that peculiarly organizes the book and that renders its quality as not only a collection of dialectical images, but as, itself, a dialectical image. On that score Benjamin writes: "The dialectical image is that form of the historical object which satisfies Goethe's requirements for the object of analysis: to exhibit a genuine synthesis. It is the primal phenomenon of history."[72] A genuine synthesis would render history dialectically in the contradictory process of its unfolding, and thus not spectacularly, ideologically, or consensually. In such an image, nothing is resolved.

Monsiváis captures and holds up the first moment of the violence on the Plaza de las Tres Culturas and sustains the as-yet undecided and unresolved nature of the clash between two gestures: the hand holding the gun ("la mano con el revólver, la mano con el revólver, la mano con el revólver") and the hand that opposes it ("otro gesto inacabable"). Together these hands form a dialectical image, a concept of the history of 1968. By sustaining this image—for these gestures will never be "abandoned"—the text never imagines, much less images, the dead, "the unfortunately unphotographable dead."[73] Plenitude threatens to become the image-fetish that conceals what cannot be made present in the image, the still-uncounted dead who will constantly pierce the image's surface—another tearing. A single pause, a singular delay makes present those missing by means of the repetitive allusion to that which exceeds representation, which exceeds the naming that would organize it and mutilate it, that would cut it (in another tearing, a photographic extraction) from what surrounds it. Monsiváis pauses narration before bloody culmination and, in so doing, allows these two opposing hands to sustain themselves, eternally—together in the image—as objects for reflection.

If there is something messianic about Monsiváis's plenitude of the unfinished, it presents itself not only as a refusal to complete the task of representation, to consign experience to its formalization, but also as a refusal to look, a refusal to remember defeat and violence, a refusal to mourn (a desire for the repression of the repression, but only as desire). Naturally, it is not only for that which has not yet concluded to claim this kind of plenitude. This image—a moment forever unfinished, that never becomes a different moment, that never gives in to the future— sustains plenitude, sustains a social collectivity in the very desire to negate its own negation. In this sense, we should understand Monsiváis's invocation of "the unfortunately unphotographable dead," not only as the formal and ever-hyperbolic invocation of an ontological limit of the image, but also as the demand of and for politics, sustained through the

prohibition on the congealment of experience in the image. Monsiváis thus affirms the possibility of politics, indeed, that there will be politics, by renouncing the obsessive identification with one's own desolation as a politics that could ever merit that designation.

This image is always a counterimage. It "illuminates" and founds the "archontic principle of the archive," "the takeover of the archive by the brothers," "the equality and liberty of brothers."[74] The dead cannot be photographed because this moment of defeat cannot be turned over to the continuity of images ("continuidad de las imágenes," "continuidad de represión"). These days are observed and kept sacred, as ineffable and untranslatable as the Tetragrammaton. Deferring this moment, we eternally encounter a placeholder to which the guardians of its tradition must nevertheless "hold fast"—to the image and in the image—until the defeat of its enemy, an enemy that "has never ceased to be victorious."[75]

MERE FACTICITY

The man facing the camera is Florencio López Osuna. His body is battered. He looks into the apparatus, and thus at the viewer, through the photographer's prosthetic eye. Almost naked, shimmering with vital fluids, his forearms are obscured by his jacket. His hands are cuffed behind his back. All of this gives the momentary impression of a bodily mutilation; the darkness into which his arms disappear not only is an abyss but also creates the illusion that the man's arms have been severed from his body, an amputation. The man will soon be dead, but in the present of the photograph's release, not in the instant of its capture. Indeed, he will live thirty years longer in obscurity before reappearing from this long parenthesis, giving his testimony (or promising to give his testimony), and finally dying only weeks after the photograph's public emergence. It is this image, taken from the cover of issue 1310 of the Mexican political journal *Proceso* (9 December 2001), which allows the man to become rediscovered: he reappears.[76]

"A photograph," says Eduardo Cadava, "speaks as death, as the trace of what passes into history . . . Yet speaking as death, the photograph can be neither death, nor itself. At once dead and alive, it opens the possibility of our being in time."[77] Herein is revealed a peculiar coincidence between photography and its object: the photograph speaks as death, but is not. The photographic object is, like López Osuna himself, "simultaneously" dead and alive, speaking as death, but not death, unable to be

FIGURE 2.3
Front cover of **Proceso** *1310 © Revista Proceso. Courtesy of Revista Proceso.*

as itself, a trace of what passes into history, that is, history. In the meantime, an empirical truth has come to light: the white glove on the man behind him proves the existence of the paramilitary organization Batallón Olimpia.

"Reconozca y reconózcase"—Recognize and recognize yourself (or recognize and be recognized)—reads the text below the second photograph in the special report, a call to readers: "Those who have [*Quienes tengan*] a story to tell about the people, victims or victimizers, that appear in these photographs, contact the editors of *Proceso* by calling the operator's number 56 29 20 00, or by e-mail pbr@proceso.com.mx."[78] These images were only the most prominent of thirty-five photographs brought to light in the early twenty-first century by a secret source, initially published in *Proceso*, and subsequently reprinted in a kind of archi-

val collection, *Parte de guerra II*, edited by Mexico's chronicler (Carlos Monsiváis) and Julio Scherer García, the founder of *Proceso*.

This coming to light serves to illuminate once more the logic of an archival madness that characterizes Mexican reflection on the events of 1968. The magazine lauds the final emergence of an established truth—the man in the white glove, the brutalization of the student's body, the pseudo-clandestine nature of this violence, its perpetrators, and their victims—and immediately reinitiates the call for *more archive*: "Those who have a story to tell." In this subjunctive mood, whosoever, should such a person exist, should such a person chance upon these photographs and should they remember, should these images inspire resonance, please call: "contact the editors of *Proceso*."

The text opens onto the deferral of 1968, of thinking 1968, before this reunion. This trope of the "quienes" (who), and of their potential, haunts our reflection, demanding not a recognition of its incomplete nature, but assuring that it can never properly take place because we will never have enough archive. Yet also, simultaneously, even in their numerical multiplicity, these "found" or recovered images only underline once more the remarkable univocity of the image of 1968, for it is an image of defeat, of sacrifice, of loss (the citation of Tlatelolco, closing itself off, casting the light of 2 October on the future and the past). López Osuna is not only a man whose visage and body are detained in a still photograph, he is also a man subjected to police power. The subject photographed is arrested in time in the image, just as the subject was physically arrested, detained, held onto by the authorities.

Florencio López Osuna faces the camera "again": a similar photograph, taken moments earlier or moments later. The image appears on the cover of *Proceso* 1312. He no longer peers into the camera; his eyes are closed. This photograph is rather like a detail of the previous one in which he appears much closer, alone. The white-gloved man, the soldiers, the other captured activists behind him are no longer there, only the singular pain of a man who will die (and also live forever) in this image, by this image.

This series reminds us, once again, that we will perhaps never know what a photograph is, what it captures, where it operates within history. (Does it capture a site or a scene? Does it index the larger process from which it is captured, or is it always irrevocably severed from its moment by the very procedures through which it communicates with our present?) Yet the image stages the truth—or, rather, its claim is the staging of a truth—of a moment passed that cannot be refused. A demand is

FIGURE 2.4

Front cover of **Proceso** *1312 © Revista Proceso. Courtesy of Revista Proceso.*

placed upon us, the viewers, the listeners, to bear witness to the truth of an event in its aftermath, a demand to collect the documents that prove the circumstances of a defeat.

There is something inscribed on the subject photographed, but this thing is concealed, written over, scratched out by the photographic inscription that transmits it to the viewer. If this is the case, then, what are the possible circumstances of legibility for such images? Can they be read beyond their evidentiary potential (and would that make them art)? And how does the logic of the photographic image, finally, inscribe itself in the history of the aesthetic reflection on Tlatelolco generally, given that the photographic capture of events is the most indexical and yet secretive, the most instantaneous and yet enduring form through which they are mediated and transmitted?

Photographs are both revelatory and secretive: in the faithful, indexical transmission of the instant framed and flashed upon, there is always a cutting, a mutilation that attends the capture of the image, a framing that is both spatial and temporal in nature, for only a determinate object or set of objects is captured, for only a determinate instant. In a sense, this is the lesson borne out by the revelation of the photographs of López Osuna: a photograph is López Osuna, this capture and also this gradual, eternal, death.

For, indeed, López Osuna is dead now—not in the instant of the flashbulb, but in the present of *Proceso* 1312's publication. Once a CNH delegate, Florencio López Osuna is a subject in time in a way obscured by these stills. In 1968—after 1968—López Osuna, a fairly prominent activist, faded away, only to reappear following the publication of this photograph. This lost figure frames the arc of a lost cause, the outline of his photo-history identifiable with that of 1968. His reappearance in *Proceso* 1310, curiously, precedes his death, a death that announces the end of another parenthesis, concluding the reappearance. The mysterious circumstances surrounding this death seem to reenact and follow through with his missed encounter with death at Tlatelolco; he receives the death he missed on 2 October 1968, prompting both a closure of the parentheses opened by the photographs and, again, the promised reopening of the Tlatelolco archives in the light of this new, secret death.

"Sobrevivió 33 años . . . " is the title of the first of a series of texts dedicated to López Osuna's death to appear in *Proceso* 1312 (also in December of 2001). The title is superimposed upon an image of López Osuna now, thirty-three years after the student movement, thirty-three years after a government photographer captured the shocking photographs pub-

lished on the covers of *Proceso* 1310 and 1312. The image reveals thirty-three years in an instant: López Osuna stands again on the Plaza de las Tres Culturas (the photograph bears the caption "López Osuna, 13 December, in Tlatelolco"). He wears a suit now and is gesturing with his hand toward an area off-camera, outside of the frame. The subject narrates a past that is beyond the camera's eye. His gesture serves as a metaphor for the temporal impossibility that the camera, that the viewing subject present, today, might view what happened there over thirty years earlier.[79] Yet López Osuna will soon die, will already be dead at the moment of the magazine's publication. His body will soon appear in the Hotel Museo, where he returned with a woman who will never be identified, after a night spent drinking beer and listening to music in the Café Montes.[80]

He had passed the day with old friends from the movement. Their spirits were renewed by the publication of the thirty-five photographs. Alfonso Revilla, the last comrade to see López Osuna alive, recounts, bears witness to, his friend's last words: "We should organize a commission to review the facts and clarify them. We should plan a meeting with all of the *compas*, because I know that many have continued looking for documents. Without a doubt, this is the moment. We just need to avoid manipulation and naïveté in the use of these *testimonios*."[81] These last words—really, a bearing witness to last words—call forth a Tlatelolco archive whose principle will be not only "democracy" but also fraternity. On this account, fraternity—"a meeting with all of the *compas*"—will found the archive to come and will guard it from any future appropriation ("manipulation and naïveté"). The archive, as conceived here, not only will assemble documents but will be present itself in the reconstitution of 1968's collectivity in the present. However, this "strange death," the implication appears to be, interrupts once more what might have occurred. The declaration, that is, of a "strange death" insinuates that violence closes once more the possibilities of fraternization.

Presenting these images for the first time, Sanjuana Martínez writes: "One need not be an expert to prove that these photographs show part of what happened on 2 October 1968, on the Plaza de las Tres Culturas in Tlatelolco."[82] The images show what happened, but only part of what happened. They make a truth visible in ways that the testimonies of students and foreign journalists have not. The truth they offer is original, exclusively photographic: "These photos offer the chance for the first time to see the killers' faces, and show the white-gloved men in action.

Finally, the possibility that they might be identified has opened up."[83] This is to say, once again, it is perhaps toward these photographs—or photographs like them—that López Osuna gestures in the photograph of 2001 accompanying the article. The faces of 1968 will finally be made visible; a possibility is opened.

Here, the way in which the still photograph engages a truth-telling capacity beyond its capability to bear witness recalls Marey's interest in photography as a scientific resource; the photograph, according to the conceit of this orientation, is beyond ideology. It transmits the plenitude of the visible in a moment of stillness to which we otherwise would not have access. Or as Benjamin writes: "Photography, with its devices of slow motion and enlargement, reveals the secret."[84] The photographic object is forensic, awaiting a witness to its capture of time that will make use of its revelation.

"The debt remains unpaid," writes Martínez, pointing to the final arrival of justice regarding the events of 1968.[85] These photographs point to a conclusion, a resolution of the events at their center by means of which everything will be counted, every injustice will be recompensed. For the photos show that "in the state's archives is all the documentation necessary for knowing who committed the Tlatelolco massacre."[86] That Martínez imagines its possession of such knowledge underlines once more the state's perceived social and political extensiveness. Somewhere, elsewhere, the entire truth is held secretly. This truth is thus only partially registered in thirty-five heretofore unpublished photographs that find their way into Martínez's hands over thirty years later. The archive of the state, held in secret, knows everything and can no longer suture its wound; it discloses itself, opening the wound of its secret: 2 October 1968.

According to Martínez, photographs such as these promise something like a glimpse of the democracy that attends the opening of the archive. Along these lines Derrida writes: "There is no political power without control of the archive, if not of memory. Effective democratization can always be measured by this criterion: the participation in and the access to the archive, its constitution, and interpretation."[87]

Yet the partial appearance of the state's documentary and criminological photographs must be read as the contrary of that hoped-for opening. For somewhere in the state's archive—whether or not it exists as such—is every possible photograph, from every possible angle, of every face, the effective production of what, in an essay on criminology and photogra-

phy, Alan Sekula calls "a generalized, inclusive *archive*, a *shadow archive* that encompasses an entire social terrain while positioning individuals within that terrain."[88]

The photographs find their way to Martínez in Madrid. Thirty-five photos taken on the night of 2 October 1968 arrive at her house in an anonymous package. She recounts how the photos were sent to her by a secret source, a *fuente*. Soon thereafter followed an anonymous telephone call. "We want the truth to be aired publicly [literally, to be brought to public light]. We want justice," he tells her.[89] But why? the correspondent wonders. Why now? "Right now is the exact moment. It is when we must bring them to light."[90]

This seizing of the image at such a precise conjunction (in dangerous times) again recalls Benjamin (whose text provides the epigraph of the essay by Monsiváis that follows Martínez's introduction to *Parte de guerra II*). Martínez asks who shot the photographs. "Ask Luis Echeverría," the source responds.[91] When pressed to elaborate, the anonymous caller adds: "He knows. Ask him about the photographer and about everything else."[92] She asks many times who the photographer was; her source insists that it was not him. Echeverría, interior secretary under then-president Gustavo Díaz Ordaz, the man considered most responsible for the violence, only he knows the answer to this question, and to everything else.[93]

We have yet to see everything else, *todo lo demás*, that which resides beyond these particular photographs, beyond anything photographable and in Echeverría's secret and, finally, immaterial archive. Such, to be sure, is a question beyond photography, beyond the public archive or any possible archive, and is the question of truth, of justice. These photographs are thus the archive of our present, the "now" of their recognizability. Had the photographs been published earlier, had they "come out" much closer to their capture, then the official explanation would have seemed ridiculous, obscene, as Monsiváis notes. But it did seem ridiculous and obscene. The truth is already known, for as Monsiváis tells us, the thirty-five images published in *Proceso* "prove what is already known."[94] That is, there is a final coincidence, a final parity between knowledge and proof (a coming out of the closet, a public publication of truth, the saying that is necessary for what is known to be proven). But, Martínez implies, the state's archive is once again closed: López Osuna is found dead two weeks later, "Extraña muerte [Strange death]," she writes, echoing the words on the cover of *Proceso* 1312. The rest of the ar-

chive promised by the secret source is never revealed: "Following López Osuna's death, the anonymous sender never reestablished contact."[95]

According to Alberto del Castillo Troncoso, however, an anonymous delivery would not have been necessary for the photographs' dissemination and the name of the photographer is known. Indeed, Manuel Gutiérrez was assigned by Luis Echeverría to produce the police archival record of the 1968 movement and thus attended their meetings, protests, and arrests.[96] Rather, according to del Castillo Troncoso, the photographer's widow gave his archive, containing some 1,200 images, to the Centro de Estudios sobre la Universidad nearly a year before Martínez received the images from an anonymous sender in Madrid.[97] For this reason, Andrea Noble suggests that "invented or real—and it would be difficult to resolve this issue conclusively—the anonymous donation bespeaks the political urgency of a pivotal moment in Mexico's transition towards greater democratic openness, as steps were being taken to start to investigate acts of state terrorism in the past."[98] In other words, Noble suggestively reads this rather dramatic (and global) appearance of the images in light of the demand for producing Mexico's long-awaited transition. Their publication renews the demand for justice, for remembrance, but most of all, for transition and for moving on, now seemingly possible under the then-recently installed transitional regime of Vicente Fox.[99] However, Carlos Monsiváis had already questioned the images' effective revelatory power and thus the very idea that we can ever find our justice in the archive.

"Las fotos salen del closet," reads the title of the first section of the essay by Monsiváis that appears in *Parte de guerra II* (and previously published in *Proceso* 1310). In light of these conflicting portrayals of the images' emergence, Monsiváis's reading is perhaps the best way to reconcile Martínez's narrative with that of del Castillo Troncoso. Here Monsiváis more or less recounts the story of the photographs, the many years passed, López Osuna's reappearance and mysterious death. He begins the section with an epigraph culled from Benjamin's "On the Concept of History."[100] "The true image of the past flits by. The past can only be seized as an image that flashes up at the moment of its recognizability, and is never seen again . . . For it is an irretrievable image of the past which threatens to disappear in any present that does not recognize itself as intended in that image."[101] The images—no matter where they were—only *now* seem to have become visible, because they are images of our present. Monsiváis invokes the approach he adopted for the writing

of 1968 in *Días de guarder*; that is, he intempestively foresees the logic of a past writing:

> Had they been published the third or fourth of October, these photos would have instantly given the lie to the official explanations and to the Partido Revolucionario Institucional's discourse of perpetual whitewashing. Of course, these are not the first pictographic testimonies of the Tlatelolco massacre, for in October of 1968 a special issue of the weekly journal *Por qué!* contains devastating photos of children in the morgue and piles of bodies, but the journal has a small circulation and in a climate of fear the funerary display rather discourages dissent. In 2001, the photos from *Proceso* don't allow "grumblings between the teeth," the extremely forced apologies of the regime and its party, and prove what is already known: the attempt to eradicate the spirit of the movement by force follows the military-led massacre.[102]

Had the photographs been published earlier, had they "come out" much closer to their capture, then the official explanation would have seemed ridiculous, obscene. But it already did, because photographs like these—images similar to these—had already emerged. These earlier photographs, however, failed to gain wide circulation. They could not cut through an atmosphere of fear. Despite this small circulation, however, Monsiváis tells us, the thirty-five images published in *Proceso* "prove what is already known."[103] That is, there is a final coincidence, a final parity between knowledge and proof (a coming out of the closet, a public publication of truth, the *saying* that is necessary for what is known to be proven).

This coincidence between what is proven and what is already known results in an illumination: the eradication of the *spirit* of the movement, Monsiváis notes, follows the massacre. The photographs, to be sure, do not show the massacre—whose light marks the retinas of the witnesses and the nonwitnesses alike—but demonstrate its aftermath, a time more like the present, in which the student movement is already a spirit, a ghost of itself, whose very spectrality is the object of a further eradication: an archival domiciliation. The obsessive return of this photographic evidence—the desire to constantly prove what is known—reduces 1968 to mere historical fact—"1968 is a historical fact" writes Monsiváis.[104]

By way of concluding here, why search for these images if we already know what they will contain? Our obsession with finding the image is an obsession with finding what we already have. It compensates our

imagination for the image that we can never have: the event and its duration. Perhaps in this regard and despite the possibly cowardly tone of its avoidance of casting blame, Abel Quezada's 3 October 1968 illustration—a simple black rectangle with the title *¿Por qué?*, published in the newspaper *Excélsior*—has remained the image most faithful to this possibility, displaying before us the *im*possibility that we could ever see that thing we need to see—the moment of a "slightest" decision, the event of a politics, the possibility of a collective becoming.[105]

From that deferral and melancholy, we move now to mourning, sad passions, to hegemonic designs, to the reinvestment of loss through a literary construction of civil society in Elena Poniatowska's testimonial novel, *La noche de Tlatelolco*.

TESTIMONIO AND
THE FUTURE WITHOUT EXCISION

Tlatelolco is the dividing point between two Mexicos.

LUIS GONZÁLEZ DE ALBA

What did the students want? The writers and historians who have seemed to be most faithful to 1968's unfolding have largely organized their work around variations on this question. The present chapter reads the most significant and resonant version of such reflection, Elena Poniatowska's 1971 testimonial novel, *La noche de Tlatelolco*, and identifies it with the very hegemonic impulse that the student-popular movement challenged. *La noche de Tlatelolco* works to convert multitude into people, under the very logic at work in the perceived elsewhere or outside of the Mexican state formation.[1] In Jon Beasley-Murray's words, "the state is effectively dissolved into what was once known as civil society. But this means that civil society, which is defined by its distinction from the state, has now withered away."[2]

In this chapter I attempt to convey critically the logic of such a dissolution and, in order to do so, I proceed to engage in the perhaps unwelcome critique of some high pieties in Latin Americanism and beyond, among them, the maudlin and Christological affair called *La noche de Tlatelolco*. Sad things bring good things—there is always, melodramatically, redemption of some kind—and so the question that is perhaps least useful to politics in the sense that interests me here becomes an abusive, collective emotional blackmail.

So, in *La noche de Tlatelolco*, what did the students want? They wanted justice for the dead, understood as the collective recognition by state and society that what happened at Tlatelolco was tragic. But that would be a deeply untimely desire, for the students and their movement are gone by now, mortified and imprisoned; they are represented by civil society. The students and their movement, if there is or was a movement, can

thus only be read through something like the negative image of sacrifice and condescending moral outrage that forms the object of this chapter. Such is perhaps the persistent form of Mexican sovereignty. Gareth William calls this "melodramatic consciousness," after Althusser. Writes Williams, "melodramatic consciousness is nothing more than the bourgeois reproduction of the ideological contradiction that is its very content."[3] If it is the case, as Williams has more recently suggested, that "posthegemony is the interruption of melodramatic consciousness," then the present chapter turns on interrupting a signal moment of its constitution.[4] In *La noche de Tlatelolco* we encounter, as Althusser puts it, the "'law of the heart' deluding itself as to 'the law of the world.'"[5]

This chapter begins a posthegemonic reading of that text in order to retrace the consignment of the properly political to a rather more melodramatic, unreal, and ideological remit. Or put more precisely, Poniatowska's text confronts the reader, as Williams puts it, "at the undecidable limit between the democratic and the demagogic, and therefore between the democratic and the melodramatic."[6] In this sense—by occupying this limit—Poniatowska returns the thinking of 1968 to a rather well worn tradition.

"The Photograph is violent," writes Barthes, "not because it shows violent things, but because on each occasion it fills the sight by force, and because in it nothing can be refused or transformed."[7] Perhaps something similar might be said of *testimonio* as a genre: it is violent not (only) because it shows violent things, but because it fills the sight by force, because nothing in it can be refused or transformed unless we refuse to look. *Testimonio* and photography stage the truth of a moment past that cannot be refused. They both appeal to a similar conceit and place a similar demand upon us, the viewers, the listeners, to bear witness to the truth of an event (here in the more common acceptation) in its aftermath. In the aftermath of an event, memory becomes a tool for naming that event as event. This name, born in aftermath (and at a particular juncture, from within a particular moment of aftermath), condenses what comes before aftermath and conditions what is to come in its name. All of this is not to say that the truth to which *testimonio* and photography call us to bear witness makes itself freely available, or that these media portray their object in a way that demands our consent; rather, *testimonio* and photography make their demand upon us, and this demand, as Barthes elegantly puts it, fills the sight by force. Put in other terms, like the photograph, *testimonio* touches us, pierces its own narrative surface, is penetrated by and pricks us with a kind of punctum.

In *Subalternity and Representation,* John Beverley uses a famous Lacanian anecdote to explain the relation between the terms in his title that relates also to the scene of a punctual realization. In book XI of *The Four Fundamental Concepts of Psychoanalysis,* Lacan recounts the following experience: "Being a young intellectual, I wanted desperately to get away, see something different, throw myself into something practical."[8] He decides to go off to a small port city to live and work among the fishermen. One day, while he is out fishing with Petit-Jean, the latter points out a small can floating on the waves. Petit-Jean turns to Lacan and says: "You see that can? Do you see it? Well, it doesn't see you!"[9] Beverley comments: "Lacan's story is about a kind of seeing in reverse."[10] In a peculiar way, however, this story is not only about the relation between the intellectual and some desired object. It also illustrates the relation or, better, structural similarity between the image and *testimonio*: the object of neither *testimonio* nor photography sees us. Or as Jacques Rancière has put it:

> Photography became an art by placing its particular techniques in the service of this dual poetics, by making the face of anonymous people speak twice over—as silent witnesses of a condition inscribed directly on their features, their clothes, their life setting; and as possessors of a secret we shall never know, a secret veiled by the very image that delivers them to us. The indexical theory of photography as the skin peeled off things only serves to put the flesh of fantasy on the Romantic poetics of everything speaks, of truth engraved on the very body of things.[11]

We, the viewers, the listeners, the readers, have been called into an undeniable relationship with the object of our gaze, which cannot look back and whose absence implies an afterward and an aftermath. Both genres draw their authority from the irrefutable power of the event whose truth they trace. And like *testimonio*, the photo-aesthetic object lays claim to a secret that the viewer would like to possess. Simply by our looking at them, they draw us into a relation with the truth of the aftermath they cannot, as yet, name, that we can never hold but for the appropriating force that is the power of the name. To name the past is to name in aftermath, and to thus command the truth of that aftermath.

In Poniatowska's extensive writings on the massacre, an illumination emerges with such immediacy regarding the catastrophic event to which it responds that it seems to spontaneously displace—or fully restitute—

its own catastrophic origin. "Something was irretrievably lost," affirms Poniatowska. The phrase continues, however, with a parenthesis leading to a conjunction that interrupts and negates what comes before: "(death is always unrecoverable), but something was gained."[12] Appearing in *Fuerte es el silencio*, a collection of chronicles of then-recent or contemporary Mexican social movements published some years after her more immediate and more urgent *La noche de Tlatelolco*, the utterance suggests a kind of balance sheet, a tally of the debt, as it were. (The title of the English translation of *La noche de Tlatelolco*—*Massacre in Mexico*—recalls the aesthetically questionable and politically obscure marketing decision to title the U.S. release of Primo Levi's *If This Is a Man* as *Survival in Auschwitz*.) According to the logic of the melodramatic subject, on the side of loss stand the lives of the victims, and with those lives, the PRI-ist Mexican state's legitimacy. Yet along with the loss of the state's legitimacy or, rather, the perception thereof, the possibility for something new opens up.[13] That is to say, loss transforms into gain by way of what might be construed, in its ultimate consequences, as a sacrifice. In loss, a rebirth or renewal is implied.

The destruction of a collectivity at Tlatelolco stands as the conditions of possibility for the net gain of Tlatelolco, that is, for Poniatowska, a certain notion of democracy in civil society. I return to her words: "Something was irretrievably lost (death is always unrecoverable), but something was gained." As the phrase stands, loss is immediately eluded in favor of what can be gained in the tragic aftermath. Something was lost, something unrecoverable. But what was lost, if unrecoverable, can yet be pushed aside by the "but" that simultaneously conjoins and forces the sentence apart (forcing the thought of loss into a parenthetical, almost tangential utterance—something close to, on the verge of, forgetting while, at the same time, joining it to gain; loss meets and is replaced by redemption).

Along similar lines, early on in *La noche de Tlatelolco*, we read the voice of Luis González de Alba: "Tlatelolco is the dividing point between two Mexicos" (Tlatelolco es la escisión de dos Méxicos).[14] This "escisión" emerges, on the one hand, as the symptomatic appearance of a disagreement (understood as politics) which had been repressed by the party-state that lasted for most of the over seventy years of the PRI's rule in Mexico. The year 1968 convenes and provides the terms that organize this sociopolitical divide at its point of rupture.

At the same time, "escisión" might be understood as a temporal division, the time before Tlatelolco, and the time after. As Poniatowska

would write, again in *Fuerte es el silencio*: "After that moment, the lives of many Mexicans was divided in two: before and after Tlatelolco."[15] Such a notion of "escisión" also, finally, describes the wresting of the historical moment as a sign of its legibility, its capture of a time and the yielding of that time to historical thinking. Before and after Tlatelolco stand the "fore-history" and "after-history" of the event's becoming. Benjamin says: "Every dialectically presented historical circumstance polarizes itself and becomes a force field in which the confrontation between its fore-history and after-history is played out . . . The historical evidence polarizes into fore- and after-history always anew, never in the same way."[16] This confrontation produces a splitting in the unfolding of history, a splitting and perhaps also a war, a continuation of or a sequel to the war that organizes Mexicanism at its origin: the deep social conflict, economic inequality, and racial enmity that, through successive social orders, Mexico has sought to administer, understood as the originary fantasy for which Mexico cannot break its habit (an origin from which, despite Paz, despite Poniatowska, there is no splitting).

"Escisión," readers will recall, is repeated in the very structure of Poniatowska's text, which is divided in two. The first half, "Ganar la calle" (Taking to the streets), presents Mexico, 1968 largely along romantic lines—freedom, rebellion, and dreams—while at the same time it attempts to give voice to the dispersed tendencies within the movement and their reception by the society as a whole. The second part of the book, "La noche de Tlatelolco" (The night of Tlatelolco), names not only the book but the thing that happened in Mexico in 1968: Tlatelolco. The selection of the book's second half as the material that should provide its title signals the photopoetic act that rules it, the citation that renders legible 1968, but legible only in the moment of its foreclosure. The second conception of Mexico, 1968 cancels the first conception.

The privileging of the second title thus indicates that Tlatelolco convenes and makes coherent the diverse upheavals of the months that preceded the massacre. As such, and in light of the book's own annexation by the name Tlatelolco, the first part of the text becomes prelude to a death that can henceforth only haunt the entirety of Poniatowska's endeavor, and indeed any politics to occur in Tlatelolco's after-history, including the so-called democratic transition to which the massacre has been sutured as its moment of origin and the social movement that sought such democratization under the banner of Tlatelolco's restitution.

This chapter might best be read under the sign of the following act of witnessing:

Everything was a blur—I don't know if it was because I was crying
or because it had started to rain. I watched the massacre through this
curtain of rain but everything was fuzzy and blurred like when I de-
velop my negatives and the image begins to appear in the emulsion
. . . I couldn't see a thing. My nose was running, but I just snuffled
and went on shooting pictures, though I couldn't see a thing: the lens
of my camera was spattered with raindrops, spattered with tears.[17]

So says the press photographer Mary McCallen, writes Poniatowska, in
the book that has arguably provided the canonical reading of 1968 in
Mexico.

We will read her words more slowly now, but not before reflect-
ing on a second quotation, which comes from Walter Benjamin: "The
events surrounding the historian, and in which he himself takes part,
will underlie his presentation in the form of a text written in invisible
ink. The history which he lays before the reader comprises, as it were,
the citations occurring in this text, and it is only these citations that oc-
cur in a manner legible to all. To write history thus means to cite history.
It belongs to the concept of citation, however, that the historical object
in each case is torn from its context."[18] It is the logic of citation that ex-
poses itself against the fog of war, the uncertain inscription of which
might never pass into history understood as the history of war.[19]

"Everything was a blur—I don't know if it was because I was cry-
ing or because it had started to rain." A cloudy vision makes present the
massacre, as if the rain itself might occasion a return to another elemen-
tal state; the narrator is unsure whether her field of vision is clouded by
rain or by tears. But why clouded? Rainfall is indeed the end of the cloud
or the fog, the precipitation that signals release. The metaphorical prox-
imity of rain to the cloud grounds the almost-literal character of Mc-
Callen's figurative language, while the slippage between rain and tears
secures, despite the semantic proximity that threatens to undo it, the
metaphorical status of "nublado" ("blur" in the translation). Language
stands between her narration and the desire for a photographic real in
which it is based; wanting to transmit only this photograph, this ideal
and total citation of history, McCallen's truth can only cloud itself in the
figurativeness that is all language.

"I watched the massacre through this curtain of rain," McCallen con-
tinues, now seemingly deciding that it is rain that obscures her view.
Yet it remains *unclear*, metaphorically speaking, whether it is rain that
clouds her vision, or whether the signifier "lluvia" has now itself become

a metaphor for tears, "but everything was fuzzy and blurred like when I develop my negatives and the image begins to appear in the emulsion." But, McCallen observes, everything is undulating, everything is blurred, as always: blurred and undulating, the relation between literal and figurative language. The field of vision is itself—another figure— like photographs still in the process of revelation. "I couldn't see a thing. My nose was running, but I just snuffled and went on shooting pictures, though I couldn't see a thing: the lens of my camera was spattered with raindrops, spattered with tears." The lens of the camera or the lens of the eye, the photograph here becomes the absolute metaphor for all witnessing (and for historical thinking).

Such figurative language obscures itself in the photographic topos through which it cites history and records the very fate of the student-popular movement as an object for historical thinking. The logic of its revelation emerges only a few years later for Octavio Paz; where once, as I discuss in the first chapter, it was the blur of the stain, an absence, a defeat of poetry, it would soon become the very process of photographic revelation.[20] Like Benjamin's text, "written in invisible ink," Tlatelolco forms the citation "legible to all," casting its illumination over a subterranean history for which it now serves as the sign. It is the photographic moment of a revelation (*revelar*, meaning to develop and make images). Benjamin again: "To write history thus means to cite history." The citational nature of the Tlatelolco massacre, indeed, forms part of a sequence of the last century's catastrophic visual politics.[21]

If for Paz the massacre's productive moment turns on its revelatory violence in photographic visibility, Poniatowska is even more explicit. The second part of *La noche de Tlatelolco* begins with an editorial comment that might help explain the sense in which the Tlatelolco massacre is read here as the sacrificial origin of a new Mexican future: "The wound is still fresh, and Mexicans, though stunned by this cruel blow, are beginning to ask themselves questions in open-mouthed amazement. The blood of hundreds of students, of men, women, children, soldiers, and oldsters tracked all over Tlatelolco has dried now. It has sunk once again into the quiet earth. Later flowers will bloom among the ruins and the tombs."[22]

In this respect the student movement will always have been seen as victorious, if only in the Pyrrhic fashion sustained by Poniatowska's appeal to redemptive flowers. For not only has the productive and properly political autogestive agonism of the movement been overcome in vi-

olence, but so are the soldiers who in part perpetrated the massacre, if not exactly voluntarily; they are counted not as enemies, but among the mortified and innocent collective. The violence on the square becomes the basis for a future overcoming of Mexico's social antagonisms, that is to say, the reconstitution of the social bond through which the war that constitutes so-called Mexican society is forever delayed.

If the photogenic writing discussed thus far is characterized by a cutting, by a constant excision of the moment that, according at least to Monsiváis's method, is never fully reinserted into narrative order or into the flow of a chronological organization, Poniatowska's *La noche de Tlatelolco* maintains much of the archival pretense of Monsiváis's work and yet takes up the completion of the narrative that in *Días de guardar* is consistently deferred. In this sense, *La noche de Tlatelolco* works toward a collection of data, a compilation of images, offered up to a reader tasked with deciphering the actions the text relates. There is, however, despite this pretense, very little left to decipher by the time the text arrives in the reader's hands.

THE TESTIMONIAL RELATION

La noche de Tlatelolco constantly reveals its nature as an intervention into a powerful and also seductive rethinking and reconstitution of the social order once convened under the name of the national-popular, whose decline as a collective subject entered a critical period after the events of 1968.[23] As a hopeful and redemptive gesture, Poniatowska's text reproduces in the avatar of civil society the democratic promise once associated with the national-popular—as a formulation of a kind of popular sovereignty—as well as what Poniatowska deems to be the more legitimate expression of that sovereignty, as performed in the streets by the activists of the student-popular movement, but also in the subsequent search for justice and restitution in the aftermath of their demise. If we recall the archival orientations of both Monsiváis's and Poniatowska's texts, it could be said that both the originary archival moment and its opening to the future, its necessarily unfinished nature, are appropriated in Poniatowska for the delineation of a new totality or new democratic Mexican peoplehood, understood as civil society.[24] In her text's pluralistic selection of images—sometimes photographic, sometimes textual—from 1968, Poniatowska forces the symbolic restitution of the

energies snuffed out at Tlatelolco. Or, perhaps more precisely, the text constructs an as-yet inexistent collectivity-to-come in the violent aftermath of Tlatelolco.[25]

Driven initially by a desire to remember the student-popular movement in the stultifying atmosphere that followed, Poniatowska's text becomes an obsessive encounter with the disaster that led to this stultification. In other words, her powerful narration constructs 2 October as the only possible horizon for thinking about 1968 and thus imagines it as the only possible point of origin for a democratic order to come. Democracy and emancipation are coupled with sacrifice. The book offers a rather sentimental narrative in which redemption is offered in place of the very process that would make the student-popular movement more fully comprehensible.[26] For now, the present clings to 2 October not only as a defeat but also as a power. On the other side of 2 October (not the political upheaval that came before it but the very instant before the violence, Monsiváis's "plenitude of the unfinished") remains something that might have been, and for *La noche de Tlatelolco*, something that might still be, if by other means.

To reiterate, then, in slightly different terms my central argument here, in Poniatowska's text, Tlatelolco is always posited centrally as the possible foundation for the reconstitution of something *like*—but more complete, more just, more democratic than—the former national-popular state whose crisis is definitively registered in the massacre and the actions that led to it.[27] In part, this operation hinges on the extent to which the book identifies Tlatelolco as that which brings intelligibility to the disparate student movement and which grants it a future as the basis of a new Mexican peoplehood (again, as civil society), which, in other words, constructs 1968 as the foundation of a new national narrative. Put still otherwise, it is through Tlatelolco that Poniatowska imagines the future of a Mexican collectivity. A collective mourning task will initiate a future of democracy and brotherhood in Mexico. As Beth E. Jörgensen concludes: "By carrying out a dialogue with the silenced protagonists of 1968 and with the Mexican past, *La noche de Tlatelolco* and Elena Poniatowska oppose the monolithic discourse of authority and propose a creative, responsible distribution of discursive power."[28] Following Jörgensen, Poniatowska's text might be said to restitute the dead her text makes visible, creating a "discursive" space for the mourning and redress of those deaths that leads to a new, redeemed community. Such a "discursive" space opposes the "monolithic discourse of authority" that made necessary the mobilization of a student-popular move-

ment and that also crushed that movement once it began to threaten this authority's continued prevalence.

Along these lines it is worth invoking the general Latin American cultural milieu of the moment. *La noche de Tlatelolco* appears on the heels of the decline of the so-called Spanish American narrative Boom. This coincidence is not gratuitous, for it emerges in the midst of (or, more precisely, in the time leading up to) a double crisis, the conditions of which are rather elegantly set forth by Alberto Moreiras in terms of both an "exhaustion" of the "possibility of a convincing allegorization of the national," the apogee of which was experienced with the Boom, as well as the decline of revolution, understood, generally, in "cultural-national" rather than "socialist" terms as the instance that "regulated [cultural workers'] relation to the state."[29] In Mexico this decline takes on a per-haps somewhat early local inflection, given the way in which Tlate-lolco itself announces not only what could tiresomely be called a cri-sis in representation, but also the crisis of the revolutionary party-state, what Long identifies as the decline of the "totalizing novel" concomi-tant with that of the national-popular state.[30] This first decline gave rise, it might be averred, to the largely innovative, unconventional, or even simply "fragmentary" means through which 1968 has been represented. In other words, the testimonial genre stakes a generic claim against, as Jörgensen puts it, "the monolithic discourse of authority" identified not only with the Mexican party-state, but also, frequently—whether cor-rectly or not—with the Boom novelists as well.[31]

Yet *La noche de Tlatelolco* is not only a book of testimonies. Those who are familiar with the text will recall that while it is "fragmentary," com-posed of disparate materials (chants, news clippings, interviews, poems, and so on), and in some sense betrays the journalistic drive that aligns it with Monsiváis's work, unlike *Días de guardar*, it strongly obeys the principle of a carefully orchestrated, chronological narrative. That is, the book's pretense of being a fulfilled representation of 1968 necessar-ily avoids the gesture toward a deferral that characterizes *Días de guardar* and assumes the more or less complete narration of the student-popular movement through the stretch of time that it claims as its object.

Incidentally, here it could be said that the opposition or (non)relation between a melodramatic sensibility and an ironic one structures the op-position Monsiváis–Poniatowska. That is, lacking Monsiváis's character-istic irony, *La noche de Tlatelolco* can achieve no rhetorical distance from the melodrama that organizes Mexican society. This melodrama might be described as the sacrificial origin of Mexican subjectivity, which I

will address later in this chapter. For now, allow me to say that such is the text's power and its tension.

There is, to be sure, a certain biographical explanation for this appellation or epithet (that of melodramatic), which perhaps also relates centrally to the vicissitudes of the testimonial genre that are at play here. Elena Poniatowska, as is well known, was born in Paris in 1932 to a father who was a descendent of Polish nobility and a mother who was a daughter of a Mexican ruling-class family that, in effect, "lost their rural holdings, but not their capital, during the agrarian reforms of the Lázaro Cárdenas administration (1934–1940)."[32] Poniatowska's mother fled to Mexico in 1942, taking her daughters with her, hoping to protect them from experiencing the war.[33]

In Mexico, Poniatowska learned Spanish from her family's servants. Her first significant work was 1969's *Hasta no verte Jésus mío*, a text that both draws on her early journalistic vocation by taking the form of a kind of interview and also repeats the scene of her first encounter with the Spanish language by producing a dialogue between two people of radically different social classes.[34] While I haven't the space here to fully elaborate these suggestions for a reading of *Hasta no verte Jésus mío*, I would like to underline how one of the book's most frequently cited passages—the last lines—might be read as a certain restitution or vindication of those very servants who gave Poniatowska language.

The book tells the story of the Mexican twentieth century through the life of Jesusa Palancares, a marginalized and exploited woman who in the text's unfolding becomes the figure of what we are expected to read as a powerful feminist agency. By the book's end, our protagonist finally settles the score with the writer who has documented her story: "Stop bothering me now. Go away. Let me sleep."[35] As Carmen Perilli writes: "The nannies, those first mythological others in her personal history, remain forever like little mules. They cannot change their roles or subvert them. They are born and they die in her kingdom of silence, their only resistance the rabid cynicism of Jesusa Palancares."[36] Perilli directly engages Poniatowska's "debt" to her servants ("The author shamelessly recognizes her debt to them"), citing her comments in an interview with Margarita García Flores: "In feeling close to the maids, I looked to create characters that were like them. In part, I did it to avoid what I am."[37]

According to such a reading, aristocratic origins motivate Poniatowska's frequent idealization of the poor; shame serves as the genesis of her hopes to represent and, ultimately, to melodramatically redeem these poor. Her foreign birth and European upbringing transform these

poor figures into Poniatowska's desired belonging. They gave her Spanish; they are her soil.[38] By way of this seeming return to—or construction of—a certain origin (through a sacrifice of the other), by way of this weak vindication, Poniatowska also evokes one of the central antagonisms of *testimonio*, namely, as John Beverley writes in a discussion of Rigoberta Menchú, "the tension between the injunction to grant Menchú the respect and autonomy she deserves as a human being in these terms, and the desire to see myself (my own projects and desires) in and through her."[39] What this all suggests is that even before the appearance of Poniatowska's sequence of more full-fledged *testimonios* and chronicles, her work reflects critically on the tensions of the genre, that is, its tendency toward the instrumentalization of the testimonial subject for the political project and social identity of the writer.[40] That is, we must repeat the obvious, for there is something about *testimonio* that enacts, or obeys the desire for, redemption not only of the so-called subaltern, but also of the bourgeois writer like Poniatowska or the academic like Beverley.

Beverley's *Testimonio* is interesting for its own status as an archive of sorts, for it collects some of his most important writings on the testimonial genre, which span from the late 1980s to the early 2000s (the book also sports an introduction written for the occasion of its publication). These essays appear in unrevised form as, the author notes, "a record of my involvement over the past fifteen years with the narrative form called in Latin American Spanish *testimonio*."[41] I mention this because the wager that *Testimonio* gradually makes in its unfolding is that if subalternity as such cannot be redeemed by *testimonio*, then perhaps something like a democratic promise indeed can, for *testimonio* announces new forms of social association that might be organized more organically and that might open onto a better future, offering itself as something like the cultural form that has the potential to advance more "organic" social associations. These social associations would be modeled upon the relationship that *testimonio* fosters between scribe and speaker, between the intellectual and her object.

As both Beverley's critical text and Poniatowska's book of *testimonios* make clear, these new social associations, in turn, are intended to serve as the point of departure for thinking the possibility of an emancipatory politics in general. The project that develops across Beverley's collected essays—that of a decision against *testimonio* as the grounds of subaltern redemption or restitution and in favor of *testimonio* as a somewhat vaguely democratizing force—might be said to be forecast in Poniatow-

ska's own oeuvre. If we read once more the last lines of *Hasta no verte Jé-sus mío*—"Stop bothering me now. Go away. Let me sleep"—as a decisive statement on the impossibility of the testimonial relationship's bringing about the just representation, much less the redemption, of the subaltern, then it would seem that her next book, *La noche de Tlatelolco* explores the more generally "democratic" possibilities of the genre. While certain antagonisms are indeed formalized in the text's unfolding, the narrative of the massacre and its aftermath largely overcome them in a bid to construct a promise of the future in the memory of the massacre. I will develop this line of argumentation more explicitly, but first it will be necessary to make some formal observations about the text.

PICTURE-MAKING

Like *Días de guardar*, *La noche de Tlatelolco* opens with a series of black-and-white photographs that recall very much the kind of photo-aesthetic sequence of phrases with which Monsiváis introduces Sergio Zermeño's study of the student movement, *México: Una democracia utópica*. In Poniatowska's case, this series announces the nature of the written text itself, composed as it is of found fragments (or what pretend to be found fragments)—poems, chants, headlines, audio recordings—arranged by a complier or editor to tell a story. The essential content of the narrative related through the textual fragments that compose the bulk of the work is similarly forecast by this photographic sequence. In other words, these images serve as a kind of double overture that orients the reader to the text's formal structure as well as to its narrative content, for the book also, in a sense, is entirely organized by images, the effect of which is to authorize its claim to truth.[42] As Allan Sekula puts it, writing of an earlier moment of the relation between photography and the police order, "Photography was to be both an *object* and a *means* of bibliographic rationalization."[43] The photograph is evidentiary, not only because it holds the still image of a moment passed and the possibility of that past's spectral return, but also because its very self-evidence grants the object captured a kind of real presence in the moment of its viewing. Here I have in mind what André Bazin has written about the forcefulness of the photograph's credibility, which I think applies also to testimonial texts like Poniatowska's: "The objective nature of photography confers on it a quality of credibility absent from all other picture-making. In spite of any objections our critical spirit may offer, we are forced to accept as real

the existence of the object reproduced, actually re-presented, set before us, that is to say, in time and space. Photography enjoys a certain advantage in virtue of this transference of reality from the thing to its reproduction."[44] One thinks of the testimonial author, the scribe, in the position of the photographer whose task is the faithful and truthful capture (or representation) of the object. To be sure, Bazin has in mind the specificity of the photographic medium. The justice of the comparison, however, seems to be secured by the way in which the opening photographic sequence of *La noche de Tlatelolco* raises a mediatic confusion, or rather, infects the mediatic purity of the book's divisions by registering the book's fragmentary written narrative through a fragmentary photographic overture by means of which the book posits the following analogy: *testimonio* is to writing as photography is to picture-making. The object captured is held in place before the reader as an irreducible presence. Its truth, despite one's critical faculties, is undeniable. This presence cannot lie; it is truth itself. Or, as Octavio Paz is quoted in *La noche de Tlatelolco*: "I do not believe that images can ever lie."[45] The testimonial text exploits its own photographic nature, its own relation to the photograph (a relation posited from the outset of Poniatowska's book) as precisely, in Bazin's terms, "the transference of reality from the thing to its reproduction," what Ulrich Baer refers to as a "crisis of referentiality."[46] *Testimonio* takes the place of the thing it documents, standing in for it, transmitting its reality, marked as it is by the presence of that original thing in its very material constitution.

In Poniatowska's case, then, the *testimonio* performs a double transference, moving from thing, to photographic reproduction, to photo-aesthetic writing. This double transference admits to something like the insufficiency of photojournalism alone to tell the story, just as it admits to the insufficiency of writing alone to narrate Tlatelolco. The photographic character of Poniatowska's writing is announced in these images, and, at the same time, these photographs assert the truth of the written text to follow. Finally, they are prefatory, an overture. They are arranged, again, much like Monsiváis's prefatory textual fragments, to form a narrative of the student movement's rise and fall, from its early stages until the Tlatelolco massacre and its tragic aftermath.

This order was upset by the publication of the "special edition" of the book in 2012. I will throughout this chapter cite its original—and originary—organization, but the "special edition," one could say, merely doubles down on the symptomatic relation between truth and image that is extended in the original. Perhaps for economic reasons, the book's pho-

tographic material traditionally appeared before the printed text; here the photographs are far more numerous and appear dispersed throughout the volume on glossy paper in a dozen short asides. This, along with the appearance at the end of the book of the relevant photographic credits—not included in the editions I have seen—confers a more glaring patina of objectivity upon the materials collected and grants its melodramatic unfolding a more authoritative archival aspect. A new prologue by the author, linking the 1968 movement to the contemporary scene, confirms the book's original faith in the future of civil society, finding in it an antecedent to #Yosoy132 (I Am 132) and in that youthful persistence a measure of hope against dark present times.[47]

From the photographs that open the text, the work announces what is to be the paradoxical nature of the narration of Tlatelolco (or Tlatelolco/1968), or the very paradox of its intentions, for which Sorensen provides an excellent definition: "One of the paradoxes that haunts the study of some of the writings on the Massacre of Tlatelolco is that the violence it unleashed entailed the possibility of a revelation. Indeed, we are forced to confront the possibility that violence may unmask not only its foundational presence, but also the fact that its power may yield epiphanic results."[48] The revelation, to be sure, reveals what is already known: there is no democracy; the Mexican state is violent; it rules a divided people. As, once again, Poniatowska puts it in *Fuerte es el silencio*: "Something was irredeemably lost (death is always unrecoverable), but something was gained." At great human cost one gains the revealed knowledge of what one already knew.

The sequence's first photographs depict the masses taking to the streets, turns to images of police repression, the images of the dead, and then to the final photograph of the families of the murdered attending a vigil, a metonymic vision of a kind of national mourning work to be commenced following the publication of Poniatowska's book. I will soon turn to this mourning work. First, however, I should note how the sequence of photographs depicting the Tlatelolco massacre repeats this narrative structure, which is to say, it is not merely part of the narrative of events, but a more intense and temporally compact repetition of their order. Following an image of students lined up and being searched by police officers, the sequence offers photographs of the Plaza de las Tres Culturas during the day of 2 October, full of protesters. The caption of the last of these reads: "By the ancient church of Santiago Tlatelolco, an innocent crowd of bystanders gathered."[49] This daytime sequence is followed by the night, by the photographs taken, or, rather, not

taken, or not completely displayed, "half an hour later," as it were. And these (mostly missing) photographs return the reader to the greater narrative presented by the sequence, opening onto the mournful aftermath: dead bodies and jailed activists, but also vigilant new collectives ready to mourn the loss and calculate the gain.

The book seems to be composed of a series of formalizations of essentially this same narrative structure: repression leads to mobilization, which leads to social discord, which leads to the act of violence, which leads to social reconstitution. The photographic sequence with which the book opens obeys this series and, as I note above, even holds within itself a more compact version of this series concerning the violence at Tlatelolco. The book's narrative content is also described by this structure: the first half of the book, "Ganar la calle," opens with a short comment by Elena Poniatowska that lists the major events of the summer of 1968 leading up to the massacre. It then moves on to a collection of fragments, testimonies of the actors, which are then interspersed with text from chants, signs and posters, fragments of written texts. Even as it assumes a kind of narrative form, it appears also like a little archive; it collects what is essential, for example, the *pliego petitorio* (list of demands), Javier Barros Sierra's letter of renunciation, and materials much more ephemeral (the text of flyers, posters, and chants).

What this first half also accomplishes through its forceful arrangement is the representation of the hoped-for heterogeneity of the movement. Or better put, the heterogeneity of the book's composition homologizes Poniatowska's presentation of the movement's plurality. This heterogeneity is suggested in three spheres. The first concerns the movement itself, which is to say, the heterogeneity of the people who took up positions as activists within the movement. As Poniatowska takes pains to underline, the CNH (the movement's representative body, the Consejo Nacional de Huelga) tried to police the movement's tendencies, particularly regarding the public presentation of its more militant face, which, it was perceived, would limit its potential influence in Mexican society. Yet, the most significant hegemonizing instance the book offers is not its own relation to the CNH leadership and its repression of other currents within the movement. Rather, it concerns the way in which the text itself relates and resolves (in death) the debate surrounding the movement's repertoire of symbols. Poniatowska cites UNAM student Claudia Cortés González: "I never really thought of Zapata as a student symbol, an emblem. Zapata has become part of the bourgeois ideology; the PRI has appropriated him. Maybe that's why we chose Che

as our symbol at demonstrations from the very first. Che was our link with student movements all over the world! We never thought of Pancho Villa either. His name never even crossed our minds!"[50] Compare Cortés González, then, to the following "Consigna del CNH," which appears only a few pages later: "Let's have no more vituperative slogans, no more insults, no more violence. Don't carry red flags. Don't carry placards of Che or Mao! From now on we're going to carry placards with the portraits of Hidalgo, Morelos, Zapata, to shut them up. They're our Heroes. *Viva Zapata! Viva!*"[51]

On this score, the first part of the book offers insight into various of the ideological groupings under which the movement activists fell, housing as it did reformist, communist, hippie, and poseur currents (and all the overlaps and points in between), and even offers the suggestion of the deepest sort of conflict within the CNH, owing to the double meaning of the signifier *porra*, understood both as a chant and also as the name given to the clubs that led chants during the schools' soccer matches and also that supported their teams. Some of these clubs were influenced by the government to the extent that *porra* became another term for agent provocateur.[52] Here, the red flag is identified with *porras*—which might suggest the word's meaning of "infiltrators," an accusation that recalls the Mexican state's repeated charge that the students were under subversive foreign influences, or were themselves infiltrators. Hegemonic articulation thus is mortification: the consignment to death of whatever cannot enter its field of equivalence. As such, perhaps the student movement's death itself becomes the figure of what hegemonic operativity demands to be the necessary consignation. I will soon return to this point.

The second sphere of relevance clearly overlaps the first and concerns the ways in which the student movement articulated its relation with the workers. The book relates the internal debates in the movement regarding the possibility of a real alliance with the working class and collects some of the movement's propaganda directed toward consolidating such a relation. For example, Poniatowska presents texts like the chant in the 13 August demonstration calling for the freedom of political prisoner and railroad workers' activist Demetrio Vallejo, which recalls the desire of many movement activists to align the present struggle with struggles in the past.[53] The book also provides the *testimonio* of individuals like market vendor Antonio Careaga García, who, despite not being a student, but a worker, joined the movement. He rather symptomatically defines his solidarity with the movement in terms of his youth: "No, I'm not a student, but I'm young."[54]

Against such texts, however, one finds juxtaposed the testimonies of participants like UNAM student Rebeca Navarro Mendiola and CNH delegate Florencio López Osuna, who despair of the possibility of such an alliance. As Navarro Mendiola puts it: "The fact is, workers are very reactionary."[55] López Osuna (whose fate is discussed at length in chapter 2) is rather more diplomatic: "Government control of factories and labor unions cannot be broken."[56] Elaine Carey discusses the difficult work of the "lightning brigades" in this regard: "The resistance that the students encountered in working-class neighborhoods resonated with the government's portrayal of students as opponents to nationalism and the Mexican Revolution."[57] Indeed, such insights into the state's powerful appropriation of the workers led José Revueltas to conclude that because the workers were unable to rebel, the students had assumed something like the allegorical form of the workers in order to struggle in their place, at least temporarily, by way of undoing or overcoming the historical defeat of the working class after the repression of the railroad workers' strike of 1958–1959.[58]

Third, the book presents the heterogeneity of public opinion surrounding the movement, which, to be sure, is intricately related to the other heterogeneities the book documents. On this score, the text presents the opinion of Esteban Sánchez Fernández, "father of a family": "If the one thing the Student Movement has accomplished is to strip the Mexican Revolution bare, to show that it was a filthy, corrupt old whore, that alone is enough to justify it."[59] The reader of *La noche de Tlatelolco* is invited to compare such sentiments with those of a "mother of a family and grade-school teacher," María Fernanda Vértiz de Lafragua: "I was simply dumbfounded by the attitude of the university professors . . . They were as bad as the kids: they seemed to delight in stirring up trouble."[60] At the same time, because of this rather Manichean opposition, the book fails to sufficiently open the question of the political dimensions of *relajo* (trouble) itself, that is, the very presence of the students on the street as politics.

The narrative task of the book on the whole, then, given the nature of the heterogeneities and disputes that are recorded in its first part, is to unify these diverse tendencies and currents in the foundational trauma of Tlatelolco. It need not do so, but it does, perhaps out of habit. Mexican letters, as Ryan Long has shown us, have demonstrated "totalizing" desires.[61] The book's second half, to which I will turn below, does not construct a similarly diverse array of fragments of "La noche de Tlatelolco," but, rather, narrates a singular visual event. Its traumatic struc-

ture, indeed, refers to the violent refoundational story of the Mexican nation. As I will discuss below, this night serves as the grounds of a *new* imagining of the nation.

However, first it should be underlined that the repetitive nature of the narrative structure that organizes the book slightly undermines its pretense to a sort of found quality. If the book's conceit is that it allows the reader to intervene and reconstruct this only fragmentarily offered narrative, then this conceit reaches its limit in the rigorous editing that grants it order. Jörgensen has described this narrative arrangement as the function of the editor, Elena Poniatowska, who, as Jörgensen notes, appears occasionally as E.P.: "The editorial function, apparently secondary as narrative frame, begins to take on a central value in the meaning of the text."[62] At times it indeed seems that only a few narrative strands are left to the reader to decode, as a kind of highly simulated self-deauthorization on the part of Poniatowska.[63]

This editorial function is thus something close to both authorship and cinematic montage. In a move that makes visible the editorial function exerted by E.P./Elena Poniatowska as a symbolic democratic formalization, Poniatowska's selection of fragments, voices, and images from 1968 bespeaks a kind of (already disavowed) mutilation of the visual and social fields that provide the primary material for her text. As Jörgensen writes: "Elena Poniatowska's assumption of the selection and ordering of diverse material turns *La noche de Tlatelolco* into a very carefully structured piece of writing . . . By portraying the Mexican student movement as representative of a broad spectrum of Mexican society, the editor has confirmed from the outset the democratic claims made by the students, and she has thus already invested the text with meaning, creating an image of democracy in action."[64]

Like the photographic image, the democratic formalism that Poniatowska's narrative brings to bear conceals the "off-frame" that is lacking here. In this case, however, what is lacking does not lack representation: there is no mystical appeal to the unrepresentable as such, for it produces itself in the very place of what is absent (the students). The text contrives to make present in every instant the complexity of the student movement, the viciousness of its enemies, and, to be sure, the violence of its defeat in order to construct an "image of democracy" as its horizon. In other words, this contrivance of a total representation over against Monsiváis's gesture toward Tlatelolco's deferred representability maintains the conceit that it cannot will its own closure, identified, as it is, in his text with the termination of the movement's potential. *La noche*

de Tlatelolco, that is to say, wishes to be formally democratic in its invitation to the reader, yet it largely forecloses this reconstruction (or offers it as a false choice) by way of not only the already existing narrative and chronological arrangements of its fragments, but, indeed, by way also of Poniatowska's deployment of literary tropes, in particular, metonymy and allegory. It is this question, perhaps the central question, regarding the text's literariness and its connection to the textual construction of the people to which I turn in the final section of this chapter. For now I want to discuss what it means to construct a people in the first place, particularly in light of the melodramatic subject at the heart of Poniatowska's work.

THEORY AND THE ACT

In pursuing the broad base of support deemed necessary for a hegemonic contestation with the Mexican state, the CNH's demands were necessarily vague, its ultimate demand, finally empty, in the way Ernesto Laclau describes the signifier in his work on populism and social antagonism. The student movement coheres as movement "not because their concrete objectives are intrinsically related but because they are seen as equivalent in confrontation with the repressive regime."[65] It is indeed fitting that Laclau's theory sets itself against a vaguely repressive regime, establishing the pursuit of freedom—without qualification—as the maxim of politics.

José Revueltas denied this defeat as much as he could, denied both its having taken place and its revision as Pyrrhic victory. For him, the student movement constituted a "theoretical action," a "historical act," which, by definition, "cannot be understood outside of its unfolding, united to the succession of moments that never offer a linear continuity and resists univocal definition."[66] Taken from this continuity, sacrifice will, despite Poniatowska, never hold a future meaning, in part precisely because this futurity (in the case of Paz or Poniatowska) or postponement of meaning (in the case of Monsiváis) separates the moment from its historical unfolding or becoming. Inasmuch as both options posit the intelligibility of the movement as a function of the sequence in which it is included, Revueltas's assertion somewhat recalls that of Zermeño, who writes that "those three months can only be understood during those three months."[67]

For Zermeño, this intelligibility rests on a witnessing and the impos-

sible transmission of that witnessing. Its duration is closed. For Revuel-
tas, on the contrary, the student movement belongs to a flow that is open
and nonlinear. It is not *a* history, but a theoretical action *within* His-
tory. From this perspective the student movement is not, in Pyrrhic de-
feat, united with the democratic transition of today, which announces
the modernization of the Mexican political system. Rather, it is the trace
to be found in successive (and, perhaps, preceding) moments, the nar-
row gateway opened toward the real history (*la historia real*) of Mexico.[68]

Zermeño presents the construction of political identities in the con-
text of the student movement in terms strikingly similar to those set
forth in Laclau's theory of hegemonic articulation several years later.
One of the major tasks that Zermeño sets out turns on an analysis of
the diverse tendencies of the distinct sectors of the student movement, a
task he performs without giving way to the highly synthetic edifice that
organizes and ultimately hegemonizes the very plurality of the move-
ment's makeup as if this were its effective ideological content (though
his work might indeed head in that direction). For Zermeño, the move-
ment appears to open a space, in a relatively closed and authoritarian
cultural-political milieu, for what political philosopher Laclau refers to
as "the power struggle for which there is a name: hegemony."[69] Yet there
is something in the *pliego petitorio* that is more than the *pliego petito-
rio*, more than a list of six demands, and that is its capacity for *conven-
ing* dispute.

Returning to Poniatowska's melodramatic orientation, the move-
ment's democratic edifice, which would be the condition of its hege-
monic vitality, is, finally, composed of the very ruins of the movement.
Defeat, violence, and noncommunity, in this case, reside as the condi-
tions of possibility for what Sorensen terms "collective memory," the
act of resistance, and the experience of community: "The generational
Utopia of 1968 was met with traumatic closure on October 2; the work
of mourning and elaboration has produced impressive intellectual re-
sponses that continue to sustain resistance and the fleeting configura-
tions of collective memory."[70] Thus, Poniatowska's narration of 1968 can
only extend the consequences of the violence on 2 October 1968. After
La noche de Tlatelolco, 2 October 1968 resides as the condition for intelli-
gibility of the student-popular movement that preceded it. It is through
the tragic end of the movement that the movement itself forms the co-
herent figure that today holds it together. More generally, as might be
expected, each intensification of state repression forces the movement

into greater coherence, until the final massacre constructs its monolithic presence for the future, that is, today.

As Zermeño writes in his discussion of what he defines as the fourth and final phase of the uprising, the period leading up to the massacre on the square characterized by "the reconstruction of the identity or the alliance, which had already shown signs of weakening, in the face of the new wave of repression that would soon be total and that would confuse amid the rubble, for collective memory, the distinct elements that made up the movement."[71] Regarding those elements, Zermeño discusses in detail the movement's list of demands, drafted at a meeting on 28 July and subsequently revised and debated over a period of days. They were approved in their final form on 4 August. The student movement's relatively limited program, as articulated in the six points of the CNH's list of demands, is intended to serve as the point of departure for a potentially much broader social-political transformation. Ramón Ramírez provides the final appearance of the *pliego petitorio* in a public forum:

> We, the students demand of the appropriate authorities the immediate solution of the following points:
>
> 1. Freedom of political prisoners.
>
> 2. Removal of Generals Luis Cueto Ramírez and Raúl Mendiela.
>
> 3. End of the riot police, direct instrument of repression, without the creation of similar forces.
>
> 4. Repeal of articles 145 and 145 bis of the C.P.F. (crime of social dissolution), legal instruments of aggression.
>
> 5. Compensation for the families of the dead and wounded who were victims of aggression from Friday, 26 July, onward.
>
> 6. Demarcation of responsibility for acts of repression and vandalism on behalf of the authorities as carried out by the police, the riot police, and the army.[72]

This list was compiled and revised with an eye toward denying the students' adversary, in advance, the opportunity to justify repressive actions.[73] In this spirit, the list was limited to well-defined and reform-centered demands and gave an organized, almost demure face to the spontaneity of the actions on the streets. It demanded the application of

the law and the end of the state forces' impunity. It also served as a blanket under which the divisions of the student movement were protected and granted coherence in a well-defined edifice. As Zermeño writes: "The student body—or any social aggregate—can frequently find itself deeply divided; however, for whatever reasons, in a specific conjuncture an alliance is generated across these divisions, and this identity can even be extended toward more or less similar social aggregates."[74] Laclau has described this relationship in terms of a procedure by means of which "one particular difference assumes the representation of a totality that exceeds it."[75] The *pliego petitorio* organizes this conjuncture, sustaining and extending the alliance to which it bears witness.

Indeed, in comparing two drafts of the *pliego petitorio*, Zermeño finds it striking how "the demand for the 'freedom of all arrested students' was substituted by the demand for the 'freedom of political prisoners.'"[76] That is, the text finally asserts the cohesive and extensive demand for the "freedom of political prisoners" in its attempt not only to appeal to other nonstudent sympathizers, but also, more specifically, to link the student movement to past struggles, and perhaps most directly to the railroad workers' strike of the late fifties. Indeed, two of the leaders of the 1959 railroad worker strikes were still incarcerated: Demetrio Vallejo and Valentín Campa. Monsiváis describes theirs as a movement "aimed at creating independent unions" and thus at finally politicizing a depoliticized nation.[77] However, perhaps the most significant demand is that of the "repeal of articles 145 and 145 bis," the law against so-called social dissolution. Here the student movement demands the right to dissolve the violently integrated social field whose edification (in both the didactic and the constructive valences of the term) the Mexican state posits as its reason for being. The *pliego petitorio*'s hoped-for social extensivity assumed, following Tlatelolco, a temporal dimension.

Along these lines, for Alain Badiou the twentieth century might be characterized by its staging of "the clash between two manners of conceiving the 'not-we.'" On the one hand, that which is exterior to the "we," to the collective subject, might be understood as a "polymorphous formlessness," or, on the other, it might be conceived as "another 'we.'" Continues Badiou: "The conflict between these two conceptions is fundamental . . . If, in effect, the 'we' relates externally to the formless, its task is that of formalizing it. Every fraternity then becomes the subjective moment of an 'information' of its formless exterior . . . If, on the contrary, the 'not-we' is unavoidably *always already formalized* as antago-

nistic subjectivity, the first task of fraternity is combat, where what is at stake is the destruction of the other."[78]

Given the extensive collectivity of elements that the Mexican state claimed to represent, the student-popular movement had difficulty in formalizing the content of its opposition to the state beyond the points of the *pliego petitorio*. A formalist procedure thus works by way of a constant inclusion that finally isolates, that is, *formalizes* its "not-we" by (to follow roughly Badiou's examples) uniting the reformists to the revolutionaries rather than, as the destructive procedure would have it, terrorizing the reformists into defeating the ruling class. For Badiou, this is a difficult lesson of the twentieth century. This conflict can be mediated only dialectically, Badiou, following Mao, writes, through formalization: the conflict between formalization and destruction must be resolved through formalization.

In this spirit, foreseeing this unfinished working out of the conflict that animated the Mexican student-popular revolt, Revueltas writes: "The Movement's socialist content is real only to a certain extent and, in the future of the Movement—in historical terms, of varying duration—it tends to exhaust itself, to the extent to which arise inevitable, necessary, differentiations, including those for which a Marxist movement must struggle, pushing them, clarifying them."[79] It is through the conflict between formalization and destruction that the content of the movement can appear and endure, and only at junctures at which it is not threatened by internal differences—"contradictions among the people," as Badiou, after Mao, would say—that would threaten to divide the power of the "we" at stake. In light of these challenges, the "we" of the student movement is most convincingly consolidated and given origin, ironically, in a final, blinding illumination that *gives an end* to 1968 in Mexico. Such is the wager that Poniatowska takes up as the explicit object of the book's second half, "La noche de Tlatelolco."

ESCISIÓN: THE ONLY NAME

Here I return to Poniatowska's citation of González de Alba. To some degree, the quotation functions as a sign for the text as a whole: "Tlatelolco is the dividing point between two Mexicos."[80] Or as David E. Johnson puts it, "Tlatelolco . . . divides Mexico from itself."[81] A division emerges as the symptomatic appearance of a disagreement, which has

been repressed by the party-state. The year 1968 convenes and provides the terms that organize this sociopolitical divide at its point of rupture. At the same time, *escisión* might be understood as a temporal division, the time before Tlatelolco, and the time after.

Escisión is repeated in the very structure of the text, which, as I note above, is divided into two parts. The first, "Ganar la calle," presents Mexico, 1968 as something more or less akin to the romantic imaginary surrounding the French May of 1968.[82] The second part of the book, "La noche de Tlatelolco," names the Mexican 1968 event as Tlatelolco. The problem this presents for democracy, however, as Sorensen intimates above, is that the second conception of Mexico, 1968 cancels the first. In other words, the book itself forms a symptomatic appearance of a fundamental contradiction in narrating, let alone thinking, 1968 in Mexico. Indeed, in a reflection on 1968 some thirty years later, Poniatowska writes that "1968 was the year of Vietnam, Biafra, of the murder of Martin Luther King and Robert Kennedy . . . of the self-assertion of black people, of the Black Panthers, the Prague Spring, the hippie movement, which arrived even in María Sabina's humble, smoky hut in the mountains of Oaxaca, where she officiated at the ceremony of hallucinogenic mushrooms, and yet, to Mexico, 1968 has only one name: Tlatelolco, October 2."[83]

The aftermath posited by Poniatowska's line of thought thus originates in the imposition of a name for the diverse processes of Mexico's 1968. This name, to be sure, is brought to bear from almost the very initiation of Tlatelolco, as reflected in her book's title. Poniatowska's imposition of the name "Tlatelolco" is precisely related to the editorial function of which Jörgensen writes.[84] The impact of the defeat is also registered on a global scale here. The year 1968 is exhausted for the world in an Olympian defeat. Indeed, in a later text Poniatowska will caption a photograph depicting the gathering just before the massacre in the following way: "If in other countries they used tear gas, here they fired bullets."[85]

Yet this rupture, this *escisión*, presents a historical orientation. Rupture conjures the Janus-like face of Mexican society, always conceived as dualistic, indeed, as the product of a violent cultural collision between (and subsequent mediation of) Indian and Spaniard. The Mexican revolutionary state, which itself emerged as the product of the continual clash between "two Mexicos"—whether this war is conceived according to ethnic, socioeconomic, or cultural determinations—installed as its sovereign act the final overcoming of war, evidenced above all in both the consolidation of the one-party state (a party that sought to represent

all interests) and the promotion of the mestizo national subject. The subject symbolically overcomes the violence that rules the origin of Mexico by producing a normative ethnicity that is allied neither to Spanish violence nor to Indian defeat exclusively.[86] Indeed, the mestizo subject might best be described as a harmonization of both tendencies. So, too, the revolutionary state declares the sovereignty of the people as such and thus appeals to the symbolic overcoming of the profound socioeconomic inequalities among them.

Taking both approaches to rupture together, in the formal as much as the historical acceptation, Poniatowska's lack of a mediating name between the two poles or the two halves of the text works as something like a final allegorization of the crisis of the state's capacity to mediate and pacify the war that constitutes the social field (in the very way it had under the names national-popular and mestizo and, subsequently, in the avatar that Poniatowska's text opens onto: civil society). The second half violently takes over the book's formalization and becomes the name of the entire book.

Such failed mediation serves as a point of departure as well for the composition of the material within the text's formal edifice. The proliferation of voices in the text intimates the extent to which these two Mexicos are at home in its pages. For example, the inclusion of the *testimonios* of those who stand against the movement evokes a democratic formalism. This also partially explains the rationale that demands that the movement be narrated from many different perspectives. This shift in emphasis at the level of narrative form evinces the emergence of a certain form of "democracy" as the political desideratum of our times. Yet in an ironic turn, these voices are largely silenced within the second part of the text, pointing to the fraternity that attends the construction of a new people in the wake of the massacre.

During the narration that constitutes the second part of the book, Diana Salmerón de Contreras's voice breaks through at several points, constituting a prominent narrative thread that metonymizes the national and tragic character of the massacre through the family. In perhaps the most moving and most memorable account that makes defeat and death visible, Salmerón de Contreras attends her wounded brother following the violence. These interventions penetrate the narrative surface to touch the reader, a kind of punctum that recalls the photographic tendency of Poniatowska's writing. Salmerón de Contreras petitions the soldiers for a stretcher and demands that her brother be taken immediately to the hospital. This exchange is not recounted but recorded directly: "Hey, lit-

tle brother, what's the matter? Answer me little brother."[87] Such moving utterances are interrupted by a series of descriptive fragments of the events, culled from newspapers, such as the following from the 3 October edition of *Excélsior*: "A number of dead bodies lying in the Plaza de las Tres Culturas. Dozens of wounded . . . Yet the shooting went on and on."[88] Salmerón de Contreras herself at times interrupts this dramatic flow with her own narrative addenda: "They gave me permission to leave the Plaza with the stretcher-bearers. I climbed into the Army ambulance with my brother."[89]

In an editorial decision that owes something to dramatic cinema, the fragment that follows evokes the infinity of the collective against the finitude of individual death that is now imminent. It is here, I would suggest, that the book's thesis is most economically presented. A chorus chants "PEOPLE—UNITE—PEOPLE—UNITE—PEOPLE—UNITE."[90] There finally appears a metonymic inscription of collective defeat that both culminates and resolves the tensions of the Salmerón de Contreras subplot: "Why don't you answer me, *hermanito*?"[91] The episode is transformed into yet another iteration of the book's core structure as I describe it above: repression leads to mobilization, which leads to social discord, which leads to the act of violence, which leads to social reconciliation.

To underline the now almost cinematic style that Poniatowska adopts I will turn to the denouement of the Salmerón de Contreras subplot, which consists of two more fragments. The first of these reveals the innocence of the brother: "Julio was fifteen years old, a student at Vocational 1, the school out by the Tlatelolco housing unit. That was the second political meeting he'd ever gone to. He had asked me to go with him that day. The first meeting we went to together was the big Silent Demonstration. Julio was my only brother."[92] Here the death of the brother formalizes something like a posthumous repetition of the Silent March, which it is hoped will constitute a greater social-political event than the first by giving testimony to the innocent dead. It might be argued that during its Silent March the movement reasserted the undecided structure of the students' thought and action against any possible content of the movement, what Revueltas calls its "internal content," which at the same time threatened to turn itself into the innocent material of the empty signifier awaiting its determination. The demands as stated here formalize and contain a fundamental immateriality. The students' dispute is pure dispute; their demand is the right to make demands.

The insistence upon the Silent March thus underlines the brother's

innocence; the Silent March, on this account, is open, empty. It does not split the movement, much less Mexican society. The collective is understood, again, in terms of what Badiou calls a "polymorphous formlessness" whose task is not political combat but its own (silent) subjective formation. This is to say, the task—especially difficult, given the powerful hegemonic desire exercised by the Mexican party-state—consists of constituting an oppositional political alliance out of the disparate, disorganized, and contradictory desires of those Mexican subjects merely capable of voicing opposition.[93] To be sure, to read politics this way, as discourse, forgets also the intervention of bodies on the streets as politics. That instance, once more, we shall protect as 1968's event.

Yet, in a gesture toward the most macabre version of such politics—the formless collectivity of the grave—the consequences of the massacre are registered in the familial microcosm: "My father died shortly after Julio was killed. He had a heart attack as a result of the shock of his death. Julio was his only son, his youngest child. He would often say. 'Why did it have to be my son?' My mother has managed to go on living somehow."[94] It is here, according to Poniatowska, that flowers will sprout amid social ruin and political defeat. To put this once more in the terms offered by Sorensen, this family will sustain a mourning work that envisions (or, in many ways, that *is*) a future democratic politics. To continue living will demand restitution, a restitution that can only arrive in the form of a democratic compensation that retroactively provides meaning for the Tlatelolco massacre. Poniatowska's text, in other words, renders Tlatelolco "fotografiable" by ceaselessly naming 1968 "Tlatelolco" and by thus formulating a most important articulation of the conception of 1968 *as* Tlatelolco, and of Tlatelolco as a tragedy, but also as a sacrifice that opens onto democratic transition.[95]

The mourning work is intended to sustain—the gesture that presents its lingering duration—what Sorensen refers to as "collective memory as an act of resistance founded in the experience of community."[96] The image itself stands in the place of the nation to come, as the principle of the people who will, it is intimated, in demanding justice for the murdered, establish the terms of the broader justice that the movement desired. Sorensen's formulation, however, takes for granted that there *is* a collective that *shares* a memory and, moreover, posits a kind of vague resistance without object. The notions of community and experience, like the vagaries of collectivity and memory to which Sorensen refers, cannot be given in advance. That is, Sorensen's series of three objects—collective memory, act of resistance, experience of community—is not given

in the moment of rebellion and has been largely constructed retroactively through narratives like those of Poniatowska. Indeed, it is the social force of Poniatowska's text that has constructed and linked these objects to the name Tlatelolco. A consequence of this text is, indeed, that it establishes through mourning, through tragedy, in the aftermath of what it imagines, now, as a sacrifice, the *enduring* potential of the 1968 student-popular movement, granting it the futurity that secures its status as a rallying point for a future democratic politics of the nation.

Despite the necessity of preserving these images and ordering their archive, *La noche de Tlatelolco* already imagines a future without excision, without division, in which what happened at Tlatelolco promises a better and more democratic order. Yet, quite to the contrary of Sorensen's conclusions regarding Tlatelolco and reflection on Tlatelolco, I want to suggest something simpler and also less melodramatic: it is precisely "trauma," to use Sorensen's term, that *obscures* the memory of the student movement, putting in its place the memory of trauma. The referent of these images, of these wounds, has been obscured. It is trauma that is remembered, and it is trauma that gives substance to (rather than sustaining in the mourning work) resistance and so-called collective memory. This traumatic rendering stands not as a resistance to the logic of the Mexican state but, rather, as its rebirth through the redeployment and renewal of Mexico's traumatic origin story.

The Mexican state posits trauma as the origin of the collectivity it commands. The Tlatelolco massacre occurred on a site in which this trauma was powerfully staged and commemorated. The potential for renewal, for repetition could not be clearer. Today *two* memorials stand on the plaza as a powerful visual metaphor of this formal continuity between the two traumatic narratives that related to (if not organized) two successive regimes, as it were, of Mexican peoplehood. The first monument, discussed at length in chapter 1, commemorates an originary war, the birth of modern Mexico from a violent confrontation.[97] Nearby, on the same square, stands a monument to the fallen at Tlatelolco. A slightly more elaborate sculpture, the piece recalls those murdered on 2 October 1968, their names inscribed on its flat vertical face, in clear contradistinction to the once horizontally arranged bodies of those remembered. While the sculpture's pedagogical message is not directly referenced in the discursive content of the inscription, its location and spatial proximity to the other memorial are both highly indicative of one legacy of Tlatelolco by means of which the tragic, violent end of the movement becomes a basis for the regrounding of a Mexican people in

a new traumatic instance. It is not a triumph or a defeat, but the birth of Mexican democratic transition. It is the moment in which, to return to Poniatowska's formulation, "something was irretrievably lost (death is always unrecoverable), but something was gained."

The next chapter sets into motion the still images that have thus far occupied our attention. Transition, I will argue, is reflected in a series of moving images. If an earlier, somewhat "fragmentary," generally photographic and testimonial approach to a cultural reflection on or narration of Tlatelolco sought to maintain its specter not only as an object for thought but also as a site of struggle, then cinema has been tasked with exorcising this specter as required by neoliberal and democratic transition. *Testimonio* provided—in its moment—an object for contestation, a field of battle, if for somewhat different ends. To overcome this setting aside, to move through the duration of Tlatelolco, however, is the task required of cinema.

That cinema begins such a task in the late eighties, during the presidency of Carlos Salinas and the full-fledged entry of Mexico into the neoliberal era, is no coincidence. Turning now to the cinematic reflection on Tlatelolco that appeared many years after these initial responses, we will encounter the playing out of the legacy established in an immediate aftermath. In other words, cinema promises to complete the renewal proposed here through cultural-political transition. For perhaps only there, in the future of Tlatelolco, can we determine what was lost, what was gained.

EXORCINEMA

Spectral Transitions

The PRI ruled Mexico for seventy years until becoming an opposition party in late 2000. It maintained that status until 2012, when it returned to power with renewed legitimacy following the unraveling of what remained of federal sovereignty after Felipe Calderón's devastating war with the drug cartels. As a political institution, it held a nearly exclusive claim on what endured of the legacy of the Mexican Revolution, particularly the demand for agrarian reform and the redistribution of wealth and justice, or at least the memory thereof.

To be sure, while the PRI was responsible for maintaining the names of Revolutionary figures like Emiliano Zapata in the gallery of national heroes, it did not generally pursue the political project (land and freedom) that these figures evoked beyond the very logic of its name. Throughout its history, the PRI subsumed a plurality of political desires for which the various combatants in the revolution struggled. Subsequently, it became the edifice that held together the diverse tendencies of Mexican society. As a revolutionary party, it claimed to embody popular sovereignty as such, structuring the powerful identity between Mexican peoplehood, the state, and itself. Its ideals of protectionism, nationalism, and central planning were frequently compromised, perhaps most definitively during the rule of the party's penultimate president, Carlos Salinas de Gortari (1988–1994), whose reforms continue to shape the present.

As we have seen in the previous chapters, until the late 1980s, Tlatelolco was represented almost exclusively through photojournalism and journalistic or testimonial writing. With the production of *Rojo amanecer* (Red Dawn) in 1989, Jorge Fons's low-budget, independently produced, and once-banned fictionalized reenactment of the massacre, the representation of Tlatelolco entered the movie houses (in a certain *domiciliation*, to which I will now attend). Some readers will object that Leo-

bardo López Arretche's 1968 documentary *El grito* or Felipe Cazals's 1976 *Canoa* are earlier examples of the representation of Tlatelolco in the moving image, and I would have to agree to a point. Significantly, however, and as I argue in the introduction, López Arretche's striking documentary relates the massacre through a series of still images, edited with sound recorded on the scene. For its part, Cazals's film—which I discuss below—owes its association with Tlatelolco to the fact that it relates an entirely different massacre, in this case, one that was perpetrated against university employees by superstitious villagers whipped into an anticommunist frenzy by their village priest. The Mexican Army arrives as the students' savior in this film, which seemingly tries to reestablish ties between the state, intellectuals, and the middle classes in the period following Tlatelolco.

For readers unfamiliar with *Rojo amanecer*, Fons's film takes place within the walls of the Tlatelolco apartments, facing the Plaza de las Tres Culturas. It recounts the story of 2 October from one morning to the next, as lived by a middle-class family. Apart from their two teenage sons, university students who are active in the movement, the rest of the family is, according to the film, completely innocent; indeed, the grandfather fought in the Mexican Revolution, and the father works for the city government. Yet the titular "red" refers to the spilling of their blood by the paramilitary Batallón Olimpia at dawn, within the apartment's walls. These innocent members of the family stand in for a multitude that suffers the massacre and is united and subjectivized as a people (in Laclau's sense), not prior to the violence of 1968, but only during and after this violence.[1]

By reenacting the events of 2 October along such lines, the film replaces the potentially militant political desires of the movement's activists with the innocence of a family. The two are not sutured together. Rather, one takes the place of the other, forming an image of loss that is itself soon replaced by the blank surface onto which the film is projected, the very blankness of which is always revealed once the house lights go on. Such a substitution characterizes the way in which *Rojo amanecer* ingeniously exploits cinema's potential for processing the archive of 1968. The film reproduces or reenacts other, earlier, representations of 2 October. It does not deny or overcome the earlier testimonial and documentary texts that generally still dominate reflection on Tlatelolco, but, rather, consumes those texts, as an archive that would collect them, to finally exscribe them onto the cinematic screen that will eventually become blank. In other words, the film not only draws on the authority of

previous representations of Tlatelolco which bear the trace of their witness, but also, in so doing, parasitically draws its own authenticity from that act of appropriation, this despite the fact that it is a fictional work produced some twenty years after 1968.

Those earlier representations of Tlatelolco hold to the trace, sustaining Tlatelolco's memorial incidence in the sacrificial image of its loss, and thus constitute the funerary character of 1968's continued emancipatory potential. Indeed, as noted in chapter 2, cultural critic Carlos Monsiváis's original move toward a photographic writing of Tlatelolco closes on an image that interrupts any possible narration of the massacre itself. In Monsiváis's account, the massacre does not occur; rather, a still image of the moment immediately prior to the massacre sustains itself in place of the violent events on the square: "The peace sign stood opposite the hand with the revolver and the agonistic twilight used both gestures and eternalized them and fragmented them and united them without end, plenitude of the unfinished . . . the hand will never stop brandishing the revolver, the hand will never abandon the protection of the peace sign."[2] Writes Siegfried Kracauer: "All images are bound to be reduced to this kind of image, which may rightly be called the last image, since it alone preserves the unforgettable."[3]

The relation between this kind of last image and the motion picture reflects precisely the distinction Walter Benjamin makes between a "historical materialist" notion of history and a "historicist" one. I cite the sixteenth thesis, "On the Concept of History," in its entirety:

> The historical materialist cannot do without the notion of a present which is not a transition, but in which time takes a stand and has come to a standstill. For this notion defines the very present in which he himself is writing history. Historicism offers the "eternal" image of the past; historical materialism supplies a unique experience with the past. The historical materialist leaves it to others to be drained by the whore called "Once upon a time" in historicism's bordello. He remains a man in control of his powers—man enough to blast open the continuum of history.[4]

The mythologizing and simultaneously demoralizing powers of a transitional, progressive notion of the present—"progressive" understood in the formal and not political sense of the word—is opposed to a photographic freezing of the instant. The present, in turn, cannot liberate itself from this continuity, in which the conquerors have always already

won. The moving image, in other words, performs something of an exorcism on the unforgettable still that defers or interrupts such a progressive notion of history. This is so not merely for thematic motives related to the film's dramatic narrative unfolding, but also for reasons related to the mechanisms of cinematic form as such. There is no *discernible* last image on the film reel, which exhausts itself in its unfolding; cinematic form tends to return any such last image to the "continuum of history," though there is indeed a material last image that is purloined from the viewer and from the reel through the flow of time.

In *Rojo amanecer* the photograph, as both building block of cinema and originary object for reflection on Tlatelolco's place in history, regains its motion, reconstituting the moving visual field—heretofore arrested in the photographic image—in the form of a cinematic reconstruction. This cinema, in turn, desires to be redemptive in a way that photography and testimony cannot. Put simply, these earlier, thoroughly indexical, and seemingly more immediate representational modes hold to the still image that constantly refers them to the moment past, to their origin. Cinema, as we shall see, is a different sort of time machine. It performs the visual transition, as it were, that prepares the ground for a social and political transition. In 1989, Jorge Fons invited the spectator to labor in the cinematic factory of this transition.[5]

The still image with which Monsiváis's narration concludes blocks the proper emergence of sacrificial illumination by omitting this event from narration. Time is at a standstill, the Benjaminian *Stillstellung*. The image awaits the "now of its recognizability." It is that to which the guardians of its tradition cling as a resistance to dangerous times against the enemy who would appropriate that tradition by placing it at the service of "progress" or transition. As Benjamin writes: *"Even the dead* will not be safe from the enemy if he wins."[6] *Rojo amanecer* promises to give this photographic deferral back to the future, to end this pause, to give motion back to the still image, and thus, to finally take the viewer through the process of bearing witness to Tlatelolco that was set aside by Monsiváis in 1970. *Rojo amanecer*, as cinematic reenactment of Tlatelolco, in its unfolding scrapes off the film, the *residue* of Tlatelolco, seeking to lead Mexico out of its obscurity, promising, finally, to bring viewers into the present of the film's viewing rather than leaving them behind in 1968. Cinema becomes a machine of transition, the promise of movement in time, to a future beyond the shadow of Tlatelolco, to a future organized, yet, by its sacrificial illumination.

My point of departure is thus what seems to be a coincidence: the

habitation by the specters of 1968 of post-1988 Mexican cinema, a transitional medium for the moment of transition. If photo-aesthetics holds an image sustaining its ghostly potential, then the moving image represents a kind of exorcism. Cinema turns against the haunting that constitutes it and must survive the conflict within its becoming.

In this chapter, I will reflect on the relation between 2 October 1968 and the political and economic transitions that occurred in Mexico from the late 1980s until the early twenty-first century as this relation is imagined in cinema. The transition to which I refer turns on the interruption of some seventy years of PRI-ist rule, first threatened by the controversial 1988 elections, which opposition candidate (and son of former president Lázaro Cárdenas, 1934–1940) Cuauhtémoc Cárdenas appeared to have won until the peculiar breakdown of the machines used to count the ballots.

Carlos Salinas de Gortari assumed power. Salinas was, to be sure, quite unlike previous PRI leaders, a technocrat who, despite key ideological differences, followed Luis Echeverría (1970–1976) in making great efforts to extend good relations between the state and intellectuals. It was Salinas who initiated the changes that in 2000 led to the twelve-year ouster of the PRI from the Mexican presidency and the entry of Vicente Fox of the Partido de Acción Nacional (PAN) to Los Pinos, the presidential residence.[7]

Héctor Aguilar Camín and Lorenzo Meyer's book on the Mexican Revolution describes the debt crisis of the 1980s as a series of phenomena, including "the readjustment of the development model, the shrinking of the state, the end of the subsidized economy, and the expansion of the external market, at the expense of a strong decline in the internal demand and consumption, [which] had a concentrating effect in the upper class, and an effect of absolute impoverishment even on the successful middle classes."[8] The 1980s represent the final decline of the Mexican Miracle, the economic boom founded on the petrodollars that also facilitated—according to not a few observers—the student movement. This shrinking of the state demanded what Aguilar Camín and Meyer refer to as "the reduction of compensatory public expenditure."[9] To be sure, such compensatory expenditure arrived largely in the form of food subsidies to some of the poorest Mexicans.

Yet, as the relative pauperization of the Mexican middle classes moved forward throughout the 1980s, a novel and perhaps more ambivalent form of compensatory public expenditure emerged in the form of cultural production, in many ways a reactivation of the cultural pol-

icy pursued by Echeverría. Compensatory expenditure now emerged in ways that were both connected to and independent of the state. These new kinds of subsidies, directed to a certain middle class and, above all, not to the national-popular subject (whatever his or her social class might be), would help provoke the cinematic, cinegenic reflection on the sixties that, in part, forged transition.[10] This reflection, as Fons's film makes clear, always revolves around the construction and constant re-appropriation of the sixties as an event of and for the middle classes. As Niamh Thornton puts it: "In *Rojo amanecer* there is almost a tick box approach to showing an archetypical middle class family."[11]

The offerings of the Consejo Nacional para la Cultura y las Artes (CONACULTA), a cultural policy organ founded early in the Salinas administration, constitute perhaps the most visible face of this tendency. Its work projects a symbolic integration of the popular that appears to supplement the literary-symbolic capital of the middle classes. Without the strong ideological connection to or backing of a purportedly revolutionary national-popular state, these efforts work to redistribute cultural-symbolic wealth rather than proposing the fulfillment of social justice in the old sense. An immaterial redistribution must occur. As George Yúdice's work on the "uses of culture" suggests, the termination of both revolutionary praxis and the ideal of the planning state and its collective subject—the national-popular—as modes of social reconciliation and means of justice accomplished under or as preludes to neoliberal transition have opened the space for a necessary and new apparatus for the cultural management of various forms of social antagonism. Hinging on the perceived real subsumption of culture into political economy, so-called cultural work responds to new demands placed upon it to "reduce social conflicts and lead to economic development" as the ultimate conditions of its self- and social authorization.[12] Culture today forms an apparatus whose explicit goal is social governability. And this governability appears to us through culture as a *kind* of social justice. If Yúdice is right, our moment is that of a new episteme, namely, culture-as-resource, in which "culture is expedient for attaining an end."[13] In other words, there is no end to the state or to its sovereign investment, but, rather, there is a redistribution of relations and the desired outcomes of those relations.

Gabriel Retes's 1991 film *El bulto* (The Burden) presents the Mexican version of this trajectory. It, too, might well be a transitional film, a film of Tlatelolco. It begins when its protagonist—a leftist journalist in the thick of an early 1970s demonstration—comes under attack by riot po-

lice. He is injured and in a coma for twenty years. The event referenced here is the Jueves de Corpus massacre of 10 June 1971, also known as the Halconazo, in which a student march was infiltrated by paramilitary thugs, the Halcones, who then brutally attacked the protesters among whom they marched.

The journalist, awakening to Carlos Salinas's Mexico, sees his former comrades now financially successful and quite a bit more conservative. He clashes with his family and friends, who are all sellouts, he thinks. By the end of the film, however, he makes peace with all.

As the film makes clear, the very weight (*bulto* in a different sense) of those years must melt away. Only by dint of having missed the transitional period is the film's protagonist able to perceive (and only momentarily) the violent and final cleaving of radical emancipatory desires from more modest demands of the post-1968 period, which is to say, he perceives transition *as* transition.[14]

In the properly historiographical field, Héctor Aguilar Camín's *Después del milagro* demonstrates the transitional periodization of 1968 through its connection to the beginnings of the neoliberal era in Mexico. Indeed, he begins his final chapter, "Un voto particular" (which opens with the subsection "1968/1988"), with a mythologizing gesture for his generation: "It was a generation with a radical temperament that radically dreamed of the changes it wanted for Mexico. At the height of the great institutional monologue of the sixties, it forcefully demanded dialogue."[15] A rearticulation of the democratic transition, which came to light in 1988, from its origin in the 1968 generation, the statement annexes 1968 for reformism and establishes that moment as the horizon and brother of the present, its mere yesterday. And yet, Aguilar Camín underlines the fetishized nature of democracy: "Inequality, not democracy, is the difficult problem of Mexico, the real burden of its history."[16]

A partial coincidence between the goals of neoliberal transition and the student movement thus evinces the seeming ambivalence of the political disposition of the events of 1968 (of the sixties in general, one should say). While, on the one hand, the sixties are rightly regarded as a moment of social experimentation and emancipatory politics, on the other hand, the decade represents Mexico's powerful opening to an early stage of the neoliberal era, evidenced by the convergence of the increased entry of foreign capital, the intensification of consumer society, and the denationalization of the banking system. In other words, I once again recall the ambivalence regarding whether the emergence of the 1968 student movement in Mexico is a harbinger of a Mexican

opening to neoliberalism, or whether it constitutes a resistance to or rupture with respect to this opening. If the student movement produced in Mexico an opening to what Octavio Paz called "the spontaneous reality of the now," then for the eighties this residue opened onto neoliberal times.[17] In the face of the demand to pursue the most radical promise of the 1960s, the democratic moment only desires to move beyond, to kill the very name of that other world by appropriating what it claims to be its own origin.

IMAGES BEGIN TO TREMBLE

About an hour into Chris Marker's *A Grin without a Cat* (Le fond de l'air est rouge: Scènes de le troisième guerre mondial, 1967–1977) begins "May 1968 and all that," the second section of the first part of the film (titled, in turn, "Fragile Hands," a reference to the fragile hands of the students that would in due time, it was hoped, join in struggle with the workers). While the filmmakers' allegiances are dissimilar, Marker's film is—much like *Rojo amanecer*—a reflection on the violent historical events that preceded our own era, characterized in these films by the loss of revolutionary desire and hope. Marker returns here to the overexposed, blurry fragments from Eisenstein's *Battleship Potemkin* that organize the film. This footage serves as a nodal point for Marker's film essay; it is the screen upon which his own film is constantly imposed and the specter by which it is haunted. In announcing the arrival of 1968— both as a year within history and as an explicit theme within the film— Marker interweaves the *Potemkin* footage with images from the barricades of the student revolts, inserting a series of intertitles that pulse between the Eisenstein cuts: "Pourquoi . . . quelquefois . . . les images . . . se mettent-elles . . . à trembler?" The narrator in the English version of the film translates: "Why . . . sometimes . . . do images . . . begin . . . to tremble?" The intentionally degraded quality of the *Potemkin* footage along with the roughness of the cuts draws attention, in a certain vocabulary of avant-garde cinema, to "the mechanism and the material of film . . . closing the gap between the filmstrip and the screen."[18] We are made doubly aware that this is cinema, for just as the images begin to shake, the spectator is asked to why this sometimes happens. Why— *sometimes*—is it that images begin to tremble? And this question, to be sure, is a question of *time*. Why this beginning? Why only *sometimes*? What is it that causes these images to tremble, and when does it occur?

In part, motion itself is a trembling of the image; the shaking that marks the loss of a stillness characterizing each singular photographic image that constitutes the reel. The answer to the question, from this perspective, is thus that cinema establishes the trembling of the image. The cinema of Tlatelolco is the same, but now-trembling images and fragments that I have so far discussed. Yet the cinema of Tlatelolco to which I will refer here was not filmed on the night of Tlatelolco. It was not filmed in 1968 at all, but some twenty years later. Rather, *Rojo amanecer* serves as a peculiar kind of reenactment of these events in the medium of cinema. To be sure, Fons's film relies on the support of the photograph, on the relation between film frame and photograph, but it does not inscribe directly the setting to motion of these same indexical, putatively original Tlatelolco images that one finds, for example, among the pages of Poniatowska's *La noche de Tlatelolco*.

For this reason, let me consider a second trembling of the image, also suggested in Marker's film. As I note above, the frame in this sequence establishes not only the motion of images but also another trembling-shaking of the moving image itself. Here cinema distorts and blurs. In this orientation, trembling is the activity that cinema undertakes compulsively, nervously, or in a state of sadness or shock when faced with the intensity of matters too overwhelming to capture. Trembling is cinema's response to these intensities; images tremble when they can no longer contain what is framed by the lens. A rupture or a disconnection occurs here between medium and apparatus, "between the mechanism and the material of film," between the event captured and the camera eye, between the surface of inscription and its subsequent projection. And yet, between each reproduction, the intensity of the event fades and another trembling commences to recapture, to remember, to reenact an original impression. Images tremble as the mark of this intensity, which is, finally, the only remaining mark or index of this intensity, that is, its residue on the filmic surface *as* residue.

Marker points to this problematic cinematic transmission of events through his work's very formalization, structuring his film essay by its recurrent reference to *Battleship Potemkin*. The Eisenstein film serves as both commemoration and narration of the 1905 uprising from which it takes its title (celebrating the uprising, but marking the fictional sacrifice of civilians on the steps at Odessa). It is, after a fashion, a reconstruction, a reenactment of events to which Eisenstein's camera could not have borne witness. But also, in Marker's appropriation, it becomes now the original to which *A Grin without a Cat* bears witness. And in so

doing, Marker's film suggests something like an analogical relation between the failures and defeats of 1905 and those of the period 1967–1977. As *A Grin without a Cat* reconstructs its moment (as film essay), it reenacts *Battleship Potemkin*.

In Marker, cinematic form obeys the logic of a certain reenactment. Marker intends to condense not only a history but also the structure of feeling that is proper to 1967–1977 into *A Grin without a Cat*. The film sets out to *evocatively* reenact the period and, in the process, points to the very sense in which cinema is, constitutively, a medium of reenactment. The selection of *Battleship Potemkin* underlines this suggestion.[19] Through *Battleship Potemkin*, Marker presents the "third world war" by reenacting the reenactment.

Yet, there is an even more allusive orientation of reenactment upon which the film draws and which shapes its conception of the political. In this orientation, it is politics, and not cinema, that is submitted to the notion of reenactment. By evoking and commemorating the revolutions of 1968 and 1905 as a twin legacy of possibility and defeat, Marker points to the reassertion of repressive violence and the appropriation of the insurgent moment for a subsequent noninsurgent politics as the constantly "reenacted" limit to emancipatory political desires. Further, as the film sets aside these exemplary instances, it also reflects upon how new emancipatory political sequences might emerge in the face of the very repetitions of which even this most critical and sharp film is guilty.

Much the same might be said of Fons's *Rojo amanecer*. However, if there is something insurgent in *Rojo amanecer*, it concerns not politics but, rather, the more modest renewal of cultural forms. Indeed, it was a well-made, or at least interesting and intelligent Mexican film at a time during which Mexican cinema had become, as the writer Salvador Elizondo put it in an essay celebrating Fons's achievement, "kindergarten or brothel amusement."[20] This renewal, however, turns on another site of repetition, of reenactment, as it were. By returning to the time of not only political but also artistic renewal, that is, the 1960s, when creators like Elizondo were at their peak, the film takes up the banner of this promise and returns it to the present.

Somewhat surprisingly, the film seems to have made a strong impression on Elizondo, whose short essay invokes the definition of art as tragedy. However, he notes also that *Rojo amanecer*, if it communicates a tragedy, it is in the assertion of the authenticity or directness of its relation to the event it documents. Yet in many ways, Elizondo notes, the film's artistry is marred by a series of poor decisions that would seem to

undermine his own claims about the film, but they are forgivable, as far as Elizondo is concerned.[21] Among these weaknesses, he mentions the poor lighting, which gives little sense of the passing of time: "Color film works against the film's tragic spirit, especially when the lighting is flat, lacking gradations consistent with the time of day or the stage of the drama, in order to accentuate them, to measure or place them without having to resort to the image of a clock, since time, as is known, is an essential element of tragedy."[22] In a sense, then, the work does not display tragedy, does not unfold itself in the tragic becoming of the dramatic acts that it narrates; rather, it holds to the original event it references, transmitting some trace of that event, in part by virtue of the constant reference to the film's having been shot (so it seems) in the Tlatelolco apartments, but also by drawing on the viewer's power of memory and linking that memory to a cinematic temporality.

Along these lines, in *The Emergence of Cinematic Time*, Mary Ann Doane recounts Thomas Edison's *Execution of Czolgosz*, the filmed reenactment of the electrocution of anarchist Leon Czolgosz, who in 1901 shot U.S. president McKinley. "It is clear that Edison would have liked to shoot the actual execution," she writes, "but in the absence of permission to do so the crew had to settle for a panorama of the prison walls taken the morning of the execution joined with a reenactment of the electrocution."[23] *Rojo amanecer*, indeed, contains such a panoramic shot. The nature of its reenactment is compensatory in the sense Doane describes: there was no camera there; the panorama of the prison walls shot in synchronicity and in proximity to the execution serves as a kind of authenticity that bleeds into the remake.[24] "In a reenactment," writes Doane, "the time of the image does not coincide with the time of the event signified. The construction of the Czolgosz film is evidence of an awareness of that disjunction and of an attempt to rectify it."[25] Mexican historian and writer Carlos Montemayor makes this connection explicit when he tries to dispel the idea that cameras had been placed on the Plaza de las Tres Culturas, on top of the church: "We can rule out that emplacement for a simple reason: on the roof of the church there was a command of snipers not of cameramen."[26] Montemayor's observation underlines the necessarily compensatory nature of a film like *Rojo amanecer*: there was no camera there and in that place (even though we now know there was). Cinema begins with such reenactments. More to the point, Mexican cinema returns to these reenactments in 1989, much closer to cinema's end than to its beginning.

In *Rojo amanecer* a young boy stands in as witness and victim both:

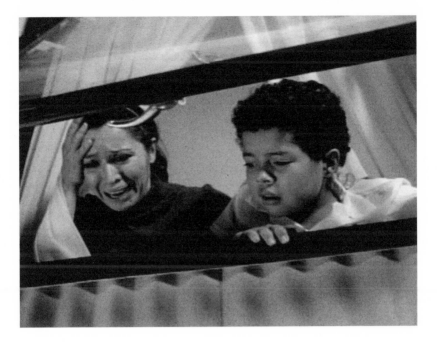

FIGURE 4.1
Still from Rojo amanecer, dir. Jorge Fons, 1989.

he watches the grisly massacre take place through his apartment window, but also, because the students are never seen, his anguished face stands in the place of theirs. This act of teichoscopia characterizes the procedure of the film as a whole; it represents, it takes the place of another. In that place of another, it places itself, exploiting a conceptual relation between film as cinema, and film as residue. As the singular cinematic film of Tlatelolco, it takes the place of the film, the residue, of Tlatelolco from which it draws its tragic authenticity. It stands in the place of a day in whose shadow the present can never give way to the future. By going through the day, by starting and finishing, cinema promises to wipe away the residue of the past through a logic of substitution and supplementarity.

CINEMATIC REFUGE

Just as they might object to the assertion that *Rojo amanecer* is the first film of Tlatelolco, some readers might take exception to the claim that

Rojo amanecer is in any sense singular, that it is even remotely the singular film of Tlatelolco. Yet, there persists another film of Tlatelolco—a residue of Tlatelolco—to which a great many Mexican films bear witness, making these films also, in a sense, the films of Tlatelolco. Consider, for example, the early 2000s trend of well-made Mexican films that generally star some version of Mexico City. Bruno Bosteels has argued that the two most famous such films, *Amores perros* (Alejandro González Iñárritu, 2000) and *Y tu mamá también* (Alfonso Cuarón, 2001), both "give an account of what is left of the sixties and seventies at the beginning of the twenty-first century." These films, as Bosteels writes, "confront the viewer with the legacy, not just of neoliberalism today, but of the earlier dreams to 'put society back together' without seeking refuge in the strictly imaginary."[27]

Following Bosteels, allow me to suggest, in the spirit of a provocation and also in the way of a speculative investigation toward a theory of contemporary Mexican cinema, that contemporary Mexican cinema as such bears witness to the film of Tlatelolco. *Amores perros* and *Children of Men*, to name two examples, both turn on the redemption of the sixties, of an exorcism of its specters. In the former, the ex-militant Chivo begins his return to family life; in the latter, our disillusioned hero—also an ex-militant—is cleansed, again, by the reestablishment of the family. Or let us recall a moment in *Y tu mamá también* in which our protagonists ride, relentlessly, into a future of unbridled individual freedom while the camera turns and lingers, looking out of the automobile window, on the uncounted poor that stand between them and their beach paradise. Reading the scene in the key Bosteels suggests, we encounter the cinematic registration of the cleaving of individual freedom from social justice that, as David Harvey has suggested, is a secret legacy of 1968.[28] Indeed, the sexual act that culminates the film turns on the redeployment of these individual desires into a quasi-collectivization. The camera turns away from this scene before long, pointing to the scene's status, perhaps, as experience that refuses cinematic representation. The rest of the film presents the violent reterritorialization of these figures and their desires. Certainly, the specter of 1968 is one of the residues that covers any reading of the film and, one should say, completely haunts its unfolding.[29]

However, in a number of fora in which I have offered this thesis on *Rojo amanecer*'s singular appearance as the cinematic expression of Tlatelolco—always in a polemical spirit, to be sure—my interlocutors have offered as counterargument not the spectral returns of the 1960s as im-

plicit thematic horizon in 1990s and early 2000s cinema (as per Bosteels's suggestion) but, rather, Felipe Cazals's 1976 *Canoa*. *Canoa* adopts a pseudodocumentary visual rhetoric as it relates the story of a group of young employees from the Universidad Autónoma de Puebla who, in the fall of 1968, and thus shortly before the Tlatelolco massacre, travel to a rural area in the state in order to go camping. When a rainstorm quells their plans of ascending the mountain where they had planned to set up camp, they try to stay in the town, which has come under the spell of a despotic priest, paranoid about communist infiltration. The townspeople, stirred into frenzy, try to kill their guests. The army arrives in an attempt to rescue of them.

Yet this is the very opposite of what a film about Tlatelolco would be, for here the government arrives as the students' liberators, not their assassins. The film should, rather, be read as an attempt to recompense the middle-class members of the student movement through a pseudo-omission of the state's responsibility, and, much more important, to remind the middle class that it is the sovereign power of the state that secures the contemporary order. Despite the imperfect balance of that order, without it, the suggestion appears to be, the middle class would be consumed and annihilated by the ignorant brutes with whom they tried (and failed, according to this narrative) to build alliances throughout the sixties and seventies. Moreover, because *Canoa* presents these peasants as having been stirred into such a frenzy (against communists) by their priest, a critical reading of this film would correctly note that the PRI historically protected Mexico's citizenry, so to speak, from the political influence of the church by insisting on its own history as an anticlerical state. There is thus a very strong and contradictory belief that Cazals's film is about 1968, that it "represents the atmosphere of 1968."[30] On the one hand, many viewers imagine that the film's narrative recovers the repressed memory (or the memory of a repression) of what occurred in Tlatelolco. On the other hand, the film is inhabited by the specter of Tlatelolco, which forms the horizon of its appearance. Therefore, even if the film does not represent or narrate Tlatelolco precisely, it is a symptom of Tlatelolco. In other words, *Canoa* is not directly about 1968; 1968, rather, provides its conditions of possibility. Write Hester Baer and Ryan Long:

> Although—or perhaps because—1968 exposed the Mexican state's weakening legitimacy, exposed it to its own posthegemonic agony, the administration of Luis Echeverría (1970–1976), which immediately

followed that of Díaz Ordaz, responded to the aftermath of 1968 by expanding the role of the state in Mexican society. Thus he met the crisis of the national-developmentalist state with a paradigmatically national-developmentalist response. Emblematic of this response was Echeverría's attention to cultural production, which formed part of his general reform policy known as the *apertura* (opening). The *apertura* enacted a series of reforms that attempted to co-opt dissidence through state institutions, such as the official sponsorship of critical cinema.[31]

The crisis of 1968 stimulates or makes necessary a form of sociopolitical suture, which takes place on the grounds of culture. This compensatory expenditure, to return to Aguilar Camín and Meyer's phrase, turns on a kind of symbolic democratization, opening the state to a criticism that *it* makes possible, and thus annexing such critique to cultural form rather than allowing it to pass into the juridico-political sphere to which it is arguably proper. As Long and Baer note: "A particularly sinister fact that belies the limitations of the *apertura* is that Echeverría was almost certainly involved in organizing the massacre of October 2, 1968 that ended the student movement."[32] In this sense, the film both compensates for and serves as an oblique apology for the massacre.

Yet, to be clear, *Canoa* is not about the massacre of 1968 on the Plaza de las Tres Culturas. It is based on the real events of a quite different massacre. The film is experienced as about 1968 for purely thematic reasons. It is about a massacre of people from the university, but different people from a different university. As such, it forms what John Mraz has convincingly designated the "phantom memory of '68."[33] Writes Mraz: "*Canoa* killed two birds with a single stone. On the one hand, it stood Tlatelolco on its head by asserting that the Mexican people are barbaric; as in *María Candelaria*, the brutal, ignorant, blood-thirsty *pueblo* requires the patriarchal control of the police and army. On the other hand, *Canoa* filled the cinematic space for '68—once a fictional movie had been made about those events, it would be some time before funding for another could be found."[34] This other massacre *takes the place* of the Tlatelolco massacre until the 1989 production of *Rojo amanecer.*

To follow Mraz's suggestion, a film that effects this substitution of one massacre for another must necessarily, in 1976, be read as a film "about" Tlatelolco. This reflection works itself out beyond the common theme of massacred students. In a way, *Canoa* learns another profound lesson from 1968 regarding the end of the fantasy of the national-popular

state; now the people or *pueblo* is just a kind of ignorant, violent mob from which the state must protect the middle classes. That is, *Canoa* advances a reflection on the failure of Mexican culture's force as a form of state pedagogy, demonstrating the ruling and middle classes as united in their isolation. The danger of economic injustice and socioeducational inequality is to be shared equally. This move finally annexes even the middle class and its aspirations, among which, it should be recalled, was to form alliances with the working classes and peasants in the 1968 revolts: "During Echeverría's presidency, the state's investment in promoting national culture remained significant, a role that was to diminish radically during the decades following his government."[35] *Canoa* figures as the remnant of this regime of interaction between culture and the state. If there is some true antecedent to *Rojo amanecer* to be found in *Canoa*, it is the way in which *Rojo amanecer* mourns this relation's decline by being an independent film that is nevertheless useful for the regrounding of the state form, just as it denies this relation's ever having existed through the constant staging of its own lack of state subvention. A secret indivisibility between mourning and denial conserves the perceived independence of the production, even as its independence no longer seems fully credible.

THE FILM OF TLATELOLCO

As I suggest above, with the advent in 1989 of a Tlatelolco cinema, the representation of 1968 gives way to moving images. This cinema is formally redemptive, for, as Mulvey has argued, "the still photograph represents an unattached instant, unequivocally grounded in its indexical relation to the moment of registration. The moving image, on the contrary, cannot escape from duration, or from beginnings and ends, or from the patterns that lie between them."[36] Tlatelolco cinema thinks through a certain duration, claims as its object the very beginning and end of Tlatelolco itself; through motion, it constantly brings us to this beginning and back to its end. History is framed, relinked, rebound to the logic of its progressive flow, and recent criticism has sought to at least partially affirm that narrative. As Daniel Chávez puts it, writing in particular about *Rojo amanecer* and *El bulto*: "These fiction films and other documentaries on the subject made strides in the critical representation of the state by showing for the first time direct army and police involvement in the repression of students and other activists of the pre-

vious era."[37] It would be ungenerous to say that the observation is wholly incorrect, and yet, the critical task should demand we suspend that affirmation in order to think the mechanisms through which an entire history of so-called democratic transition encrypts itself in such symbolic "strides."

Rojo amanecer opens with a blank screen and the sound of a ticking clock. The still image is thrown into motion. And yet, ingeniously, this motion is not made present through the moving image in its most expected form, as objects moving on the surface of the screen, but, rather, in an assertion of the very *technical* capacity of cinema to move. The slight, scratchy movements of the titles in the credit sequence express this motion, just as the ticktock of the clock points to a return to temporal progression, marking the unfolding of time while the credits roll, before an image appears. This sequence serves as a visually registered moment of silence, simultaneously organized and punctuated (and the relation here, between punctum, punctuation, and punctuality, should be observed) by the sound of the clock.[38] The clock commands a moment of preparatory silence in advance of the wave of transitional images. It is a preparation, in other words, for the duration that cinema exacts, and this duration is its demand. Yet, it is not a true moment of silence, for it is counted out by the relentless ticking of the clock, which not only presages the end of a pause but, as a kind of aural punctum, also recalls how the specter of Tlatelolco resides as a haunting figure, punctuated by the sound that marks its persistence. The clock thus establishes the spectrality of Tlatelolco as the condition that cinema must overcome and insists on the necessity of cinema, on this task as the singular task of cinema.

This timepiece, as we will soon see, belongs to the grandfather, who lives with his daughter, her husband, and their four children. All of them, save the youngest child, will be dead by dawn, killed by the rogues of the Batallón Olimpia. For now, the grandfather wakes up, coughs, and takes his pills. He ambles through the small apartment, turning the wall calendar to the day that will soon become the name of history. Time is thus inscribed on the wall of the domicile and returns the spectator to 2 October 1968 in Tlatelolco. The time-place crystallizes as the spectator is rather artlessly spirited away to a moment, to a space, to an image that today, in 1989, "flashes up in the now of its recognizability," as Benjamin puts it. But in the transitional "now," which is to say, at the moment of a false recognizability, the time of repetition (anniversary) will claim command of these images and turn them over

to the requirements of these transitional times, and will turn them into motion toward a future.

On the scratchy surface of the credit sequence, an austere residue underlines the proposed authenticity of the film's realization. This, so goes the conceit, is a rare work of cinema that breaks with the Mexican state's subvention apparatus, which by 1989 was, in any case, almost null. In other words, the film dramatically performs its rupture from a regime of state subvention for the arts that is at one of its lowest points in postrevolutionary Mexican history. It is thus *Rojo amanecer*'s pretense of performing a kind of aesthetico-political rupture that Andrés de Luna criticizes as derivative and repetitive. He notes that "an endless number of films have been produced that acknowledge the power of memory and of oblivion. The obstacle lies in the repetition of clichés." Of *Rojo amanecer* in particular he writes: "This chronicle alludes to the massacre of civilians in the Plaza de las Tres Culturas in Mexico City. The film is pathetically obvious and influenced by mainstream Mexican films of the 70s: the plot invariably leads to a final cathartic slaughter."[39]

De Luna's observations underline the precisely "non-ruptural" and continuous nature of the film (which he designates a "chronicle"). Even certain of the features that seemed to constitute its aesthetic originality are highly derivative. While the film's clichés or, more precisely, its highly melodramatic unfolding provoke a constitutive failure to "acknowledge the power of memory and of oblivion," its repetitiousness, its reenacted nature, assures that its relation to 1968 goes beyond the merely thematic or representational modes on its surface. Indeed, at the center of this film resides a Tlatelolco archive, hinted at by what de Luna correctly refers to as an "allusion." The film never bears witness to the Tlatelolco massacre, and this is part of the strategy by means of which it avoids even the confrontation between memory and forgetting that would further sustain 1968 as an object for thought and as a site of social and political struggles.

David William Foster explicitly disagrees with de Luna's assessment of the film: "Fons's film is a skillful and eloquent record of the massacre . . . I disagree with de Luna's comment that 'The film is pathetically obvious and influenced by mainstream Mexican films of the 70s: the plot invariably leads to a final cathartic slaughter'—as though the 'final cathartic slaughter' were fiction and not based on historical fact."[40] Foster's disapproval of de Luna's critical appraisal illuminates the symptomatic nature of the film and of the reception that accepts its ruse; *Rojo*

amanecer is anything but a record of the massacre, which is registered only through a window as the film adopts the teichoscopia that emerged in classical tragedy and was a mainstay in early modern theatre. Here the camera's gaze falls not upon the actions on the square, but upon the protagonist's faces as they bear witness to the horror. Moreover, the fictionalized eventual slaughter of the protagonists replaces this unseen central act. Here the reenactment convincingly substitutes for the event. Foster counters de Luna's (in my opinion, correct) aesthetic assessment of the film as derivative and melodramatic by reference to the event that the film proposes to reenact. According to Foster, in an echo of Elizondo's comments cited above, the film, finally, cannot be evaluated in aesthetic terms because it not only refers to an event that exceeds it, but because it has convincingly transformed itself into a substitute for that event: by taking place in Tlatelolco, it takes the place of Tlatelolco. The film, in terms offered by Christian Metz, "symbolizes new fragments of the 'real' in order to annex them to 'reality.'"[41] From this perspective it might be asserted that the "unrepresentable" horror of Tlatelolco—unrepresentable in the sense that the Real is often said to be—is annexed in preparation for the arrival of Octavio Paz's "spontaneous reality of the now," even if that now is even more faithful to Paz's vision than he'd have imagined.[42] That is to say, horror and violence are transformed into the horizon of a progressive notion of history as transition that constantly conceals the violence at its origin.

When I suggest that the film takes place in Tlatelolco, I mean to indicate that it has been filmed from within an apartment in the Conjunto Urbano Nonoalco Tlatelolco, indeed, from within the Chihuahua building, from which the clandestine forces of Batallón Olimpia opened fire on the square below. The square itself and the multitude assembled there are never represented in the image, for domiciliation is always at stake in the name "Tlatelolco." The spectator is only very strategically exposed to the image of reconciliation posited by the Plaza de las Tres Culturas twice during the film: first, as the day begins, and, again, as the day ends. In effect, the proper name for 1968 is the name of an urban dwelling. "It is thus, in this *domiciliation*," writes Derrida, "in this house arrest, that archives take place."[43] In this tension between movement and arrested time the archive appears as an archive that stands in place of another archive to come, which will either create justice or not, which, in either case, will attempt to arrest a haunting. In these apartments, the film arrives at a spatial obstruction even as the clock runs forward through the scratchy screen. On the other side of its sequence

appears, finally, the clock that ticked out the rhythm of the credits. Images of the square frame the movie, once as an image of the past, and then, as we will see, as a call to bring forth a future. The film establishes one archive in the place of another. The apartment never opens onto the square, but overlooks it. Whenever the film's protagonists' gaze falls upon the square, they are in fact looking at the spectator, again the site of a teichoscopia. The cinematic screen becomes a window through which the audience is posited in the place of the massacred students, the movie house the site onto which the unseen massacre is projected.

Following the credit sequence, *Rojo amanecer* establishes the domestic milieu: playful, familiar banter at the breakfast table establishes the normalcy of the family space. Yet, repartee among family members becomes a rather clumsy and didactic entry into the family's gender- and generation-gap dynamics. The father, a middle-class government functionary, scolds his oldest sons, both student activists. He recalls the placing of the red-and-black flag on the flagpole in the Zócalo, Mexico City's main public square, during the largest march, on 27 August, which, on the following day, inspired the government-organized "acto de desagravio" (act of atonement), in which the government compelled its employees and functionaries to attend this ceremony at the Zócalo, imagined as a kind of restoration of the Mexican tricolor. Adds the grandfather, a lieutenant in the Mexican Revolution: "In times of the Revolution, they would have been executed." Thus, at the table sit the metonymic vicissitudes of twentieth-century Mexico in the flesh: Revolution, Institutionalization, and the Student Movement, inhabitants of the apartment buildings that sit on the site of Mexico's origin, which in turn collect the names of Mexico's territory. The mother, finally, as an element excluded from this series, stands in for the masses, however defined, which are claimed simultaneously as the object of these three moments, again, the Mexican Revolution, its subsequent institutionalization, and the student movement of 1968; hers is the womb of plenitude from which futurity is promised.

When their father leaves for work, the sons engage in another unnaturally didactic dialogue with their mother, recounting, along with her, in the form of an argument, the central events of the student movement. This is perhaps the first strong intimation of the film's archival desire; it bears witness to a bearing witness, collecting and repeating what is known. It does not make visible the original events but, rather, their retelling, in mock-testimonial form.

The breakfast scene thus establishes three crucial elements of the

film. The first is structural: in their initially friendly breakfast-time discussion, the family earns itself the right to speak metonymically for the film's potential spectators—other members of a supposedly innocent middle class. The second is narrative: the scene establishes a certain sense of generational conflict between the children and their parents and between the children and their grandfather. Just as important, in showing this conflict, the scene didactically narrates the events of the summer rebellion of 1968, from its origin to its present, 2 October 1968, which is also, in a sense, our present, a long night the film itself promises to give end to. Third, the scene establishes the film's technical or generic procedure: the film will tell a story, but the film itself will not invent or visually fabricate the event to which it did not bear witness. The scenes will occur only in this apartment; cinema will be placed under house arrest. In not rendering visible the massacre itself, the film underscores its own documentary nature; it cannot and thus does not bear witness to the rebellion and subsequent violence at its center. Rather, it registers both the student movement's rally as well as its destruction on the square below through canned diegetic crowd noises and gunfire, supplemented by the eyes of the characters themselves, who bear witness—for us, in our place—to the action on the plaza. At the same time, in a strangely contradictory turn, the audience will die *in the place* of those students, for the viewer, as I note above, has been placed *in* the plaza by the relation between viewing screen and audience, by the relation between the gaze of the camera and the faces of the actors.

As the day turns into night, the family's passive experience of witnessing is transformed into a kind of siege. The electricity and phone lines are cut. Gunshots are finally heard, and the gunfire is registered in flashes of light on the actors' faces as they peer through the window onto the square below. While the grandfather goes outside to look for the daughter, who is playing with a friend nearby, the sons arrive home, with three other student activists, one of whom is badly wounded. The arrival of the students causes a stir, yet it also opens the possibility of familial—and thus (metonymic) national—reconciliation.

The square grows calm as night turns into day. The activists make their plans—they will leave one by one. The camera pans the peaceful square as a reference to both the antecedent of the finally symbolic reconciliation posited by the film's metonymic family as well as of the archival nature of the two symbolic edifices. The Plaza de las Tres Culturas' symbolic originary reconciliation between Aztec and Spaniard bleeds into the dwelling, into the domicile. The mother stitches the wounded

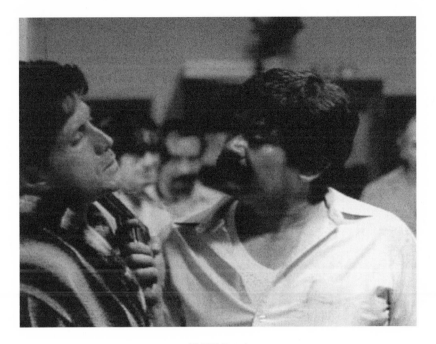

FIGURE 4.2
*Still from **Rojo amanecer**, dir. Jorge Fons, 1989.*

boy, all of the family members return home, and, in the aftermath of the
horrific act that they—and not we—have witnessed, they seem to put
their differences aside.

Meanwhile, the men coming up the stairs, as their white gloves will
soon make clear, are members of the Batallón Olimpia, marking a re-
turn to the domicile from the streets, from the public sphere, into the
home. Before the rogues burst into the protagonists' apartment in search
of a secreted witness, a hidden activist, the grandfather tells the young-
est child to hide beneath the bed, as if they were playing hide-and-go-
seek. The three students befriended by the teenage sons are hiding in the
bathroom. In a strange substitution, when the thugs assemble the family
in the entry hall, asking who else lives here, the grandfather names the
missing grandson, who, in fear, went to hide in the bathroom (where the
activists are). The thugs search the house and find, in the boys' room, a
poster bearing an iconic image of Che Guevara, which demands further
excavation. They discover a trace of the wounded student's blood on the
sheets and then slaughter the family and their guests. Only the youngest

child survives, hidden under the bed and not in the bathroom, where his grandfather claimed he was.

As David R. Maciel notes, the film concentrates on the rogue secret police, the Batallón Olimpia, and elides the regular military's significant involvement in the massacre: "By denouncing and focusing on atrocities carried out by the secret police, the film is fully in keeping with the current political climate and suits the state's purposes." Maciel continues: "It could be argued that by allowing *Rojo amanecer*, the state not only appears to be moving toward political democratization but also is sensitive to the national concern for human rights."[44] That is, despite the appearance of *Rojo amanecer* as the breaking of a long-kept silence, it also turns on a tacit relegitimization—now by an "independent" cinema—of the state *despite* the rogue actors who might be seen to act in its name. In this respect, the film expresses its continuity with the history of Mexican cinema, which, as a generally state-related popular entertainment, has historically had the reach and distribution to provide a site for the production of consensus. As Carlos Monsiváis has put it: "To government and religious censorship is added the submission of a collectivity that compulsively memorizes its own repressions and eliminates moral and political dissidence. No one need concern themselves about ethical questions. After all, everything is resolved beforehand; everyone has his place on the ladder of command and everyone knows how to react to sex, food, drink, death."[45] That is to say, concealed beneath a surface of rupture in *Rojo amanecer*, a screen, the secret archive of continuity and transition pierces through. And this secret constructs the state's version of 1968, the archive-origin of its neoliberal transition, again. It conceals and makes visible the stain of this origin, the residue it can neither see nor see through. Cinema *burns* an archive into film, through this residue. Writes Derrida: "The archive, if this word or this figure can be stabilized so as to take on a signification, will never be either memory or anamnesis as spontaneous, alive and internal experience. On the contrary, the archive takes place at the place of originary and structural breakdown of said memory." The archive, in taking place, takes the place of memory, establishes, in its place, a place "of memorization, of repetition, of reproduction, or of reimpression."[46] This is, for our purposes, the cinema.

What the viewer encounters in *Rojo amanecer* is not the violence known as the Tlatelolco massacre, but a reenactment, in the domicile, which takes the place of the original, to which the film "bears witness," which the film reenacts through the face of the child actor as he looks

FIGURE 4.3
*Still from **Rojo amanecer**, dir. Jorge Fons, 1989.*

through his window at the square below. The original action is not visually represented, but is made present, as I noted earlier, by sound effects and lights flashing on the actors' faces. Yet, as the strangely triumphant extradiegetic music at the film's conclusion suggests, this red dawn to the night of Tlatelolco is yet a dawn. The night is over and has violently archived and overcome the past—revolution, institutionalization, the student movement, and the national-popular state. The figure of the mother grounds this reconciliation, but is also erased in it.

By dawn, when, accompanied by the soundtrack's Casiotone crescendo, the child steps over the bodies of his family and emerges from the apartment building, the plaza is already being cleared of bodies and of the trash of history, as suggested in the gestures of the janitor with his broom. The film archives all of Tlatelolco's representation, buries this representation within itself, putting itself in that place, that place of memory. It bears witness to those past texts, reenacts not a violence but a bearing witness to violence that it, finally, clears away, sweeps to the side, seeing the present, the dawn, with the eyes of a child.[47] The child's final emergence from the apartment building at the film's conclusion prefigures the spectator's emergence from the cinema. The child is posited in our place, emerging from the dark into the light of day (as we the spectators shall soon do, as the *archive* is now bound to do): the future of the present is illuminated, an archive suffused with light.

This final emergence into the light of day brings the spectator dangerously close to the realization that the film is from 1989, that the present into which the child walks is not 3 October 1968, but, rather, some slightly more recent date. The film leaves behind the pretense of having

traveled into the past and reveals for us the reenactment through which it has drawn us all. As the boy enters the day, to the left of the frame a janitor sweeps the plaza. The image evokes Paz's poem "Intermitencias del oeste (3)." As in the poem, the bloody trace disappears from the archive, only to be imperfectly captured by the stain of the ink on the page. But the film leaves no stain and continues cleaning the plaza.

CINEMA: RESURRECTION

These tropes (light and dark, temporality and mourning) frequent the most recent Mexican cinema. Film must become the very place of the cinema in order to reestablish itself, for cinema is the very form of resurrection. The clock that begins in *Rojo amanecer*—the dawn that breaks to forge the future we inhabit—haunts Mexican cinema still. Here I will discuss a rather unexpected film, but it is a film that should be read as a kind of bookend to *Rojo amanecer*. Fons's film, as I suggest above, presents the return of a certain national Mexican cinema in the neoliberal era, the apogee of which has been the works of the so-called three Amigos (Alfonso Cuarón, Alejandro González Iñárritu, and Guillermo Del Toro).[48] The director Carlos Reygadas arrives somehow after these friends—by himself—the "Lone Ranger," to their "Three Amigos," as Sánchez Prado puts it.[49] If I am right that Mexican cinema returns to Tlatelolco as a condition of its contemporaneity, the constellation Fons-Reygadas figures an illuminating constellation of that sequence.

Characterized by their sparse dialogue, their extraordinarily long shots, their slow pacing, and their use of strictly nonprofessional actors, the films of Reygadas constantly suggest something contingent, unplanned, and accidental. Unlike the more commercial recent Mexican cinema mentioned above, which had by the beginning of the 2000s reached a certain extension and renown, Reygadas's works seem to, at least partially, avoid their encounter with their local context. Partaking of a long tradition in Mexican cinema, the makers of films like *Amores perros* and *Y tu mamá también* accepted, in the key of a certain perhaps unconvincing or unachieved realism (an old-new realism or late-capitalist social realism), what might be considered the duty to represent for the viewing public the social order in which they lived and to project whatever future becoming of that order might seem credible. That those interventions were already made anachronistic in advance, after Tlatelolco, seems to be the ever-ghostly demand at work in Reygadas.

Understandably, given the relatively short history of his work in cinema, scholars are just beginning to read Reygadas. In a recent, Spinozist, reading of *Silent Light*, Niels Niessen asks: "How does one recognize [the] miracle through which cinema aspires to become the world?"[50] Niessen's reading largely turns on a comparison between *Silent Light* (Stellet Licht) and Carl Theodor Dreyer's *Ordet* (1955), which, as Niessen notes, was an explicit reference for Reygadas.[51] Such a comparison serves largely to support the transcendent, mystical, or miraculous status that Niessen tends to grant the work (which would seem to have been the intention of Reygadas himself). As Niessen puts it: "Whereas *Ordet*'s miracle appears as a fairly isolated moment, *Stellet Licht* [Silent Light] is made entirely of miraculous matter."[52] The suggestion here would appear to be that if Dreyer's work reproduces diegetically a miraculous instant, then *Silent Light*'s miracle resides within the materiality of the film itself: "*Stellet Licht* does not merely give the representation of a miracle; that is to say, show its effects. Instead, it becomes it."[53] Niessen thus agrees with the conceit of the film to have conquered representation and to have produced the very miraculous world that the viewer inhabits through its viewing. This division is perhaps already present in the two films' titles. *Ordet* is the "the word," the site of representation and the symbolic order. *Silent Light*, however, recalls the very origin of cinema in a double register: its historical beginnings in silent film and also its material origins in the light of which all such images are composed and which renders visible the world before us. All light is silent, indeed, but that silent and seemingly impassive materiality of cinema, *its* silent light, is the immaterial grounds of its material inscription, or the place of a displaced or deferred materiality (the sun, the stars, the order of our very world as the order of cinema).

And here I will depart from the idea offered by Niessen that "there is a strong suggestion of divine inspiration in Marianne's reaching out to the sun" with the possibility that if there is any "miracle" in *Silent Light*, let us imagine that it is the secular miracle of cinema itself. That is to say, Reygadas conjures something between the joy and duty of cinema and conjures it away from the norms of mimetic Mexicanism and toward a radical sort of photopoïesis—a miracle, if you want, of a different kind.

Reygadas's first feature-length film, 2002's *Japón*, from the very title displaces the scene of action, just as its opening shots portray a flight from Mexico City into the open countryside. A man takes refuge in the wilderness to live in an indigenous village, where he plans to take his own life. Reygadas's second feature, 2005's *Battle in Heaven*, marks the

possibility of a peculiarly brutal reflection on race and class division, yet these considerations—central to films such as *Amores perros*—are, finally, a ruse for the display of the inner turmoil of its protagonists, their misery, their joy, their sacrificial longings. Likewise, there is no acting in his third film, *Silent Light*, just pained faces from which below lurks the depth of an internal struggle. No writing, one imagines: there is very little dialogue and a skeleton of a plot. No directing: the camera happens upon scenes of domestic life (uncomfortable and intimate, accidentally captured), the guilt of a husband, the pain of a wife betrayed, a cinematic world or a world made cinema.

The gentle film centers on a Plautdietsch-speaking Mennonite community in northern Mexico, and on the turmoil of Johan, who, against the law of God, has fallen in love with Marianne, a woman not his wife. The film allows itself to encounter, as if by accident, the struggle of a husband and his wife (Esther), members of a peripheral community in Mexico, neither indigenous nor Hispanic, and certainly not mestizo. They are something for which Mexico has never had a name.

The selection of a non–Spanish speaking community serves to highlight the turn of cinema away from language and also to underline cinema's capacity to show us beautiful things without teaching us, without, finally, edifying us as a people. Such would be something like what I want to call a posthegemonic cinema: it cannot serve the reason of the social bond in the way that has usually authorized Mexican cinema. The film convokes a different and more uncertain community. It presents not its appropriation of history nor its prescriptions for the future, but, rather, this present, the present of its viewing as a bearing-witness to its constant miracle. It draws its public through the very contingency of its realization toward a novel experience that proposes no particular end. We arrive at an encounter with cinema then, with the world, through this film, the accident of a sunrise, of children bathing, and of resurrection.

Like anyone, I am tempted to read the film as a function of its inhabitation of a marginally Mexican scene; that is to say, I am tempted to at least consider a Mexicanist or post-Mexicanist reading.[54] What would or could the Mexicanist tradition say about this film? If *Japón* evoked a violent, Rulfian world, and *Battle in Heaven*, the race and class tensions of the contemporary Mexican cityscape, *Silent Light* deals with matters that would hope to at least seem unexpected in this context: the personal trials of an Anabaptist sect, speakers of an insular Germanic language,

and their material surroundings—their houses, shops, and clinics—not of Mexico nor precisely of our present. Its peculiar displacements, its air of mystery would seem to, then, index a certain anxiety regarding the post-Mexican moment: what can or should be the object of representation in the Mexican arts once its grounding desire and reason are no longer credible, when that very desire and even its transgression is boring. Thus, one might be tempted to speak of alternative communities, or marginal communities, or of a kind of turn to multiculturalism, as a way of locating the object of *Silent Light*. Such a thinking would, however, still serve to reground the work in its guild-bound duty to the region, to Mexico. Rather, *Silent Light* returns the flicker of the cinema to itself, the only community, as it were, convoked around its light, bearing witness in silence to the miracle of cinema in cinematic representation, to the light that inscribes it and which it exscribes and projects.

The film, indeed, contains an unexpected miniature cinema: at some point, when Johan and Marianne steal away for their final tryst, the children seem to have disappeared. The spectator and the protagonist both are led to a dodgy van. The door slides open, and one expects to find—in a key similar to Reygadas's previous films—scenes of rape or murder. Instead, the children, and now, soon, Johan as well, delight, along with their would-be killer, in the glowing screen upon which pass the black-and-white scenes of a performance by Jacques Brel.

The object of cinema is made visible through a burning, through an originary photo-graphic imprint; light burns itself into a filmic surface to capture the visual field wherever, whenever, the camera is placed. As Akira Mizuta Lippit has put it: "Cinefaction . . . a visuality that moves away from view, a cinema and one that burns away from view, cinders. Bound by the secret homonym and visuality formed from two romanized classical prefixes, cine . . . To cinefy: to make move, to make cinema and to incinerate, to reduce to ashes."[55]

Fernando Solanas and Octavio Getino, in what they proposed to be Latin America's *only* cinema, set out in 1968, as the goal of a Third Cinema, such a "cinefaction," a making-ash as cinema's true object: fire and ash, the cinefaction of alienated man (from whose ashes will rise the new man, who will stoke the fires that burn alienated man).[56] Despite all the differences of epoch and tenor, of political ethos and aesthetic form, I must claim the same desire for *Silent Light*—a burning and resurrection, the ash of Latin America's original endeavor. "Now life begins for us," as Mikkel says to the newly resurrected Inger at the end of Dreyer's

FIGURE 4.4

*Still from **La hora de los hornos**, dir. Fernando Solanas and Octavio Getino, 1968.*

Ordet, the film that haunts *Silent Light* at every turn. Circular and self-generating, this logic forms a kind of narrative loop that suggests the shape and function of the cinematic reel itself.

Silent Light begins with a gorgeous time-lapse shot of the sunrise. Is this the silent light that records the film and that the film also records; is this the light that it is? Like *Rojo amanecer*, it continues to a scene of the family breakfast table at which sit Johan, Esther, and their seven children. The sound of cornflakes in milk, a ticking clock, of plates being placed in the sink. Esther leaves Johan alone at the kitchen table, and he stands at a chair and winds a clock only slightly out of the reach of the camera's frame. Here, through the avoidance of any identification between its gaze and that of its seeming protagonist, the film stresses its nature as a kind of accidental contemplation. In a citation of *Ordet* and also an echo of the opening and closing sequences of *Rojo amanecer*, Johan is setting a clock that seems to have stopped. This image will be cited again near the film's end, when, at Esther's wake, Johan's father winds the clock. But here, much earlier, at the film's beginning, Johan returns to his seat at the table and brutally weeps, the sound of his sobs linked to the distant lowing of cattle.

Through such spare and gentle scenes, *Silent Light* develops the minimal narrative of a love triangle and the impossible decision that faces its

protagonist. After their final encounter, a leaf falls from the hotel ceiling to the bed where they lie, and Johan and Marianne decide to end their romance. However, Esther's pain over Johan's infidelities apparently breaks her heart: she dies in the rain, on the side of a road. At her funeral, the supposed miracle occurs: Marianne kisses Esther on the lips; Esther sheds a single tear (the remainder of the rain) and returns from the dead.[57]

Despite and through this narrative, the film seems to center on the display of tactile relations: a devastating kiss between Johan and Marianne; the scene of Johan washing his children's hair as they bathe and swim; Marianne's kiss upon the dead Esther's lips that occasions her resurrection; Marianne's embrace, her reaching up, as Niessen convincingly suggests, "not to protect her eyes but rather to touch the light."[58] Each image, each touch, divides duty and joy, forcing a decision that is also a certain sacrifice.[59] As Niessen puts it: "Even though it remains explicitly ambiguous whether the film at all points offers a mere representation of religious people, or itself bears in its diegesis the mark of a transcendent and/or pantheistic god, it by all means is a moral (but nonmoralizing) story centering on religious themes of guilt, forgiveness, and ultimately self-sacrifice, first by Esther and then by Marianne, who, by undoing time, gives up her 'perfect man,' as she called Johan earlier."[60]

The question for this film is thus not the turn or re-turn Mexicanist desire, of its sovereign cultural ethos, but, rather, of the turn and re-turn of the global, signified here (not as a certain tradition of Latin Americanist film criticism would have it) by the precisely nonuniversal spheres of consumption and inequality that haunt the so-called cosmopolitan Latin American and Mexican cinema, but, rather, by the sphere, perhaps even literally understood, of the true universe and universality: our turning earth.[61] That turn or re-turn of the world as such, documented in the film by the irreducible figure of night becoming day and day becoming night brackets the work. Cinema thus more generally achieves once more its radical secularization, purging from itself the representative mechanisms that tie it still to certain religious theatricality and rite; more punctually, a Mexican cinema here radically secularizes itself in the face of its former apparatus of capture and political instrumentalization, understood as the "Mexican Office."

In light of a 1990 exhibition at the Metropolitan Museum of Art (*Mexico: Splendors of Thirty Centuries*), Roger Bartra notes that Mexico has long faced the political interregnum that has by now appeared as a symptom in the realm of the visual. Writes Bartra: "Just as there is a Di-

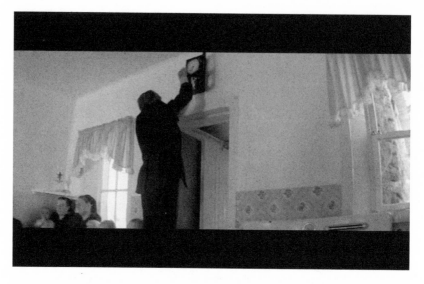

FIGURE 4.5
Still from **Silent Light**, *dir. Carlos Reygadas, 2007.*

FIGURE 4.6
Still from **Silent Light**, *dir. Carlos Reygadas, 2007.*

vine Office that marks off the hours of the canonical day with prayers, psalms, and hymns, so there is a Mexican Office that marks off the days of the nation according to officially established canons. There is a Mexican Office that sings and tells of the national splendors. The Mexican Office is the 'official culture' that stamps its *nihil obstat* on the works of time. That Mexican Office is what decrees that Mexico has been re-splendent for Thirty Centuries."[62] Eschewing this long-held demand,

cinema becomes what it is: a material light, the matter of the universal, and yet powerfully desutured from the material of its former power as dispensed in the practices and institutions of the Mexican Office.[63]

Unlike *Ordet*, the faith of Reygadas's protagonists is never in question; it is, rather, their relation to the law of God that grounds their community, which is uncertain, another division between duty and joy. Shortly before the miraculous event at Esther's funeral, Marianne and Johan stand together outside, in the light. Johan tells her he only wants to return, to go back to how things were before (before their affair, before Esther died of a broken heart, we imagine, but also to the moment of indecision); but perhaps thinking of the clock that Anders stops and pushes forward at the end of *Ordet*, the clock that persists in *Rojo amanecer*, Marianne tells Johan: "That is the only thing we cannot do." There is a freedom to transgress everything but time. She reaches up to block the sun but also, to sustain Niessen's insight, to touch its light with her hand, like the leaf falling or like the rain in which Esther dies, a peculiarly pagan imbrication of the natural world and ours, of the universe itself and the closed Anabaptist sect—another eternal gesture, as Monsiváis might have put it, "plenitude of the unfinished."[64]

This light: we will see it again following Esther's resurrection, when the film produces, seemingly against its own law, a kind of return to the place in which it began. Closing on another time-lapse sequence, a long contemplation of the sunset, the lens of the camera is forced to recede from the Mennonite village to return to the place from which it began. As the lens documents the recession of the sun, the way in which the sun begins to no longer touch our eye, the cattle begin to low (and we must imagine, though we cannot hear what we are too far away to hear, that Johan has once again begun to weep, for his cries are linked to those of the cows). The end of cinema, which we must understand as the end of that thing called Mexican cinema as well, is no longer brought together by the images it projects; we are left alone in the darkness, to feel our way back to the light.

Fons's *Rojo amanecer*, on the other hand, violently releases us back to the place of the archive, when, as I note above, the boy-survivor walks into the light of day. He is yet consigned to the archive; his survival will be meek, limited, duty-bound to that place, which, Fons's film suggests, is always our place. Before continuing to burrow out from that archive in the final chapter, I will, in the next, consider the consequences once more of having conferred upon the archive the capacity to authorize cultural and political renewal.

LITERARY RESTORATION

*Other peoples have found a means for changing their former enemies
after their death into guardians, friends and benefactors.*

SIGMUND FREUD

In this chapter I take as my point of departure the relative lack of a
contender for the title "novel of '68" in Mexico. For certain readers this
claim itself will seem highly polemical, so I will endeavor to qualify this
designation of lack. Here I will argue that Jorge Volpi's 2003 *El fin de la
locura* constitutes the final writing of such a novel to appear some de-
cades after the events of 1968. I will explore the double renewal pursued
by Volpi's work, understood both as an intended restoration of the liter-
ary to a place of social privilege after a period of decline and as a con-
servative restoration of sovereign power following the shriveling of the
national-popular state in the neoliberal era and the decline of the rev-
olutionary sequences of the twentieth century. Badiou's conception of
this restoration orients what follows, for as he puts it, "every restoration
is horrified by thought and loves only opinions; especially the dominant
opinion."[1] *El fin de la locura* finds, however, that it cannot commit to ar-
tistic renewal without also confirming the madness of the century, as
it were.

Volpi's novel thus forges the future of the return to 1968 as the site of
an experiment in social being and hypothetical politics that is necessary
today; the literary renewal pursued in such texts thus is contingent upon
the very political renewal that Volpi sought to avoid. Politics therefore
returns immaterially, accidentally: a return to what was set aside both by
the original repression at Tlatelolco and in the subsequent cultural dis-
course of its representation. So too, its appropriation of the historical se-
quence of the 1960s brings the work intimately close to the very crisis of
the literary in Latin America.

This very symptom is repeated in the body of criticism and might partially explain the delayed arrived of a "novel of '68." Luis Leal studies the literary expression of grief and concludes with a peculiar suggestion regarding the literary power of revelation: "The literature of Tlatelolco *revealed* that the ideals of the revolution, so strongly defended by the party in power, had become empty."[2] However, this emptiness is, indeed, not revealed by the literary representation of trauma, but by the confrontation in the summer of 1968 between police power and radical politics on the streets of Mexico City. And an accidental return to that confrontation and to our present's responsibility to that confrontation—and not grief, and not lament—is what is at stake in Volpi's attempt at a renewal of the literary through the writing of a novel of 1968.[3]

Paco Ignacio Taibo II begins *'68*, a memoir in which he recalls his involvement in and continued fidelity to the Mexican student-popular movement, with a dedication to two friends that encapsulates the problems of thinking and remembering events that have lasting personal and political consequences: "This book, which I am never going to get right, is for my very close friend Guillermo Fernández, because without a doubt his memory is better than mine; it is also for Óscar Moreno, whose memory must have been loaned to him, because on the day that tanks rolled into Ciudad Universitaria he had not yet been born."[4] From the beginning, Taibo asserts the uncertain and impossible nature of the task of remembering and, more important, of doing justice to that memory. He describes the book as one "which I am never going to get right," a sentiment—for one would be at pains to name it an anxiety, given the tone and attitude of the book—that Taibo consistently allows to surface. He dedicates the book to two people, to memory and to postmemory, as if this dual dedication were an amulet to ward off forgetting, oblivion, and appropriation. To Guillermo Fernández he grants memory (a better memory than that of the author) of the events recalled here; he is the faithful repository. And to Óscar Moreno he assigns the perhaps even more delicate task of so-called postmemory, the future of the archive.[5]

Taibo closes one of the memoir's first chapters (itself a list of questions of fact regarding what happened in 1968) with a clear articulation of the demand that guides political struggle in the aftermath of 1968, the irruption of the very secret that mere reflection on Tlatelolco cannot disclose: "Where did they throw our dead? Where did they toss our dead? Where, for fuck's sake, did they throw our dead?"[6] Here Taibo refers to the material body of the movement, gone missing, in some hidden crypt, another secret archive yet to be revealed.

The author has given the book's chapters anachronistically descriptive names, evoking titles such as those one finds heading the chapters of picaresque novels. The titles' descriptiveness indeed suggests the picaresque tendencies of '68 (and perhaps also of 1968). The first of these reiterates the dedication's "This book, which I am never going to get right" reading: "Wherein It Is Explained That with Stuff Like This I Could Never Write a Novel."[7] These statements intimate a resignation that haunts the book, an imperfect book that could not have been a novel and exists, thus, as a kind of half-forgotten memoir, or as fodder for future borrowed memories. It is this opening of the right to remember, of the right to a legacy, that for Taibo permits 1968 to remain as an event that holds the potential of a radical emancipatory politics despite the fact that its memory is merely borrowed.

This call is issued, again, from the beginning, to Óscar Moreno, the borrower of memory, the dedication to whom partially nullifies a certain understandable, but nevertheless frequently authoritarian, privileging of firsthand experience.[8] Taibo at once unleashes the legacy. In a way, to be sure, such is the mechanism through which he ensures that 1968 will never be finished. For Taibo, 1968 can never be a kind of dead history as long as the future continues to borrow it.

Yet the legacy is closed to a certain kind of representation, by which I mean the (now-broken) prohibition on 1968's novelistic formalization. One should not write a novel about such a thing, and yet, Taibo *has* written a novel, which, to be sure, will never come off well. In Taibo's immediate, indeed, simultaneous breaking of the very prohibition with which he set out, he rebels against the consecration of 1968 to which his own prohibition has contributed. That is to say, the fear of writing about 1968, the fear of committing some injustice in the narration, is the very fear that secures it as a limited object of reverence and thus assures the obscurity of its legacy. '68 is thus also a peculiar kind of will, bequeathing, in advance, a legacy to a generation that needs that legacy. It is, in other words, highly significant that Taibo's late gesture emerged in the years of the notoriously corrupt neoliberal presidency of Carlos Salinas de Gortari, who, as I explain in chapter 4, famously strove to patronize intellectuals and artists (as reflected, to be sure, in *El fin de la locura*). Indeed, Deborah Cohn provides a wonderfully economical description of this relation: "Former President Carlos Salinas (1988–1994) in particular capitalized upon the ties linking intellectuals and the State by cultivating a coterie of intellectuals who would accompany him on his travels

and by fostering good will by setting up a system of grants supporting artistic activity."[9]

Taibo recalls for us once more the Benjamin of "On the Concept of History": "Articulating the past historically does not mean recognizing it 'the way it really was.' It means appropriating a memory as it flashes up at a moment of danger."[10] Taibo resurrects this memory in a dangerous time, to serve as a reminder of an insurgent possibility, which he traces from the past into the present. Indeed, in a chapter titled "In Which We Return to the Idea of Ghosts and Their Persistence in Time," Taibo speaks of 1968's peculiar, unexpected persistence: 123 days become the model for "popular resistance" during twenty years.[11] And now, many years later, the old folks from the Revolution continue to see one another in encounters that sometimes inspire hope. But sometimes they recall defeat. Thus, Taibo concludes the memoir: "And then I realize that we seem doomed to remain ghosts of 68. Well, what's so bad about that? I ask myself: better to be Draculas of resistance than PRIist monsters of Frankenstein, or of modernity. And then the keys produce graceless sparks, weak flares, memories that are sometimes painful but most of the time raise a slight smile; and I long for that old spirit of laughter; I mourn, growing fearful of the dark, for an intensity now lost, for that feeling of immortality, for that other me of that never-ending year."[12] To be a Dracula, an immortal but also a ghost, lost in the interminability of a year—but what of those Frankenstein's monsters? What of the monstrous creations of the mad scientists (or technocrats) against whom the interminability of the year must be protected? Or, to put the question otherwise, does the novelization of 1968 portend precisely its termination, its final mortality?

This opening of the legacy (or bequeathing of the inheritance) is, in part, what I wish to address here by reading Volpi's *El fin de la locura*, a narrative reflection on the passage from the '60s to the fall of the Soviet Union, and thus on the decline of the utopian desires of the twentieth century. Volpi, like Óscar Moreno, must have a kind of borrowed memory, for he was born in 1968. Yet while he accepts this inheritance, he breaks one of its executor's laws by writing 1968's novel and thus establishing himself as a Frankenstein's monster to Taibo's Dracula.

I will argue that it is, in fact, Jorge Volpi who spends this inheritance—against the previous holders' desires—on the writing of a forbidden novel, a novel that does not *want* to enter being. I once more recall that phrase from early in Taibo's memoir: "with Stuff Like This I Could

Never Write a Novel," or as he recalls the already failed attempt: "I never was able to write that novel [about 1968]. It's probably a novel that does not want to be written."[13]

It nevertheless seems curious to think that a writer like Volpi—given his age and generation—might be the first writer of the novel of 1968. To be sure, there are other novels about 1968 that we should certainly consider here. For example, Luis Spota published *La plaza,* a kind of fictionalized narrative of what was known about 1968, in the early 1970s.[14] In its incorporation of other materials and voices, it slightly recalls the more masterly and formally experimental—and more politically engaged—book of testimonies *La noche de Tlatelolco,* by Poniatowska, studied in chapter 3. One thinks also of the novelized prison writings of Luis González de Alba and José Revueltas.[15] Of the two, *Los días y los años* is more concerned with the narration of 1968, while *El apando* is a more experimental piece that attempts to evoke the experience of incarceration.[16] Both men were imprisoned in Mexico City's Lecumberri Palace, today the Archivo General de la Nación, a coincidence that eerily draws out the relation between the book, the archive, and the prison.[17] An example of a quite different order than these other texts, given its much later publication and more indirect relation to 1968, Héctor Aguilar Camín's political thriller *La guerra de Galio* exhibits the spectral habitation by those events.[18] Indeed, as Sara Sefchovich notes: "Nearly 30 books were published in the 15 years immediately following the event and with the most diverse narrative tendencies and ideological positions."[19] These books belong to distinct genres and political currents and touch the question of 1968 or Tlatelolco—Sefchovich does not distinguish between the two terms—with varying degrees of directness.

In my estimation, none of these texts, both for their years of appearance and also for the desire, common to almost all of them, to tell some part of the history of those times, to bear witness to something that passed, marks the history of 1968 from within the framework of the global repression and conservative restoration of which the violence at Tlatelolco is a spectacular illustration; none of these texts bears witness to 1968 in its inauguration of the present order. Volpi's objective and perhaps technocratic judgment of the era (and his failure to effectively render that judgment), I suggest, makes visible our present's relation to those times. My discussion here will thus explore Volpi's novel as a kind of archive that captures 1968 and commits it to obscurity by committing it to the transition to which we must link it today. However, the novel it-

self cancels the judgment it imposes and opens itself to the possibility of confirming the very madness that it ostensibly condemns. In this way, too, the novel narrates the problem of our moment: we cannot sever our political possibilities from the horizon of the 1960s, and thus the restoration cannot conclude its task.

· At the same time, while the abovementioned novels, like Volpi's, all seem to betray a core archival impulse, Volpi's novel returns to the tradition of the great totalizing novels in a fashion unavailable to other potential novels of 1968. It is this particular "anachronism" that I think is at stake, for *El fin de la locura* commits the writing of a novel of 1968, *as* final writing, as a *"fin,"* and writing of ends and finalities, some twenty-five years after the original events of 1968. To echo Andrea Revueltas and Philippe Cheron, no one has written the novel of '68—not even José Revueltas.[20] And that is in part because Revueltas could not abandon himself to that *fin*.

My intention here is thus to understand Volpi's novel as a belated literature of Tlatelolco, which arrived intempestively, and with a sense of failure regarding revolt, as Horacio Legrás puts it in the context of the novel of the Mexican Revolution.[21] It was first necessary, perhaps, to bequeath this legacy, as Taibo did, and, more important, to bequeath it to an heir that would rebel against its previous holder.

Concerning the journey of Aníbal Quevedo, a Mexican psychoanalyst residing in Paris who gradually joins and ultimately betrays the revolutionary sequence of the 1960s, *El fin de la locura* tracks its narrator's Quixotic misadventures, tracing his involvement in, among other events, the Paris student movement, the Cuban Revolution, Chile under Popular Unity, and Mexico under Salinas. Indeed, the Cervantes intertext is completely overdetermined vis-à-vis *El fin de la locura*; in addition to his "Dulcinea," Claire, Quevedo relies upon his "Sancho Panza," Josefina, and publishes with the Rocinante imprint. Along the way, he crosses paths with illustrious intellectuals—Michel Foucault, Jacques Lacan, Roland Barthes, and Louis Althusser—as well as political figures like Fidel Castro, Salvador Allende, Subcomandante Marcos, and Mexican president Carlos Salinas de Gortari. Seduced first by the possibilities of the sixties-era Left, and particularly by the events of 1968 in Paris and Mexico City, Quevedo ultimately ends his journey in disgrace when it is revealed that he has become corrupted by the Salinas regime. He is found dead, an apparent suicide. It is, indeed, what seems to be his suicide note with which the novel begins. This note also intimates that the

novel is not quite simply a novel, but a collection, an archive, comprising diverse materials—diaries, letters, interviews, and book reviews—that bear witness to his life.[22]

Roughly the first half of *El fin de la locura* occurs in Paris. It begins with the events of May 1968. The emergence of the Mexican student movement, as well as its sacrifice at Tlatelolco, on the other hand, is largely absent from the narrative. Rather, Quevedo reads of these events in a Paris café and takes these occurrences as the sign of his future struggle: "Tlatelolco baptized me."[23] Yet despite its relatively allusive appearance, Tlatelolco serves as perhaps the most significant of many events in a Quixotic journey that drives its protagonist toward the madness of the century. An image travels from Mexico and becomes the sign that organizes Quevedo's future. If, on one level, Tlatelolco produces the protagonist's political subjectivization, then, formally, Tlatelolco opens and organizes the narrative disenchantment of this subjectivity, that is, *transition*, turning on the decline of the Mexican state's national-popular form and its reconfiguration in the neoliberal era. Tlatelolco serves, indeed, as a narrative point of departure, as partial impetus for the titular "*locura*," the event of reading that drives the protagonist mad. This Tlatelolco-image arrives as something like the inversion of the image of the "Marianne de Mai" in González de Alba's *Los días y los años* that Gareth Williams understands as evental in the Derridean sense, and not merely because it inverts the territorial lines (taking the form Mexico-to-Paris, rather than the Paris-to-Mexico directionality we find in González de Alba).[24] Rather, it confirms Quevedo's political longings as narcissistic, founded upon his melodramatic decision in favor of loss.

The second half of the novel takes place in Mexico, where Quevedo becomes a prominent intellectual, serving the revolution by other means, in particular, though the publication of a journal, *Tal Cual*, modeled on the French *Tel Quel*. Says Quevedo: "Like Barthes, I also feel profoundly disenchanted toward the revolution; however, unlike him, it seems to me its task has shifted to the world of contemporary art."[25] Over the course of his time in Mexico, the reader finds confirmed not only Quevedo's unethical approach to his personal life—he apparently abandoned his wife and young daughter to go to Paris in 1967—but also his involvement with Salinas, whom he serves as analyst, which in turn provokes the scandal that threatens to unleash itself and destroy him: "Now I have to decide what must be done: ally myself with him and thus betray myself, or resist his wrath until the end."[26]

In short, by linking the desires of the 1960s to a host of other, more

obscure, phenomena through the figure of Quevedo, Volpi's novel advances a solution that the state perhaps could not (particularly in light of the international pressure that the Olympics presented), thereby seeming to let the madness run its course into political-cultural obscurity and condemning much of the legacy of that madness to a similar obscurity. In other words, the novel integrates the memory of the sixties into a long and cynical story of decline.

It is worth noting that *El fin de la locura* is the second installment of Volpi's trilogy on the twentieth century. Across the three novels, Volpi traces the crisis of our modernity, from the Second World War (*En busca de Klingsor*), to the struggles of the sixties and the legacies thereof (*El fin de la locura*), to the global era (*No será la tierra*). If *En busca de Klingsor* shook things up by proving that there could be a Latin American literature that did not authorize itself in the name of the local—by no means an original feat, despite its having been received as such in some quarters—then the second novel performs something of a self-conscious return home, not only casting the Latin American sixties as a central moment of this crisis, but also placing 1968 as signal event. *No será la tierra* continues this reflection, documenting the end of the socialist bloc and the turn to a global order that characterized the world in which, perhaps until quite recently, we seemed to be living.[27]

En busca de Klingsor won the 1999 Premio Biblioteca Breve from the Spanish publishing house Seix Barral, which was associated with building the renown and reputation of the Spanish American literary Boom. Indeed, *Klingsor* "reinaugurated" the prize, which had not been awarded since the early seventies.[28]

El fin de la locura saw a more modest success, however. The novel, like the other texts in the trilogy, is perhaps most notable for its transmission of "knowledge" to the reader.[29] While the pedagogical dimension of this attitude shares much with the Boom novels, its precise terms, that is, the very suggestion of a "novel of ideas" is, as Domínguez Michael has noted, straight out of Umberto Eco: the best that middlebrow literature has to offer.[30] Domínguez Michael considers such features to indicate an attempted renewal of the novel as form; it will once more be an intelligent *and* commercially successful genre.

Such a desire for novelistic renovation and renewal also recommends that we approach Volpi's production and, in particular, the novel discussed here, *El fin de la locura*, as bearing a certain trace that constantly refers it to the sixties—for reasons simultaneously literary, political, and, perhaps even autobiographical—for again 1968 marks the year of Volpi's

birth as well as the period of the novel's perceived decline in Latin America. In this regard, the Crack Generation's principal intervention, the "Crack Manifesto," originally published in 1996 and the subject of not a little controversy and resentment, may well be an important antecedent to Volpi's more recent sixties-based novel.

TRANSITION AND CONTINUITY

In the mid-nineties, closely following the implementation of the North American Free Trade Agreement (NAFTA), the confirmation of a transition long under way toward a neoliberal present (understood as the decline of the national-popular state in favor of the understanding that, as David Harvey puts it, "the social good will be maximized by maximizing the reach and frequency of market transactions") a group of young writers exploded on the scene with a "crack!"[31] However, theirs was not the crack that signifies cleaving, snapping off, or rupture, but, rather, the onomatopoeia that follows the Spanish American literary Boom, understood as the confluence of aesthetic experimentation, international success, and leftist political sympathies that characterizes a certain group of Spanish American writers in the 1960s.[32] Theirs is less an ethos of rupture than of transition and continuity. As Eloy Urroz puts it: "There is, therefore, no rupture, but rather continuity."[33]

Danny J. Anderson notes an initial filiation between the Crack and the Boom, citing the way in which "Volpi's novels construct complex systems of interrelations as did the *novelas totalizantes* of the 1960s."[34] In much the same vein, Burkhard Pohl insightfully illuminates the extent to which we might aver a comparison between the "Crack Manifesto" and Boom-era authors' capacity to generate their own myth: "At a poetological level, the spirit of continuity with and similarity to the Boom shines, especially in the affinities between the Crack Manifesto and the manifesto-essay *La nueva narrativa hispanoamericana* (1969) by Carlos Fuentes. From the perspective of an interpretation of literary modernity that takes Agustín Yáñez as founder of the new Mexican narrative . . . both texts attribute greater importance to linguistic renewal, i.e., the 'resurrection of lost language' [and] the 'opening to discourse.'"[35] Pohl adds to these points in common Carlos Fuentes's acceptance of the Crack Generation as a kind of heir to his generation's literary and cultural legacy.[36]

The Crack Generation (Ignacio Padilla, Jorge Volpi, Eloy Urroz, Pe-

dro Ángel Palou, and Ricardo Chávez-Castañeda) opted for an aes-
thetic form widely, if equivocally, already believed to be on the wane
at the time of the manifesto's publication, near the end of the twenti-
eth century. In this sense, they stand—or can understand themselves—
as guardians of a tradition. Yet there remains a certain anachronism in
the adoption of this tradition, which suggests a drive to protect and pre-
serve literary production in light of the crises that affront it, primar-
ily but not exclusively its perceived irrelevance to the political and social
fields that once invested the literary with such prestige. This crisis in lit-
erary value, in turn, finds its historical correspondence to the crisis of the
national-popular state form that once valorized cultural investment as a
means of social and economic equality. Under the moniker of Crack, the
literary becomes strategically redefined in its relation to both the realm
of economic necessity—the material conditions of cultural production—
and the social world in which it appears. This becomes necessary for the
late *renewal* of literature's cultural authority following the period dur-
ing which it had become unmoored from what critic Brett Levinson
has described as its "modern function." As Levinson forcefully suggests:
"When we cannot distinguish 'literature as intervention' from 'litera-
ture as conservation,' when aesthetic innovation, revolt, disturbance, and
difference represent entrances into the market, into the Same, literature
ceases both to sustain and disrupt the social dichotomies upon which the
globe banks and thus concludes its modern function."[37] Indeed, as Ryan
Long has noted, Mexican novelists, particularly following 1968, have
found it increasingly difficult or perhaps unnecessary to address a now
disarticulated (if always phantasmal) national-popular subject.[38] Never-
theless, the literary maintains a certain social prestige, at least insofar as
it retains the capacity for articulating the parameters of the social field, a
power that manifests itself, above all, in a literary maintenance or recon-
stitution of class, which serves in Mexico to secure the middle classes as
a decreasingly economic and increasingly sociocultural bulwark in an in-
tensely class-divided Mexican social field. The literary offers the (cul-
tural) capital necessary to keep the middle classes afloat.

"Sevilla me mata" (Seville is killing me), Roberto Bolaño's planned
intervention at Seix Barral's by-now infamous Primer Encuentro de Se-
villa, offers a devious thesis on the historical emergence of contempo-
rary Latin American literature, that is, the emergence of the generation
whose writers count themselves among the Crack Generation, the pro-
ponents of McOndo, and so on, which has usually been enunciated in a
highly self-laudatory fashion. A footnote in a book collecting the acts of

the meeting, bearing the geographical title *Palabra de América*, clarifies that Bolaño did not have occasion to finish the planned text before the meeting and instead read a different text, "Los mitos de Cthulhu." Given the confrontational nature of the piece, whose title nearly accuses the meeting of homicide, it may well be that the planned text could never have been finished in time to be read at the meeting, for it would have introduced far too much disagreement into the proceedings. Here literature comes off as abject matter, as curious symbolic economy seeking to establish itself or reestablish itself in light of its new situation: "We come from the middle class or from a more or less established proletariat or from families of second-rate drug traffickers who no longer wish for bullet wounds but respectability. The key word is respectability."[39]

Bolaño's characteristically cutting remark is directed at those writers who seek respectability, that is, those writers who seek to transform literature's marginalized position into one that, despite lower circulation, enjoys greater symbolic value. It might thus be said that where Urroz sees in high literature's fallen status, in its lack of circulation, a confirmation of its continued existence as high literature, Bolaño—arguably the greatest Latin American writer since Borges—has intentionally engaged this debasement of the literary as project. That is to say, his novels stand as an example of a literary work that resists the work of transition, that finds neither aesthetic refuge nor justification in anachronistically pursuing the modern task of Latin American literature.[40] Indeed, here he casts literature as work in the strongest sense, as labor *and* as aesthetic endeavor. Bolaño seems to suggest that writers like the Crack novelists are much more middlebrow than perhaps they let on and that their occasional pretensions to innovation are more an effort to assure that literature can continue to provide to the reader (and, of course, the writer) an elevated *symbolic* social space (and, occasionally one hopes, a lucrative career).

The most prominent signatory to the Crack Manifesto remains Volpi. After the manifesto and the movement it inaugurates, it is left for Volpi's writing to fulfill the transitional task proper to the moment (perhaps no longer our present, but, rather, the prologue to our present crisis) between the waning of the cultural-political energies of the sixties and the peculiarly bellicose postpolitical formations of recent years. By this I mean not that his writing represents an aesthetic innovation over that of those who have narrated the Mexican transition since the Salinas presidency, nor that previous attempts have not done so. Rather, I mean that Volpi's writing, beyond its narrative thematization of transition, is in ef-

fect an agent of that transition, here understood not only as the long politico-economic transition from the national-popular ethos that characterized the Cárdenas period and the times of the Mexican Miracle to the neoliberal present that began in the 1980s and continues to characterize our own moment. Rather, I also intend to invoke a different, but related, shift characterized by what Alain Badiou has called the "restoration" that characterizes the last twenty years of the twentieth century: "a restoration is never anything other than a moment in history that declares revolutions to be both abominable and impossible."[41]

In reading Volpi's *El fin de la locura*, I will explore the text's narrative annexation of a particular political sequence associated with the sixties as the project of an attempted renewal of the literary in neoliberal times by linking narrative to the project of restoration. Volpi's work buries this sequence, by which I mean May of '68, the Cuban Revolution, Chile under Popular Unity, and, most of all, 1968 in Mexico. It is the final, novelistic appropriation of this sequence, I suggest, that hopes to ultimately process and *finish* the events of the sixties and liberate the present from the burden of the past.

Volpi's novel narrates not only a history of radical political fervor toward the end of the century but also, more obliquely, the political transition of Mexico from a national-popular state to a neoliberal order centered on the liberation of both the "voter" and the market economy (the free market along with "free elections"). However, this narration takes place only in the most elusive fashion. That is, while the obsessions of the novel are world-historical in nature, pertaining as they do to the decline of utopian dreams, the post-1968 Left, the rise of theory, and so on, the text holds to Mexican history as an uneasy and uneven backdrop. By way of this backdrop, which constantly moves to the fore, the novel narrates Tlatelolco not as horror or injustice, but now as the "baptismal" moment of a transition. Put otherwise, the novel's wager is that Tlatelolco can be narrated today by narrating transition. Rather than narrating the local effects of the tragedy, as has been the tradition, the novel takes up the world-historical sequence that Tlatelolco forecasts, that is, the turn to a "restoration" on Badiou's terms.

ART, POLITICS, CLOSURE

If the events of 1968 in Mexico stand as a certain but by no means decisive limit to the Mexican state's capacity to furnish its own conditions of

possibility by the means through which it had traditionally secured its domination—above all, its historical alliance with the collective subject designated by the national-popular state—Volpi's text transforms this limit into a kind of rebirth, an appropriation required under transitional times. Literature's condition of renewal in this sense depends upon its rhetorical separation not from the political but, more particularly, from a seemingly outdated emancipatory politics that corresponds to, inhabits, opposes, and is circumscribed by an outmoded state form. Moreover, the emancipation of writing from the Spanish American Boom and its perceived political commitments—the national-popular state, solidarity with Cuba, and so on—is achieved by way of assuring the post-sixties' and post-seventies' place of literature, securing a place for literature after the Boom or, more generally, after the decline of its "modern function."

The Mexican state reached a point of crisis in the catastrophic moment of violence at Tlatelolco by exhausting its capacity to narrate both foundational violence and the everyday forms of violence through which it administered society. The very extreme nature of the act not only contributed to discrediting the state's claim on the representation of a popular sovereignty that legitimated its highly undemocratic nature but also hindered its capacity to endorse the narratives that had long held together, more or less well, Mexico's deeply divided social field. Volpi's novel, perversely, settles accounts with the excesses of Díaz Ordaz and Echeverría by declaring the entire emancipatory sequence that ended in the sixties pathological, a madness that is fully recognizable by the novel's historical endpoint, in 1989, with the opening to neoliberal transition and the fall of the socialist bloc. Put otherwise, Volpi's text reedits history: the instant at Tlatelolco, and the student-popular movement that it evokes, are reintegrated into a long narrative about the decline not only of the Left as such but also of the larger, cynical narrative into which Volpi inscribes the generalized madness of an epoch, of an entire century, perhaps. Here the Mexican century begins with the Revolution and peaks under Cárdenas; the entire emancipatory desire of the twentieth century is linked in the supposed disaster that Volpi's trilogy explores. A single narrative emerges from the last century, and it is not a hopeful one.

El fin de la locura incorporates a series of interventions, interruptions, and appearances by intellectuals, mostly from France, whose thought has transformed literary studies, philosophy, and political thought since the late sixties. Volpi's biography might partially explain a fascination

with such figures. François Cusset writes of Mexico and its special relationship with "French theory" as "the first Spanish-speaking country to begin spreading French structuralism."[42] After noting the thesis that Rafael Guillén (Subcomandante Marcos) wrote on Althusser and Foucault, Cusset goes on to declare that Volpi's novel is the "first fictional saga dedicated to French theory."[43] Volpi, indeed, was the cultural attaché in France and directed the Instituto de México in Paris for some years. He also wrote part of this novel in residence at Emory University, that is, in a scholarly milieu bearing some historical association to so-called French theory.

Of course, such an explanation is only a partial and anecdotal one. My suggestion is, rather, that this incorporation of theoretical discourse, as oblique and indirect as it must, finally, be—for theory is made present mostly as biography or anecdote—is essentially analogous to the text's appropriation and condemnation of the legacy of the sixties. Theory enters the unfolding of the literary and can hold no distance from it. Its avatars serve as talismans that ward off theoretical speculation.

The novel achieves a certain kind of closure by conjuring and then domesticating these specters. On the one hand, the narrative presence of these thinkers seems to make superfluous the theoretical speculation that might make use of the novel, that might uncover the peculiarly commonsense ethos that underlies it. Thinkers' inclusion as fictionalized characters evokes the possible readings of the text that any future critic might aver and thus tacitly embeds these readings in a substratum of the text. The novel, indeed, begins with a kind of self-disavowal, perhaps customary or pro forma in many regards: "This book is a work of fiction. Any similarity to reality is the fault of the latter."[44] In this sense, the novel invites the reader to disregard the gravity of the matters traversed in its unfolding.

The reading I offer, I feel, is already given in advance, mocked by the novel it desires to understand. The work's deployment of these names, in particular, those of Althusser and Foucault, also, by inference, suggests or implicates the carceral hopelessness with which the novel imbues any future emancipatory politics, not to mention the possibility of a speculative reading, which is not to say that the novel endorses this notion.[45]

Both Althusser and Foucault might be popularly described as thinkers of strikingly closed fields, conceived as "ideology" in the former case and as "discipline" in the later. It is worth noting that the selection of figures that appear in the novel—Foucault, Althusser, and Lacan, in

particular—is peculiar, for they are all more or less thinkers rather hostile to the kind of humanist freedom-without-axiom characteristic of the (neo)liberal tradition into which Volpi's text inscribes itself. Yet at the same time, they serve as figures—in the popular appropriation of their thought—of the very hopelessness of our present situation. The novel's condemnation of the sixties, in effect, the denial that things could be other than they are, seems to be embedded in the text's critical references in a way that I would like to explore further here.

One possible way of understanding the text's narrative surface, then—the story of Aníbal Quevedo, which, to be sure, thematizes the story of the Left itself—would be to read in it the narrative of a gradual realization that, despite naïve militant fantasies, there is no outside to power, to ideology, and so on, and thus, finally, there is virtually no ground for resistance or exteriority to power. In other words, through a superficial reception of critical thought, the novel rejects politics because there *is* politics.

From this perspective, theory appears as a certain violence toward the truth of art, just as politics appears as a pathological disturbance of the good order. Volpi knows about theory and evokes the names of authors but is strikingly uninterested in witnessing the theorization of the work. It might be, especially in light of the narrative thrust toward a decline of the militant Left, that this appropriation of theoretical discourse turns on the symbolic closure of interpretive disagreement and, thus, is a form of consensual thought. Following the philosopher Jacques Rancière, who does not appear in the novel (although his teacher, Althusser, does), "disagreement," a structuring principle for politics' organization as a politics proper, has been effectively undermined in the tendency toward consensual thinking that presages, finally, the neoliberal present. In other words, a consensual thought attends neoliberalization.[46] In its hasty condemnation of so-called madness, understood as theoretical speculation or as political experimentation, Volpi's book organizes a "policing." For Rancière, "police" logic is one form of our being together: "Politics is generally seen as the set of procedures whereby the aggregation and consent of collectivities is achieved, the organization of powers, the distribution of places and roles, and the systems for legitimizing this distribution." However, for Rancière, this is not a politics deserving of that name. Rather, he continues, "I propose to give this system of distribution and legitimation another name. I propose to call it *the police*."[47]

Volpi's work thus does not link itself to politics, properly under-

stood—understood that is, on terms Rancière would endorse. As Rancière puts it: "I now propose to reserve the term *politics* for an extremely determined activity antagonistic to policing . . . Political activity is whatever shifts a body from the place assigned to it or changes a place's destination."[48] Or as Badiou puts it in terms that are surprisingly complementary: "Every restoration is horrified by thought and loves only opinions; especially the dominant opinion."[49] There is a sense in which Volpi's extensive encounter with philosophy and theory aims at a reassertion of the literary as a privileged space for thought in Latin America over against the superfluity of theoretical speculation in order to restore the literary author to a traditional place of prestige as an agent in what, on Rancière's terms, would be the police logic of our being (and reading) together.

Thus the crucial point of the novel's intervention, not only in its farcical account of literary theory but also in the policing of the possible linking of art and politics proper, comes about with reference to the Padilla affair.[50] The novel integrates the crisis into which literature enters globally as well as regionally, with both the rise of theory and the crushing of leftist movements, and it does so by revisiting the event that did much to found the Latin American (or, perhaps, Latin Americanist) narrative of that crisis. It serves as a kind of turning point and also presages Quevedo's gradual return to Mexico. Quevedo finds himself in Cuba, where he has followed Claire, his militant and idealized French lover (Claire, the unconfused, the clear idea or sound, *claire*). During this stay, he acts as psychoanalyst to Castro, who turns him into a kind of prisoner of the Cuban Revolution. At the end of his stay, before departing with Castro and Claire to accompany the Cuban leader on his legendary state visit to Allende's Chile, he and Claire hold a lengthy and heated discussion of the Padilla affair and its implications for a Left literary politics.[51] From a corner of the Sierra Maestra, the two stage the positions of what for Volpi will be the fundamental intellectual postures after 1968: "bootlicker" (*lamesuelas*) and "conspirator" (*conjurado*).[52]

In this case, Quevedo seems to adopt the position that will eventually make him a *lamesuelas*, while Claire, the *conjurada*, continues to adopt the postures of the Cuban Revolution uncritically. "Padilla is a counterrevolutionary," she tells him. "Everyone knows . . . And now he has recognized it himself."[53] When Quevedo speaks of the public condemnation of Padilla's treatment by many intellectuals, Claire counters that "it's all because of the plot promoted by Padilla . . . That is why Cortá-

zar and García Márquez disapproved of the publication [of the manifesto protesting his mistreatment]."[54] Their disagreement leads to a kind of withdrawal and, ultimately, to a pathologization of Claire's politics: "Like so many young people of the epoch, she remained hypnotized by the *comandante*."[55]

During the weeks before their departure for Chile, the two try not to argue. They finally attempt a reconciliation. Quevedo declares to Claire that he doubts his capacity to commit himself to armed struggle; he finally states his inability to practice a kind of militant activist fidelity, already portended. For earlier in the novel, in the midst of a hunger strike, Quevedo consumes a kilo of petits fours, thus confirming a poseurish relation to radical politics heretofore only intimated: "I committed no infraction against the cause, but rather simply surrendered to the unbreakable laws of survival."[56]

With this scene, Volpi foreshadows Quevedo's betrayal, a constitutive and necessary betrayal, founded, as it is, on an impossible commitment to the radical Left of the sixties. However, before considering this betrayal as a prologue to the conservative restoration, it is worth commenting on the irony of Quevedo's succumbing to the "laws of survival" in a novel whose very conditions of possibility are supposed to reside in the death of its protagonist.[57]

Without the protagonist's death, no archive. Yet, even if no death will occur as a result of the hunger strike, the reader needs this death to be deferred until the novel can unfold for a duration that is sufficient to allow for the retroactive reading that renders this episode particularly pathetic. Quevedo's death is thus peculiarly foreshadowed, peculiarly because, to be sure, the novel materially bears witness to his death, being itself always the posthumous archive of his life.

In Cuba, Quevedo expresses his desire to serve revolution by other means, which are at the time known only to him: "I finally understood what I had to do: write like Lacan and like Althusser, like Barthes and like Foucault. If I did not dare tell Claire, it was because to be a writer in Cuba in those times meant identifying with the enemies of the revolution. It was then that chance diverted our paths."[58]

Quevedo's decision suggests that the failures of the sixties and seventies to achieve something like a radical emancipatory future is owed not to insufficient action but to an insufficient thought, that is, the failure to think and, in the place of thought, an insistence on action. What, then, is the nature of the thought that once had the potential to rescue us from thoughtless action?[59]

RENUNCIATION AND RENEWAL

In *Discipline and Punish*, Foucault advances the concept of the carceral network as a defining feature of modernity. The concept of modernity he offers is thus one of tendential totalization, one of a visual and spatial field of complete saturation of its logic, a system that "has neither exterior nor gap."[60] For Foucault, the subject is the object of the multiple movements of this nonexteriority: "The carceral network, in its compact or disseminated forms, with its systems of insertion, distribution, surveillance, observation, has been the greatest support, in modern society, of the normalizing power."[61] Modernity multiplies its own conditions of possibility, "its systems," for the rule of the social. Such forces cohere in what Foucault calls the "carceral city," enclosing the subject in "a multiple network of elements—walls, space, institution, rules, discourse."[62] "Our society," he writes, responding to Guy Debord, "is not one of spectacle, but of surveillance," for, he explains, "under the surface of images, one invests in depth."[63]

In turn, toward the end of an essay on Foucault, Derrida evokes the rather Hegelian thought-image of the spiral: "It is the spirit of this spiral that keeps one in suspense, holding one's breath—and thus keeps one alive."[64] This spiral is figured as the drive for power or power/pleasure, which is without principle in the sense of initiation or genesis. Pleasure without principle is an-archic or an-archival ("*a-principial*," as Moreiras might put it).[65] Paz was right, despite himself.[66]

This spiral might otherwise be figured as the turning back on itself of will or antagonism, which is here characterized as pleasurable. The power of the living body is invested in movement, in a spiraling textuality or narrativity, understood as the moment proper to the dialectic: we await its unfolding, and that waiting is pleasurable; we survive and live on in that waiting.

Along related lines, Foucault writes: "Now it is over life, through its *unfolding*, that power establishes its domination; death is power's limit, the moment that escapes it; death becomes that most secret aspect of existence, the most private."[67] Power, according to this perspective, is *fundamentally* biopolitical: power over life. Such power invests bodies; it does not merely colonize them. There is no biopolitical secret, only the secret kept from life, which is death. As a regime in fear of its own limit, death cannot be known, for it is modernity's master, the power over power itself (the end of power, in a vulgar reading, the end of politics). This, finally, seems to be the vulgar nihilist lesson that Volpi takes

from Foucault, in my view, mistakenly, which codes the meaning of the death that organizes the novel, to which I will turn shortly.

First, however, it is notable that such a death is symptomatically inscribed in Volpi's earlier essay, an intellectual history of 1968. Published thirty years after the year it studies, *La imaginación y el poder* seems to be a kind of preparatory gesture in advance of the writing of *El fin de a locura*. In this compendious tome, a master's thesis written at UNAM and later published by Era, Volpi sifts through the archives of the Mexican cultural supplement to the weekly *¡Siempre!* titled *La Cultura en México*, then edited by Carlos Monsiváis. Volpi's history proposes a certain return to 1968 through a reading of the issues of *La Cultura en México* published in 1968. It is another archive (an archive of an archive).

Here I want to detain myself on the way in which to book closes on a call to free the legacy of 1968, which, in turn, demonstrates a highly symptomatic understanding of the content of this legacy. Writes Volpi: "In the end, the sprit of Tlatelolco will only truly triumph when democracy, tolerance, and justice become, finally, an everyday reality."[68] Out of context, the notion of a "spirit of Tlatelolco," which Volpi wishes to see triumph, that is, the name of a military massacre perpetrated on students and neighbors, would not appear to be democratic, tolerant, or just. The explanation of this most symptomatic name resides in the historical substitution of the struggle for justice and truth in the name of those killed on 2 October 1968, in place of the recovery of the very struggle for which they fought.

This substitution invokes thinking the possibility of the student movement by reflecting on the massacre that ended it, effecting a secondary, discursive repression of the movement that merely follows its desolation at Tlatelolco. It might be said that Volpi's deployment of the word Tlatelolco illuminates how the spirit of Tlatelolco crushes the students and installs its own spirit of democracy, tolerance, and justice, which does not necessarily have much in common with the desires of 1968, but, rather, more with those in each present into which the memory of the massacre reemerges. According to what I have called the *sacrificial* logic of the political, it is death that holds political potential. This base finitude contains the possibility of what never was properly fulfilled, for, according to this rather paranoid or melancholic approach to the political, everything alive can be appropriated. This assertion of the plenitude of extreme finitude is the final meaning of the death upon which Volpi's novel centers.

El fin de la locura arrives to its reader's hands (we are invited to imag-

ine) by way of an archival process of collection, revision, and compilation. Volpi's novel was already in the diaries, letters, notes, and book reviews written by and about its protagonist. In other words, the reader might discern a struggle against authority and authorship in this retelling of the sixties, whose events have long been fixed in a certain historiographical register by the major actors on the Mexican cultural scene. For example, Volpi rather pointedly and, in a mode perhaps best understood today as irony—one hopes—writes of Carlos Fuentes in *La imaginación y el poder* that "after the sixties, Fuentes sees himself not only as a novelist, but as a 'Latin American intellectual.' His historical responsibility is tremendous."[69]

I mention this reference to Fuentes by way of suggesting that *El fin de la locura* breaks with the willful and imposing structure of the earlier form of the totalizing novel, displacing or postponing the kind of authorial will that is evident in, for example, that other novel of ends, of political disillusion, Fuentes's *La muerte de Artemio Cruz*. Yet it also offers us a Volpi who has a tremendous historical responsibility, even if he chooses to exercise that responsibility differently, if no less sovereignly, than Fuentes did. Here the reassignment of Volpi the author as Volpi the mere compiler suggests the author's experiment in self-concealment, which again discloses the authorial anxiety of giving something away: the text's fear, its contempt for its own manifestation as a historical symptom redoubles under Volpi's formal resistance to signing the novel as his. This, given the novel's hostile engagement with critical theory, betrays, most of all, a horror that the reader will begin to excavate the text's symptomatic investments, which is even more unsettling in times when the very function of literature is in question and under scrutiny. For all of these reasons, Volpi's work opens onto a kind of pseudo-self-analysis to be carried out within the text's unfolding beforehand, that is, before the text is read and discussed from outside it by a reader. This self-analysis results in a contradictory demonstration of something like a critique that coextends the cultural object itself. The thinking of the object remains entirely within the object, for *El fin de la locura* comes to us already digested, thought through, interpreted. It is the archive of something already existing, the anthology presented to us by our humble editor: Jorge Volpi. And yet is this gesture not inscribed somehow in every text I have so far discussed?[70]

To recall once more Volpi's expansive novel in a few words: the protagonist trains with Lacan and serves as psychoanalyst to Fidel Castro and then Carlos Salinas, for which he falls prey to scandal. As this

rough outline probably suggests, the novel cannot but perform the literary task of neoliberal transition, that is, of transforming the sixties and, more particularly, 1968 into the matter of Mexico's recent political and economic transitions, even as it endeavors to disentangle itself from the stitches between literature and any effective political commitment. This is so not because 1968 itself implements the neoliberal era. Rather, the image of Tlatelolco epically undermines the national-popular imaginary that Mexican state form had earlier exploited. At the same time, the unpolitical liberation of desire often ascribed to the student movement in its aftermath frequently links itself to the flexibilization and casualization characteristic of the present mode of production.[71]

In this spirit, *El fin de la locura* also traces a kind of denial of the very transitional task it performs and, indeed, quite unexpectedly closes on the demand for intransigence in transitional times. Again, this staging of both transition and the countervailing desire (however denigrated) to maintain the ruptural nature of the sixties constitutes for Mexican literature the final arrival of the "novel of '68."

As I note above, the novel begins with an entry closer to our present day, an epistolary prologue. Dated 10 November 1989—the day on which the Berlin Wall begins to fall and thus the symbolic beginning of the end of the socialist bloc—the note lacks a named addressee (we will later learn that it is directed to Claire). It begins with a peculiar solicitation of forgiveness and concludes on the promise of a violent settling of accounts: "Perhaps it's time to return to sanity."[72] The letter to which this prologue is responding appears at the end of the novel and confirms its status as Quevedo's last public words. In the letter, Claire declares a radical commitment to madness, that is, revolutionary utopias, even as that madness begins to look exactly like pathological insanity and can no longer be justified in the name of now seemingly discredited collective projects: from Mexico's national-popular state, to the Cuban Revolution, to the 1968 rebellions, to Allende's Chile and beyond. The lines that close her letter, and thus the novel, intimate the gravity of the betrayal for which Quevedo seeks pardon: "I am the crazy one, the violent one, the rebel, remember? I hear voices. I am always at war. And I never give up. Sorry, Aníbal: unlike you, I will not renounce madness."[73]

Yet Quevedo's own final renunciation (much like Volpi's authorial cynicism) betrays its contradictory nature: he was never a militant. In a novel that holds militancy up to examination and treats it with some disdain, the most ridiculed figure of that militancy has not acted in a fashion that would properly earn him this judgment. The burial of the radi-

cal Left is thus carried out on a metonymic figure of that Left who was *not* an honest participant in its project, just as its settling of accounts with critical theory has not taken on a theorist, but an imposter. Put in the terms the novel itself establishes, if Tlatelolco served as a kind of baptism, it was insufficient. Quevedo has already betrayed the political positions that Volpi would have him exemplify, and that treasonous suspension has kept 1968 alive, perhaps even despite Volpi's intentions. For Volpi, indeed, the political itself must be conceived of as a kind of betrayal, and we should confirm this suspicion. As Volpi writes elsewhere: "In a country built on the notion that a single party or a single individual should dominate the entirety of the social sphere, not many options remain for intellectuals."[74]

The system is closed, carceral. Mexico's ruling party was generally capable—with few exceptions—of producing a constituted power that successfully appropriated and effectively eliminated its outside. In turn, Volpi's desire to avoid this appropriation by imagining a kind of autonomous sphere for the intellectual and artist is, once again, notably articulated in the Crack Manifesto that marks his early, generic return to the sixties. This much-maligned and occasionally admired text attempts to safeguard a post-1968 space for something like the ambitious and intellectually adventurous novel. By tracing this return, Volpi and his comrades are tallying the unpayable debt to the past, which, because it is unpayable, becomes the legacy that must be renounced. The dead reside in the realm beyond their appropriation, now beyond the reach of the state, and so, too, their legacy.

The resolution of Volpi's novel centers on the final condemnation of Claire's politics as a pathology, while Quevedo's suicide provides a peculiarly ethical act of self-cancellation (as the cancellation of a relation between intellectuals and power). This death-politics, an impoverished form of the political, transforms itself into a form of militancy.[75] That is to say, it becomes a novel form of fidelity to 1968: Quevedo dies to join the ghosts of 1968 and thus to redeem his betrayal of them and also to confirm his betrayal of the author in whose book he appears. The novel's resolution, indeed, appears as an act of extreme violence, which, symbolically, repeats Tlatelolco. That is, the suicide that the protagonist pledges to commit in the letter that begins the novel refers to the death he missed at Tlatelolco. Indeed, the two letters that serve as the novel's narrative bookends intimate a possible withdrawal from or renewal in self-cancellation that remains open to intellectuals like Quevedo at the end of the madness. The protagonist's implied intended murder of his

militant Dulcinea, Claire, and implied subsequent self-cancellation re-
solve the apparent aporia that remains at the center of the narrative,
namely, how to think an art and a politics that are irreducible to their
appropriation or organization by some form of sovereign power (mili-
tant, populist, neoliberal, or otherwise).

The constant indeterminacy between Left-intellectual corruption that
occurs in the 1980s and a fidelity to the 1960s organizes the novel and
forms its resistance to its own totalizing becoming. Volpi's novel thus
overcomes Paco Ignacio Taibo II's prohibition on the writing of a novel
of 1968—"with Stuff Like This I Could Never Write a Novel"—and
provides support for the narrative transformation of Tlatelolco into the
state's renewal, however cosmetic, in the neoliberal era. Yet, this support
dramatically betrays itself in a gesture that we should identify as Volpi's
own narrative self-cancellation. Given the conviction of the note on
which the novel ends—the certitude of this note is Claire's certitude—it
would seem that the text also voids this baptism and, finally, condemns
those like Quevedo or, more strongly, writers like Volpi who try to efface
the so-called madness of the century—our utopian desire—by recasting
it as base criminality.

From the perspective of this reading—against the grain to be sure—
the novel reaffirms Quevedo's "Tlatelolco me bautizó" and keeps Claire's
intransigence as last words. The novel—Volpi's novel but also, I hope,
the novel in the generic sense—is redeemed, unexpectedly, and so is
1968, as an active politics. Literature is renewed by virtue of its own ges-
ture toward a past from which it cannot break, from its own responsibil-
ity to a past that it has yet to inherit. And this past is not so much the re-
turn of the novelist as a cultural-political authority as the return of the
novel as the site of a necessary and accidental political inscription. Volpi,
because he has no other choice, it seems, does justice to 1968, confirming
its madness as the very condition of art and of politics. Quevedo is con-
demned to die to atone for his betrayal and in this death renews the very
legacy that the novel threatens to appropriate.

I shall conclude my discussion of *El fin de la locura* in the following,
more Benjaminian, mode. Much is at stake in Volpi's ambitious novel,
which, finally, seems to be convinced, as we must be, that 1968's incorpo-
ration, denial, or destruction by its enemies will not only diffuse political
potential, but will also kill again the dead that the name 1968 remembers
and the hope this name projects.[76] The novel, finally, cannot so easily
dismiss the twentieth century's madness, cannot so readily cede the six-
ties, as they are the grounds that organize the possibility of both literary

and political renewal, that, indeed, *vouchsafe*—not merely as archive, but as theoretical practice—an emancipatory future. The two characters and their exaggerated division become mere alibis for Volpi's celebration of the hegemonizing impulse within the literary and then for its betrayal. What is needed now, what Volpi's gesture ultimately points to, is politics against such an impulse. Or an infrapolitics "that refuses to totalize the political as its own sphere of action."[77]

In this spirit, I will turn now to an an-archival, an-archaeological thinking of 1968.

AN-ARCHAEOLOGIES OF 1968

*Xaltelolco (shal-teh-LOHL-coh). Former name of Tlatelolco;
lit., "mountain of sand."*

SALVADOR NOVO

ENFRAMING THE EVENT

A partition, conceptual or real, painted or sculpted, is a line. Lines are, for example, drawn on a map, sketched onto a plan or survey (think of the peculiarly straight lines of Africa), and enforced by our fantasies that the etchings that took place elsewhere, above, and before us, must take effect here and now for us. Lines are forged in a sculpture—think of the border walls that are erected even today to divide a destiny in the Americas. The years that pass form a timeline, a past in reference to the "here" of the present, opening, with anticipation, over there, onto the future. The traveler's itinerary, likewise, is a line. We trace and are traced, our movements from here to there, rendered by Google to orient our direction and grant efficiency to our displacements. And our cities traced these lines in us long before that in the meanderings of the medina, the A-to-B of the grid. Our bodies, too, are lines (of a kind), a threshold that contains, to my eyes, the matter that constitutes me.

These lines, and others, are explored in the works of Francis Alÿs (b. Antwerp, 1959). Trained as an architect, his first such experiments were often solitary, often taking the shape of sculptural drifts around Mexico City's historic center, where the artist has lived since leaving Belgium to opt out of national military service.[1] A 1997 video, *Paradox of Praxis I*, is often referred to by the "axiom" that organizes it: "A veces el hacer algo no lleva a nada" (Sometimes Making Something Leads To Nothing). The work—truly *work* that, like many of Alÿs's projects, engages cen-

trally the question of labor and endurance—witnesses Alÿs push a large block of ice around Mexico City, leaving an ephemeral liquid trace behind him, a *line* threatened by evaporation. The block melts, and Alÿs kicks along what is at the end a tiny cube. As one critic puts it: "An arduous task has imperceptibly turned into a game."[2] The piece engages the transformation of labor into play (but the work remains irreducible as labor) and then into money (not visible in the video but, rather, as video), as determined by the speculative value of the work wherever its rentable object inheres.

Alÿs's works are thus about lines and are themselves lines, itineraries; they wander, they exact a duration, they achieve their end, however uncertain, provisional. Their object, I will suggest, is an investigation and improvisation of what, today, "the word 'emancipation' means," understood, in the fashion that Jacques Rancière does, as "the blurring of the boundary between those who act and those who look; between individuals and members of a collective body."[3] This blurred boundary, the politics of the line of the work, is traced both formally and thematically in Alÿs's projects. His works do not merely re-present a division that we see everywhere; rather, they reconfigure and redistribute the sensible world before us, turning on the potential political subjectivation of the artist, the world he creates and inhabits, and the spectators who gaze upon such representations. Writes Rancière: "This is what a process of political subjectivation consists in: in the action of uncounted capacities that crack open the unity of the given and the obviousness of the visible, in order to sketch a new topography of the possible."[4]

Perhaps thinking of this will to inscribe a "new topography"— a collective faith in this will—art theorist and frequent Alÿs collaborator Cuauhtémoc Medina describes what is arguably Alÿs's most famous work, *When Faith Moves Mountains* (*Cuando la fe mueve montañas*), which is to be the central focus of my analysis here, in deceptively simple terms: "Maximum effort, minimum result." As we shall soon see, the supposed uselessness of the topographical effort both clarifies and suspends the division between the work of art and work itself.

In order to mount an action whose trace reaches us only through the extensive documentary record, the artist traveled from Mexico City to Lima, where he organized a group of 500 university students to travel to the dunes outside of the city. Writes Benjamin: "In even the most perfect reproduction, *one* thing is lacking: the here and now of the work of art—its unique existence in a particular place."[5] Once there, the students "displaced" one of these dunes by a few centimeters. Armed with shov-

els and wearing t-shirts marking their participation in the project, they formed a line on the bottom of a dune to push the dirt from one side to the other. They succeeded, so to speak, by displacing the dune to an infinitesimal degree.

According to the more or less canonical reading of such artworks, the piece exists to document an action, to produce or reproduce "sociability," a "specific sociability," as art critic Nicolas Bourriaud puts it.[6] A mountain is not moved as such; instead, a kind of "social fiction" is created in which participants are momentarily invited to believe in the effectiveness of their collective action and in so doing are constituted as a temporary community. For Reinaldo Laddaga, such artworks fashion something like "experimental communities" that resemble the general conditions of the world, the social life, out of which they emerge.[7]

According to this line of thought, in *When Faith Moves Mountains*, we encounter a kind of art that establishes a "new subjectivity," a "new community," or a "practicality of the communion."[8] Such works are based on "the generation of 'artificial modes of social life.'"[9] The work as such exists as the contingent moment of collective experience; it cannot be housed in a museum but is lived and told (documented). That is, in such projects persists the question regarding whether the work is located in this documentary record or in something else: the experience, even the thing that is not recorded (for example, as we shall see, the moment at the very end of the action, as one participant recounts on the video that documents the piece that "se perdió," that was lost, that went uncaptured by the camera). In this respect, the work, whatever its object-form, has a tenuous permanence that corresponds to the very contingency of the collectivity that its becoming convokes.

Yet, those who witness and, often unwillingly or unwittingly, contribute to the works of Alÿs are not readers of the work, nor are they its artists in any expected sense of that word. They are part of the larger coordination of the artist; their collaboration (at least in the work I intend to read here) is of a limited nature. I have in mind Grant Kester's critical reading of *When Faith Moves Mountains*, which I will explore further below. Writes Kester: "Although the video includes comments by several (unidentified) student volunteers, Alÿs's installation does little to convey the nature of their participation, or their particular investment in the Sisyphean task that he has assigned them. They have been summoned by Alÿs not as collaborators (that status is reserved for Medina and Ortega), but as bodies to illustrate a 'social allegory' about the inevitable failure of Latin America to successfully modernize."[10]

On the terms identified by Rancière, the works stage and make visible the conceptual and material demarcations of the sensible: "The distribution of the sensible reveals who can have a share in what is common to the community based on what they do and the time and space in which this activity is performed."[11] In this regard, the embodied performance—the interaction between Alÿs, his counterparts, and the surrounding environment—is not the work either. Only through its recording and subsequent mechanical reproduction can the work itself dispose of a space, of a public, and then only as object; Alÿs stages the uncertain and perhaps nearly immaterial return of the art object and of its relation to an emancipatory politics in the present.

The fate of such an emancipatory politics is perhaps best signaled by the very deployment of the word "emancipatory," with its connotation, today, of a vague, groundless freedom, which more and more seems to be conceptually adequate to the neoliberal program. It would not be incorrect to suggest that this name for any future politics—this name without body—might well be rooted in or traced to the epochal beginnings of what Alain Badiou has called our current "resigned surrender." As Badiou puts it: "The mid-1970s saw the beginnings of the ebb of the 'red decade' . . . It finds its subjective form in a resigned surrender, in a return to customs—including electoral customs—deference towards the capitalo-parliamentarian or 'Western' order, and the conviction that to want something better is to want something worse."[12]

I have been tempted to adopt this line of critique, and perhaps of affirmation, of Alÿs's work against a tendency to read in such works a kind of apolitical and consensual "sociability" (how genteel that word!), but without yet affirming a rather more populist critique, such as that of Kester. For its part, Kester's reading of *When Faith Moves Mountains* illuminates its tendency to highlight play, indeterminacy, and futility over commitment, systematicity, and organization. Thus does Kester draw a link between its ethos and the unprogrammatic and perhaps overly romantic politics of May '68. According to the logic of works such as Alÿs's, writes Kester, "'we' can't yet be trusted with the freedom that would result from a total revolution. Instead we must practice this freedom in the virtual space of the text or artwork, supervised by the poet or artist."[13]

I am indeed sympathetic to Kester's concerns regarding *When Faith Moves Mountains*. Even the reader less inclined toward populisms might hesitate before the supposedly radical proposals offered in a piece by one of the world's most prominent plastic artists, represented by one of

the world's most powerful galleries (David Zwirner). Yet, here I follow Claire Bishop's call for the need, despite Kester, to "discuss, analyse and compare this work critically as *art*."[14] In other words, I aim here to occupy a middle position in which the artwork is read politically in light of its symbolic potentials. As I cite above, "[The volunteers] have been summoned by Alÿs not as collaborators (that status is reserved for Medina and Ortega), but as bodies to illustrate a 'social allegory' about the inevitable failure of Latin America to successfully modernize."[15] However, it is my sense that the work is much more equivocal and speculative than Kester or, more important, Alÿs imagine. To honor that intuition, in the pages that follow I hope to reactivate the work as the site of a politics, of a certain possibility that there will be a politics that deserves that name, by moving through a series of gestures which, like the artwork they concern, might appear to be largely preparatory. After these preliminary reflections, I will discuss an early attempt by Alÿs to explore 1968 in the plastic arts. Then I will offer a brief history of the archival display to which 1968 has been submitted in recent years, because my speculation here concerns, above all, pushing to its limit the relation that Kester draws between Alÿs's work and 1968. I will then turn to the scenes of rehearsal and of labor topoi and topographies of the arts today, contextualizing these lines of Alÿs's production. Finally, I will return to the question of faith as a substitute for a politics and as a politics itself.

All are, again, provisional gestures, for my speculation here advances the following thesis: any politics of art that we can call politics—again, a politics of emancipation deserving of that name and which gives meaning to the signifier emancipation—must address the time of practice (rehearsal) and waiting (whether it be programmatic or playful), for art is not politics, nor is politics art. The artwork on which I focus here, again, Alÿs's epic project from 2002, *When Faith Moves Mountains*, centers on such a finitude, maintains such a temporal distinction, an orientation toward the future, an attachment to that which is to come that is central to its functioning. The artistic present is a moment set aside for waiting, a time for practice, rehearsal, and staging for a future that will be properly political.

To be sure, this perspective is intentionally vulnerable to assignment to the category of thought that Bruno Bosteels has placed under the heading of "speculative leftism," which I embrace at least provisionally. Writes Bosteels, here thinking of communism as a signifier deployed by Nancy: "The future of communism will not be given over to the pure

self-immanence of the people as people; instead, it belongs to the core of all future politics, according to the temporality of what is yet to come, to be marked by the radical finitude of each and every community."[16] In this key, *When Faith Moves Mountains* is also about the idea of political faith in a future becoming, perhaps here forged in the experience of a past political sequence that has not yet passed, which, again, Kester rightly associates with the year 1968, though I will suggest that he is correct in a fashion that he perhaps did not intend.

Without adopting Bosteels's term, Kester casts *When Faith Moves Mountains* as the working out of something like speculative leftism in its most unproductive form, by way of inscribing it in a certain post-'68 mode:

> Here we find echoes of Schiller's skepticism and one of the key linkages between the post-structuralist theoretical tradition and early modern aesthetic philosophy: political action or change here-and-now is intrinsically futile. Existing systems of power and resistance to power are so corrupt, so inhumane, so irredeemably compromised, that one must reject any accommodation with, or proximity to, them. The only possible way to move forward and to retain the purity and integrity of the revolutionary message, is to work indirectly, via the insulating protection of ancillary, quasi-autonomous, institutions (the arts, higher education), to develop covert, subversive "interventions" in the cultural sphere, which will reproduce the contagion logic of the street action at the level of the individual reader, viewer, or student.[17]

Indeed, as I argue in chapter 5, this is the judgment that Volpi (to be sure, not a militant, ally, or even fellow traveler of the radical Left) seems to pronounce upon Aníbal Quevedo, at least until the character becomes irredeemably corrupted. Yet before that, Quevedo is identified with a certain speculative leftism, and of the worst kind: "Like Barthes, I also feel profoundly disenchanted toward the revolution, however, unlike him, it seems to me its task has shifted to the world of contemporary art."[18] As Volpi's Quevedo suggests, the figure of the speculative leftist seems historically linked to the problem of May '68.[19]

Indeed, although I find the term "speculative leftist" a bit too pugnacious, I will adopt Bosteels's terminology and perhaps extend it, for, as he puts it, speculative leftism potentially revitalizes communism. That is, despite what he calls its "maddening" desires and drives (or, rather,

its resistances), speculative leftism keeps communism alive. It is the moment of suspension and self-resistance within communism and also of resistance to its fully communist inscription.[20]

Yet a reading of Alÿs within such a speculative current would perhaps be more convincing if we were to consider *When Faith Moves Mountains* in relation to the 1968 to which the piece is much closer, that is, Mexico, 1968 not as logics of failed revolt, to borrow Peter Starr's phrase, but of a doubly defeated revolt (defeated in its moment, defeated in its representation).[21] That failure is not taken for granted in *When Faith Move Mountains*, but, rather, forms the core of its critical exploration. The piece offers an artistic working-out of our thinking of 1968, and also of our action. Rather than reading the work as a depoliticizing or pseudo-political action, I suggest we read it as the repoliticizing re-presentation of Mexico, 1968 in its unbearable contingency.

To be sure, the work begins with a necessary displacement, from Mexico to Peru. Such a displacement reflects the nearly global character of the student rebellions. And yet at the same time it offers the geographical spacing correlative to the temporal spacing that has been necessary to reconsider 1968, stripping from it a certain melodramatic proximity or melancholic familiarity. The structure of the work, placing, as it does, students from the city in noncontact with working-class people from outside, ironically reworks the desired popular articulation of the student-*popular* movement. And perhaps most significant, the nature of the action documented inverts the archival, archaeological procedure of the 1968 canon. There is no digging up, no unearthing, no fealty sworn to the authority of archival consignation, just movement along the line as an-archaeological action, thought, and politics.[22]

PATRIOTIC STORIES

In October of 2007, Mexico City witnessed the opening of the Centro Cultural Universitario Tlatelolco in the former buildings of the Secretaría de Relaciones Exteriores, right off the Plaza de las Tres Culturas at the Nonoalco Tlatelolco Apartments. The center comprises four projects: an area in which seminars and conferences are given; the Colección Andrés Blaisten, which displays modern Mexican art; a section that is dedicated to offering computational, linguistic, and artistic instruction to the inhabitants of the neighborhood; and a space that commemorates the student-popular movement of 1968, the Memorial del 68.[23] This last

is an archive of 1968 that appears in the space set aside, left unfinished, left open—or blasted away—by those who survived and in accordance with, once more, the "archontic principle of the archive," "the takeover of the archive by the brothers," "the equality and liberty of brothers."[24] It not only recalls the legacy of 1968 (and not merely in its defeat) but also reestablishes and extends that legacy through creating, once more, hopes of relations between middle-class students and the popular sector, public dialogue, and a space for beauty that is not a mere refuge, but a site of social intervention: "The memorial does not intend to be the forum of a definite [definitive] version of the great movement that shook the country, but to make the visitor a part of a collective and individual memory exercise that will place him in the threshold of a personal truth."[25] That is, there is an exercise here, perhaps something like a ritual, a kind of memory that is not only remembered but also created. The memorial, in other words, does not remember, it creates memories, perhaps along the lines that Paco Ignacio Taibo II suggests when he writes of the borrowed memory of Óscar Moreno, to whom, in part, he dedicates '68.[26] Here the spectator inhabits memory and even undertakes a physical traversal that constitutes itself as a kind of memory whose goal is to create stories, to not become an end to the storytelling as the definite or definitive story, but to begin the telling of stories: "a part of a collective and individual memory exercise."

But why does this "collective and individual memory exercise" open only "onto the threshold of a personal truth" and not also onto some kind of collective truth? Indeed, can there be collective truth today, or only individual truth, founded, despite it all, in collective action? Perhaps this is the end to which Marcelino Perelló points in one of the testimonial videos on display in the memorial: there are *sparks* of a collective truth, he notes, but that world has ended. The great revolution, as the site of a possible grand collective truth, as the only hope for achieving such a collective truth—this has ended. The still permanence of the light, but only in sparks, not embers—but the sparks that flash, in tentative return in the construction of a space to traverse and a gathering to politicize it.

Alÿs's earlier and more direct exploration of 1968, *Cuentos patrióticos* (1997), is on display in the Memorial del 68. Despite the curatorial text's suggestion that the work is metaphorical, I would prefer to reserve that term for a piece like *When Faith Moves Mountains*. I might suggest that we locate *Cuentos patrióticos* among the series of more or less direct reenactments that Alÿs has explored throughout his career.[27] Indeed, it

FIGURE 6.1

Francis Alÿs, **Cuentos patrióticos**, *Mexico City, 1997. In collaboration with Rafael Ortega, video documentation of an action, 25 minutes 35 seconds, film still.*

FIGURE 6.2

Francis Alÿs, **Cuentos patrióticos**, *Mexico City, 1997. In collaboration with Rafael Ortega, video documentation of an action, 25 minutes 35 seconds, film still.*

would probably not be off the mark to consider *When Faith Moves Mountains* a sort of bridge, or even the site of an indecision, between metaphor and reenactment, while *Cuentos patrióticos* is rather more referential and situated.

Its disposition in the Memorial del 68 serves to highlight this referentiality. The museum space is organized in a more or less chronological fashion, beginning with a hall for the period 1958–1968, which serves to contextualize both globally and nationally the emergence of the student movement. A timeline with photographs depicting global highlights of this history runs the length of one wall (usually one photograph for each month), while the other wall charts more punctual and particular questions: the relation of counterculture, literature, art, and the Mexican economic "miracle," which had among its outcomes the construction of a larger middle class, Mexico's hosting of the Olympics, and the construction of the Conjunto Urbano Nonoalco Tlatelolco, which now stand only meters away from the Memorial del 68. And yet before any of this is a cavelike antechamber in which two screens play images from the '60s (many of them psychedelic) while music (the Doors, et al.) plays at such a volume that it can be heard throughout much of the museum.

The next hall introduces the high point of the student movement, running from its emergence in late July to just before Díaz Ordaz's threatening Informe Presidencial of 1 September. The last phase of the movement opens onto the lower level of the museum, a striking spatial metaphor for what many perceive to be the decline of the movement. Here, below, the museum depicts the Díaz Ordaz speech, the Silent March, which was conceived as a kind of response to the speech, the late negotiations, the massacre, and the imprisonments that followed the opening of the Olympic Games. The museumgoer then returns to the upper level, where the exhibition seems to tilt toward a kind of optimistic narrative (though far from exclusively so) regarding the continuity of struggle in the aftermath of 1968.

The placement of the Alÿs piece is notable, for the museum is composed almost entirely of photographs, explanatory text, and screens displaying filmed testimonials. The Memorial del 68 thus has yet to escape the purely testimonial mode. Its supposed innovation is that one no longer need read the transcript, but, rather, might come face to face with its televisual reproduction.[28] *Cuentos patrióticos* punctuates the museum's narration of the period from late July through August. Indeed, while watching the edited testimonials regarding the protests and the "acto de desagravio" in a small screening room, the sonic contamina-

tion from the Alÿs piece is unavoidable: the sound of a bell tolling, a reference to the appropriation of the cathedral bell by the students at the 27 August march to and (brief) occupation of the Zócalo. In portraying Alÿs's march—sheep in tow—around the flagpole, the video also refers to the students' other transgression, that of having raised the red-and-black flag where the enormous Mexican tricolor should properly have been. The sheep are themselves a reference to the aftermath, the ceremony of "desagravio" of 28 August, in which the government forced its employees to restore the flag and the supposed sanctity of the Zócalo. The employees, however, bleated like sheep, as Monsiváis puts it: "The bureaucrats hauled into the Zócalo laugh at their own sheep-like condition."[29]

Alÿs's work anticipates his later reflection on reenactments, *Reenactments* (2001) and stands as perhaps a rehearsal for the later reflection on 1968 that he would advance in *When Faith Moves Mountains*. For now, however, it is significant to mention its displacement of the site of the museum from the archaeological mode in which it establishes itself (and in some ways quite literally, for the museum overlooks the site of the excavation of Aztec ruins that forms one of the three cultures at Tlatelolco). Here I want to suggest the beginning of an an-archaeological moment for the reflection on 1968, a reflection that does not limit itself to the voice of the witness, the search for evidence, or even the cynical assertion of our present's continuity with 1968. Instead, Alÿs offers reflection in an infrapolitical register. Delinked from feelings of either triumph or defeat, the toll of the bell expresses some other temporality, caught between 27 and 28 August, undecidable in its relation to rebellion or repression, what James C. Scott might call a "resistance below the line."[30] Or, rather, the piece marks the being-in-common of the demonstration, occupation, and reappropriation of public space that 27 August constitutes, understood as a mode of political expression proper to 1968. And yet, it also reactivates the properly infrapolitical moment of the bureaucrats in their peculiar and perhaps sad expression of (infra)political solidarity with the students, that is, their "foot-dragging" in the face of their masters' demands.[31] That displacement, indeed, opens a new mode of thinking about 1968, no longer as the infinite melodrama of defeat, or as its courageous denial, but, rather, as the undetermined and indeterminate capacity of those assembled to continue their resistance by whatever means are at hand, that is, the properly an-archaeological thinking of 1968.

DISCREPANCY

To recall the formulations offered by Octavio Paz in the more imme-
diate aftermath that forged the student-popular movement's more res-
onant afterimage, the massacre is the site of two illuminations. In life,
the student-popular movement gives the lie to the future-oriented logic
of the revolutionary party-state, whose grounding reason was always
the *eventual* integration and political representation of marginal sub-
jects, the *eventual* modernization of the society and territory falling un-
der its sovereignty, the *eventual* redistribution of land and resources.
For Paz, in death, the movement illuminates the secret of all Mexican
history: not only is Mexico not modern, it is fundamentally premod-
ern, brutal. It transmits not an *eventual* overcoming of the trauma of
conquest, but, rather, a constant living-out of trauma and violence. The
Plaza de las Tres Culturas does not archive the past and forecast the fu-
ture; rather, it serves as the symbolic space of a never-ending reinscrip-
tion of premodern violence throughout and across a succession of essen-
tially aesthetico-historical moments. It is the student movement's crypt
that serves as this archive.

What interests me here is not exactly *what* is illuminated, but the
very structure of the illumination in sacrifice, for "sacrifice is equal to
productive destruction."[32] *Luces de bengala* (flares) fall from the sky and
signal in a singular and guiding light the path that Tlatelolco will illu-
minate in each, determined present of the aftermath of Tlatelolco. Tla-
telolco returns, *flashes up*, is extended and appropriated at the demand of
determined presents. Its grave instant becomes the horizon of social and
political transformation, opening an "age of discrepancy," as it were.

Such is the title of a recent exhibition at UNAM's Museo Universita-
rio de Ciencias y Arte. *La era de la discrepancia*, curated by two of Mex-
ico's major art critics, the late Olivier Debroise and his legatee, Cuauhté-
moc Medina, takes its name from Javier Barros Sierra's 1970 retirement
speech. The exhibition catalogue recalls this famous utterance, itself an
expression of fidelity to 1968, superimposing its text over a photograph
taken during the protest march headed by Barros Sierra himself on 1
August 1968. The appropriation of Barros Sierra's phrase in the title in-
vokes 1968's continuity, its opening onto an era, and thus its persistence
as the site of a possible contestatory politics: "They attack the university
because we differ. Long live discrepancy, for it is the spirit of the univer-
sity. Long live discrepancy, because it allows us to serve."[33] The exhibi-

tion, its curators tell us in their introductory catalogue essay, recuperates a trajectory the nature of which is initially intimated by the exhibition's subtitle, *Arte y cultura visual en México, 1968–1997*. More particularly, *La era de la discrepancia* focuses on a history of Mexican visual culture that was marginalized following the crisis of Mexicanism—the philosophical and aesthetic counterpart to the logic of the Mexican state—in 1968.[34]

Mexicanism, in turn, is the name of the ideology that regulated the dutiful carrying-out of the relation between art and the people that the Mexican state organized until Tlatelolco. At least, so goes the story of *La era de la discrepancia*. Without allowing this chapter to become a study of Mexicanism as such, I will recall only some very disperse and thus, I hope, representative examples. The relation between muralism and the Mexican Revolution, naturally, stands as a persistent reminder of the horizon of the state as the irreducible condition of possibility for any art under the Mexicanist regime of aesthetic production. Such a horizon obtains in the literary field as well; one need only recall how even the rather critical novels of a writer like Carlos Fuentes end up extending, reconstituting, or suturing the failures of the kind of redemptive social totalities posited by the Mexican state as part of its modernizing drive. For Mexicanism, literature becomes the object that instructs or the symptom that proves the perceived existence of a historical state of being or becoming. In such a perspective, art stands as the hysteric before thought, the master.[35] This particular master is called Mexicanism, which consistently was able to recruit the arts to speak the truths of the Mexican state. According to this procedure, one can constantly make art speak the name of Mexico as its truth, as the discontinuous thought, the spirit that haunts and must be revealed by thought. Every work speaks the reality of its present (or the past, when the present is haunted by the past), of its state, of the state. If they are not post-Mexicanist, then they reside in the long, lingering decline of Mexicanism, the moments after a searing revelation of the truth of Mexican history.

If the Mexicanist regime sought aesthetic vessels for the symbolic proliferation of a certain modernity (the modernity promised by the Mexican Revolution), this post-Mexicanist moment for the arts is merely a series of formalizations of the same instant.[36] And unlike the era in which Mexicanism reigned supreme, the works that transmit this moment are unavailable to a final organizing horizon of thought. There is no Mexicanism in them and thus no established way to more or less clearly establish their relation—if one is to be supposed—to politics, to

society, or to history. This simplicity or pureness in the social appearance of these post-Mexican texts is registered at the level of the aesthetic. As we have seen, in *testimonio*, for example, there is—we suppose—no longer the problem of semblance or mimesis that obtains throughout most of literary modernity, simply the transmission of the truth itself, as an intensity, as an affect, to the reader. The truth of the work is constantly unveiled in simple reading. Post-Mexican art has no sphere of reception and is robbed of its hermeneutic tradition; it must create the society that interprets it.[37]

But is there a post-Mexicanist *moment* to speak of? I am not so sure. Post-Mexicanism should best be considered a line of flight away from the name, the crypt, the archive. In Alÿs's work, it runs toward Peru and thus away from the very site of violence, that square upon which Mexico and institutional Mexicanism experiences a strange new vitality.

REHEARSAL-REPETITION-REACTIVATION

Practice and preparation figure as common preoccupations in Alÿs's oeuvre. Indeed, even formally, his works' ends are secondary to a sequence of preparation and planning (that is, process). At times they even engage a certain mockery of ritual, in this case, the contingent, nonreproducible sequence that leads to the final object, toward which Alÿs himself has expressed with some frequency a certain indifference. Each work creates an archive of the preliminary gestures, of the essays and sketches, of the conversations and e-mails, of the accidents that produced it. The finished project always maintains an unfulfilled and arbitrary distance from its process, a line constantly under attack.[38] In turn, the line between the work and life itself is divided and held by the gallery. The work is a line and is about a line. As Luis Camnitzer writes of the period following the high point of sixties-era conceptualism: "By 1970 the art-life merger seemed to have failed, and at that point, art activity started returning to the gallery space."[39] The violence of another line divides the work from its most public appearance yet simultaneously assures, through the mechanisms of a certain kind of public display, the work as art. Several of Alÿs's most well-known projects seem to mourn precisely this return, at the end of a certain conceptualism, by way of exploring this partition between art and world.[40]

In *Reenactments*, one of Alÿs's most widely viewed works, a tall, thin man (Alÿs) has just purchased a gun. He loads it and begins to drift

through the streets of Mexico City's historic center. The gun hangs at his side. Despite the discomfort the weapon causes his fellow pedestrians, the armed ambulation takes place for several minutes before the man is arrested and taken away in a police car. On another screen, the story is repeated, simultaneously, the purchase of the gun, the walk, the arrest, but this time, as reenactment. The two screens run the loops of Alÿs's video, in which we see two versions of one story: a tall, thin man wearing sunglasses enters a store. He selects a pistol, purchases and loads it, and begins a walk through Mexico City. After frightening his fellow pedestrians, he is arrested. A clock appears on the left-hand screen in order to establish the duration of the action and to underline the reenacted nature of what the viewer encounters on the right-hand screen. The conceit of the clock appears to be that only through intentional reenactment can the second screen capture the same series of actions at such a precise interval.

Two screens divide the viewer's experience. Two logics of movement divide the story. On the one hand, *Reenactments* imagines an urban deterritorialization; on the other hand, the piece conspires in (or demonstrates no distance from) the violence of art, making visible the socioeconomic force that conditions the reception and transmission of aesthetic experience. Yet, the work's division between these two screens also makes visible the conditions of reflection on the work, its realization, reproduction, and display. The first, putatively original, action recorded suggests the instantaneousness of presentation itself, pointing to its own insufficient and incomplete nature as the registration of an event and its effects. The second moment, as re-presentation, bears witness to the now infinitely postponed original action, serves as testimony of the actions that unfold on the first screen. The now synchronic nature of the two sequences, in turn, suggests that *Reenactments* imagines the possibility of a faithful resonance between presentation and re-presentation, between documentary and witnessing, which is not to say that the piece in any sense endorses this possibility. Indeed, it should be remembered that the work is not *Reenactment*, but *Reenactments*, plural. The two screens are finally leveled in the title as a pair of reenactments.

To what, then, do these two screens bear witness? What is it that they both reenact? Perhaps the second screen's more obvious form of repetition is a ruse that conceals the reenactment that motivates the work as a whole. This working out of "neoliberal urban violence," this return to "urban practice" turns on the division between origin and reproduction, on an encounter with the site of the work's material event.[41] The ques-

tion of the materiality of the work, of its disposition, its location, its orientation—and only *this* question of the work's materiality, for there are too many such questions to treat comprehensively all of the possible materialities of the work—haunts us in a rather postconceptualist frame. The foregrounding of participatory rites (as I want to call them) effaces the line between production and reception; one does not precede the other, but, rather, they are simultaneous.[42] Whenever there is a work to be received, it is produced again as original, originary, perhaps even auratic or pseudoauratic. Even without the materiality of the work, as work in its material body—which is also acted upon by this simultaneity—the emergence of a "new perceptive behavior," as Oiticica calls it, marks the tendential overcoming of the object and its displacement by the rite. The work is a work, or oeuvre, and is also a play, or *spiel*. Again: "An arduous task has imperceptibly turned into a game."[43] The line of the work symbolizes this imperceptibility, in a sense, makes intelligible the very imperceptibility of the line between the task of the artist and that of the spectator, production and consumption, original and reproduction, work and play. And yet there is nothing particularly notable about any of this today, in a contemporary scene ruled by the transit between such positions. Alÿs's work suggests a return, however: the immaterial reconstitution of a politics of the concept that explores such a separation by way of nonsymbolically annulling the very sociopolitical alienations that constitute and protect the forms of difference that ground the work in the spheres of both production and display. Indeed, the work, as participatory rite, effaces the temporal and spatial lines that maintain such a distinction.

Alÿs's 2005 project, *Sometimes Doing Something Poetic Can Become Political and Sometimes Doing Something Political Can Become Poetic*, a walk carried out in Jerusalem, sees the artist drip green paint along the so-called Green Line that divides Israel from Occupied Palestinian Territory. The painted line underscores the absurdity and also the violence of this separation, which occurred elsewhere and earlier but which is enforced by the Israeli border guards, who watch as the strange figure allows the green paint to rematerialize the name accorded to an imaginary, but effective, line. Mark Godfrey locates the work within the return of historical representation to contemporary artistic production. Calling the work a "re-creation" for, indeed, in this sense it forms another take on the question of "reenactment," Godfrey writes: "Walking through Jerusalem with a leaking can of green paint, Alÿs both ridiculed (by mimicry) the arbitrariness of [Moshe] Dayan's border and resusci-

tated its memory at a moment when even Israelis on the left maintain a dedication to a 'United Jerusalem.'"[44] The "sculptural idea" is in both cases largely "inaccessible" to the observers who witnessed the original action.[45] As we shall see, Alÿs's works turn on this disjunctive state, this line between production and consumption, witnessing and participation ("those who act and those who look," as Rancière would put it), labor and contemplation, politics and nonpolitics.

An early drift, *The Collector* (1991), sees Alÿs drag a small magnetic dog through Mexico City, gathering debris along the way. A slightly later take on the same idea suggests possible grounds (conceptual and topographical) for thinking such projects. His work for the fifth Havana Biennale, *Magnetic Shoes* (1994), reveals the specter at work within these pieces. The project, captured on video, sees the artist traverse the city in the eponymous magnetic shoes; a ghostly collector of the communist remainder's (metallic) residue, Alÿs brings about the figuration of a trace of a past remnant.[46] Writes Rancière: "When art is no more than art, it vanishes."[47] Its existence beyond an art world, as Schiller proposes in an origin story, is the *Urszene* of the aesthetic. "Primitive man," Rancière recalls, "gradually learns to cast an aesthetic gaze on his arms and tools or on his own body, to separate the pleasure of appearance from the functionality of objects . . . the self-education of mankind is its *emancipation* from materiality, as it transforms the world into its own sensorium."[48] Such a gaze converts what is visible into a generalized field of objects for appreciation. What is visible finds itself, under the purview of this gaze, always within a potentially aestheticized topography. Within what Rancière calls the aesthetic regime of the arts, the line between commodity and art object is only ever temporal. The object, such as it is—whether or not there is an "object"—submits itself to this twin face in the same body, whatever its appearance. "Any object" he writes, "can cross the border and repopulate the realm of aesthetic experience."[49]

This thin membrane of the aesthetic sphere is what creates the conditions of avant-gardes. They arrive on the scene to defeat this duality, to suggest the impossible response to the nonautonomy of art, to reclaim or recover, as it were, a "power" for art. Says Rancière: "Whether the quest is for art alone or for emancipation through art, the stage is the same. On this stage, art must tear itself away from the territory of aestheticized life and draw a new borderline, which cannot be crossed." This scene is the site of an "enframing"; the line that cannot be crossed is the frontier between commodity form and art object. From this perspective, Alÿs might be said to pursue a fundamentally worthless artwork whose

use value is not purely aesthetic. The autonomy effect that might be gleaned resides in the vertiginous tension between two heteronomies.[50]

On one side of this line, says Rancière, "the spirit of forms is the logos that weaves its way through its own opacity and the resistance of the materials . . . to become the smile of the statue or the light of the canvas."[51] In this case, the logos of the work presents the highest concentration of its form, basing itself in a chronologically previous ontology of the work that always precedes its material realization. To be sure, this inscription, any inscription (like the ice trace, like footwear penetrated by metallic residues, like the green line, like, as we shall see, the line on the hill that moves the sand), must overcome the medium and the material upon which it acts. The idea or concept arrives with difficulty to achieve its visibility through a mere surface of inscription (a procedure that becomes almost too literal in the work of Alÿs). Such a surface imposes, always, certain limitations (particular to the surface in question— a sidewalk, a dune, a canvas). Crossing this line of resistance imposed by the material, the work achieves visibility; indeed, it has no other way of doing so.

On the other side of this line, writes Rancière, the work "is identified with a pathos that disrupts the forms of doxa, and makes art the inscription of a power that is chaos, radical alterity."[52] From the perspective of logos, the task undertaken by the artwork is a kind of conquest. The work, in its purest moment, must be inscribed. Yet from the perspective of pathos, the work resides in complete disharmony, as much in relation to itself as to the surface upon which it becomes visible. This inscription is always provisional and preserves both the alterity of the material upon which it is inscribed and that of the force that inscribes it. It is not mediated by the form; rather, it is a *spontaneous* link to what is close. That is, each work is a will to inscribe itself despite the recognition of its eventual, impure materialization.

Benjamin begins "The Work of Art in the Age of Its Technological Reproducibility" with a preface that links the essay to a Marxian prophecy, to the future projection of capital's self-abolition [*Abschaffung*]: "When Marx undertook his analysis of the capitalist mode of production, that mode was in its infancy. Marx adopted an approach which gave his investigations prognostic value. Going back to the basic conditions of capitalist production, he presented them in a way which showed what could be expected of capitalism in the future. What could be expected, it emerged, was not only an increasingly harsh exploitation of the proletariat but, ultimately, the creation of conditions which would

make it possible for capitalism to abolish itself."[53] A future unfolding promises the eventual truth of an actualization or reactivation; the logic of *Aktualisiert* is intrinsic to the technique of reproduction.[54] Such a future logic organizes the work's becoming.

FAITH: "THE WORKSHOP AS A WHOLE"

Writes Marx: "The collective working organism is a form of existence of capital."[55] The quotation already features the effacement of the notion of an individuated subject and, further, its collective existence as the mediation of capital. Capital appears insofar as it is mediated through the subject's collective, participatory body.[56] In the sixth chapter of *Capital*, Marx formally forecasts this new kind of body: "instead of being able to sell commodities in which his labor has been objectified, [the possessor of labor-power] must rather be compelled to offer for sale as a commodity that very labor-power which exists only in his living body."[57] Marx describes a process that coextends similar transformations that occur in capitalism qua logic: the body is a vessel in which capital is extended and reproduced.[58] This very act of collective labor, which constitutes the social totality, is now increasingly thought of as an instance which occurs not only in the factory. Under late capital's expansive purview, it is clear that the subject's existence as alienated labor, which is constituted by the (social) mode of production, cannot be thought of as a distinct experience belonging only to its proper spheres and times, and accorded discrete purposes. It is, rather, life itself.

Marx writes: "The knowledge, judgment and will which, even though to a small extent, are exercised by the independent peasant or handicraftsman . . . are faculties now required only for the workshop as a whole . . . the capitalist represents to the individual workers the unity and the will of the whole body of social labor."[59] The body of the worker, from which labor is extracted, is figured as the incarnation of "knowledge, judgment and will." These categories—human attributes, or the attributes that in part designate so far what is "human"—are not left intact by capitalism (according to the Rousseau-inflected line of Marx's thought), as a logic of totalization of the social under the purview of a generalized field of fetishization. In previous, and, for this line of Marx's thought, old-fashioned forms of artisanal labor, the human qualities are not appropriated by labor itself, because labor is still labor in itself. Artisanal labor is not yet fully constituted in service to some broader

cultural-economic logic. In order to make visible such a transition, Marx deploys the image of a singular intelligence and will, which both constructs and commands "the workshop as a whole" or of the "will of the whole body of social labor."

Alÿs's turn to the topography of the dune is not merely a contingent circumstance; there is already something quite artisanal in the fantasy of the dune itself, outside the city, surrounded by neighborhoods of improvised houses that are the residue and the excess of contemporary capital. There is something savage and difficult in the terrain, but at the same time, the material of which it is composed appears smooth, clean, and light. Sand, to be sure, properly disposed, also configures the registration of time, the hourglass but also wind on the dune face. And in this time and place, a line of workers assembles, their social relation, or "sociability," configured by and mediated through the art object that they produce.

In an interview on BBC's *HARDtalk* by Stephen Sackur, broadcast on 24 March 2009, the journalist asks Alain Badiou whether his communism is nothing more than a kind of faith. Rather than granting the refusal one might expect, Badiou's response simply affirms the question: "Faith is a great thing sometimes." *Sometimes*, to be sure: sometimes a faith—faith in the to-come of communism—is a great thing. "Sometimes," said Badiou, in an unintentional echo of the title of one of Alÿs's projects, *Sometimes Doing Something Poetic Can Become Political and Sometimes Doing Something Political Can Become Poetic*. In both cases, action encounters its own temporality, its occasion, its juncture or moment. Such tonalities resonate as well in the "when" of *When Faith Moves Mountains*. The "when" of this faith awaits its effectivity, perhaps not confined to ritual and rehearsal, but as a kind of practice that extends the possibility that there is faith.

The very first failure of such collective actions is confirmed before the event took place: 1,000 t-shirts and 1,000 shovels were purchased for the project. Thus, for each participant, for each volunteer that held the line, there was the phantasm of another whose "wasted effort" refused to record itself in the action. A specter haunted the work: 500 specters followed the 500 participants over the hill, phantasms of the other 500 individuals who were elsewhere, not together, but in different locations, taking up distinct activities, each and every one. Nothing to hold this group together but faith: faith in *what* moves the mountain?

As we can see from the displacement, there is not a displacement in the strictest sense. In what is certainly an unintentional echo of 2 Oc-

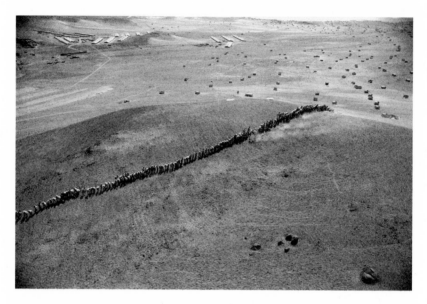

FIGURE 6.3

Francis Alÿs, **When Faith Moves Mountains,** *Lima 2002. In collaboration with Rafael Ortega and Cuauhtémoc Medina, video documentation of an action; photo: Francis Alÿs.*

tober, a helicopter hovers overhead during the action to assure that its survey-plan is recorded. At some point, it comes too close to the line on the ground. Its spinning blades raise and move far more of the dune than do the participants with their shovels. This accident—whether or not it is an accident—undermines any possible separation between the action and its recording, for there is only the event in its recording. Yet at the same time, it sets apart the most worklike aspect of the work—faith: our faith that there is or will be a work; our faith that there is or will be a land displacement; our faith, finally, in the collective nature of the faith we hold as a line, standing in the sun, over the dune in a shared and mutual project. In this regard, the work returns to the assembly line of the factory; it re-creates or reenacts the scene of alienated labor. Here "the workshop as a whole" is deployed in the demonstration of its own expropriation, despite the artisanal fantasy that the work extends about its own working-out. *When Faith Moves Mountains* reproduces—reenacts— the site of a now unlikely political subjectivation.

Yet, there will not be work, much less *a* work, despite all faith, for anyone outside the line except in the work's technological reproducibility.[60] In a formulation I cite earlier, Eduardo Cadava writes: "What makes an

event an event is its technological reproducibility."[61] There is no event that has taken place as an event—beyond this line of 500 witnesses—if it is not a series of images of light and sound. "In other words," as Benjamin once put it, *"the unique value of the 'authentic' work of art has its basis in ritual, the source of its original use value."*[62] The line is the original site of this ritual, or it recalls this ritual—the possibility of a rite. The very convocation of a ritual today, in the era of technological reproducibility, which can be accessed only through its recording and repetition, dramatizes the division between orders or epochs at the center of the work. The unique event-ness of the work will always be lost, as one of the participants bears witness: "That part was lost, I think, in the shot. It wasn't seen."[63] The most secret aspect of the ritual (or pseudoritual), the most unique moment of the work is the invisible political subjectivation on which the event turns. This pseudoauratic lost moment is the moment of collective faith in the work itself. The visibility of action obeys an inverse relation to the invisibility of the faith held by the volunteers on the line. And yet, rather than a ceremonial object "destined to serve in a cult," as Benjamin puts it, what is here produced is the ceremony itself, but because it is worthless, useless, and also labor-intensive, it is a ceremony destined to be unique. The tension between two sides of the work turns on an exploration of the way in which, as Benjamin puts it, "technological reproducibility emancipates the work of art from its parasitic subservience to ritual."[64] *"Instead of being founded on ritual,"* he observes, *"it is based on a different practice: politics."*[65] The ritualistic theme of the work is betrayed precisely by the lack of an object through which to center the work, a body to consign it to, by means of which to *delineate* it; it would seem to possess neither material nor endgame. A disappearing, ironically sincere faith, the wasted effort of an inoperative march over the dune face, the extensive documentation of what never properly occurred (endurance upon endurance), or if it occurred, the thing that truly occurred was never filmed, never witnessed, only felt along the line.

All of this points to some other more *immaterial* practice: politics, the symbolic working out of a being-in-common, unburdened by its failure and held together by faith in the process of the hypothetical form it extends. An arduous task has turned into a game, a peculiar ritual into a politics. It is, indeed, the appearance of a possibility that Alÿs has himself suggested, the "counterpart" to the axiom that guided *Paradox of Praxis I*: sometimes making nothing leads to something.[66] Indeed, it leads to a political art that deserves that name beyond moral judgment or calculation.

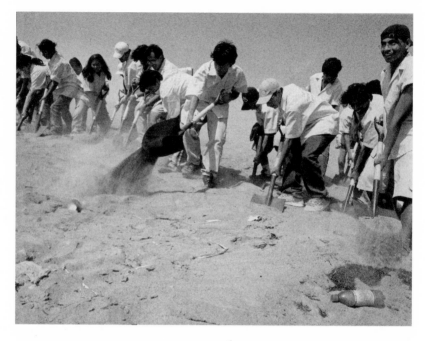

FIGURE 6.4

Francis Alÿs, **When Faith Moves Mountains,** *Lima 2002. In collaboration with Rafael Ortega and Cuauhtémoc Medina, video documentation of an action; photo: Francis Alÿs.*

"On the one hand," writes Rancière, "the 'community of sense' woven together by artistic practice is a new set of vibrations of the human community in the present; on the other hand, it is a monument that stands as a mediation or a substitute for a people to come."[67] The work divides itself and reunites itself for the people present and the people future. It constructs the possibility of the contingent and temporary reunion of our contemporaries. And yet it is also, necessarily, an immaterial monument, a monument constructed immaterially, directed toward an as-yet unconstructed being-in-common: "The images of art do not supply weapons for battles. They help sketch new configurations of what can be seen, what can be said and what can be thought and, consequently, a new landscape of the possible. But they do so on condition that their meaning or effect is not anticipated."[68] What is truly needed is not to critique the artist but, rather, the prevailing conditions of thought and action that do not open any figure for the semblance of a program, for the artwork cannot be a politics as a semblance; it must commit itself to action. The nature of that action, then, is what is essayed in the works

of Francis Alÿs. They comprise rehearsals for a future moment in which the practiced effectivity of the "social" intervention will no longer be at stake. In effect, they are wagers on the very success of political action, the working out of a hypothesis, the accidental return—as reenactment—of a collective politics, speculative or otherwise.

These events have not yet concluded. The ghost is here and is not here, because the event whose aftermath it haunts has not yet taken place: there has been no failure, and thus the time is not out of joint in the way we have imagined. It must return as the nonghost of its immaterial and unyielding demand—the demand for justice. This call for justice concerns not the restitution of failure but the only return of the political for which the ghost can claim responsibility: a defeat or the momentary retreat of a line that resists still, as the an-archaeological trace of 1968. Such a collective artwork does not recall only the legacy of 1968 (and when it does, not merely in its defeat). It does not only reestablish and extend that legacy through creating, once more, hopes of relations between middle-class students and the popular sector. Rather, if there is an event, it is not represented in *When Faith Moves Mountains*. On the contrary, the work begins an enactment as reenactment, the moment of confused actions that no archive can rule, that moment of work toward what Williams calls the "slightest decision" in which "students are confused with workers from various factories and unions; groups of peasants are also present."[69]

NOTES

INTRODUCTION

José Revueltas, *México 68: Juventud y revolución*, ed. Andrea Revueltas and Philippe Cheron (Mexico City: Era, 1978), 188: "No hemos sido derrotados . . ."

1. "*El grito* (The Scream), a documentary film edited after the Tlatelolco massacre and signed by Leobardo López Arretche, who took over the editing and sequencing of material shot by CUEC students, was clearly understood as the result of a collective effort" (Álvaro Vázquez Mantecón, "Visualizing 1968," in *La era de la discrepancia: Arte y cultura visual en México, 1968–1997*, ed. Olivier Debroise, trans. Joëlle Rorive, Ricardo Vinós, and James Oles [Mexico City: Turner, 2007], 37). For an excellent account of this production, see John Mraz, *Looking for Mexico: Modern Visual Culture and National Identity* (Durham: Duke University Press, 2009), 202–205.

2. The point of reference is, naturally, Sigmund Freud, *The Interpretation of Dreams*, trans. and ed. James Strachey (New York: Basic Books, 2010), 457: "A dream is a conglomerate which, for purposes of investigation, must be broken up once more into fragments. On the other hand, however, it will be observed that a psychical force is at work in dreams which creates this apparent connectedness, which, that is to say, submits the material produced by the dream-work to a 'secondary revision.'" I borrow the phrase "uncertain light" from Salvador Elizondo, *Camera lucida* (Mexico City: Fondo de Cultura Económica, 2001), 11.

3. Mraz, *Looking for Mexico*, 203.

4. Georges Didi-Huberman, *Images in Spite of All: Four Photographs from Auschwitz*, trans. Shane B. Lillis (Chicago: University of Chicago Press, 2008), 45 (original emphasis).

5. My point of reference is Walter Benjamin, "On the Concept of History," in *Selected Writings*, ed. Howard Eiland and Michael W. Jennings, trans. Edmund Jephcott, 4: 391 (Cambridge: Harvard University Press, 2003).

6. Alberto Moreiras, "Posthegemonía, o más allá del principio del placer," *alter/nativas: Revista de Estudios Culturales Latinoamericanos* 1, no. 1 (2013), http://

alternativas.osu.edu/es/issues/autumn-2013/essays/moreiras.html: "se instala, como práctica teórica, en la zona de indiferenciación entre teoría y práctica." All translations are mine unless otherwise noted.

7. Revueltas, *México 68*, 178: "La conciencia colectiva se expresa en la autogestión."

8. Ibid.: "Conciencia colectiva no quiere decir uniformidad ni regimentación, sino libertad de tendencias, confrontación, autoconfrontación."

9. Ibid., 49: "Se ha dicho que el Movimiento Estudiantil julio-agosto de 1968 carece de una bandera—es decir, de objetivos precisos y 'miras elevadas' . . . Con esto se quiere tender una cortina de humo que oculte no sólo el contenido real de nuestros propósitos, sino la raíz y razón de los mismos." The original text of the CNH response appears in Ramón Ramírez, *El movimiento estudiantil de México (julio/diciembre de 1968)* (Mexico City: Era, 1969), 2: 224–227.

10. Revueltas, *México 68*, 52: "¡Somos una Revolución! Ésta es nuestra bandera." See also ibid., 126–148.

11. See José Luis Villacañas Berlanga, "The Liberal Roots of Populism: A Critique of Laclau," trans. Jorge Ledo, *CR: The New Centennial Review* 10, no. 2 (2010): 172.

12. Mark Kurlansky, *1968: The Year That Rocked the World* (New York: Ballantine, 2004), xi.

13. Ibid., xvii, xviii, my emphasis.

14. Ibid., xix.

15. My point of reference is Alain Badiou, *Philosophy for Militants*, trans. Bruno Bosteels (London: Verso, 2012), 42: "Our current historical moment is disoriented." I will return to several figures of that disorientation, particularly Badiou's own notion of the "Restoration."

16. Gilles Deleuze, "May '68 Did Not Take Place," in *Two Regimes of Madness: Texts and Interviews 1975–1995*, ed. David Lapoujade, trans. Ames Hodges and Mike Taormina (Los Angeles: Semiotext(e), 2006), 233.

17. Key events of this sequence include the 1968 student revolts, the guerrilla movements of the 1970s (and concomitant "dirty war"), the 1982 debt crisis, the 1985 earthquake to which the state could not adequately respond and which has been credited with inaugurating Mexico's civil society movement, and the 1988 elections, in which Cuauhtémoc Cárdenas posed a credible challenge to continued Partido Revolucionario Institucional (PRI) rule. The election of Vicente Fox in 2000 culminates this democratization. Such accounts, however, do not give the proper due to the 1959 rail workers' strike, not to mention a very long series of earlier political demands and social upheavals. Among the most systematic attempts at restituting that sequence counts Raúl Jardón, *1968: El fuego de la esperanza* (Mexico City: Siglo XXI, 1998). By now, however, Jardón's book deserves an update, for we must wonder how genealogies of political struggles have recently been reoriented by the still-opaque politics of narco-terror and the reentry of the PRI.

18. Kurlansky, *1968*, 343.

19. Ibid., 344.

20. Roger Bartra, "Dos visiones del 68," La jaula abierta, blog of Roger Bartra, 2 October 2007, http://www.letraslibres.com/blog/blogs/index.php?blog=11: "El año de 1968 nos ha dejado dos herencias: la derrota y la transición."

21. Elaine Carey, *Plaza of Sacrifices: Gender, Power, and Terror in 1968 Mexico* (Albuquerque: University of New Mexico Press, 2005), 191.

22. In this regard, see also Jaime M. Pensado, *Rebel Mexico: Student Unrest and Authoritarian Political Culture during the Long Sixties* (Stanford: Stanford University Press, 2013). The book's very periodization strikes out against the way in which we have too often reduced thinking the sixties to 1968, and thinking 1968 as a function of 2 October.

23. See, among others, Soledad Loaeza, "México 1968: Los orígenes de la transición," in *La transición interrumpida: México 1968–1988*, ed. Ilán Semo (Mexico City: Nueva Imagen, 1993); Héctor Aguilar Camín, *Después del milagro* (Mexico City: Cal y Arena, 1990); Miguel Ángel Centeno, *Democracy within Reason: Technocratic Revolution in Mexico* (University Park: Pennsylvania State University Press, 1997).

24. Loaeza, "México 1968," 23: "frente a otros regímenes autoritarios, el mexicano tenía la ventaja de contar con orígenes revolucionarios que le permitían reclamar una representatividad popular del Estado, antes que en elecciones libres."

25. The reader is invited to consider the so-called *reforma energética*, undertaken in 2013.

26. Gareth Williams, *The Mexican Exception: Sovereignty, Police, and Democracy* (New York: Palgrave Macmillan, 2011), 12.

27. Roger Bartra, *El reto de la izquierda* (Mexico City: Grijalbo, 1982), 31–32: "Pareciera, pues, que el Estado mexicano mantiene en su amplio seno a grupos de la burguesía conservadora, corrientes socialdemócratas, marxistas, católicos, sindicatos, organizaciones campesinas y de capas medias, populistas y militares: todo cabe en el Leviatán mexicano."

28. A virtual tour is available here: http://www.tlatelolco.unam.mx/Recorrido/recorrido.html.

29. See Eric Zolov, *Refried Elvis: The Rise of the Mexican Counterculture* (Berkeley: University of California Press, 1999).

30. My point of reference is ibid., chapter 4.

31. Ernesto Guevara, *The Bolivian Diary* (North Melbourne: Ocean Press, 2006), 266.

32. Alberto Moreiras, *Tercer espacio: Literatura y duelo en América Latina* (Santiago de Chile: LOM/Arcis, 1999), 324: "una postergación del sentido."

33. Salvador Elizondo, *Farabeuf, o la crónica de un instante* (Mexico City: Joaquín Mortiz, 1965), 11: "¿Recuerdas . . . ? Es un hecho indudable que precisamente en el momento en que Farabeuf cruzó el umbral de la puerta, ella, sentada al fondo del pasillo, agitó las tres monedas en el hueco de sus manos entrelazadas y luego las dejó caer sobre la mesa."

34. Ibid., 75–76.

35. This, indeed, is one of the lessons to be taken from the Borgesian parable of Funes, the Memorious: true memory demands forgetting.

36. Elizondo, *Farabeuf*, 106: "Es preciso evocarlo todo."

37. Ibid., 11: "De hecho ni siquiera es posible precisar la naturaleza concreta de ese acto."

38. Ibid., 66: "¿Ve usted? La existencia de un espejo enorme, con marco dorado, suscita un equívoco esencial en nuestra relación de los hechos."

39. See the conclusion to Georges Bataille, *The Tears of Eros*, trans. Peter Connor (San Francisco: City Lights, 1989).

40. Williams, *The Mexican Exception*, 133.

41. See Jacques Derrida, *Archive Fever: A Freudian Impression*, trans. Eric Prenowitz (Chicago: University of Chicago Press, 1995), 3.

42. Quoted in Olivier Debroise, ed., *La era de la discrepancia: Arte y cultura visual en México, 1968–1997*, trans. Joëlle Rorive, Ricardo Vinós, and James Oles (Mexico City: Turner, 2007), 16–17: "Atacan a la Universidad porque discrepamos. Viva la discrepancia que es el espíritu de la universidad. Viva la discrepancia, que es lo mejor para servir."

43. Ryan F. Long, *Fictions of Totality: The Mexican Novel, 1968, and the National-Popular State* (West Lafayette, Ind.: Purdue University Press, 2008), 88.

44. Deleuze, "May '68 Did Not Take Place," 235.

CHAPTER 1: ARCHIVE AND EVENT

1. Revueltas, *México 68*, 8: "Un fantasma recorre México, nuestras vidas. Somos Tlatelolco." Elaine Carey also invokes this haunting: "The brutal response of the Mexican leaders toward their youth haunted the capital and the country in the years to come" (*Plaza of Sacrifices*, 1); or, "Even in 2004, a brutally destroyed social movement and its remnants continue to haunt the political, intellectual, and cultural landscape of Mexico" (193).

2. See Lorenzo Meyer, "Una democracia mediocre," *Metapolítica* 10, no. 48 (2006): 31–37.

3. The term "anti-event" comes from Alain Badiou, *Logics of Worlds: Being and Event, 2*, trans. Alberto Toscano (London: Continuum, 2009), 59–60: "In the panic sown by Spartacus and his troops, the patrician—and the Vendean bishop, and the Islamist conspirator, and the fascist of the thirties—systematically resorts to the invocation of a full and pure transcendent Body, an ahistorical or anti-eventual body (City, God, Race . . .) from which it follows that the trace will be denied (here, the labour of the reactive subject is useful to the obscure subject) and, as a consequence, the real body, the divided body, will also be suppressed. Invoked by the priests (the imams, the leaders . . .), the essential Body has the power to reduce to silence that which affirms the event, thus forbidding the real body from existing."

4. Revueltas, *México 68*, 149–154.

5. Diana Sorensen, *A Turbulent Decade Remembered: Scenes from the Latin American Sixties* (Stanford: Stanford University Press, 2007), 77.

6. Revueltas, *México 68*, 83: "Tlatelolco . . . una historia que no terminará porque otros la seguirán escribiendo."

7. See Deleuze, "May '68 Did Not Take Place."

8. Ranajit Guha, "The Prose of Counterinsurgency," in *Selected Subaltern Studies*, ed. Ranajit Guha and Gayatari Chakrovorty Spivak (Oxford: Oxford University Press, 1988), 84, my emphasis.

9. Gyan Prakash, "The Impossibility of Subaltern History," *Nepantla: Views from South* 1, no. 2 (2000): 293.

10. Georges Didi-Huberman, *Confronting Images: Questioning the Ends of a Certain History of Art*, trans. John Goodman (University Park: Pennsylvania State University Press, 2005), 31.

11. Carlos Monsiváis, *El 68: La tradición de la resistencia* (Mexico City: Era, 2008), 14: "Por desgracia, y con resonancia interrumpida, la envoltura vista y gran albergue simbólico del Movimiento estudiantil del 68 es la Plaza de las Tres Culturas."

12. Octavio Paz, *The Other Mexico*, in *The Labyrinth of Solitude and Other Writings*, trans. Lysander Kemp, Yara Milos, and Rachel Phillips Belash (New York: Grove Press, 1985), 291; idem, *Postdata*, in *El laberinto de la soledad: Postdata: Vuelta a El laberinto de la soledad* (1969; Fondo de Cultura Económica, 2004), 291.

13. This relationship between domiciliation and shelter turns or returns to the archive, a question I will soon examine. For now, I wish only to clarify that the word "domiciliation" is, indeed, borrowed from Derrida: "At the intersection of the topological and the nomological, of the place and the law, of the substrate and the authority, *a scene of domiciliation becomes at once visible and invisible*" (Derrida, *Archive Fever*, 3, my emphasis).

14. Jacques Derrida, "*Fors*: The Anglish Words of Nicolas Abraham and Maria Torok," foreword to *The Wolf Man's Magic Word: A Cryptonymy*, by Nicolas Abraham and Maria Torok, trans. Barbara Johnson (Minneapolis: University of Minnesota Press, 1986), xiv (original emphasis).

15. Derrida, *Archive Fever*, 11. See also ibid., 12, on compulsion and the death drive.

16. Ibid., 3 (original emphasis); cf. idem, *Specters of Marx: The State of the Debt, the Work of Mourning, and the New International*, trans. Peggy Kamuf (New York: Routledge, 2006), 36: "An inheritance is never gathered together, it is never one with itself."

17. See Williams, *The Mexican Exception*, 129.

18. "El 13 de agosto de 1521, heroicamente defendido por Cuauhtémoc, cayó Tlatelolco en poder de Hernán Cortés. No fue triunfo ni derrota. Fue el doloroso nacimiento del pueblo mestizo que es el México de hoy."

19. For a discussion of the "Christological" register of the narration of 1968, see ibid., 143: "1968 was the product of a stirring at the heart of the relation between the

subject and the decision. As such, it is the product of a decision in the true sense. But the decision as such has escaped full measure and calculability . . . those who ascribe to the melancholic legacy of 1968 do not have such problems. But neither can they face up to the relation between 1968 and the singularity of the event, or to the relation between thought and freedom, because they have already laid down all ideas obediently at the feet of sovereign decisionism and Christian sacrifice."

20. Derrida, *Archive Fever*, 17.

21. The most significant chronology of the movement remains Ramírez, *El movimiento estudiantil de México*.

22. Derrida, "*Fors*," xiv.

23. Again, my point of reference is Williams's "police narrativization" (*The Mexican Exception*, 129).

24. Jacques Lacan, *The Seminar of Jacques Lacan, Book II: The Ego in Freud's Theory and in the Technique of Psychoanalysis 1954–1955* (New York: Norton, 1991), 307–308.

25. Ibid., 308.

26. Slavoj Žižek, "Against the Populist Temptation," *Critical Inquiry* 32, no. 3 (2006): 553.

27. Ernesto Laclau, *On Populist Reason* (London: Verso, 2005), 72.

28. My point of reference is Joshua Lund, *The Mestizo State: Reading Race in Modern Mexico* (Minneapolis: University of Minnesota Press, 2012).

29. Paz, *The Other Mexico*, 291; idem, *Postdata*, 291: "Doble realidad del 2 de octubre de 1968: ser un hecho histórico y ser una representación simbólica de nuestra historia subterránea o invisible . . . lo que se desplegó ante nuestros ojos fue un acto ritual: un sacrificio."

30. My point of reference here is Eduardo Cadava's reading of Benjamin; see *Words of Light: Theses on the Photography of History* (Princeton: Princeton University Press, 1997).

31. Ignacio M. Sánchez Prado, *Naciones intelectuales: Las fundaciones de la modernidad literaria mexicana, 1917–1959* (West Lafayette, Ind.: Purdue University Press, 2009), 236: "La nación reconciliada de Paz es la sublimación del conflicto, de la resistencia, de la inconformidad, por la identificación con el mito."

32. Octavio Paz, *The Collected Poems of Octavio Paz, 1957–1987*, trans. and ed. Eliot Weinberger (New York: New Directions, 1991), 225–227; idem, *Ladera este*, in *Obra poética I*, vol. II of *Obras completas*, ed. Octavio Paz (Mexico City: Fondo de Cultura Económica, 2006), 347.

33. Georges Didi-Huberman, *Invention of Hysteria: Charcot and the Photographic Iconography of the Salpêtrière*, trans. Alisa Hartz (Cambridge: MIT Press, 2004), 48.

34. Elena Poniatowska, *Massacre in Mexico*, trans. Helen R. Lane (Columbia: University of Missouri Press, 1992), 314; idem, *La noche de Tlatelolco* (Mexico City: Era, 1971), 265: "No creo que las imágenes puedan mentir . . . He visto noticieros, fotografías."

35. "Manchada / Antes de haber dicho algo / Que valga la pena / la limpidez" (Paz, *Ladera este*, 347).

36. Paz, *Postdata*, 248 (my translation): "una mancha de sangre disipaba el optimismo oficial." My reading here is highly influenced by that of Long, who writes: "The adjective's feminine ending also allows associations with the two surfaces enumerated in the text, the plaza and the page. If 'stained' is taken to refer to the plaza, then it is obvious that the surface has been stained before the poet could say anything that was worth it, that, in the Spanish expression, was literally 'worth the pain.' If, on the other hand, 'stained' is taken to refer to the page, then the last sentence adopts an ironic tone that suggests that the poem itself is not worth it. But even though Paz's words could never be worth the murders of Tlatelolco, they are indeed worth something. And that something is their condemnation of the concept of cleanliness, which returns the final sentence to its grammatical meaning, that clarity is unclean, stained. But ink appears implicitly as a productive kind of stain on a page that is as always already stained as the Plaza of Tlatelolco. In 'Intermitencias,' writing rejects originary clarity by recognizing its own stains as its necessary starting point" (*Fictions of Totality*, 100).

37. Paz, *The Other Mexico*, 325; idem, *Postdata*, 317: "la crítica: el ácido que disuelve las imágenes."

38. Paz, *The Other Mexico*, 282; idem, *Postdata*, 286: "El pensamiento independiente es casi siempre impopular."

39. Paz, *The Other Mexico*, 236; idem, *Postdata*, 253: "La matanza de Tlatelolco nos revela que un pasado que creíamos enterrado está vivo e irrumpe entre nosotros."

40. This theme is central to Alain Badiou, *The Century*, trans. Alberto Toscano (Cambridge, U.K.: Polity, 2007).

41. Paz, *The Other Mexico*, 225; idem, *Postdata*, 244: "Ahora sabemos que el reino de progreso muestra al fin su verdadero rostro: un rostro en blanco, sin facciones. Ahora sabemos que el reino del progreso no es de este mundo: el paraíso que nos promete está en el futuro, un futuro intocable, inalcanzable, perpetuo. El progreso ha poblado la historia de las maravillas y los monstruos de la técnica pero ha deshabitado la vida de los hombres. Nos ha dado más cosas, no más ser."

42. Sergio Zermeño, *México: Una democracia utópica: El movimiento estudiantil del 68* (Mexico City: Siglo XXI, 1978), 320: "En condiciones como las de nuestra sociedad, la presencia de un Estado fuerte o populista-estructural se ha constituido en la única fórmula organizativa capaz de mantener el orden y, por lo tanto, capaz de asegurar esa mínima coherencia y estabilidad sociopolítica que requiere nuestro desarrollo capitalista tardío. Las medidas redistributivas de este prolongado sistema populista la aseguran legitimidad y abonan el mercado sobre el que ha de florecer el régimen de propiedad privada. Con ello se echa andar, al mismo tiempo, el principio de progreso, de desarrollo, y así la legitimidad del Estado fuerte populista queda doblemente alimentada." See also César Gilabert, *El hábito de la utopía: Análisis del imaginario sociopolítico del movimiento estudiantil de México, 1968* (Mexico City: Miguel Ángel Porrúa, 1993), 23, cited in Jorge Volpi, *La imaginación y el poder: Una his-*

toria intelectual del 1968 (Mexico City: Era, 1998), 31. Gilabert describes Mexico's national-popular state and its remnants: "For the Mexican leadership, real inequality derived from an unequal distribution of wealth does not contradict the State's generosity and effectiveness regarding the goal of achieving social justice. On the contrary, the distance of the objective confirms the 'necessity' of the State itself, with precisely the features that have characterized it until now" (Para los gobernantes mexicanos, la desigualdad real derivada de una inequitativa distribución de la riqueza, no contradice la bondad ni la eficacia estatales en el objetivo de lograr la justicia social. Por el contrario, la lejanía de la meta confirma la 'necesidad' del Estado mismo, precisamente con las características que hasta hoy se la conocen).

43. As Patrick Dove has put it: "Through the projection of a colossal and unified tradition, the state emerges as the archive of the past as necessity" ("Exígele lo nuestro: Deconstruction, Restitution and the Demand of Speech in *Pedro Páramo*," *Journal of Latin American Cultural Studies* 10, no. 1 [March 2001]: 28).

44. Paz, *The Other Mexico*, 225; idem, *Postdata*, 244: "El sentido profundo de la protesta juvenil—sin ignorar ni sus razones ni sus objetivos inmediatos y circunstanciales—consiste en haber opuesto al fantasma implacable del futuro la realidad espontánea del ahora. La irrupción del ahora significa la aparición, en el centro de la vida contemporánea, de la palabra prohibida, la palabra maldita: placer. Una palabra no menos explosiva y no menos hermosa que la palabra justicia."

45. Claudio Lomnitz-Adler, *Exits from the Labyrinth: Culture and Ideology in the Mexican National Space* (Berkeley: University of California Press, 1992), 281.

46. Ibid.

47. Paz, *The Other Mexico*, 236; idem, *Postdata*, 253. From 2010 to 2011, TV Azteca's U.S.-style police procedural *Drenaje profundo* would literalize this metaphor; in the program, the youth of 1968 live, as Paul Julian Smith translates the title, "in the sewers." See *Mexican Screen Fiction: Between Cinema and Television* (Cambridge, U.K.: Polity, 2014), 191–219.

48. Paz, *The Other Mexico*, 292; idem, *Postdata*, 292: "la verdadera, aunque invisible, historia de México."

49. I am here adopting Paz's notion of the "intrahistorical." See *The Other Mexico*, 253; idem, *Postdata*, 266.

50. *The Other Mexico*, 294; idem, *Postdata*, 294: "Tiempo petrificado, los cuatro lados de la pirámide representan los cuatro soles o edades del mundo."

51. By my appeal to "different circumstances," I want to point to the possibility that I hope the present study opens: once we have finally secularized the question of Tlatelolco, perhaps we will return to thinking the student-popular movement as such.

52. Despite the significant differences between the two studies, the points of reference are John Andrés Ochoa, *The Uses of Failure in Mexican Literature and Identity* (Austin: University of Texas Press, 2004), and Brian L. Price, *Cult of Defeat in Mexico's Historical Fiction: Failure, Trauma, and Loss* (New York: Palgrave Macmillan, 2012).

53. Bruno Bosteels, *Marx and Freud in Latin America: Politics, Psychoanalysis, and Religion in Times of Terror* (London: Verso, 2012), 23.

54. David E. Johnson's invitation to speak at a SUNY Buffalo colloquium in March of 2013 productively opened this question regarding Bosteels's important book.

55. Bosteels, *Marx and Freud*, 23.

56. Ibid., my emphasis.

57. Williams, *The Mexican Exception*, 119.

58. Ibid., 128.

59. Alain Badiou, *Metapolitics*, trans. Jason Barker (London: Verso, 2005), 28. My use of the word "facts" refers to Badiou's opposition between these and "events." Writes Badiou: "I call 'facts' the consequences of the existence of the state" (*The Communist Hypothesis*, trans. David Macey and Steve Corcoran [London: Verso, 2010], 244).

60. Williams, *The Mexican Exception*, 142.

61. Cadava, *Words of Light*, xxiii.

62. Hermann Bellinghausen and Hugo Hiriart, "Nace el movimiento: Entrevista con Gilberto García Niebla," in *Pensar el 68*, ed. Hermann Bellinghausen (Mexico City: Cal y Arena, 1988), 51.

63. Zermeño, *México*, 95: "El movimiento estudiantil mexicano de 1968 fue un movimiento reformista, que readecuó muchos aspectos de la organización social y política de México, que 'modernizó' a la sociedad mexicana dentro de su continuidad sin llegar a revolucionarla—podemos decir ahora, años después de aquellos acontecimientos."

64. See chapter 3 here for the list of demands and a reading of them.

65. Ramírez, *El movimiento estudiantil*, 1: 64. It is worth noting here the resonance of this perspective with the earlier thought of Badiou. See his *Théorie de la contradiction* (Paris: François Maspero, 1975), 24.

66. Paco Ignacio Taibo II, *'68*, trans. Donald Nicholson-Smith (New York: Seven Stories Press, 2004), 12; idem, *'68* (New York: Siete Cuentos Editorial, 2004), 10: "¿Cómo se cocinó la magia? ¿Con qué se alimentaba la hoguera? ¿De dónde salieron los 300 mil estudiantes que llegaron al Zócalo el día de la manifestación silenciosa?"

67. Williams, *The Mexican Exception*, 14.

68. Ibid., 149.

69. Ibid., 128.

70. Badiou, *The Century*, 98.

71. Rancière, cited in Williams, *The Mexican Exception*, 14.

72. Badiou, *Metapolitics*, 23 (original emphasis).

73. Jacques Derrida, *Rogues: Two Essays on Reason*, trans. Pascale-Anne Brault and Michael Naas (Stanford: Stanford University Press, 2005), 84, my emphasis.

74. Ibid., 152.

75. Bosteels, *Marx and Freud in Latin America*, 171–172.

76. Badiou, cited in ibid., 169.

77. Ibid.

78. Ibid.

79. Hangers-on, poseurs, revisionists, reformers, and other such nonradical positions remain even within the very situation that emerged as an object for critique. See Revueltas, *México 68*, 42: "El objetivo ideológico fundamental de la autogestión académica es el de establecer en la esfera universitaria y de la enseñanza superior, el concepto y la práctica de la *democracia cognoscitiva* como instrumento de la lucha por la libertad y como la libertad misma del futuro." See also René Viénet, *Enragés and Situationists in the Occupation Movement: Paris, May, 1968* (New York: Autonomedia, 1993).

80. Bosteels, *Marx and Freud in Latin America*, 194.

81. Derrida's *Archive Fever* is again my point of reference. "Topo-nomological" refers to the "intersection" of "the place and the law" (3). That intersection conditions a "consignation," a "gathering of signs," through which, and *at* Tlatelolco, from the disparate materials of the student-popular movement, its precursors, and its consequences, "a single corpus" is "coordinated."

82. Bosteels, *Marx and Freud in Latin America*, 173.

83. Badiou, cited in ibid., 305.

84. Ibid., 187.

85. Ibid., 192–193.

86. See, for example, the second chapter of Bruno Bosteels, *The Actuality of Communism* (London: Verso, 2011). I develop this opposition further elsewhere; see Samuel Steinberg, "Cowardice—An Alibi: On Prudence and *Senselessness*," *CR: The New Centennial Review* 14, no. 1 (2014): 175–194.

87. Jacques Rancière, *Disagreement: Politics and Philosophy*, trans. Julie Rose (Minneapolis: University of Minnesota Press, 1999), 33.

88. Ibid.

89. Ibid., 55.

90. Ramírez, *El movimiento estudiantil*, 1: 63: "Estudiantes se confunden con obreros procedentes de diversas fábricas y sindicatos; grupos de campesinos también están presentes." Cf. Revueltas, *México 68*, 146.

91. Derrida, *Rogues*, 84, 159, 152.

CHAPTER 2: POSTPONED IMAGES

1. Carlos Monsiváis, "1968: Dramatis personae," prologue to *México: Una democracia utópica: El movimiento estudiantil del 68*, by Sergio Zermeño (Mexico City: Siglo XXI, 1978), xi: "fotografías suspendidas en el vacío de la memoria."

2. Taibo, *'68* (trans.), 108; idem, *'68*, 97: "con la retina invadida para la eternidad por la luz de las dos bengalas que dieron inicio a la masacre."

3. Benjamin, "On the Concept of History," 391.

4. This opening of the archives has to this day not fully taken place, even as successive political regimes have gestured toward such an opening. See, for example, Sergio Aguayo Quezada, *1968: Los archivos de la violencia* (Mexico City: Grijalbo/ Reforma, 1998).

5. Indeed, the Mexican Congress formed something on the order of a truth commission around the thirtieth anniversary of the events, but it, too, largely failed to gain access to the archive. Regarding the distinction between "event" and facts in Badiou, see Quentin Meillassoux's gloss: "The political example is, as it often is with Badiou, the most immediately accessible. What exactly do we mean, when we say that 'May 68' was an event? In this expression, we are not merely designating the set of facts that have punctuated this collective sequence (student demonstrations, the occupation of the Sorbonne, massive strikes, etc.). Such facts, even when joined together in an exhaustive way, do not allow us to say that something like an event took place, rather than a mere conjunction of facts without any particular significance" ("History and Event in Alain Badiou," trans. Thomas Nail, *Parrhesia* 12 [2011]: 2).

6. Aguayo Quezada, *1968*, 261: "imponer su versión de los hechos y lograr el rápido olvido."

7. Ibid., 272: "se impuso una férrea disciplina con listas negras, delaciones y despidos."

8. Juan Rámon de la Fuente, prologue to *Parte de guerra II: Los rostros del 68*, ed. Julio Scherer García and Carlos Monsiváis (Mexico City: Aguilar, 2002), 13.

9. Monsiváis, "1968," xviii: "/ El rector de la UNAM Javier Barros Sierra preside la manifestación de protesta del primero de agosto . . . / los brigadistas se emocionan legitimidad y el despegue del Movimiento Estudiantil. Al protestar por la ocupación de la Ciudad Universitaria el 18 de septiembre le da vida efímera a esa famosa abstracción y hablan con voz quebrada en cines y camiones y mercados y cafés / un estudiante es asesinado por la espalda mientras hace una pinta / estudiantes tomados de la mano interrumpen el tráfico en las principales calles solicitando dinero y haciendo propaganda al Movimiento / los jueces probos les dictan lecciones de moral a los estudiantes presos / el Zócalo se colma de antorchas la noche del 27 de agosto / la madre de un estudiante muerto encabeza el sepelio elevando el signo de la V / los estudiantes detenidos al entrar el ejército a la Ciudad Universitaria entonan el Himno Nacional / un puñado de jóvenes defiende las instalaciones politécnicas en el Casco de Santo Tomás / los habitantes de la Unidad Tlatelolco se solidarizan con los estudiantes / los burócratas acarreados en el Zócalo se burlan de su condición borreguil / los asistentes al mitin intentan guardar la calma / los familiares de los presos o desaparecidos los buscan en cárceles, delegaciones, y hospitales."

10. Derrida, *Archive Fever*, 20.

11. See Akira Mizuta Lippit, *Atomic Light (Shadow Optics)* (Minneapolis: University of Minnesota Press, 2005), 5–9.

12. Olivier Debroise, *Mexican Suite: A History of Photography in Mexico*, trans. Stella de Sá Rego (Austin: University of Texas Press, 2001), 13.

13. Lippit insightfully comments on the relation between temporality, punctuation, and punctum: "Punctuality, Punctuation, and Punctum: Temporality, Inscription, Corporeality" (*Atomic Light*, 49).

14. Derrida, *Archive Fever*, 1 (original emphasis).

15. I discuss the relation between *Farabeuf* and 1968 in the introduction.

16. Ulrich Baer, *Spectral Evidence: The Photography of Trauma* (Cambridge: MIT Press, 2002), 6.

17. Ibid., 11.

18. Ibid., 180.

19. Kristin Ross, *May '68 and Its Afterlives* (Chicago: University of Chicago Press, 2002), 1–2.

20. González de Alba, *Los días y los años*, 159: "Pero después, cuando recordé aquella maravillosa fotografía de la muchacha francesa con su bandera en alto, rodeada de los que son sus compañeros en el descontento y la rebeldía; cuando pensé en todo lo que no podemos expresar claramente, pero que ella sabe y nosotros también, me indigné, me indigné ante ti y tus notas absurdas y tus plumas grabadas y el laboratorio de prácticas."

21. Williams, *The Mexican Exception*, 150.

22. François Dagognet, *Etienne-Jules Marey: A Passion for the Trace*, trans. Jeanine Herman and Robert Galeta (New York: Zone, 1992), 91–98.

23. Carlos Monsiváis, *Días de guardar* (Mexico City: Era, 1970), 337: "Ante la cámara, en un segundo, quienes van a ser fusilados recuperan toda su vida."

24. Ibid., 302: "plenitud de lo inconcluso."

25. Claire Brewster, *Responding to Crisis in Contemporary Mexico: The Political Writings of Paz, Fuentes, Monsiváis, and Poniatowska* (Tucson: University of Arizona Press, 2005), 31.

26. This placement was modified in a special edition, which I will address in the following chapter. See Elena Poniatowska, *La noche de Tlatelolco*, edición especial (Mexico City: Era, 2012).

27. See Carlos Monsiváis, *Maravillas que son, sombras que fueron: La fotografía en México* (Mexico City: Era, 2012).

28. Linda Egan, *Carlos Monsiváis: Culture and Chronicle in Contemporary Mexico* (Tucson: University of Arizona Press, 2001), 130.

29. Ibid., 165.

30. Carlos Monsiváis, *Entrada libre: Crónicas de la sociedad que se organiza* (Mexico City: Era, 1987), 15: "Ésta es la generación del terremoto, y ya no creemos en la 'normalidad' del autoritarismo."

31. Carlos Monsiváis, *Los rituales del caos* (Mexico City: Era, 1995), 17: "La hora de la identidad acumulativa: ¿qué fotos tomaría usted en la ciudad interminable?"

32. Monsiváis, *Los rituales del caos*, 19: "¿Adónde se fue el chovinismo del 'Como México no hay dos'? No muy lejos desde luego, y volvió protagonizando el chovinismo de la catástrofe y del estallido demográfico."

33. Monsiváis, *Días de guardar*, 280: "la canonización del desastre."

34. As Mabel Moraña has written: "Catastrophe allegorically points to a moment of enlightenment: a key point in the crisis of the hegemony of the dominant sectors and a return to the origins of community solidarity that is now readapted to a social reality seared by the savage effects of modernity. Catastrophe opens the possibility of a new birth of a public consciousness that demonstrates and claims the force of the social over the insufficient structures of political institutionality" (La catástrofe indica entonces, alegóricamente, un momento de iluminación: un punto clave en la crisis de la hegemonía de los sectores dominantes y vuelta a los orígenes de la solidaridad comunitaria, que es readaptada ahora a una realidad social marcada a fuego por los efectos salvajes de la modernidad. La catástrofe abre la posibilidad de un nuevo nacimiento de la conciencia pública que demuestra y reivindica la fuerza de lo social por encima de las insuficientes estructuras de la institucionalidad política). In other words, according to Moraña, in Monsiváis catastrophe is revelatory and, as such, immediately becomes noncatastrophic. It lays waste to "savage" modernity and, in demonstrating the ineffectiveness of an organized politics—the very futility of the political as such—restitutes to humankind a nearly prepolitical communitarian sociality. See Mabel Moraña, "El culturalismo de Carlos Monsiváis: Ideología y carnavalización en tiempos globales," in *El arte de la ironía: Carlos Monsiváis ante la crítica*, ed. Mabel Moraña and Ignacio M. Sánchez Prado (Mexico City: Era/UNAM, 2007), 37.

35. The reader is invited to compare this organizational logic with that operative in Elena Poniatowska's similar and more widely remembered endeavor, *La noche de Tlatelolco*. Poniatowska's text will be the object of the chapter to follow. It is worth noting here that the "fragmentary" nature of the text, frequent in Monsiváis's books, is what, for many critics, grants his writing a kind of nontotalizing ethos. On this score, see Moraña, "El culturalismo de Carlos Monsiváis," 22–23.

36. Sergio Pitol, "Con Monsiváis, el joven," in *El arte de la ironía: Carlos Monsiváis ante la crítica*, ed. Mabel Moraña and Ignacio M. Sánchez Prado (Mexico City: Era/UNAM, 2007), 358.

37. Viviane Mahieux, *Urban Chroniclers in Modern Latin America: The Shared Intimacy of Everyday Life* (Austin: University of Texas Press, 2011), 162.

38. Fredric Jameson, "Periodizing the Sixties," in *The 60s without Apology*, ed. Sohnya Sayres et al. (Minneapolis: University of Minnesota Press, 1984), 179–180.

39. Ibid., 180.

40. Monsiváis, *Días de guardar*, 75: "2 de octubre de 1968: toda catástrofe humana que carece de consecuencias visibles (ajenas a la intención de quienes la provocaron) es un deterioro a corto plazo, un lento inexorable desangrase de la especie."

41. Ibid., 329: "la progresión, la secuencia seguida y perseguida de unas cuantas imágenes, de unas cuantas instantáneas: el Poder, el Pueblo, la Derrota, la Gloria (posiblemente), la Destrucción."

42. Roland Barthes, *Camera Lucida: Reflections on Photography*, trans. Richard Howard (New York: Hill and Wang, 1981), 91.

43. Monsiváis, *Días de guardar*, 331: "las fotografías de Casasola no conversan

nunca. No son idea: nos la dan. La cámara es excesiva: atrapa al Poder en el ejercicio del Poder."

44. Debroise, *Mexican Suite*, 195–196.

45. The poem, which also appears in nonfragmentary form on the book's back cover, reads: "Días de guardar: No se engañe nadie, no, pensando que ha de durar lo que espera más que duró lo que vio: multitud en busca de ídolos en busca de multitud, rencor sin rostro y sin máscara, adhesión al orden, sombras gobernadas por frases, certidumbre del bien de pocos consuelo de todos (sólo podemos asomarnos al reflejo), fe en la durabilidad de la apariencia, orgullo y prejuicio, sentido y sensibilidad, estilo, tiernos sentimientos en demolición que informan de una realidad donde significaban las imágenes, represión que garantiza la continuidad de represión, voluntad democrática, renovación del lenguaje a partir del silencio, eternidad gastada por el uso, revelaciones convencionales sobre ti mismo, locura sin sueño, sueño sin olvido, historia de unos días" (Days to keep: Let no one be fooled, no, into thinking that what waits longer lasts more than what sees: a multitude in search of idols in search of multitudes, a faceless, naked hatred sticking to law and order, shadows ruled by phrases, certainty of the good of the few and the solace of the many (we can only peek at the reflection), faith in the endurance of appearance, pride and prejudice, sense and sensibility, style, tender collapsing feelings that speak of a reality where images meant something, repression that guarantees the continuity of repression, democratic will, the renewal of language out of silence itself, an eternity exhausted in use, conventional revelations about yourself, madness without sleep, without dreams, sleep without forgetting, history of a few days to keep [translation by Marco Dorfsman, unpublished]). The text's first lines come from Jorge Manrique's (1440–1479) "Coplas por la muerte de su padre," while other phrases will certainly be familiar in the English translation.

46. Monsiváis, *Días de guardar*, 259: "se ha vuelto imprescindible el olvido."

47. Ibid., n.p.:"No se engañe nadie, no, pensando que ha de durar."

48. On the countercultural moment in Acapulco, see José Agustín, *El rock de la cárcel* (Mexico City: Editores Mexicanos Unidos, 1986).

49. Monsiváis, *Días de guardar*, 22: "Lástima que el reportero tampoco distingue entre un nehru y un tuxedo o entre una creación de Pucci y otra del Palacio de Hierro."

50. Ibid., 24: "Irrumpe un desfile de carteles no demasiado celebrables a la manera de textos de esos botones que han infestado suéteres y sacos a nombre de la singular rebelde originalidad de las mayorías, so pretexto de la adquisición industrial del sentido del humor: 'Jesucristo usaba el pelo largo,' 'Ir juntos es magnífico. Venirse juntos es divino' [. . .]. 'El PRI toma LSD.' Se genera una innovación: 'RECUERDE EL 2 DE OCTUBRE.'" Though Zolov does not underline the comparison, Monsiváis's disdain for the hippies' inauthentic or imitative character adopts the official line and, moreover, the same charge of foreignness that the Mexican state and its allies in the media would use to dismiss the student-popular movement itself. See Zolov, *Refried Elvis*, chapter 3, esp. 108–112.

51. Monsiváis, *Días de guardar, 24*: "Recordarle a este público crímenes masivos es invitarlo a que los vuelva a cometer."

52. Monsiváis, "1968," xi: "La táctica dilatoria llamada Unidad Nacional pospone oficialmente la lucha de clases y la colaboración armoniosa entre quienes mandan y quienes obedecen recibe ahora el marco de los Juegos Olímpicos."

53. Barthes, *Camera Lucida*, 26.

54. I have in mind Christian Metz's notion of the off-frame. According to Metz, while cinema has a variety of devices to mask or transform this space of absence, photography does not. Any element left out of the frame, anything existing off-frame, "will never be heard—again a death, another form of death." Yet, although any element off-frame is excluded, it is nevertheless present, constantly "insisting on its status as excluded by the force of its absence inside the rectangle of paper, which reminds us of the feeling of lack in the Freudian theory of the fetish" ("Photography and Fetish," *October* 34 [1985]: 87). The Barthesian punctum allows us to come in contact with or at least feel the presence of this off-frame. That is to say, this punctum, the dead bodies of the murdered at Tlatelolco, is constantly breaking through the surface of the photographic images that begin *Días de guardar*. To advance a thesis that will become clearer in my discussion of Poniatowska, democracy has been postulated by Tlatelolco reflection as the replacement object for the dead.

55. John Kieran and Arthur Daley, *The Story of the Olympic Games: 776 B.C. to 1968* (Philadelphia: J. B. Lippincott, 1969), 431.

56. Ibid., 433. The image appears in Poniatowska's *La noche de Tlatelolco*, which I discuss in the chapter that follows.

57. Ibid., 420.

58. Williams, *The Mexican Exception*, 56.

59. Bartra, "Dos visiones del 68": "El año de 1968 nos ha dejado dos herencias: la derrota y la transición."

60. Barthes, *Camera Lucida*, 45.

61. Monsiváis, *Días de guardar*, n.p.

62. Jacques Rancière, *The Future of the Image*, trans. Gregory Elliot (London: Verso, 2007), 46.

63. Egan, *Carlos Monsiváis*, 143.

64. Ibid., 147.

65. Monsiváis, *Días de guardar*, 253: "El Movimiento Estudiantil de 1968 daba comienzo."

66. Ibid., 288: "la siempre pospuesta solidaridad mexicana."

67. Ibid., 280: "Casanova es importante en nuestro precario mapa de emblemas porque significa la legalización del pesimismo, la canonización del desastre."

68. Ibid.: "nacido para perder" (original emphasis).

69. Ibid., 297: "No es una peregrinación a las fuentes de la tiniebla: es un acontecimiento social, una sospecha del deber que se cumple contra la muerte y contra la vida, sin auspicios de la trascendencia o el compromiso."

70. Ibid., 300: "Hace un mes, hubo un mitin en Tlatelolco."

71. Ibid., 302: "Se opuso la V de la victoria a la mano con el revólver y el crepúsculo agónico dispuso de ambos ademanes y los eternizó y los fragmentó y los unió sin término, plenitud de lo inconcluso, plenitud de la proposición eleática: jamás dejará la mano de empuñar el revólver, jamás abandonará la mano la protección de la V."

72. Walter Benjamin, *The Arcades Project*, trans. Howard Eiland and Kevin McLaughlin (Cambridge: Harvard University Press, 1999), 474.

73. Monsiváis, *Días de guardar*, 295: "los muertos por desgracia no fotografiables."

74. Derrida, *Archive Fever*, 95.

75. Benjamin, "On the Concept of History," 391. On the last image, see Siegfried Kracauer, "Photography," in *The Mass Ornament: Weimar Essays*, trans. Thomas Y. Levin (Cambridge: Harvard University Press, 1995), 51: "All images are bound to be reduced to this kind of image, which may rightly be called the last image, since it alone preserves the unforgettable."

76. The most significant critical reading of these images is to be found in Andrea Noble, "Recognizing Historical Injustice through Photography: Mexico 1968," *Theory, Culture & Society* 27, nos. 7–8 (2011): 184–213.

77. Cadava, *Words of Light*, 128.

78. "Quienes tengan una historia que contar sobre los personajes, víctimas o victimarios, que aparecen en estas fotografías, comuníquense a la Redacción de Proceso, al número de conmutador 56 29 20 00, o al correo electrónico pbr@proceso.com.mx."

79. This is perhaps something like what has been called "rephotography." The word, in its strictest use, should be confined to the photographic study of landscapes. In this regard, see Mark Klett et al., *Third Views, Second Sights: A Rephotographic Survey of the American West* (Santa Fe: Museum of New Mexico Press, 2004). However, Milton Rogovin's work on human subjects is perhaps more relevant in this case. See Joann Wypijewski and Milton Rogovin, *Triptychs: Buffalo's Lower West Side Revisited* (New York: Norton, 1994).

80. The story of López Osuna's death is recounted in Álvaro Delgado and Rodrigo Vera, "Sobrevivió 35 años . . . ," *Proceso*, 23 December 2001, 8–13.

81. Quoted in ibid., 9–10: "Hay que hacer una gran comisión que revise los hechos y los esclarezca. Hay que hacer una gran reunión entre todos los compas, porque sé que muchos han seguido buscando documentos. No hay duda, éste es el momento. Lo que sí debemos evitar es la manipulación y la ingenuidad en el uso de esos testimonios."

82. Sanjuana Martínez, "2 de octubre: Imágenes de un fotógrafo del gobierno," *Proceso*, 9 December 2001, 11: "No se necesita ser un experto para comprobar que estas fotografías muestran parte de lo sucedido el 2 de octubre de 1968, en la Plaza de las Tres Culturas de Tlatelolco."

83. Ibid.: "Estas fotos ofrecen por primera vez la oportunidad de ver las caras de los victimarios, y muestran en plena acción a los hombres del guante blanco,

los integrantes del Batallón Olimpia. Se abre la posibilidad de que por fin sean identificados."

84. Walter Benjamin, "Little History of Photography," in *Selected Writings*, ed. Howard Eiland and Michael W. Jennings, trans. Edmund Jephcott, 2 (Cambridge: Harvard University Press, 1999), 510.

85. Martínez, "2 de octubre," 17: "La deuda está pendiente."

86. Ibid.: 11: "en los archivos del Estado existe toda la documentación necesaria para saber quién cometió la matanza de Tlatelolco."

87. Derrida, *Archive Fever*, 4n1.

88. Allan Sekula, "The Body and the Archive," *October* 39 (1986): 10 (original emphasis).

89. Martínez, "2 de octubre," 13: "Queremos que salga a la luz pública. Queremos que se haga justicia."

90. Ibid.: "Ahora es el momento preciso. Es cuando hay que sacarlas."

91. Ibid.: "Pregúntele a Luis Echeverría."

92. Ibid.: "Él lo sabe. Pregúntele por el fotógrafo y por todo lo demás."

93. Echeverría was elected president following the Díaz Ordaz *sexenio*.

94. Carlos Monsiváis, "Persistencia de la memoria," in *Parte de guerra II: Los rostros del 68*, ed. Julio Scherer García and Carlos Monsiváis (Mexico City: Aguilar, 2002), 31–32.

95. Sanjuana Martínez, introduction to *Parte de guerra II: Los rostros del 68*, ed. Julio Scherer García and Carlos Monsiváis (Mexico City: Aguilar, 2002), 22.

96. Alberto del Castillo Troncoso, "La frontera imaginaria: Usos y manipulaciones de la fotografía en la investigación histórica en México," *Cuicuilco* 14, no. 41 (2007): 206.

97. Ibid.

98. Noble, "Recognizing Historical Injustice," 193.

99. Ibid., 191, 205.

100. I reproduce the quotation as found in the translation I use elsewhere in this text; Monsiváis, however, relied on the Spanish version of *Illuminations*.

101. Benjamin, "On the Concept of History," 390–391.

102. Monsiváis, "Persistencia," 31–32: "De publicarse el 3 o 4 de octubre de 1968, estas fotos habrían ridiculizado al instante las explicaciones oficiales y el discurso de perpetua blancura del Partido Revolucionario Institucional. No son, desde luego, los primeros testimonios gráficos de la noche de Tlatelolco, y ya en octubre de 1968 el número especial del semanario *Por qué!*, contiene fotos demoledoras, de niños en los depósitos de cadáveres y cuerpos arracimados, pero la revista circula poco y en un clima de amedrentamiento el despliegue funerario más bien aleja la protesta. En 2001, las fotos de *Proceso* no admiten los 'rezos entredientes', las disculpas forzadísimas del régimen y su partido, y prueben lo ya sabido: el 2 de octubre, luego de la matanza a cargo de militares, se intentó erradicar a golpes el espíritu del Movimiento."

103. Here Monsiváis cannot but recall the concept of "closetedness" explored in Eve Kosofsky Sedgwick, *Epistemology of the Closet* (Berkeley: University of California Press, 1990).

104. Monsiváis, "Persistencia," 40: "El 68 es un hecho histórico."

105. Williams, *The Mexican Exception*, 128.

CHAPTER 3: *TESTIMONIO* AND THE FUTURE WITHOUT EXCISION

1. See Jon Beasley-Murray, *Posthegemony: Political Theory and Latin America* (Minneapolis: University of Minnesota Press, 2011), 236.

2. Ibid., xii.

3. Williams, *The Mexican Exception*, 84.

4. Gareth Williams, "Why Write a Nineteenth Century Novel for the Twenty-First Century? Juan Villoro's *El testigo* and the Melodrama of Crisis," paper presented at the annual meeting of the Latin American Studies Association, Chicago, May 21–24, 2014.

5. Louis Althusser, *For Marx* (London: Verso, 1990), 133–134.

6. Williams, *The Mexican Exception*, 71.

7. Barthes, *Camera Lucida*, 91.

8. Jacques Lacan, *The Four Fundamental Concepts of Psychoanalysis*, ed. Jacques-Alain Miller, trans. Alan Sheridan (New York: Norton, 1998), 95.

9. Ibid.

10. John Beverley, *Subalternity and Representation: Arguments in Cultural Theory* (Durham: Duke University Press, 1999), 26.

11. Rancière, *The Future of the Image*, 15.

12. Elena Poniatowska, *Fuerte es el silencio* (Mexico City: Era, 1980), 43: "Algo se perdió irremediablemente (la muerte es siempre irrecuperable), pero algo se ganó."

13. In deploying such concepts as "civil society" and "social movement," I once again have in mind Beasley-Murray's critique: "The new social movements give civil society positive content, flesh out what would otherwise be an obscure and ill-defined term, and (civil society theorists tell us) make it worthy of our approbation and encouragement" (*Posthegemony*, 72).

14. Poniatowska, *Massacre in Mexico*, 6; idem, *La noche de Tlatelolco* [1971], 16.

15. Poniatowska, *Fuerte es el silencio*, 51: "A partir de ese momento, la vida de muchos mexicanos quedó dividida en dos: antes y después de Tlatelolco."

16. Benjamin, *The Arcades Project*, Convolute N7a, 1, 470.

17. Poniatowska, *Massacre in Mexico*, 227; idem, *La noche de Tlatelolco* [1971], 188: "Empecé a ver todo nublado, no sé si por las lágrimas o por el agua que caía. Presenciaba la matanza a través de esa cortina de lluvia, pero todo lo veía borroso, ondulante, como mis fotografías en la emulsión, cuando empiezan a revelarse . . .

No veo bien, no veo. Moqueaba, sorbía mis mocos, sacaba fotos sin ver, el lente salpicado de agua, salpicado de lágrimas."

18. Benjamin, *The Arcades Project*, Convolute N11, 3, 476.

19. To be sure, the point of reference is Clausewitz: "The general unreliability of all information presents a special problem in war: all action takes place, so to speak, in a kind of twilight, which, like fog or moonlight, often tends to make things seem grotesque and larger than they really are" (*On War*, ed. Beatrice Heuser, trans. Michael Howard and Peter Paret [New York: Oxford University Press, 2006], 88–89). I thank Gareth Williams for reminding me of this passage.

20. My point of reference here is Paz, *The Other Mexico*, 236; idem, *Postdata*, 253.

21. To be sure, and as I note in the second chapter, that thinking has largely taken as its point of departure the events of the Second World War.

22. Poniatowska, *Massacre in Mexico*, 208; idem, *La noche de Tlatelolco* [1971], 171: "Todavía fresca la herida, todavía bajo la impresión del mazazo en la cabeza, los mexicanos se interrogan atónitos. La sangre pisoteada de cientos de estudiantes, hombres, mujeres, niños, soldados y ancianos se ha secado en la tierra de Tlatelolco. Por ahora la sangre ha vuelto al lugar de su quietud. Más tarde brotarán las flores entre las ruinas y entre los sepulcros."

23. Long, *Fictions of Totality*, 7.

24. I have in mind the following insight from Dragan Kujundzic's gloss on Derrida's *Archive Fever*: "Derrida keeps the strongest, most forceful protest of his polemics with Yerushalmi for the moment when this appropriation of both the inaugural moment of the archive (the past, the memory), and its disseminative, unrestrained capacity for the to-come, become appropriated by Yerushalmi for the unique, singular and totalizing topos of 'Israel'" ("Archigraphia: On the Future of Testimony and the Archive to Come," *Discourse* 25, no. 1 [2003]: 175).

25. This move defines Poniatowska's politics. See, for example, *Nada, nadie: Las voces del temblor* (Mexico City: Era, 1988), on the 1985 Mexico City earthquake. According to Poniatowska's reading of this later catastrophe, the earthquake produced another such "grassroots," democratic solidarity in Mexico. (It is significant, too, that the area around Tlatelolco suffered a great deal of the damage.) What these two texts suggest, in any case, is something like a Christological dimension inscribed in the relation between sacrifice and redemption, a redemption that, needless to say, is national.

26. Here I intend "sentimental" in the literary sense. I believe that Carlos Monsiváis was the first to make such a suggestion about the work. Poniatowska's sentimentalism is further discussed by Aníbal González, who, significantly, notes that, unlike that of García Márquez, whose sentimentalism, he argues, is ironic, like that of Stendhal and Flaubert, Poniatowska's belongs to a different order, described as "the imitation and rewriting of earlier forms of sentimental discourse" (la imitación y reescritura de formas previas del discurso sentimental) ("Viaje a la semilla del amor: *Del amor y otros demonios* y la nueva narrativa sentimental," *Hispanic Review* 73, no. 4 [2005]: 391).

27. Beverley has referred precisely to such a potential for *testimonio* as a genre, which he describes in terms of its postulation of a kind of "queered" nation. See *Testimonio: On the Politics of Truth* (Minneapolis: University of Minnesota Press, 2004), 24.

28. Beth E. Jörgensen, *The Writing of Elena Poniatowska: Engaging Dialogues* (Austin: University of Texas Press, 1994), 99.

29. Alberto Moreiras, *The Exhaustion of Difference: The Politics of Latin American Cultural Studies* (Durham: Duke University Press, 2001), 210.

30. Long, *Fictions of Totality*, 1.

31. I will attend to such questions in greater detail in the fifth chapter.

32. Jörgensen, *The Writing of Elena Poniatowska*, xiii.

33. Ibid.

34. I call the book a "work" here, as a way of intentionally sidestepping the thorny but by now somewhat played-out issue of its genre—put most simply, whether it is a narrative fiction or a work of *testimonio*—upon which Doris Sommer and Beth Jörgensen have commented extensively. See Doris Sommer, "Taking a Life: Hot Pursuit and Cold Rewards in a Mexican Testimonial Novel," *Signs* (1995): 913–940; Jörgensen, *The Writing of Elena Poniatowska*.

35. Elena Poniatowska, *Hasta no verte Jésus mío* (Mexico City: Era, 1982), 316: "Ahora ya no chingue. Váyase. Déjeme dormir."

36. Carmen Perilli, *Catálogo de ángeles mexicanos: Elena Poniatowska* (Rosario, Arg.: Beatriz Viterbo Editora, 2006), 14: "Las nanas, los primeros otros mitológicos de su historia personal, permanecen para siempre como mulitas. No pueden intercambiar sus lugares ni subvertirlos. Nacen y mueran dentro de su reino de silencio, sin otra resistencia que el cinismo rabioso de Jesusa Palancares."

37. Ibid.: "La autora reconoce sin pudores el peso de la deuda que tiene con ellas"; "Al sentirme cerca de las criadas, buscaba personajes que se les parecieran. En parte lo hice para evitar lo que soy."

38. Ibid., 33.

39. Beverley, *Testimonio*, 65.

40. In addition to the works discussed here (*La noche de Tlatelolco* and *Fuerte es el silencio*), I should add a text published in the aftermath of the 1985 Mexico City earthquake, *Nada, nadie*, mentioned above. Along similar lines, Poniatowska published a kind of personal chronicle of the protests following the controversial 2006 elections: *Amanecer en el Zócalo: Los 50 días que confrontaron a México* (Mexico City: Planeta, 2007).

41. Beverley, *Testimonio*, ix.

42. Sorensen, *A Turbulent Decade Remembered*, 75.

43. Sekula, "The Body and the Archive," 57 (original emphasis).

44. André Bazin, "The Ontology of the Photographic Image," trans. Hugh Gray, *Film Quarterly* 13, no. 4 (1960): 7–8.

45. Poniatowska, *Massacre in Mexico*, 314; idem, *La noche de Tlatelolco* [1971], 265: "No creo que las imágenes puedan mentir."

46. Baer, *Spectral Evidence*, 181.

47. Poniatowska, *La noche de Tlatelolco* (edición especial), 13–31.

48. Sorensen, *A Turbulent Decade Remembered*, 63.

49. Poniatowska, *Massacre in Mexico*, 186–187; idem, *La noche de Tlatelolco* [1971], n.p.: "Junto a la vieja Iglesia de Santiago Tlatelolco, se reunió confiada una multitud que media hora más tarde yacería desangrándose frente a las puertas del Convento que jamás se abrieron a niños, hombres y mujeres aterrados por la lluvia de balas."

50. Poniatowska, *Massacre in Mexico*, 32; idem, *La noche de Tlatelolco* [1971], 40: "Yo nunca he pensado realmente en Zapata como un símbolo estudiantil, un emblema. Zapata ya está integrado a la ideología burguesa; ya se lo apropió el PRI. Quizá por eso, en un principio, en nuestras manifestaciones escogimos al Che. ¡El Che nos unía también a todos los movimientos estudiantiles del mundo! Tampoco pensamos jamás en Pancho Villa. ¡Ése ni siquiera nos pasó por la cabeza!"

51. Poniatowska, *Massacre in Mexico*, 41; idem, *La noche de Tlatelolco* [1971], 48: "Ya no más porras injuriosas, olvídense de los insultos y de la violencia. No lleven banderas rojas. No carguen pancartas del Che, ¡no de Mao! ¡Ahora vamos a llevar la figura de Hidalgo, la de Morelos, la de Zapata, pa' que no digan! ¡Son nuestros héroes! ¡Viva Zapata! ¡Viva!"

52. The most extensive study of the matter is Pensado, *Rebel Mexico*.

53. Poniatowska, *Massacre in Mexico*, 150; idem, *La noche de Tlatelolco* [1971], 144.

54. Poniatowska, *Massacre in Mexico*, 22; idem, *La noche de Tlatelolco* [1971], 31: "No, yo no soy estudiante, pero soy joven."

55. Poniatowska, *Massacre in Mexico*, 34; idem, *La noche de Tlatelolco* [1971], 42: "Lo que pasa es que los obreros son bien reaccionarios."

56. Poniatowska, *Massacre in Mexico*, 34; idem, *La noche de Tlatelolco* [1971], 43: "No se puede romper el control gubernamental en fábricas y sindicatos."

57. Carey, *Plaza of Sacrifices*, 84.

58. Revueltas, *México 68*, 152–153. The reader is invited to relate the students' "allegorical" assumption of the workers' political struggle not only in light of the "confusion" between students and workers to which I refer in the first chapter, but also, as an introduction to the political field of the notion of illiteracy as developed in the work of Abraham Acosta: "the condition of semiological excess and ungovernability that emerges from the critical disruption of the field of intelligibility within which traditional and resistant modes of reading are defined and positioned" (*Thresholds of Illiteracy: Theory, Latin America, and the Crisis of Resistance* [New York: Fordham University Press, 2014], 9).

59. Poniatowska, *Massacre in Mexico*, 147; idem, *La noche de Tlatelolco* [1971], 142: "Si el Movimiento Estudiantil logró desnudar a la Revolución, demostrar que era una vieja prostituta inmunda y corrupta, ya con eso se justifica."

60. Poniatowska, *Massacre in Mexico*, 62; idem, *La noche de Tlatelolco* [1971], 68: "Siempre me asombró la actitud de los profesores universitarios . . . Al igual que a los jóvenes parecía encantarles el relajo."

61. See Long, *Fictions of Totality*.

62. Jörgensen, *The Writing of Elena Poniatowska*, 83.

63. Consider, for example, her treatment of the case of the student activist and perceived traitor Sócrates Campos Lemus. See, for example, Sorensen, *A Turbulent Decade Remembered*, 72.

64. Jörgensen, *The Writing of Elena Poniatowska*, 83–84.

65. Ernesto Laclau, *Emancipation(s)* (London: Verso, 1996), 48.

66. Revueltas, *México 68*, 152: "no puede comprenderse sino en su fluir, unido a una sucesión de momentos que jamás ofrecen una continuidad lineal ni resisten una definición unívoca."

67. Zermeño, *México*, 95: "Esos tres meses sólo se pueden entender en esos tres meses."

68. This evokes Paz's comments in *Postdata*, upon which I comment in the first chapter. "Narrow gateway" is a reference to the opening to messianic time of which Benjamin writes in "On the Concept of History," famously translated as "strait gate" in *Illuminations*; see Walter Benjamin, "Theses on the Philosophy of History," in *Illuminations*, trans. Harry Zohn (New York: Schocken, 1969), 264.

69. Laclau, *Emancipation(s)*, 22.

70. Sorensen, *A Turbulent Decade Remembered*, 77.

71. Zermeño, *México*, 139: "La reconstrucción de la identidad o la alianza, que ya había dado ciertas muestras de debilitamiento, ante la nueva escalada de represión que ahora será total y que confundirá entre los escombros, para la memoria colectiva, los distintos materiales que edificaron el movimiento, es la otra característica de esta etapa."

72. Ramírez, *El movimiento estudiantil*, 1: 190: "Los estudiantes exigimos a las autoridades correspondientes la solución inmediata de los siguientes puntos: 1. Libertad a los presos políticos. 2. Destitución de los generales Luis Cueto Ramírez y Raúl Mendiela. 3. Extinción del Cuerpo de Granaderos, instrumento directo de la represión y no creación de cuerpos semejantes. 4. Derogación del artículo 145 y 145 bis del C.P.F. (delito de Disolución Social) instrumentos jurídicos de la agresión. 5. Indemnización a las familias de los muertos y los heridos que fueron víctimas de la agresión desde el viernes 26 de julio en adelante. 6. Deslindamiento de responsabilidades de los actos de represión y vandalismo por parte de las autoridades a través de policía, granaderos y ejército."

73. Zermeño, *México*, 29.

74. Ibid., 24: "El estudiantado o cualquier otro agregado social puede encontrarse profundamente dividido en muchos momentos; sin embargo por alguna razón, en una coyuntura específica, se genera una alianza por encima de estas divisiones, y esa identidad puede incluso extenderse hacia otros agregados más lejanos o más cercanos."

75. Laclau, *On Populist Reason*, 72.

76. Zermeño, *México*, 34: "la demanda de 'excarcelación de todos los estudiantes detenidos' fuera sustituido por la de 'libertad a los presos políticos.'"

77. Cited in Poniatowska, *Massacre in Mexico*, 150–151; idem, *La noche de Tlatelolco* [1971], 145: "que aspiró crear un sindicalismo independiente."

78. Badiou, *The Century*, 9–10 (original emphasis).

79. Revueltas, *México 68*, 146: "El contenido socialista del Movimiento es real sólo en cierta medida y, en el futuro del Movimiento—en términos históricos, de duración variable—, tiende a agotarse, en la medida en que se vayan produciendo las diferenciaciones inevitables, necesarias, incluso por las que tiene que luchar un movimiento marxista, impulsándolas precisándolas."

80. Poniatowska, *Massacre in Mexico*, 6; idem, *La noche de Tlatelolco* [1971], 16: "Tlatelolco es la escisión de dos Méxicos."

81. David E. Johnson, "Mexico's Gas, Mexico's Tears: Expositions of Identity," in *What Happens to History: The Renewal of Ethics in Contemporary Thought*, ed. Howard Marchitello (London: Routledge, 2001), 157.

82. This conception of May 1968 has been widely dismissed as both a caricature and a reaction formation. On this score, see Ross, *May '68*.

83. Elena Poniatowska, "Son cuerpos señor . . . ," *Equis: Cultura y Sociedad* 5 (1998): 3: "1968 fue al año de Vietnam, de Biafra, de los asesinatos contra Martin Luther King y Robert Kennedy . . . de la reivindicación del pueblo negro, de los Black Panthers, de la Primavera Negra, del movimiento hippie, que llegó hasta la humilde choza ahumada en las montañas de Oaxaca de la chamana María Sabina, quien ofició la ceremonia de los hongos alucinantes y sin embargo para México 1968 tiene un solo nombre: Tlatelolco, 2 de octubre."

84. Jörgensen, *The Writing of Elena Poniatowska*, 83.

85. Poniatowska, *Fuerte es el silencio*, n.p: "Si en otros países se usaron gases lacrimógenos, aquí se dispararon balas."

86. For a study of the debates surrounding the mestizo identity in the neoliberal moment, see Carrie C. Chorba, *Mexico, from Mestizo to Multicultural: National Identity and Recent Representations of the Conquest* (Nashville: Vanderbilt University Press, 2007).

87. Poniatowska, *Massacre in Mexico*, 225; idem, *La noche de Tlatelolco* [1971], 186: "Hermanito, ¿qué tienes? Hermanito, contéstame."

88. Poniatowska, *Massacre in Mexico*, 225; idem, *La noche de Tlatelolco* [1971], 186: "Varios cadáveres en la Plaza de las Tres Culturas. Decenas de heridos . . . Y las ráfagas aún continuaban."

89. Poniatowska, *Massacre in Mexico*, 226; idem, *La noche de Tlatelolco* [1971], 188: "Entonces me dieron permiso de seguir la camilla. Subí con mi hermano a la ambulancia militar."

90. Poniatowska, *Massacre in Mexico*, 227; idem, *La noche de Tlatelolco* [1971], 188: "ÚNETE-PUEBLO— ÚNETE-PUEBLO— ÚNETE-PUEBLO— ÚNETE-PUEBLO—."

91. Poniatowska, *Massacre in Mexico*, 227; idem, *La noche de Tlatelolco* [1971], 188: "Hermanito, ¿por qué no me contestas?"

92. Poniatowska, *Massacre in Mexico*, 228; idem, *La noche de Tlatelolco* [1971], 189: "Julio tenía 15 años, estudiaba en la Vocacional número 1 que está cerca de la Unidad Tlatelolco. Era la segunda vez que asistía a un mitin político. Él me invitó a ir ese día. La primera vez, fuimos los dos juntos a la gran manifestación silenciosa. Julio era mi único hermano."

93. Badiou, *The Century*, 109–110.

94. Poniatowska, *Massacre in Mexico*, 233; idem, *La noche de Tlatelolco* [1971], 193: "Mi padre murió poco tiempo después de que muriera Julio. Como resultado del choque, tuvo un ataque al corazón. Era su único hijo, el menor. Repetía muchas veces: 'Pero, ¿por qué mi hijo? . . .' Mi madre sigue viviendo, quién sabe cómo."

95. It is significant that Poniatowska's book on her involvement in Andrés Manuel López Obrador's failed 2006 electoral campaign is titled *Amanecer en el Zócalo*: the democratic promise founded in sacrifice on the Plaza de las Tres Culturas has seen Mexico through the long night of Tlatelolco. Aside from the emotional force of the sequence, it once again intimates the book's structure, as set out in the opening photographic narrative, a sequence, as I suggest above, that possibly inscribes itself in the history of Poniatowska's writing. It could be said that a trilogy begins to take shape around the series *La noche de Tlatelolco; Nada, nadie; Amanecer en el Zócalo*; this sequence documents a gradual democratization as well as a move from Tlatelolco and into the Zócalo, Mexico City's main public square.

96. Sorensen, *A Turbulent Decade Remembered*, 75.

97. See chapter 1 here for further discussion of this site as an archive-origin.

CHAPTER 4: EXORCINEMA

1. See, among others, Ernesto Laclau's quite succinct "Why Constructing a People Is the Main Task of Radical Politics," *Critical Inquiry* 32, no. 4 (2006): 646–680, in which he writes that "the most relevant point for our subject is that fullness—the Freudian Thing—is unachievable; it is only a retrospective illusion that is substituted by partial objects embodying that impossible totality" (651).

2. Monsiváis, *Días de guardar*, 302.

3. Kracauer, "Photography," 51.

4. Benjamin, "On the Concept of History," 396.

5. This cinematic factory organizes the labor of the spectator. For this insight, I am indebted to Jonathan Beller, *The Cinematic Mode of Production: Attention Economy and the Society of the Spectacle* (Lebanon, N.H.: Dartmouth College Press, 2006). The precise nature of the labor engaged by cinema here could perhaps be described as a depoliticizing mourning work that serves as a preparation for the neoliberal, technocratic state form that was emergent in late-1980s Mexico.

6. Benjamin, "On the Concept of History," 390 (original emphasis).

7. The PRI has since regained power with the election in 2012 of Enrique Peña Nieto, who was strongly backed by Salinas.

8. Héctor Aguilar Camín and Lorenzo Meyer, *In the Shadow of the Mexican Revolution: Contemporary Mexican History, 1910–1989*, trans. Luis Alberto Fierro (Austin: University of Texas Press, 1993), 232.

9. Ibid., 230.

10. Ignacio M. Sánchez Prado offers a comprehensive account of this transition, reading its aesthetic consequences in light of the changing economic and material conditions of Mexican cinema spectatorship. See *Screening Neoliberalism: Mexican Cinema, 1988–2012* (Nashville: Vanderbilt University Press, 2014).

11. Niamh Thornton, *Revolution and Rebellion in Mexican Film* (New York: Bloomsbury, 2013), 120.

12. George Yúdice, *The Expediency of Culture: Uses of Culture in the Global Era* (Durham: Duke University Press, 2003), 1.

13. Ibid., 29.

14. See the comparison of *El bulto* and *En el aire* (de Llaca, 1995) in Sánchez Prado, *Screening Neoliberalism*, 110–121.

15. Aguilar Camín, *Después del milagro*, 283: "Fue una generación de temple radical que soñó radicalmente los cambios que deseaba para México. En el apogeo del gran monólogo institucional de los sesentas exigió a gritos el diálogo."

16. Ibid., 284: "La desigualdad, no la democracia, es el problema difícil de México, el verdadero lastre de su historia."

17. Paz, *The Other Mexico*, 225; *Postdata*, 244.

18. Laura Mulvey, *Death 24× a Second: Stillness and the Moving Image* (London: Reaktion Books, 2006), 67.

19. Indeed, the use of *Battleship Potemkin* is far too suggestive for a just treatment here. However, I would at least like to underline the force of the association between 1968 and 1905 that Marker advances as a question of naming: "When the director found himself on location in Odessa to film one segment, he was so inspired by the form of the steps which led to the port in that city, that he revised the plan and made the sequence on these steps the central focus of the resulting film— which became not the YEAR 1905, but POTEMKIN" (Maureen Kiernan, "Making Films Politically: Marxism in Eisenstein and Godard," *Alif: Journal of Comparative Poetics*, no. 10 [1990]: 94). This is to say, Eisenstein follows the very logic of naming that is pursued in the narration of Mexico, 1968 under the name of the Tlatelolco massacre. An instructive distinction might be drawn here between Odessa and Tlatelolco. The name "Tlatelolco" marks the finitude of the 1968 movement that might be recuperated in the future as a call for justice or restitution. The name "Potemkin," on the contrary, marks something quite different. If Eisenstein's film centers on the massacre of civilians by Czarist forces on the steps of the Odessa port, it equally marks the response of the *Potemkin* crewmembers, who, upon seeing this massacre, retaliate and thus inaugurate communist solidarity.

20. Salvador Elizondo, "Entre el Nuevo Cine y *Rojo amanecer*," in *Estanquillo* (Mexico City: Fondo de Cultura Económica, 2001), 13.

21. Ibid., 15.

22. Ibid., 13.

23. Mary Ann Doane, *The Emergence of Cinematic Time: Modernity, Contingency, the Archive* (Cambridge: Harvard University Press, 2002), 147.

24. See William Egginton, "Reality Is Bleeding: A Brief History of Film from the Sixteenth Century," *Configurations* 9, no. 2 (2001): 207–229.

25. Doane, *The Emergence of Cinematic Time*, 153.

26. Carlos Montemayor, *Rehacer la historia: Análisis de los nuevos documentos del 2 de octubre de 1968 en Tlatelolco* (Mexico City: Planeta, 2000), 43: "Podemos descartar ese emplazamiento por un dato simple: en el techo de la iglesia hubo un comando de francotiradores, no de camarógrafos."

27. Bruno Bosteels, "Mexico City through the Lens of Violence and Utopia," *ReVista: Harvard Review of Latin America* 2 (2003): 70. Here I should mention a late entry to the genre, Carlos Bolado's *Tlatelolco, verano del 68* (2012), which rewrites 1968 as a class-divided *Romeo and Juliet*.

28. David Harvey, *A Brief History of Neoliberalism* (Oxford: Oxford University Press, 2005), 41.

29. This specter, as a general tendency of Cuarón's cinematic endeavor, is again even more marked in *Children of Men* (2006). Indeed, at one point in that film, Cuarón seems to have been planning to make a film dedicated to 1968 in Mexico (http://www.eluniversal.com.mx/espectaculos/75477.html).

30. Maricruz Castro Ricalde, "Popular Mexican Cinema and Undocumented Immigrants," trans. Emily Hind, *Discourse* 26, no. 1 (2004): 201.

31. Hester Baer and Ryan Long, "Transnational Cinema and the Mexican State in Alfonso Cuarón's *Y tu mamá también*," *South Central Review* 21, no. 3 (2004): 153.

32. Ibid., 167n14.

33. Mraz, *Looking for Mexico*, 210–211.

34. Ibid., 211.

35. Baer and Long, "Transnational Cinema," 154.

36. Mulvey, *Death 24× a Second*, 14–15.

37. Daniel Chávez, "The Eagle and the Serpent on the Screen: The State as Spectacle in Mexican Cinema," *Latin American Research Review* 45, no. 3 (2010): 134.

38. See Lippit, *Atomic Light*, 49.

39. Andrés de Luna, "The Labyrinths of History," in *Mexican Cinema*, ed. Paulo Antonio Paranaguá, trans. Ana M. López (London and Mexico City: British Film Institute/IMCINE, 1993), 177.

40. David William Foster, *Mexico City in Contemporary Mexican Cinema* (Austin: University of Texas Press, 2002), 5.

41. Christian Metz, *The Imaginary Signifier: Psychoanalysis and the Cinema*, trans. Celia Britton et al. (Bloomington: Indiana University Press, 1982), 3.

42. See the first chapter for further discussion of this passage in Paz.

43. Derrida, *Archive Fever*, 1–2 (original emphasis).

44. David R. Maciel, "Cinema and the State in Contemporary Mexico, 1970–

1999," in *Mexico's Cinema: A Century of Filmmakers*, ed. Joanne Hershfield and David R. Maciel (Wilmington, Del.: Scholarly Resources, 1999), 218. To be sure, this perception is in part due to state censorship. See Mraz, *Looking for Mexico*, 212.

45. Carlos Monsiváis, "Mexican Cinema: Of Myths and Demystifications," in *Mediating Two Worlds: Cinematic Encounters in the Americas*, ed. John King et al. (London: British Film Institute, 1993), 145.

46. Derrida, *Archive Fever*, 11.

47. Fernando Eimbcke's *Temporada de patos* (2004) is in some sense the same film as *Rojo amanecer*. Against the verisimilitude of *Rojo amanecer*, Eimbcke's film, also shot on location at Tlatelolco but rather Jarmuschian in theme, more subtly intimates the future of emancipatory politics.

48. See Deborah Shaw, *The Three Amigos: The Transnational Filmmaking of Guillermo Del Toro, Alejandro González Iñárritu, and Alfonso Cuarón* (Manchester, U.K.: Manchester University Press, 2013).

49. See chapter 4 of Sánchez-Prado, *Screening Neoliberalism*.

50. Niels Niessen, "Miraculous Realism: Spinoza, Deleuze, and Carlos Reygadas's *Stellet Licht*," *Discourse* 33, no. 1 (2011): 28.

51. Ibid., 30.

52. Ibid.

53. Ibid., 32.

54. Sánchez-Prado, *Screening Neoliberalism*, 207.

55. Lippit, *Atomic Light*, 33.

56. "The intellectual must find through his action the field in which he can rationally perform the most efficient work. Once the front has been determined, his next task is to find out within that front exactly what is the enemy's stronghold and where and how he must deploy his forces. It is in this harsh and dramatic daily search that a culture of the revolution will be able to emerge, the basis which will nurture, beginning right now, the new man exemplified by Che—not man in the abstract, not the 'liberation of man,' but another man, capable of arising from the ashes of the old, alienated man that we are and which the new man will destroy by starting to stoke the fire today" (Fernando Solanas and Octavio Getino, "Towards a Third Cinema: Notes for the Development of a Cinema of Liberation in the Third World," in *New Latin American Cinema, Volume I: Theory, Practices, and Transcontinental Articulations*, ed. Michael T. Martin, trans. Julianne Burton and Michael T. Martin [Detroit: Wayne State University Press, 1997], 36). By "only cinema," I mean to suggest the way in which the "third-ness" of cinema would have been its condition of Latin American-ness.

57. Tiago de Luca's reading of this kiss suggests something in the direction of a secularization of the "miracle": "more than the idea of resurrection, this scene evokes a fairy tale trope: the prince who awakens the sleeping beauty with a kiss." See "Carnal Spirituality: The Films of Carlos Reygadas," *Senses of Cinema*, accessed 31 March 2012, http://www.sensesofcinema.com/2010/feature-articles/carnal-spirituality-the-films-of-carlos-reygadas-2/.

58. Niessen, "Miraculous Realism," 32. On the tactile in Reygadas, see de Luca "Carnal Spirituality."

59. On sacrifice in Reygadas, see Craig Epplin, "Sacrifice and Recognition in Carlos Reygadas's *Japón*," *Mexican Studies / Estudios Mexicanos* 28, no. 2 (2012): 287–305.

60. Niessen, "Miraculous Realism," 35.

61. In this regard, see again de Luca "Carnal Spirituality."

62. Roger Bartra, "The Mexican Office: Miseries and Splendors of Culture," in *Blood, Ink, and Culture: Miseries and Splendors of the Post-Mexican Condition*, trans. Mark Alan Healey (Durham: Duke University Press, 2002), 4.

63. See Niessen, "Miraculous Realism," 49.

64. Monsiváis, *Días de guardar*, 302.

CHAPTER 5: LITERARY RESTORATION

1. Badiou, *The Century*, 26. For more on "restoration," see Nina Power and Alberto Toscano, "The Philosophy of Restoration: Alain Badiou and the Enemies of May," *boundary 2* 36, no. 1 (2009): 27–46, as well as, in a somewhat different register, the sixth chapter of John Beverley, *Latinamericanism after 9/11* (Durham: Duke University Press, 2011).

2. Luis Leal, "Tlatelolco, Tlatelolco," in *A Luis Leal Reader*, ed. Ilan Stavans (Chicago: Northwestern University Press, 2007), 348 (my emphasis).

3. While I cannot hope to be exhaustive—the body of criticism on the literature of Tlatelolco is quite voluminous—two more studies are notable for their attempts to trace the possible continuities of this sequence in Mexican political thought and literary representation: Ignacio Corona, *Después de Tlatelolco: Las narrativas políticas en México (1976–1990): Un análisis de sus estrategias retóricas y representacionales* (Guadalajara: Universidad de Guadalajara, 2001); and Brewster, *Responding to Crisis*.

4. Taibo, *'68* (trans.), 5; idem, *'68*, 5: "Este libro que nunca me saldrá bien, es para mi cuatísimo Guillermo Fernández, porque seguro que su memoria es mejor, y también para Óscar Moreno, cuya memoria debe ser prestada, porque el día en que entraron los tanques a CU, aún no había nacido."

5. Marianne Hirsch develops the term "postmemory" in her work on photography and the Nazi holocaust. Hirsch writes: "Postmemory is distinguished from memory by generational distance and from history by deep personal connection. Postmemory is a powerful and very particular form of memory precisely because its connection to its object or source is mediated not through recollection but through an imaginative investment and creation" (*Family Frames*, 22). Hirsch's intervention centers on the memory of the Nazi holocaust in Europe; the postmemorial order of these events has a particular, if indeed problematic, delineation, Jewish peoplehood and the State of Israel being the clearest orientations of this legacy. See Eric L.

Santner, *Stranded Objects: Mourning, Memory, and Film in Postwar Germany* (Ithaca, N.Y.: Cornell University Press, 1993), which explores similar problems regarding questions of legacy and responsibility for later generations of Germans.

6. Taibo, *'68* (trans.), 13; idem, *'68*, 11: "¿Dónde arrojaron a nuestros muertos? ¿Dónde tiraron a nuestros muertos? ¿Dónde mierdas arrojaron a nuestros muertos?"

7. Taibo, *'68* (trans.), 9; idem, *'68*, 7: "Se explica que con cosas como estas nunca puede escribir una novela."

8. See Sorensen, *A Turbulent Decade Remembered*. One of the more interesting among recent interventions on the status of the sixties today, Sorensen's nevertheless inserts the category of memory, even as her book does not fundamentally concern the memory of the sixties but, rather, a revisiting of many texts written during that "turbulent decade."

9. Deborah Cohn, "The Mexican Intelligentsia, 1950–1968: Cosmopolitanism, National Identity, and the State," *Mexican Studies / Estudios Mexicanos* 21, no. 1 (2005): 144.

10. Benjamin, "On the Concept of History," 391.

11. Taibo, *'68* (trans.), 119; idem, *'68*, 108.

12. Taibo, *'68* (trans.), 122; idem, *'68*, 111: "Y entonces descubro que parecemos condenados a ser fantasmas del 68. Y bueno, ¿cuál es la bronca? Mucho mejor condes Dráculas de la resistencia, que monstruos priístas de Frankenstein o de la modernidad, me digo. Y entonces, saco chispas sin gracia de las teclas, bengalitas, recuerdos que a veces duelen a las más levantan sonrisa; yo añoro aquel sentido de humor, extraño esa perdida intensidad para tener miedo de las sombras, aquella sensación de inmortalidad, ese otro yo de aquel interminable año."

13. Taibo, *'68* (trans.), 11; idem, *'68*, 9: "Nunca pude escribir esa novela. Probablemente es una novela que no quiere ser escrita."

14. Luis Spota, *La plaza* (Mexico City: Planeta, 2006). See also María Luisa Mendoza, *Con él, conmigo, con nosotros tres* (Mexico City: Joaquín Mortiz, 1971), analyzed in the third chapter of Long, *Fictions of Totality*.

15. González de Alba, *Los días y los años*; José Revueltas, *El apando* (Mexico City: Era, 2005).

16. Significantly, Felipe Cazals adapted *El apando* (1976) for the cinema. It stars María Rojo, who plays the mother in Fons's *Rojo amanecer*.

17. Ryan Long points out the list of illustrious "witnesses" of Mexican history who have served time in the prison, and also the way in which throughout her career as a writer, Poniatowska drew on its inmates as a kind of "library." One need only scan the list of those who give testimony in *La noche de Tlatelolco* to realize how true this is: many of their names are accompanied by the supplementary information "preso en Lecumberri." See Ryan Long, "Lecumberri, Fact, and Fiction: The Prison Writings of Álvaro Mutis and Luis González de Alba," *Revista de Estudios Hispánicos* 40 (2006): 361–362.

18. Héctor Aguilar Camín, *La guerra de Galio* (Mexico City: Cal y Arena, 1989); see also Alberto Moreiras, "Ethics and Politics in Héctor Aguilar Camín's

Morir en el Golfo and *La guerra de Galio*," *South Central Review* 21, no. 3 (2004): 70–84.

19. Sara Sefchovich, *México: País de ideas, país de novelas. Una sociología de la literatura mexicana* (Mexico City: Grijalbo, 1987), 216: "Casi treinta libros se publicaron en los quince años inmediatamente posteriores al hecho y con las más diversas tendencias narrativas y posiciones ideológicas."

20. Andrea Revueltas and Philippe Cheron, prologue to *José Revueltas y el 68* (Mexico City: Era/UNAM, 1998), 23.

21. Horacio Legrás, "The Revolution and Its Specters: Staging the Popular in the Mexican Revolution," *Journal of Latin American Cultural Studies* 14, no. 1 (2005): 3.

22. At the end of the book, Volpi offers a prepared bibliography in which, in a Borgesian gesture, he includes Aníbal Quevedo's own *Obra completa* (published by Fondo de Cultura Económica and edited by Christopher Domínguez Michael), as well as a series of nonexistent critical essays on Quevedo by Fuentes, Monsiváis, and others.

23. Jorge Volpi, *El fin de la locura* (Mexico City: Seix Barral, 2003), 142: "Tlatelolco me bautizó."

24. Williams, *The Mexican Exception*, 150; González de Alba, *Los días y los años*, 159.

25. Volpi, *El fin de la locura*, 259: "Como Barthes, yo también me siento profundamente desencantado hacia la revolución pero, a diferencia suya, me parece que su desafío se ha trasladado al mundo del arte contemporáneo."

26. Volpi, *El fin de la locura*, 438: "Ahora debo decidir qué hacer: pactar con él y traicionarme o resistir su ira hasta el final."

27. Jorge Volpi, *En busca de Klingsor* (Mexico City: Seix Barral, 1999); idem, *No será la tierra* (Mexico City: Alfaguara, 2006). It is, to my mind, not trivial that Claire Bishop offers a remarkably similar periodization for the emergence of participatory arts, which will be the subject of chapter 6. Writes Bishop: "From a Western European perspective, the social turn in contemporary art can be contextualised by two previous historical moments, both synonymous with political upheaval and movements for social change: the historic avant-garde in Europe circa 1917, and the so-called 'neo' avant-garde leading to 1968. The conspicuous resurgence of participatory art in the 1990s leads me to posit the fall of communism in 1989 as a third point of transformation. Triangulated, these three dates form a narrative of the triumph, heroic last stand and collapse of a collectivist vision of society" (*Artificial Hells: Participatory Art and the Politics of Spectatorship* [London: Verso, 2012], 3).

28. Mexican literary critic Christopher Domínguez Michael cites this as a coincidence with the Boom that helped inaugurate the Crack Generation. See his "La patología de la recepción," *Letras Libres* (March 2004): 48.

29. See Rafael Lemus, "Lo que todo lectora [no] quisiera saber del siglo XX," *Letras Libres* (December 2006): 74.

30. Domínguez Michael, "La patología de la recepción," 50.

31. Harvey, *A Brief History of Neoliberalism*, 3.

32. On this score, see Gerald Martin, *Journeys through the Labyrinth* (London: Verso, 1989), 204–205. Although the list is subject to debate, the principal writers associated with this confluence are Julio Cortázar, Carlos Fuentes, Gabriel García Márquez, and Mario Vargas Llosa. Countless studies engage the so-called Boom, but in addition to Martin's evenhanded and comprehensive readings, see Ángel Rama's brilliant and classic "El 'boom' en perspectiva," in *Más allá boom: Literatura y mercado*, ed. Ángel Rama et al. (Mexico City: Marcha, 1981); see also the rivetingly polemical Jaime Mejía Duque, *Narrativa y neocoloniaje en América Latina* (Buenos Aires: Crisis, 1974).

33. Pedro Ángel Palou et al., "Manifesto del crack," in *Crack: Instrucciones de uso* (Mexico City: Mondadori, 2004), sec. II: "No hay, pues, ruptura, sino continuidad." See also the more expansive and—if also mythologizing—more fully developed work of generational periodization, Ricardo Chávez Castañeda and Celso Santajuliana, *La generación de los enterradores* (Mexico City: Nueva Imagen, 2000), which takes on the "task" of literary renewal as a defining characteristic demanded of authors born in the sixties.

34. Danny J. Anderson, "The Novels of Jorge Volpi and the Possibility of Knowledge," *Studies in the Literary Imagination* 33, no. 1 (2000): 1.

35. Burkhard Pohl, "'Ruptura y continuidad.' Jorge Volpi, el Crack y la herencia del 68," *Revista de Crítica Literaria Latinoamericana* 30, no. 59 (2004): 57: "A nivel poetológico, el espíritu de continuidad y reminiscencia del Boom trasluce, en particular, en las coincidencias entre el Manifiesto Crack y el ensayo-manifiesto *La nueva narrativa hispanoamericana* (1969) de Carlos Fuentes. Desde una interpretación de modernidad literaria que parte de Agustín Yáñez como fundador de la nueva narrativa mexicana . . . ambos textos atribuyen mayor importancia a la renovación lingüística, es decir, la 'resurrección del lenguaje perdido' [y] la 'apertura al discurso.'"

36. Ibid., 48.

37. Brett Levinson, *The Ends of Literature: The Latin American "Boom" in the Neoliberal Marketplace* (Stanford: Stanford University Press, 2001), 28.

38. Long, *Fictions of Totality*.

39. Roberto Bolaño, "Sevilla me mata," in *Palabra de América* (Barcelona: Seix Barral, 2004), 17: "Venimos de la clase media o de un proletariado más o menos asentado o de familias de narcotraficantes de segunda línea que ya no desean más balazos sino respetabilidad. La palabra clave es respetabilidad."

40. I am borrowing "refuge" from Bosteels's formulations on Mexican cinema of the early 2000s. See "Mexico City through the Lens of Violence and Utopia," 70.

41. Badiou, *The Century*, 26.

42. François Cusset, *French Theory: How Foucault, Derrida, Deleuze, & Co. Transformed the Intellectual Life of the United States*, trans. Jeff Fort (Minneapolis: University of Minnesota Press, 2008), 299.

43. Ibid., 300.

44. Volpi, *El fin de la locura*, 10: "Este libro es una obra de ficción. Cualquier semejanza con la realidad es culpa de esta última."

45. To be sure, this carceral hopelessness links the novel to the early attempts at a novel of '68, namely, González de Alba, *Los días y los años*, as well as Revueltas, *El apando*, two more ghosts among many.

46. My point of reference is, again, Rancière, *Disagreement*.

47. Ibid., 28 (original emphasis).

48. Ibid., 29–30 (original emphasis).

49. Badiou, *The Century*, 26.

50. My point of reference here is the episode surrounding Cuban writer Heberto Padilla's 1968 collection of poems, *Fuera del juego*, which the Unión de Escritores y Artistas de Cuba found too counterrevolutionary. His imprisonment aroused suspicions of a perceived Stalinization in Cuba and provoked significant sectors of the international Left, particularly of the Latin American cultural Left, to more critical postures with respect to Cuba.

51. Volpi's relation of the Castro visit seems in line with a certain liberal narrative, according to which the true betrayal of Chile occurs not on 11 September (nor in the "bourgeois uprising" that preceded it), but, rather, in the possible Cubanization of the Chilean process presaged by the apparent warmth between two charismatic leaders.

52. Jorge Volpi, "El fin de la conjura," *Letras Libres* (October 2000): 56–60; idem, "The End of the Conspiracy: Intellectuals and Power in 20th-Century Mexico," trans. Carl Good, *Discourse* 23, no. 2 (2001): 144–154.

53. Volpi, *El fin de la locura*, 225: "Padilla es un contrarrevolucionario. Todo el mundo lo sabe . . . Y ahora él mismo lo ha reconocido."

54. Ibid.: "Todo es producto de una conjura promovida por el propio Padilla . . . Por eso Cortázar y García Márquez desaprobaron la publicación del desplegado."

55. Ibid.: "Como tantos jóvenes de la época, permanecía hipnotizada por el comandante."

56. Ibid., 183: "No cometía ninguna infracción contra la causa, simplemente me rendía a las inquebrantables leyes de la supervivencia." Perhaps Aníbal Quevedo's hunger strike should be compared to the one undertaken by José Revueltas during his incarceration at Lecumberri; see Revueltas, *México 68*, 211–213, 218–220.

57. My point of reference is, again, Badiou, *The Century*. To be sure, the likely object of satire is a sacrificial notion of political action, related, in this case, to the idea of the New Man, as discussed above.

58. Volpi, *El fin de la locura*, 226: "Yo por fin tenía claro lo que quería hacer: escribir como Lacan y como Althusser, como Barthes y como Foucault. Si no me atreví decirlo a Claire, fue porque ser escritor en Cuba en esos momentos significaba identificarse con los enemigos de la revolución. Fue entonces cuando el azar desvió otra vez nuestros caminos."

59. Roger Zapata explores these engagements in "La pobreza de la filosofía

como material novelesco: *El fin de la locura* de Jorge Volpi," *A Contracorriente* 2, no. 1 (2004): 57–66.

60. Michel Foucault, *Discipline and Punish: The Birth of the Modern Prison*, trans. Alan Sheridan (New York: Vintage, 1977), 236.

61. Ibid., 304.

62. Ibid., 307.

63. Ibid., 217.

64. Jacques Derrida, *Resistances of Psychoanalysis*, trans. Peggy Kamuf (Stanford: Stanford University Press, 1998), 118.

65. Moreiras, "Posthegemonía."

66. Paz, *The Other Mexico*, 225; *Postdata*, 244.

67. Michel Foucault, *History of Sexuality: Volume One*, trans. Robert Hurley (New York: Vintage, 1980), 138 (my emphasis).

68. Volpi, *La imaginación y el poder*, 434.

69. Ibid., 69: "A partir de los años sesenta, Fuentes se ve a sí mismo no sólo como un novelista, sino como un 'intelectual latinoamericano.' Su responsabilidad histórica es tremenda."

70. To be sure, it has been argued that an archival appearance circumscribes Latin American letters as such. See Roberto González Echevarría, *Myth and Archive: A Theory of Latin American Narrative* (Durham: Duke University Press, 1998).

71. As David Harvey puts it: "The objectives of individual freedom and social justice were uneasily fused in the movement of '68. The tension was most evident in the fraught relationship between the traditional left (organized labor and political parties espousing social solidarities) and the student movement desirous of individual liberties . . . While it is not impossible to bridge such differences, it is not hard to see how a wedge might be driven between them. Neoliberal rhetoric, with its foundational emphasis upon individual freedoms, has the power to split off libertarianism, identity politics, multiculturalism, and eventually narcissistic consumerism from the social forces ranged in pursuit of social justice through the conquest of state power" (*A Brief History of Neoliberalism*, 41).

72. Volpi, *El fin de la locura*, 13: "Tal vez ha llegado el momento de volver a la cordura."

73. Ibid., 462: "Yo soy la desquiciada, la violenta, la rebelde, ¿lo recuerdas? Oigo voces. Siempre me mantengo en pie de guerra. Y nunca transijo. Lo siento, Aníbal: a diferencia de ti, yo no pienso renunciar a la locura."

74. Volpi, "The End of the Conspiracy," 145; idem, "El fin de la conjura," 56: "En un país construido con la idea de que un solo partido—o un solo hombre—domina toda la vida social, al intelectual no le quedan muchas opciones."

75. In its presentation of this death, the novel might be said to introduce death into the neoliberal market. The market, which excludes death, is faced with, to borrow Levinson's turn of phrase, that which recalls or performs mortality. See *Market and Thought: Mediations on the Political and Bipolitical* (New York: Fordham University Press, 2004), 46.

76. My point of reference is again Benjamin, "On the Concept of History."

77. Alberto Moreiras, "Infrapolitical Literature: Hispanism and the Border," *CR: The New Centennial Review* 10, no. 2 (2010): 186.

CHAPTER 6: AN-ARCHAEOLOGIES OF 1968

1. Cuauhtémoc Medina, "Francis Alÿs—'Tu Subrealismo' (Your Subrealism)," *Third Text* 11, no. 38 (1997): 39.

2. Markus Verhagen, "Wasted Effort," *Art Monthly*, no. 327 (June 2009): 15.

3. Jacques Rancière, *The Emancipated Spectator*, trans. Gregory Elliot (London: Verso, 2009), 19.

4. Ibid., 49.

5. Walter Benjamin, "The Work of Art in the Age of Its Technological Reproducibility: Third Version," in *Selected Writings*, ed. Howard Eiland and Michael W. Jennings, trans. Edmund Jephcott (Cambridge: Harvard University Press, 2003), 4: 253.

6. See Nicolas Bourriaud, *Relational Aesthetics*, trans. Simon Pleasance and Fronza Woods (Paris: Les Presses du Réel, 1998), 13.

7. Laddaga's conception here avoids naming the conditions of the present out of which such works emerge, for perhaps they have had no name before us, or perhaps there is no faith left in the line of thought that might have hoped to accord a name to the present crisis. He does mention some of the phenomena that characterize the present in which he writes as aspects of the signifier "globalization." See *Estética de la emergencia: La formación de otra cultura de las artes* (Buenos Aires: Adriana Hidalgo, 2006), 10.

8. Gustavo Buntinx, "Illusion Is Also Power," in *When Faith Moves Mountains*, ed. Francis Alÿs and Cuauhtémoc Medina (Madrid: Turner, 2005), 42.

9. Laddaga, *Estética*, 10.

10. Grant Kester, *The One and the Many: Contemporary Collaborative Art in a Global Context* (Durham: Duke University Press, 2011), 69.

11. Jacques Rancière, *The Politics of Aesthetics: The Distribution of the Sensible*, trans. Gabriel Rockhill (London: Continuum, 2004), 12.

12. Badiou, *The Communist Hypothesis*, 1.

13. Kester, *The One and the Many*, 47.

14. Bishop, *Artificial Hells*, 13.

15. Kester, *The One and the Many*, 69.

16. Bruno Bosteels, *Badiou and Politics* (Durham: Duke University Press, 2011), 275.

17. Kester, *The One and the Many*, 46.

18. Volpi, *El fin de la locura*, 259: "Como Barthes, yo también me siento profun-

damente desencantado hacia la revolución pero, a diferencia suya, me parece que su desafío se ha trasladado al mundo del arte contemporáneo."

19. Bosteels, *The Actuality of Communism*, 282–283.

20. To recall a formulation offered in chapter 5: "It is the spirit of this spiral that keeps one in suspense, holding one's breath—and thus keeps one alive" (Derrida, *Resistances of Psychoanalysis*, 118).

21. My point of reference is Peter Starr, *Logics of Failed Revolt: French Theory after May '68* (Stanford: Stanford University Press, 1995), cited in Kester, *The One and the Many*.

22. I borrow the term "an-archaeological" from Erin Graff Zivin, "Beyond Inquisitional Logic, Or, Toward an An-Archaeological Latin Americanism," *CR: The New Centennial Review* 14, no. 1 (2014): 195–211.

23. Álvaro Vázquez Mantecón, ed., *Memorial del 68* (Mexico City: Turner/UNAM, 2007).

24. Derrida, *Archive Fever*, 95.

25. Http://www.tlatelolco.unam.mx/Recorrido/recorrido.html.

26. See Taibo, *'68* (trans.), 5; idem, *'68*, 5.

27. Museum label for Francis Alÿs, *Cuentos patrióticos*, Mexico City, Memorial del 68, 1 August 2013.

28. The museum's ambient noise evokes that of a restaurant for it is largely composed of little screens (and a few larger screens) talking at the patron.

29. Monsiváis, "1968," xviii.

30. See James C. Scott, *Domination and the Arts of Resistance: Hidden Transcripts* (New Haven: Yale University Press, 1990), 198.

31. Ibid., xiii: "These patterns of disguising *ideological* insubordination are somewhat analogous to the patterns by which, in my experience, peasants and slaves have disguised their efforts to thwart material appropriation of their labor, their production, and their property: for example, poaching, foot-dragging, pilfering, dissimulation, flight. Together, these forms of insubordination might suitably be called the infrapolitics of the powerless."

32. Paz, *The Other Mexico*, 295; *Postdata*, 295: "sacrificio es igual a destrucción productiva."

33. Debroise, ed., *La era de la discrepancia*, 16–17.

34. Olivier Debroise and Cuauhtémoc Medina, "Genealogía de una exposición," in *La era de la discrepancia: Arte y cultura visual en México, 1968–1997*, ed. Olivier Debroise (Mexico City: Turner, 2007), 18–24.

35. This image is found in Alain Badiou, *Handbook of Inaesthetics*, trans. Alberto Toscano (Stanford: Stanford University Press, 2005), 1. He writes: "Historically, philosophy and art are paired up like Lacan's Master and Hysteric. We know that the hysteric comes to the master and says 'Truth speaks through my mouth, I am *here*. You have knowledge, tell me who I am.'"

36. My point of reference is again Bartra, "The Mexican Office."

37. I have made a similar argument in "To Begin Writing: Bellatin, Reunited," *Journal of Latin American Cultural Studies* 20, no. 2 (2011): 105–120.

38. See, for example, the title of a 2009 exposition in Colombia also shown at the Hammer in 2007, Francis Alÿs, *Política del Ensayo* (politics of rehearsal).

39. Luis Camnitzer, *Conceptualism in Latin American Art: Didactics of Liberation* (Austin: University of Texas Press, 2007), 183.

40. A localized reflection on such conditions seems to serve as one optic for receiving a host of works produced in Mexico in this period, which reflection might be understood as the moment of achieved neoliberalism. See, among others, Amy Sara Carroll, "*Muerte sin fin*: Teresa Margolles's Gendered States of Exception," *TDR: The Drama Review* 54, no. 2 (2010): 103–125; Ignacio M. Sánchez Prado, "*Amores Perros*: Exotic Violence and Neoliberal Fear," *Journal of Latin American Cultural Studies* 15, no. 1 (2006): 39–57; Samuel Steinberg, "Touching the Common: Contemporary Art and Mesoamerican War," *Third Text* 27, no. 5 (2013): 607–619.

41. For a thorough exploration of Alÿs's "urbanism," see the fourth chapter of Rubén Gallo, *New Tendencies in Mexican Art: The 1990s* (New York: Palgrave, 2004).

42. Writes Hélio Oiticica: "What would the object be then? A new category, or a new mode of being of the aesthetic proposition? As I see it, while possessing also these two meanings, the most important proposition of the object, of the object-makers, would be that of a new perceptive behavior, created through an increasingly higher level of spectator participation, leading to the overcoming of the object itself as the end of aesthetic expression" (quoted in Pedro Erber, "Theory Materialized: Conceptual Art and Its Others," *Diacritics* 36, no. 1 [2006]: 3).

43. Verhagen, "Wasted Effort," 15.

44. Mark Godfrey, "The Artist as Historian," *October*, no. 120 (2007): 145. Godfrey's observation is true in spirit, but I am compelled to add certain qualifications, for to be sure, there is an Israeli and even Israeli-Jewish Left that does not countenance the idea of a "United Jerusalem."

45. Medina, "Francis Alÿs," 47.

46. "This," says Rancière, "is what Godard calls the fraternity of metaphors: the possibility that a face drawn by Goya's pencil can be associated with the composition of a shot or with the form of a body tortured in the Nazi camps captured by the photographic lens; the possibility of writing the history of the century in many ways by virtue of the dual power of each image—that of condensing a multiplicity of gestures signifying a time and that of being combined with all those images endowed with the same power" (*The Emancipated Spectator*, 129).

47. Jacques Rancière, "The Aesthetic Revolution and Its Outcomes: Emplotments of Autonomy and Heteronomy," *New Left Review* 14 (2002): 142.

48. Ibid., 136.

49. Ibid., 144.

50. Ibid., 147.

51. Ibid., 148.

52. Ibid.

53. Benjamin, "The Work of Art," 4: 251.

54. My point of reference is again Benjamin, who writes that "*in permitting the reproduction to meet the beholder or listener in his own situation*, [the technique of reproduction] *actualizes that which is reproduced*" (ibid., 4: 254 [original emphasis]).

55. Karl Marx, *Capital: A Critique of Political Economy*, trans. Ben Fowkes (London: Penguin, 1976), 1: 481.

56. Indeed, the tendency toward speaking about "the Body" as such mediates both the radical registration of "the death of the subject" as a euphoric opening up of the corporeal frontiers at the delimitation of exteriority (which we can see figured at a certain historical juncture by Deleuze and Guattari's "body without organs" and a technology-infused form of capital-driven expropriation of the body under the logic of intensified forms of "dehumanization" (and we should note that this "humanity" is the one furnished by humanism).

57. Marx, *Capital*, 1: 272.

58. My reading of *Capital* owes much to Beller's *Cinematic Mode of Production*, in which he develops the "attention theory of value."

59. Marx, *Capital*, 1: 482.

60. In an interview, Alÿs put it in the following terms: "It's really two different moments. Two different, consecutive lives of a single piece: the events and the transmission or translation of the events" (Francis Alÿs and Cuauhtémoc Medina, eds., *When Faith Moves Mountains* [Madrid: Turner, 2005], 66).

61. Cadava, *Words of Light*, xxiii.

62. Benjamin, "The Work of Art," 4: 256 (original emphasis).

63. "Esa parte se perdió, me parece, en la toma. No se vio."

64. Benjamin, "The Work of Art," 4: 256.

65. Ibid., 4: 257 (original emphasis).

66. Ana Dezeuze, "Walking the Line: Interview with Francis Alÿs," *Art Monthly*, no. 323 (February 2009): 6.

67. Rancière, *The Emancipated Spectator*, 59.

68. Ibid., 103.

69. Williams, *The Mexican Exception*, 188; Ramírez, *El movimiento estudiantil*, 1: 63.

BIBLIOGRAPHY

Acosta, Abraham. *Thresholds of Illiteracy: Theory, Latin America, and the Crisis of Resistance*. New York: Fordham University Press, 2014.

Aguayo Quezada, Sergio. *1968: Los archivos de la violencia*. Mexico City: Grijalbo/Reforma, 1998.

Aguilar Camín, Héctor. *Después del milagro*. Mexico City: Cal y Arena, 1990.

———. *La guerra de Galio*. Mexico City: Cal y Arena, 1989.

———, and Lorenzo Meyer. *In the Shadow of the Mexican Revolution: Contemporary Mexican History, 1910–1989*. Translated by Luis Alberto Fierro. Austin: University of Texas Press, 1993.

Agustín, José. *El rock de la cárcel*. Mexico City: Editores Mexicanos Unidos, 1986.

Althusser, Louis. *For Marx*. London: Verso, 1990.

Alÿs, Francis, and Cuauhtémoc Medina, eds. *When Faith Moves Mountains*. Madrid: Turner, 2005.

Anderson, Danny J. "The Novels of Jorge Volpi and the Possibility of Knowledge." *Studies in the Literary Imagination* 33, no. 1 (2000): 1–20.

Badiou, Alain. *The Century*. Translated by Alberto Toscano. Cambridge, U.K.: Polity, 2007.

———. *The Communist Hypothesis*. Translated by David Macey and Steve Corcoran. London: Verso, 2010.

———. *Handbook of Inaesthetics*. Translated by Alberto Toscano. Stanford: Stanford University Press, 2005.

———. *Logics of Worlds: Being and Event, 2*. Translated by Alberto Toscano. London: Continuum, 2009.

———. *Metapolitics*. Translated by Jason Barker. London: Verso, 2005.

———. *Philosophy for Militants*. Translated by Bruno Bosteels. London: Verso, 2012.

———. *Théorie de la contradiction*. Paris: François Maspero, 1975.

Baer, Hester, and Ryan Long. "Transnational Cinema and the Mexican State in Alfonso Cuarón's *Y tu mamá también*." *South Central Review* 21, no. 3 (2004): 150–168.

Baer, Ulrich. *Spectral Evidence: The Photography of Trauma*. Cambridge: MIT Press, 2002.

Barthes, Roland. *Camera Lucida: Reflections on Photography*. Translated by Richard Howard. New York: Hill and Wang, 1981.

Bartra, Roger. "Dos visiones del 68." La jaula abierta. Blog of Roger Bartra, 2 October 2007. http://www.letraslibres.com/blog/blogs/index.php?blog=11.

———. "The Mexican Office: Miseries and Splendors of Culture." In *Blood, Ink, and Culture: Miseries and Splendors of the Post-Mexican Condition*, translated by Mark Alan Healey, 3–14. Durham: Duke University Press, 2002.

———. *El reto de la izquierda*. Mexico City: Grijalbo, 1982.

Bataille, Georges. *The Tears of Eros*. Translated by Peter Connor. San Francisco: City Lights, 1989.

Bazin, André. "The Ontology of the Photographic Image." Translated by Hugh Gray. *Film Quarterly* 13, no. 4 (1960): 4–9.

Beasley-Murray, Jon. *Posthegemony: Political Theory and Latin America*. Minneapolis: University of Minnesota Press, 2011.

Beller, Jonathan. *The Cinematic Mode of Production: Attention Economy and the Society of the Spectacle*. Lebanon, N.H.: Dartmouth College Press, 2006.

Bellinghausen, Hermann, and Hugo Hiriart. "Nace el movimiento: Entrevista con Gilberto García Niebla." In *Pensar el 68*, edited by Hermann Bellinghausen. Mexico City: Cal y Arena, 1988.

Benjamin, Walter. *The Arcades Project*. Translated by Howard Eiland and Kevin McLaughlin. Cambridge: Harvard University Press, 1999.

———. "Little History of Photography." In *Selected Writings*, edited by Howard Eiland and Michael W. Jennings, translated by Edmund Jephcott, 2: 507–527. Cambridge: Harvard University Press, 1999.

———. "On the Concept of History." In *Selected Writings*, edited by Howard Eiland and Michael W. Jennings, translated by Edmund Jephcott, 4: 389–400. Cambridge: Harvard University Press, 2003.

———. "Theses on the Philosophy of History." In *Illuminations*, translated by Harry Zohn, 253–264. New York: Schocken, 1969.

———. "The Work of Art in the Age of Its Technological Reproducibility: Third Version." In *Selected Writings*, edited by Howard Eiland and Michael W. Jennings, translated by Edmund Jephcott, 4: 251–283. Cambridge: Harvard University Press, 2003.

Beverley, John. *Latinamericanism after 9/11*. Durham: Duke University Press, 2011.

———. *Subalternity and Representation: Arguments in Cultural Theory*. Durham: Duke University Press, 1999.

———. *Testimonio: On the Politics of Truth*. Minneapolis: University of Minnesota Press, 2004.

Bishop, Claire. *Artificial Hells: Participatory Art and the Politics of Spectatorship*. London: Verso, 2012.

Bolaño, Roberto. "Sevilla me mata." In *Palabra de América*, 17–21. Barcelona: Seix Barral, 2004.

Bosteels, Bruno. *The Actuality of Communism*. London: Verso, 2011.

———. *Badiou and Politics*. Durham: Duke University Press, 2011.

———. *Marx and Freud in Latin America: Politics, Psychoanalysis, and Religion in Times of Terror*. London: Verso, 2012.

———. "Mexico City through the Lens of Violence and Utopia." *ReVista: Harvard Review of Latin America* 2 (2003): 69–70.

Bourriaud, Nicolas. *Relational Aesthetics*. Translated by Simon Pleasance and Fronza Woods. Paris: Les Presses du Réel, 1998.

Brewster, Claire. *Responding to Crisis in Contemporary Mexico: The Political Writings of Paz, Fuentes, Monsiváis, and Poniatowska*. Tucson: University of Arizona Press, 2005.

Buntinx, Gustavo. "Illusion Is Also Power." In *When Faith Moves Mountains*, edited by Francis Alÿs and Cuauhtémoc Medina, 30–63. Madrid: Turner, 2005.

Cadava, Eduardo. *Words of Light: Theses on the Photography of History*. Princeton: Princeton University Press, 1997.

Camnitzer, Luis. *Conceptualism in Latin American Art: Didactics of Liberation*. Austin: University of Texas Press, 2007.

Carey, Elaine. *Plaza of Sacrifices: Gender, Power, and Terror in 1968 Mexico*. Albuquerque: University of New Mexico Press, 2005.

Carroll, Amy Sara. "*Muerte sin fin*: Teresa Margolles's Gendered States of Exception." *TDR: The Drama Review* 54, no. 2 (2010): 103–125.

Castro Ricalde, Maricruz. "Popular Mexican Cinema and Undocumented Immigrants." Translated by Emily Hind. *Discourse* 26, no. 1 (2004): 194–213.

Centeno, Miguel Ángel. *Democracy within Reason: Technocratic Revolution in Mexico*. University Park: Pennsylvania State University Press, 1997.

Chávez, Daniel. "The Eagle and the Serpent on the Screen: The State as Spectacle in Mexican Cinema." *Latin American Research Review* 45, no. 3 (2010): 115–141.

Chávez Castañeda, Ricardo, and Celso Santajuliana. *La generación de los enterrados*. Mexico City: Nueva Imagen, 2000.

Chorba, Carrie C. *Mexico, from Mestizo to Multicultural: National Identity and Recent Representations of the Conquest*. Nashville: Vanderbilt University Press, 2007.

Clausewitz, Carl von. *On War*. Edited by Beatrice Heuser, translated by Michael Howard and Peter Paret. New York: Oxford University Press, 2006.

Cohn, Deborah. "The Mexican Intelligentsia, 1950–1968: Cosmopolitanism, National Identity, and the State." *Mexican Studies / Estudios Mexicanos* 21, no. 1 (2005): 141–182.

Corona, Ignacio. *Después de Tlatelolco: Las narrativas políticas en México (1976–1990): Un análisis de sus estrategias retóricas y representacionales*. Guadalajara: Universidad de Guadalajara, 2001.

Cusset, François. *French Theory: How Foucault, Derrida, Deleuze, & Co. Transformed the Intellectual Life of the United States.* Translated by Jeff Fort. Minneapolis: University of Minnesota Press, 2008.

Dagognet, François. *Etienne-Jules Marey: A Passion for the Trace.* Translated by Jeanine Herman and Robert Galeta. New York: Zone, 1992.

Debroise, Olivier, ed. *La era de la discrepancia: Arte y cultura visual en México, 1968–1997.* Translated by Joëlle Rorive, Ricardo Vinós, and James Oles. Mexico City: Turner, 2007.

———. *Mexican Suite: A History of Photography in Mexico.* Translated by Stella de Sá Rego. Austin: University of Texas Press, 2001.

Debroise, Olivier, and Cuauhtémoc Medina. "Genealogía de una exposición." In *La era de la discrepancia: Arte y cultura visual en México, 1968–1997,* edited by Olivier Debroise, 18–24. Mexico City: Turner, 2007.

De la Fuente, Juan Ramón. Prologue to *Parte de guerra II: Los rostros del 68.* Edited by Julio Scherer García and Carlos Monsiváis, 11–14. Mexico City: Aguilar, 2002.

Del Castillo Troncoso, Alberto. "La frontera imaginaria: Usos y manipulaciones de la fotografía en la investigación histórica en México." *Cuicuilco* 14, no. 41 (2007): 193–215.

Deleuze, Gilles. "May '68 Did Not Take Place." In *Two Regimes of Madness: Texts and Interviews 1975–1995,* edited by David Lapoujade, translated by Ames Hodges and Mike Taormina, 233–236. Los Angeles: Semiotext(e), 2006.

Delgado, Álvaro, and Rodrigo Vera. "Sobrevivió 35 años . . ." *Proceso,* 23 December 2001.

De Luca, Tiago. "Carnal Spirituality: The Films of Carlos Reygadas." *Senses of Cinema.* Accessed March 31, 2012. Http://www.sensesofcinema.com/2010/feature-articles/carnal-spirituality-the-films-of-carlos-reygadas-2/.

De Luna, Andrés. "The Labyrinths of History." In *Mexican Cinema,* edited by Paulo Antonio Paranaguá, translated by Ana M. López, 171–177. London and Mexico City: British Film Institute / IMCINE, 1993.

Derrida, Jacques. *Archive Fever: A Freudian Impression.* Translated by Eric Prenowitz. Chicago: University of Chicago Press, 1995.

———. "*Fors*: The Anglish Words of Nicolas Abraham and Maria Torok." Foreword to *The Wolf Man's Magic Word: A Cryptonymy,* by Nicolas Abraham and Maria Torok, translated by Barbara Johnson, xi–xlviii. Minneapolis: University of Minnesota Press, 1986.

———. *Resistances of Psychoanalysis.* Translated by Peggy Kamuf. Stanford: Stanford University Press, 1998.

———. *Rogues: Two Essays on Reason.* Translated by Pascale-Anne Brault and Michael Naas. Stanford: Stanford University Press, 2005.

———. *Specters of Marx: The State of the Debt, the Work of Mourning, and the New International.* Translated by Peggy Kamuf. New York: Routledge, 2006.

Dezeuze, Ana. "Walking the Line: Interview with Francis Alÿs." *Art Monthly*, no. 323 (February 2009): 1–6.

Didi-Huberman, Georges. *Confronting Images: Questioning the Ends of a Certain History of Art*. Translated by John Goodman. University Park: Pennsylvania State University Press, 2005.

———. *Images in Spite of All: Four Photographs from Auschwitz*. Translated by Shane B. Lillis. Chicago: University of Chicago Press, 2008.

———. *Invention of Hysteria: Charcot and the Photographic Iconography of the Salpêtrière*. Translated by Alisa Hartz. Cambridge: MIT Press, 2004.

Doane, Mary Ann. *The Emergence of Cinematic Time: Modernity, Contingency, the Archive*. Cambridge: Harvard University Press, 2002.

Domínguez Michael, Christopher. "La patología de la recepción." *Letras Libres* (March 2004): 48–52.

Dove, Patrick. "Exígele lo nuestro: Deconstruction, Restitution and the Demand of Speech in *Pedro Páramo*." *Journal of Latin American Cultural Studies* 10, no. 1 (March 2001): 25–44.

Egan, Linda. *Carlos Monsiváis: Culture and Chronicle in Contemporary Mexico*. Tucson: University of Arizona Press, 2001.

Egginton, William. "Reality Is Bleeding: A Brief History of Film from the Sixteenth Century." *Configurations* 9, no. 2 (2001): 207–229.

Elizondo, Salvador. *Camera lucida*. Mexico City: Fondo de Cultura Económica, 2001.

———. "Entre el Nuevo Cine y *Rojo amanecer*." In *Estanquillo*, 13–16. Mexico City: Fondo de Cultura Económica, 2001.

———. *Farabeuf, o la crónica de un instante*. Mexico City: Joaquín Mortiz, 1965.

Epplin, Craig. "Sacrifice and Recognition in Carlos Reygadas's *Japón*." *Mexican Studies / Estudios Mexicanos* 28, no. 2 (2012): 287–305.

Erber, Pedro. "Theory Materialized: Conceptual Art and Its Others." *Diacritics* 36, no. 1 (2006): 3–12.

Foster, David William. *Mexico City in Contemporary Mexican Cinema*. Austin: University of Texas Press, 2002.

Foucault, Michel. *Discipline and Punish: The Birth of the Modern Prison*. Translated by Alan Sheridan. New York: Vintage, 1977.

———. *History of Sexuality: Volume One*. Translated by Robert Hurley. New York: Vintage, 1980.

Freud, Sigmund. *The Interpretation of Dreams*. Translated and edited by James Strachey. Philadelphia: Basic Books, 2010.

———. *Totem and Taboo: Some Points of Agreement between the Mental Lives of Savages and Neurotics*. Translated by James Strachey. London: Routledge, 2001.

Gallo, Rubén. *New Tendencies in Mexican Art: The 1990s*. New York: Palgrave, 2004.

Gilabert, César. *El hábito de la utopía: Análisis del imaginario sociopolítico del movimiento estudiantil de México, 1968*. Mexico City: Miguel Ángel Porrúa, 1993.

Godfrey, Mark. "The Artist as Historian." *October*, no. 120 (2007): 140–172.

González, Aníbal. "Viaje a la semilla del amor: *Del amor y otros demonios* y la nueva narrativa sentimental." *Hispanic Review* 73, no. 4 (2005): 389–408.

González de Alba, Luis. *Los días y los años*. Mexico City: Era, 1971.

González Echevarría, Roberto. *Myth and Archive: A Theory of Latin American Narrative*. Durham: Duke University Press, 1998.

Graff Zivin, Erin. "Beyond Inquisitional Logic, Or, Toward an An-Archaeological Latin Americanism." *CR: The New Centennial Review* 14, no. 1 (2014): 195–211.

Guevara, Ernesto. *The Bolivian Diary*. North Melbourne: Ocean Press, 2006.

Guha, Ranajit. "The Prose of Counterinsurgency." In *Selected Subaltern Studies*, edited by Ranajit Guha and Gayatri Chakravorty Spivak, 45–88. Oxford: Oxford University Press, 1988.

Harvey, David. *A Brief History of Neoliberalism*. Oxford: Oxford University Press, 2005.

Hirsch, Marianne. *Family Frames: Photography, Narrative, and Postmemory*. Cambridge: Harvard University Press, 1997.

Jameson, Fredric. "Periodizing the Sixties." In *The 60s without Apology*, edited by Sohnya Sayres et al., 178–209. Minneapolis: University of Minnesota Press, 1984.

Jardón, Raúl. *1968: El fuego de la esperanza*. Mexico City: Siglo XXI, 1998.

Johnson, David E. "Mexico's Gas, Mexico's Tears: Expositions of Identity." In *What Happens to History: The Renewal of Ethics in Contemporary Thought*, edited by Howard Marchitello, 149–187. London: Routledge, 2001.

Jörgensen, Beth E. *The Writing of Elena Poniatowska: Engaging Dialogues*. Austin: University of Texas Press, 1994.

Kester, Grant. *The One and the Many: Contemporary Collaborative Art in a Global Context*. Durham: Duke University Press, 2011.

Kieran, John, and Arthur Daley. *The Story of the Olympic Games: 776 B.C. to 1968*. Philadelphia: J. B. Lippincott, 1969.

Kiernan, Maureen. "Making Films Politically: Marxism in Eisenstein and Godard." *Alif: Journal of Comparative Poetics*, no. 10 (1990): 93–113.

Klett, Mark, Kyle Bajakian, William L. Fox, Michael Marshall, Toshi Ueshina, and Byron G. Wolfe. *Third Views, Second Sights: A Rephotographic Survey of the American West*. Santa Fe: Museum of New Mexico Press, 2004.

Kracauer, Siegfried. "Photography." In *The Mass Ornament: Weimar Essays*, translated by Thomas Y. Levin, 47–63. Cambridge: Harvard University Press, 1995.

Kujundzic, Dragan. "Archigraphia: On the Future of Testimony and the Archive to Come." *Discourse* 25, no. 1 (2003): 166–188.

Kurlansky, Mark. *1968: The Year That Rocked the World*. New York: Ballantine, 2004.

Lacan, Jacques. *The Four Fundamental Concepts of Psychoanalysis*. Edited by Jacques-Alain Miller, translated by Alan Sheridan. New York: Norton, 1998.

———. *The Seminar of Jacques Lacan, Book II: The Ego in Freud's Theory and in the Technique of Psychoanalysis 1954–1955*. New York: Norton, 1991.

Laclau, Ernesto. *Emancipation(s)*. London: Verso, 1996.

————. *On Populist Reason*. London: Verso, 2005.

————. "Why Constructing a People Is the Main Task of Radical Politics." *Critical Inquiry* 32, no. 4 (2006): 646–680.

Laddaga, Reinaldo. *Estética de la emergencia: La formación de otra cultura de las artes.* Buenos Aires: Adriana Hidalgo, 2006.

Leal, Luis. "Tlatelolco, Tlatelolco." In *A Luis Leal Reader*, edited by Ilan Stavans, 335–348. Chicago: Northwestern University Press, 2007.

Legrás, Horacio. "The Revolution and Its Specters: Staging the Popular in the Mexican Revolution." *Journal of Latin American Cultural Studies* 14, no. 1 (2005): 3–24.

Lemus, Rafael. "Lo que todo lector (no) quisiera saber del siglo XX." *Letras Libres* (December 2006): 74–75.

Levinson, Brett. *The Ends of Literature: The Latin American "Boom" in the Neoliberal Marketplace.* Stanford: Stanford University Press, 2001.

————. *Market and Thought: Meditations on the Political and Biopolitical.* New York: Fordham University Press, 2004.

Lippit, Akira Mizuta. *Atomic Light (Shadow Optics).* Minneapolis: University of Minnesota Press, 2005.

Loaeza, Soledad. "México 1968: Los orígenes de la transición." In *La transición interrumpida: México 1968–1988*, edited by Ilán Semo, 15–48. Mexico City: Nueva Imagen, 1993.

Lomnitz-Adler, Claudio. *Exits from the Labyrinth: Culture and Ideology in the Mexican National Space.* Berkeley: University of California Press, 1992.

Long, Ryan. *Fictions of Totality: The Mexican Novel, 1968, and the National-Popular State.* West Lafayette, Ind.: Purdue University Press, 2008.

————. "Lecumberri, Fact, and Fiction: The Prison Writings of Álvaro Mutis and Luis González de Alba." *Revista de Estudios Hispánicos* 40 (2006): 361–377.

Lund, Joshua. *The Mestizo State: Reading Race in Modern Mexico.* Minneapolis: University of Minnesota Press, 2012.

Maciel, David R. "Cinema and the State in Contemporary Mexico, 1970–1999." In *Mexico's Cinema: A Century of Filmmakers*, edited by Joanne Hershfield and David R. Maciel, 197–229. Wilmington, Del.: Scholarly Resources, 1999.

Mahieux, Viviane. *Urban Chroniclers in Modern Latin America: The Shared Intimacy of Everyday Life.* Austin: University of Texas Press, 2011.

Martin, Gerald. *Journeys through the Labyrinth.* London: Verso, 1989.

Martínez, Sanjuana. "2 de octubre: Imágenes de un fotógrafo del gobierno." *Proceso*, 9 December 2001.

————. Introduction to *Parte de guerra II: Los rostros del 68*, edited by Julio Scherer García and Carlos Monsiváis, 15–22. Mexico City: Aguilar, 2002.

Marx, Karl. *Capital: A Critique of Political Economy.* Vol. 1. Translated by Ben Fowkes. London: Penguin, 1976.

Medina, Cuauhtémoc. "Francis Alÿs—'Tu Subrealismo' (Your Subrealism)." *Third Text* 11, no. 38 (1997): 39–54.

Meillassoux, Quentin. "History and Event in Alain Badiou." Translated by Thomas Nail. *Parrhesia* 12 (2011): 1–11.

Mejía Duque, Jaime. *Narrativa y neocoloniaje en América Latina*. Buenos Aires: Crisis, 1974.

Memorial del 68. Museum label for Francis Alÿs, *Cuentos patrióticos*, Mexico, 1 August 2013.

Mendoza, María Luisa. *Con él, conmigo, con nosotros tres*. Mexico City: Joaquín Mortiz, 1971.

Metz, Christian. *The Imaginary Signifier: Psychoanalysis and the Cinema*. Translated by Celia Britton, Annwyl Williams, Ben Brewster, and Alfred Guzzetti. Bloomington: Indiana University Press, 1982.

———. "Photography and Fetish." *October* 34 (1985): 81–90.

Meyer, Lorenzo. "Una democracia mediocre." *Metapolítica* 10, no. 48 (2006): 31–37.

Monsiváis, Carlos. *Días de guardar*. Mexico City: Era, 1970.

———. *Entrada libre: Crónicas de la sociedad que se organiza*. Mexico City: Era, 1987.

———. *Maravillas que son, sombras que fueron: La fotografía en México*. Mexico City: Era, 2012.

———. "Mexican Cinema: Of Myths and Demystifications." In *Mediating Two Worlds: Cinematic Encounters in the Americas*, edited by John King, Ana M. López, and Manuel Alvarado, 139–146. London: British Film Institute, 1993.

———. "1968: Dramatis personae." Prologue to *México, una democracia utópica: El movimiento estudiantil del 68*, by Sergio Zermeño, xi–xl. Mexico City: Siglo XXI, 1978.

———. "Persistencia de la memoria." In *Parte de guerra II: Los rostros del 68*, edited by Carlos Monsiváis and Julio Scherer García, 27–40. Mexico City: Aguilar, 2002.

———. *Los rituales del caos*. Mexico City: Era, 1995.

———. *El 68: La tradición de la resistencia*. Mexico City: Era, 2008.

Montemayor, Carlos. *Rehacer la historia: Análisis de los nuevos documentos del 2 de octubre de 1968 en Tlatelolco*. Mexico City: Planeta, 2000.

Moraña, Mabel. "El culturalismo de Carlos Monsiváis: Ideología y carnavalización en tiempos globales." In *El arte de la ironía: Carlos Monsiváis ante la crítica*, edited by Mabel Moraña and Ignacio M. Sánchez Prado, 21–59. Mexico City: Era/UNAM, 2007.

Moreiras, Alberto. "Ethics and Politics in Héctor Aguilar Camín's *Morir en el Golfo* and *La guerra de Galio*." *South Central Review* 21, no. 3 (2004): 70–84.

———. *The Exhaustion of Difference: The Politics of Latin American Cultural Studies*. Durham: Duke University Press, 2001.

———. "Infrapolitical Literature: Hispanism and the Border." *CR: The New Centennial Review* 10, no. 2 (2010): 183–203.

———. "Posthegemonía, o más allá del principio del placer." *alter/nativas: Revista de Estudios Culturales Latinoamericanos* 1, no. 1 (2013). Http://alternativas.osu.edu/es/issues/autumn-2013/essays/moreiras.html.

———. *Tercer espacio: Literatura y duelo en América Latina*. Santiago de Chile: LOM/Arcis, 1999.

Mraz, John. *Looking for Mexico: Modern Visual Culture and National Identity*. Durham: Duke University Press, 2009.

Mulvey, Laura. *Death 24× a Second: Stillness and the Moving Image*. London: Reaktion Books, 2006.

Niessen, Niels. "Miraculous Realism: Spinoza, Deleuze, and Carlos Reygadas's *Stellet Licht*." *Discourse* 33, no. 1 (2011): 27–54.

Noble, Andrea. "Recognizing Historical Injustice through Photography: Mexico 1968." *Theory, Culture & Society* 27, nos. 7–8 (2011): 184–213.

Novo, Salvador. *The War of the Fatties and Other Stories from Aztec History*. Translated by Michael Alderson. Austin: University of Texas Press, 1994.

Ochoa, John Andrés. *The Uses of Failure in Mexican Literature and Identity*. Austin: University of Texas Press, 2004.

Palou, Pedro Ángel, et al. "Manifesto del crack." In *Crack: Instrucciones de uso*. Mexico City: Mondadori, 2004.

Paz, Octavio. *The Collected Poems of Octavio Paz, 1957–1987*. Translated and edited by Eliot Weinberger. New York: New Directions, 1991.

———. *Ladera este*. In *Obra poética I*, vol. II of *Obras completas*, edited by Octavio Paz, 341–390. Mexico City: Fondo de Cultura Económica, 2006.

———. *The Other Mexico*. In *The Labyrinth of Solitude and Other Writings*. Translated by Lysander Kemp, Yara Milos, and Rachel Phillips Belash, 213–325. New York: Grove Press, 1985.

———. *Postdata*. 1969. In *El laberinto de la soledad: Postdata: Vuelta a El laberinto de la soledad*, 235–318. Mexico City: Fondo de Cultura Económica, 2004.

Pensado, Jaime M. *Rebel Mexico: Student Unrest and Authoritarian Political Culture during the Long Sixties*. Stanford: Stanford University Press, 2013.

Perilli, Carmen. *Catálogo de ángeles mexicanos: Elena Poniatowska*. Rosario, Arg.: Beatriz Viterbo Editora, 2006.

Pitol, Sergio. "Con Monsiváis, el joven." In *El arte de la ironía: Carlos Monsiváis ante la crítica*, edited by Mabel Moraña and Ignacio M. Sánchez Prado, 339–358. Mexico City: Era/UNAM, 2007.

Pohl, Burkhard. "'Ruptura y continuidad.' Jorge Volpi, el Crack y la herencia del 68." *Revista de Crítica Literaria Latinoamericana* 30, no. 59 (2004): 53–70.

Poniatowska, Elena. *Amanecer en el Zócalo: Los 50 días que confrontaron a México*. Mexico City: Planeta, 2007.

———. *Fuerte es el silencio*. Mexico City: Era, 1980.

———. *Hasta no verte Jesús mío*. Mexico City: Era, 1982.

———. *Massacre in Mexico*. Translated by Helen R. Lane. Columbia: University of Missouri Press, 1992.

———. *Nada, nadie: Las voces del temblor*. Mexico City: Era, 1988.

———. *La noche de Tlatelolco*. Mexico City: Era, 1971.

———. *La noche de Tlatelolco*. Edición especial. Mexico City: Era, 2012.

———. "Son cuerpos señor . . ." *Equis: Cultura y Sociedad* 5 (1998): 3–8.

Power, Nina, and Alberto Toscano. "The Philosophy of Restoration: Alain Badiou and the Enemies of May." *boundary 2* 36, no. 1 (2009): 27–46.

Prakash, Gyan. "The Impossibility of Subaltern History." *Nepantla: Views from South* 1, no. 2 (2000): 287–294.

Price, Brian L. *Cult of Defeat in Mexico's Historical Fiction: Failure, Trauma, and Loss.* New York: Palgrave Macmillan, 2012.

Rama, Ángel. "El 'boom' en perspectiva." In *Más allá del boom: Literatura y mercado*, edited by Ángel Rama et al. Mexico City: Marcha, 1981.

Ramírez, Ramón. *El movimiento estudiantil de México (julio/diciembre de 1968).* 2 vols. Mexico City: Era, 1969.

Rancière, Jacques. "The Aesthetic Revolution and Its Outcomes: Emplotments of Autonomy and Heteronomy." *New Left Review* 14 (2002): 133–151.

———. *Disagreement: Politics and Philosophy.* Translated by Julie Rose. Minneapolis: University of Minnesota Press, 1999.

———. *The Emancipated Spectator.* Translated by Gregory Elliot. London: Verso, 2009.

———. *The Future of the Image.* Translated by Gregory Elliot. London: Verso, 2007.

———. *The Politics of Aesthetics: The Distribution of the Sensible.* Translated by Gabriel Rockhill. London: Continuum, 2004.

Revueltas, Andrea, and Philippe Cheron. Prologue to *José Revueltas y el 68*, 7–24. Mexico City: Era/UNAM, 1998.

Revueltas, José. *El apando.* Mexico City: Era, 2005.

———. *México 68: Juventud y revolución.* Edited by Andrea Revueltas and Philippe Cheron. Mexico City: Era, 1978.

Ross, Kristin. *May '68 and Its Afterlives.* Chicago: University of Chicago Press, 2002.

Sánchez Prado, Ignacio M. "*Amores Perros*: Exotic Violence and Neoliberal Fear." *Journal of Latin American Cultural Studies* 15, no. 1 (2006): 39–57.

———. *Naciones intelectuales: Las fundaciones de la modernidad literaria mexicana, 1917–1959.* West Lafayette, Ind.: Purdue University Press, 2009.

———. *Screening Neoliberalism: Mexican Cinema, 1988–2012.* Nashville: Vanderbilt University Press, 2014.

Santner, Eric L. *Stranded Objects: Mourning, Memory, and Film in Postwar Germany.* Ithaca, N.Y.: Cornell University Press, 1993.

Scott, James C. *Domination and the Arts of Resistance: Hidden Transcripts.* New Haven: Yale University Press, 1990.

Sedgwick, Eve Kosofsky. *Epistemology of the Closet.* Berkeley: University of California Press, 1990.

Sefchovich, Sara. *México: País de ideas, país de novelas. Una sociología de la literatura mexicana.* Mexico City: Grijalbo, 1987.

Sekula, Allan. "The Body and the Archive." *October* 39 (1986): 3–64.

Shaw, Deborah. *The Three Amigos: The Transnational Filmmaking of Guillermo Del*

Toro, Alejandro González Iñárritu, and Alfonso Cuarón. Manchester, U.K.: Manchester University Press, 2013.

Smith, Paul Julian. *Mexican Screen Fiction: Between Cinema and Television*. Cambridge, U.K.: Polity, 2014.

Solanas, Fernando, and Octavio Getino. "Towards a Third Cinema: Notes for the Development of a Cinema of Liberation in the Third World." In *New Latin American Cinema, Volume I: Theory, Practices, and Transcontinental Articulations*, edited by Michael T. Martin, translated by Julianne Burton and Michael T. Martin, 33–58. Detroit: Wayne State University Press, 1997.

Sommer, Doris. "Taking a Life: Hot Pursuit and Cold Rewards in a Mexican Testimonial Novel." *Signs* (1995): 913–940.

Sorensen, Diana. *A Turbulent Decade Remembered: Scenes from the Latin American Sixties*. Stanford: Stanford University Press, 2007.

Spota, Luis. *La plaza*. Mexico City: Planeta, 2006.

Starr, Peter. *Logics of Failed Revolt: French Theory after May '68*. Stanford: Stanford University Press, 1995.

Steinberg, Samuel. "Cowardice—An Alibi: On Prudence and *Senselessness*." *CR: The New Centennial Review* 14, no. 1 (2014): 175–194.

———. "To Begin Writing: Bellatin, Reunited." *Journal of Latin American Cultural Studies* 20, no. 2 (2011): 105–120.

———. "Touching the Common: Contemporary Art and Mesoamerican War." *Third Text* 27, no. 5 (2013): 607–619.

Taibo, Paco Ignacio, II. *'68*. Translated by Donald Nicholson-Smith. New York: Seven Stories Press, 2004.

———. *'68*. New York: Siete Cuentos Editorial, 2004.

Thornton, Niamh. *Revolution and Rebellion in Mexican Film*. New York: Bloomsbury, 2013.

Vázquez Mantecón, Álvaro, ed. *Memorial del 68*. Mexico City: Turner/UNAM, 2007.

———. "Visualizing 1968." In *La era de la discrepancia: Arte y cultura visual en México, 1968–1997*, edited by Olivier Debroise, translated by Joëlle Rorive, Ricardo Vinós, and James Oles, 37–39. Mexico City: Turner, 2007.

Verhagen, Markus. "Wasted Effort." *Art Monthly*, no. 327 (June 2009): 13–16.

Viénet, René. *Enrages and Situationists in the Occupation Movement: Paris, May, 1968*. New York: Autonomedia, 1993.

Villacañas Berlanga, José Luis. "The Liberal Roots of Populism: A Critique of Laclau." Translated by Jorge Ledo. *CR: The New Centennial Review* 10, no. 2 (2010): 151–182.

Volpi, Jorge. *En busca de Klingsor*. Mexico City: Seix Barral, 1999.

———. "The End of the Conspiracy: Intellectuals and Power in 20th-Century Mexico." Translated by Carl Good. *Discourse* 23, no. 2 (2001): 144–154.

———. "El fin de la conjura." *Letras Libres* (October 2000): 56–60.

———. *El fin de la locura*. Mexico City: Seix Barral, 2003.

———. *La imaginación y el poder: Una historia intelectual del 1968*. Mexico City: Era, 1998.

———. *No será la tierra*. Mexico City: Alfaguara, 2006.

Williams, Gareth. *The Mexican Exception: Sovereignty, Police, and Democracy*. New York: Palgrave Macmillan, 2011.

———. "Why Write a Nineteenth Century Novel for the Twenty-First Century? Juan Villoro's *El testigo* and the Melodrama of Crisis." Paper presented at the Annual Meeting of the Latin American Studies Association, Chicago, May 21–24, 2014.

Wypijewski, Joann, and Milton Rogovin. *Triptychs: Buffalo's Lower West Side Revisited*. New York: Norton, 1994.

Yúdice, George. *The Expediency of Culture: Uses of Culture in the Global Era*. Durham: Duke University Press, 2003.

Zapata, Roger. "La pobreza de la filosofía como material novelesco: *El fin de la locura* de Jorge Volpi." *A Contracorriente* 2, no. 1 (2004): 57–66.

Zermeño, Sergio. *México: Una democracia utópica: El movimiento estudiantil del 68*. Mexico City: Siglo XXI, 1978.

Žižek, Slavoj. "Against the Populist Temptation." *Critical Inquiry* 32, no. 3 (March 2006): 551–574.

Zolov, Eric. *Refried Elvis: The Rise of the Mexican Counterculture*. Berkeley: University of California Press, 1999.

INDEX